A Passion for Flying

A PASSION FOR FLYING

8,000 Hours of RAF Flying

Group Captain Tom Eeles BA, FRAeS

Pen & Sword
AVIATION

First published in Great Britain in 2008 by
Pen & Sword Aviation
an imprint of
Pen & Sword Books Ltd

ISBN 978 1 84415 688 7

A CIP catalogue record for this book is
available from the British Library

Typeset in Palatino by
Phoenix Typesetting, Auldgirth, Dumfriesshire

Printed and bound in England by
CPI UK

Pen & Sword Books Ltd incorporates the Imprints of Pen & Sword Aviation,
Pen & Sword Maritime, Pen & Sword Military, Wharncliffe Local History,
Pen & Sword Select, Pen & Sword Military Classics and Leo Cooper.

For a complete list of Pen & Sword titles please contact
PEN & SWORD BOOKS LIMITED
47 Church Street, Barnsley, South Yorkshire, S70 2AS, England
E-mail: enquiries@pen-and-sword.co.uk
Website: www.pen-and-sword.co.uk

Contents

Preface

Annual Confidential Reports are an unavoidable feature of life in the Services. Even after more than forty years in uniform I could not escape them. It was therefore with some pleasure that, during the ritual debrief of my final report, I heard from my squadron commander on Cambridge University Air Squadron that I still had 'a passion for flying after all these years'.

The phrase 'a passion for flying' stuck in my mind and so after finishing my time with the squadron in late 2004 I decided to record my experiences in the cockpit, over a period of more than forty years, before the passage of time dimmed my memories. It was a fascinating era to have been involved with the RAF. The RAF that I joined still had a permanent global presence and operated a huge variety of aircraft, despite the 1957 Sandys White Paper that indicated that there was no future for manned military aircraft. The Cold War was at its height and involved nearly every RAF unit in some way or other, yet we still had many major commitments in the Commonwealth. Our combat aircraft were primitive by today's standards, yet in terms of pure performance they were exciting and challenging to operate. Nuclear weapons featured significantly in our inventory; today the RAF has none.

I was lucky enough to be involved in a wide range of military flying activity, a large proportion being in the strike/attack business. But I also dabbled in air defence and had a long association with flying training in all its variety, ranging from operational conversion right down to elementary teaching. I avoided ground tours wherever possible and in this I had a high success rate. Even when trapped in an office I seemed able to escape back into the air at the slightest excuse.

As this wonderful experience now draws to a close I can look

back and say that I always looked forward to going to work in the morning, apart perhaps when stuck on a ground tour. I hope you enjoy sharing my experiences in the air, some good, some not, some hilarious, some serious. My thanks go to my wife and family for their encouragement to set all this down 'for the record', and to my publishers, Pen and Sword, for their support.

Prologue

It was 4 January 1967. The Singaporean sun shone as bright as ever over the RAF Changi Fairy Point Officer's Club swimming pool, social centre and pride of the Headquarters Far East Air Force, yet somehow it didn't seem quite such an idyllic day like the last few had been. Various pilots and observers from 801 Naval Air Squadron lounged around the pool, eyeing up the female talent, but without the same enthusiasm that had been evident in the previous fortnight. Instead of the normal glasses of Tiger beer they were clutching innocuous drinks such as Coca-Cola or orange juice. The local Chinese barman was intrigued; what was it that had caused this unusual change in the pattern of their behaviour? Very soon the answer to this conundrum appeared, quite literally from around the corner of Changi creek. The great grey bulk of the aircraft carrier HMS *Victorious* came into view, steaming slowly down the narrow tidal waterway towards the open South China Sea. We watched her with critical eyes as she slowly slid past us. Today was the day that we were due to re-embark, and for me it would be my first time landing on board.

My goodness, she really doesn't look very big, was my immediate reaction. Up to now my visits to her had been confined to the Royal Navy dockyard in Singapore, where, lying alongside the quay, she had seemed really quite large, certainly large enough in which to become comprehensively lost whilst exploring inside her. My small number of worldly possessions was now buried down on 6 deck, in cabin 6Q6. It was really not much larger than a medium-sized wardrobe, with easy access to a large hole just outside the door giving a view of a rotating propeller shaft many feet below. This afternoon we were all going to re-embark after the Christmas and New Year break,

spent by most of the Squadron's bachelors in the fleshpots of downtown Singapore.

There had been some flying during this period, which involved getting used to operating the Buccaneer in the steaming tropical heat and carrying out many sessions of MADDLS (Mirror Assisted Dummy Deck Landings), the nearest one could simulate carrier-landing techniques ashore. Not only did this annoy the permanent RAF residents of RAF Changi, who were all in the rather more sedate transport and maritime patrol business, but also a 200 feet wide, 9000-foot long runway that never moved, could never be like a small metal flight deck 700 feet long by 60 feet wide, 50 feet above the sea, with a habit of moving up and down and travelling around at 25 knots. The married men on the Squadron had now all returned from their leave in the UK, leaving behind their families. The Squadron was up to full strength, and as the Fleet Air Arm's first squadron to be embarked at sea with the S2 version of the Buccaneer, the eyes of the Royal Navy were on us. We downed our drinks, paid our bills, gathered up our few bits and pieces and made our way to the Naval Aircraft Support Unit where the Sea Vixens and Buccaneers were waiting on the hardstanding.

There then followed the inevitable delay associated with carrier operations whilst the ship found a suitable piece of sea to sail around in whilst recovering its Air Group. The Wessex helicopters and Gannet airborne early warning aircraft were the first to land on, followed by the Sea Vixen all-weather fighters. Finally, we were given our 'Charlie' time and launched out of Changi, with ever-increasing anticipation and, in my case, a degree of apprehension. By this time the usual afternoon tropical storms had brewed up, the sun had disappeared, the clouds had rolled in and the wind had picked up, kicking up a short steep sea in the piece of ocean where *Victorious* was sailing. As a consequence *Victorious* started to pitch gently as she sailed into the prevailing wind for our recovery, making the business of deck landing, challenging enough at the best of times, now even more so. We carried out the requisite number of touch-and-go landings, interspersed with many wave offs owing to poor approaches and a pitching deck, until finally each of us was told to put the hook down and land on. Just at this point a squall came through and the ship began to pitch close to the limits; we were waved off and as all aircraft reached diversion fuel at about

the same time everyone went back to Changi for the night. I felt a mixture of relief (at least I had been told to put my hook down after some pretty poor attempts at deck landings) and disappointment – the Buccaneers were the only ones who hadn't got back on board.

The next day the storms had all evaporated, the sun shone brightly and off we all went again early in the morning, without having time to worry about what lay ahead. The sea was smooth, the deck steady, the ship was not pushing out much funnel smoke – the conditions were perfect. After two hook-up touch-and-go landings, I was told by Flyco to put the hook down. My next approach was good and steady, nicely on the approach path (as indicated by the projector sight 'meat ball'), on centre line and slightly faster than the calculated datum speed to allow for the 'cliff edge' effect as you approached the round down, which always knocked off two or three knots of speed. As the wheels hit the deck there was a massive deceleration that completely caught me by surprise. During my conversion training on the Buccaneer I had carried out an arrested landing on the airfield at Lossiemouth after a hydraulic failure but the deceleration then was nothing like this. I was flung forward into the front of the cockpit, my straps just preventing violent contact with the instrument coaming. I made a mental note to tighten the straps as hard as possible in future. As the aircraft came rapidly to a standstill the flight deck crew rushed out in front of me, indicating to me to get the hook up, fold the wings and taxi off the landing area of the flight deck as quickly as possible to allow the wire to be reset for the next aircraft in the landing pattern, which was not far behind. Hook up with left hand, fold wings with right hand, left hand back on throttles, engage nosewheel steering with left thumb and follow flight deck crew's marshalling instructions implicitly. In the brief beforehand we had been told that if they marshalled you over the side it was their fault, not yours – not a comforting thought. Eventually, after much awkward manoeuvring in a confined space, the aircraft came to a halt in the area known as Fly 1, at the bow of the carrier.

I breathed a huge sigh of relief, shut down the engines and slowly unstrapped. At last I had made it on board. Opening the canopy, I slowly climbed down the ladder and looked at the scene before me. By now the aircraft recovery was complete

and the ship was turning out of wind. With about 1000 hours' of land-based 'normal' flying under my belt, I was used to experiencing a total lack of motion in the outside world after landing, parking and vacating one's aircraft. Now, however, as I looked up, the horizon was tilted over and moving past at a fair rate as the ship continued her turn. The sensation was so disorientating that I had to clutch hard on the aircraft's access ladder to stop myself from falling over.

The Buccaneer that I flew that day was XN 981, coded 234. Very many years later, whilst wandering around an air display at Duxford, I noticed that there was a cast metal Buccaneer model, made by Corgi, painted in the colours worn by our aircraft when embarked on HMS *Victorious*. Naturally I had to buy it. When I got it home and unwrapped it, I discovered to my delight that it was XN 981. Further research in my logbook also revealed that XN 981 was also the aircraft in which I did my last catapult launch. What an extraordinary coincidence.

CHAPTER ONE

Prelude to Flying
– 1942 to 1960

I was born in September 1942 into an Air Force family. My father was one of the early Flight Cadets at Cranwell. He had a distinguished career in the RAF and was undoubtedly a strong influence on my life from an early stage. My memories of those early years are scant. I can remember being pushed into a cupboard under the stairs, presumably during a V1 attack. This must have been in 1944 when we were living at Stanmore as my father was at HQ Fighter Command. I also remember being terrified by Meteor aircraft attempting to gain the World Air Speed Record in 1946, when we lived for a while at Bognor Regis. They roared along the beach at low level and high speed – and I did not like this. Thus early omens for a flying career were not good. In late 1946 the family joined my father in the USA, where he was working as a member of the UK military delegation to the newly formed UN. Again, I remember little of our time in the USA, apart from swearing allegiance to the Stars and Stripes at the nursery school I attended and the chimney catching fire on Christmas Eve, when some surplus decorations were burnt. I was particularly concerned as to how this would affect Father Christmas's visit.

In 1948 we returned from the USA and my father was posted as Station Commander, RAF Thorney Island, a fighter base on the south coast near Chichester. By now my fear of noisy jet

aircraft seems to have disappeared, as I have only the pleasantest of memories of our time here. Thorney Island in the summer of 1949 was a wonderful place for a small boy to live. It was home to three Meteor Mk 4 squadrons of Fighter Command. Additionally, there was the sea and acres of mud just yards away from the house we lived in. It was indeed a paradise. The constant comings and goings of the Meteors excited me enormously and first generated within me a wish to fly. On the Battle of Britain 'At Home' Day that summer I got airborne for the first time. It was in a somewhat decrepit de Havilland Dragon Rapide that was offering fifteen-minute joy rides at £1 a time and I persuaded my parents to let me have a go. I don't remember much about the flight but I'm sure I enjoyed it and perhaps thoughts of being an engine driver when I grew up must have begun to dim. Messing about in boats was another favourite occupation. Thorney Creek was full of boats of various sorts and I had an old surplus RAF single-seat dinghy of wartime vintage, which even had a mast and sail but was only capable of slow progress downwind. Thus the two seeds of the subsequent work and leisure activities throughout my life were planted.

We left Thorney Island in the summer of 1950 and off I went to a prep school in Sussex. After two fairly short appointments at RAF Old Sarum and SHAPE (Supreme Headquarters Allied Powers Europe) in Paris my father was appointed Commandant of the RAF College, Cranwell. You cannot imagine what delight this gave me, as my interest and desire to fly had been growing all the time at prep school. Living at Cranwell in the early 1950s merely made my wish to fly even greater. During the holidays there were Prentices, Harvards, Chipmunks, Balliols, Provosts, Ansons and the occasional Meteor and Vampire all to be seen and envied. There were very few opportunities to fly, but I do recall the occasional passenger trip in an Anson or Devon, probably quite illegal but the rules and regulations were only lightly applied in those days.

One summer term my uncle, Squadron Leader Bobby Eeles RAux AF, OC 615 Squadron, was detailed off to take me out of school for the day. It being a Sunday he collected me and took me off to RAF Biggin Hill, where his squadron was based. It was a glorious hot summer day and I was put down in front of the

squadron offices in a deck chair, given a pile of Wagon Wheel biscuits to eat and told not to move. It was a busy day and there was a lot of flying going on. I decided to try and persuade Uncle Bobby to let me go up in a Meteor. Amazingly, he agreed. Still clad in my school blazer and shorts – there was no flying suit small enough – I was strapped into a parachute that I had little hope of using. I was strapped into the rear seat of a Meteor T7 on top of a large cushion so that I could see out.The pilot on this occasion was a gentleman called Mike D'Arcy – I forget his rank. He asked me what I would like to do. I replied – somewhat boldly – that I would like to go and beat up my school. As he did not know where it was I would have to get him there. This wasn't too difficult, all you had to do was follow the main road out of Tunbridge Wells for a few miles and there you were. The school was beaten up in fine Auxiliary Air Force style so we then went off to do some aerobatics. Much to Mike D'Arcy's disappointment I was not sick, the Wagon Wheels stayed down. After landing back at Biggin Hill, I knew for certain that military flying was the thing for me. Such an escapade would of course be impossible today, indeed I suspect Uncle Bobby went well beyond the boundaries of legality even for those days. I am eternally grateful to him and Mike D'Arcy for convincing me in no uncertain manner of what I wanted to do when I grew up.

In 1956 I moved to Sherborne School and my father was posted from Cranwell to the Air Ministry. School life became more serious with proper exams to pass and there were no more holidays to be spent on busy RAF Stations. However, the compensation was that there was a very active Combined Cadet Force at Sherborne. After the first year, which had to be spent in the Army Section, I moved across to the RAF Section in 1958 and for the first time put on an RAF uniform. Life in the RAF Section was fairly relaxed. We had a Grasshopper glider, but its use was banned because the only time it had been launched on the hallowed playing fields it had carved a huge groove across a rugby pitch on landing. Consequently the master in charge of the sports pitches refused permission for any further attempts at flight. However, we were very lucky in that our closest RAF Station was RAF Boscombe Down, the Aircraft and Armament Experimental Establishment, where our liaison officer was a pilot on the heavy aircraft test squadron. Many expeditions were

made to Boscombe Down to fly around Wiltshire in the cavernous Beverley transport aircraft at a very pedestrian pace. I also recall short trips in the Harvard photo chase aircraft and in a Meteor T7.

The highlight for me occurred on my last visit, in the summer of 1960. By now a Sergeant in the RAF Section, I was lucky enough to be offered, on a field day visit, a trip in a Hunter T7. Again, it was a beautiful English summer's day as we took off and climbed to 40,000 feet over the Channel, this time considerably more legally than my first ever jet sortie with 615 Squadron five years before. After breaking the sound barrier I blacked out completely on the recovery from the dive, but the experience was unforgettable.

That summer we went for our camp to RAF Laarbruch, in Germany, a major base with Canberras and Javelin fighters. Plenty of flying was available in the Station Flight Chipmunk and I remember well a long night sortie in a Canberra B(I)8 of 16 Squadron; I sat on the rumble seat below the pilot and next to the navigator, virtually unable to see anything. Little did I realise at the time that only a few years later I would be doing the same thing on this squadron, but from the pilot's seat.

By now I had had an RAF Scholarship for two years and a guaranteed place at Cranwell provided I passed my dreaded A levels to the required standard. We were spending a summer holiday in a family farmhouse in Teesdale and I remember well going down to Richmond to the post office to get the telegram giving the results. I had passed. My last few days as a civilian passed very quickly. On 3 September 1960, I found myself with a large number of similar individuals on King's Cross station, waiting for the train to take us to Sleaford and then on to Cranwell to join the RAF.

CHAPTER TWO

Early Days – 1960 to 1963

The RAF College, Cranwell, was a demanding establishment in the early 1960s. During the first term we members of the Junior Entry were the lowest form of life. We lived in the South Brick Lines, a collection of ancient huts dating from World War One. Living in each hut were four of us new arrivals and a 'mentor' from the Entry above us to sort us out and show us the ropes. The hut had three rooms, a communal ablution area (the first room on entry), then a dormitory (heated by an ancient front-loading coke burning stove), then finally a study room with five desks. Everything had to be kept spotlessly clean. We slid around on the ancient lino floors to keep them scratch-free and shiny. No dust was permitted anywhere, beds had always to be immaculately made and all clothes had to be folded to an exact pattern and stored precisely in accordance with a diagram – no variation was permitted. Our lives were a continuous round of early morning starts, drill, kit inspections, more drill, very short haircuts, bulling boots, lectures on service discipline and similar subjects.

The slightest misdemeanour would result in one being placed on a charge, found inevitably guilty and being put on restrictions. Being on restrictions involved parading before life started in the morning in immaculate uniform, then joining the normal working day, then parading again at 1800 hrs in immaculate uniform. After this a period of strenuous drill took place, which resulted in a completely messed up uniform. There was then

another inspection at 2200 hrs at which perfection was the only acceptable appearance. Any speck of dust or poorly blancoed webbing at any of these three parades resulted in yet more days on restrictions. It was a tough regime and some did not last through the first term.

Aircraft and flying did not feature and were not even thought about much with the pressure of surviving. We all dreaded 'Crowing', a form of ritual humiliation whereby members of the Senior Entry would swoop down on a luckless hut in the evening, when its inmates were busy cleaning, polishing or studying. The inmates were then required to perform a ridiculous task, such as mimicking the action of a four-stroke engine, or hanging upside down from the beams singing a song. Thankfully we did not suffer a great deal from this torture as it was being actively discouraged by the staff.

We were allowed out on a Saturday evening about halfway through the first term. We were not permitted to keep cars during the first term so we all took the bus into Lincoln, looking totally conspicuous with our minimalist haircuts, sports jackets, slacks and highly polished shoes. We could not have got up to much as we all had to be back in the hut by midnight! The nearer town of Sleaford was off limits to Flight Cadets, being reserved for the airmen.

It was always cold and great skill was needed to keep the coke stove on overnight without creating dust and mess. One hut foolishly decided to have the stove going the night before a particularly rigorous inspection was due to take place. After its inhabitants had bulled the interior to a gleaming state and had retired to bed, the inhabitants of the next-door hut climbed on to the roof and dropped a large firework down the chimney. The subsequent violent explosion blew the doors off the stove and filled the interior of the hut with a huge quantity of hot ash and red hot coals. Needless to say, despite working all night, they did not pass the inspection and ended up on restrictions, along with the next-door hut who were charged with destroying the stove, but not for too long as someone in authority saw the funny side of it.

We were looked after by our 'mentors' – mine was Alastair Campbell, a man of infinite patience and charm with whom I subsequently worked closely many years later. We were also driven hard by the fearsome drill sergeants, who turned us from

an ill-disciplined rabble into a passably efficient bunch of Flight Cadets by the end of this first term.

The quality of life improved considerably in the second term, as there was another Junior Entry to take our place in the South Brick Lines. We moved to the much more comfortable barrack blocks flanking the Junior Entry parade square, which had single-room accommodation. Needless to say, these rooms had to be inspected regularly, but they had central heating and were much easier to keep clean.

We were now allowed to fly once a week in the Chipmunks, which operated from the North Airfield, a huge expanse of grass that we all had to run around once a year to compete for the Knocker Cup. I note that my first flight was with a Fg Off Nichols, in Chipmunk WB 550, on 25 January 1961. Most of this flying was done in the rear seat with a non-QFI (non-Qualified Flying Instructor) in the front and counted only as air experience. Occasionally one was lucky enough to get a QFI, which enabled proper dual instruction to be given; in the spring term of 1961 I got 2 hours 20 minutes' dual.

The Chipmunk was a classic design, simple to fly but difficult to fly well. It could bite back if you took liberties with it, especially when handling on the ground. On the ground the view from the front seat, normally the student's, was poor. It was even worse from the back seat. The engine was equipped with a cartridge starter that used cartridges similar to a 12-bore shotgun cartridge. After strapping in and checking the cockpit, you placed your hands outside the cockpit in view of the ground crew and called out 'Fuel on, brakes on, throttle closed, switches safe.' The ground crew would then open the engine cowling, insert the cartridge breech, tickle the carburettor to get fuel through, close the cowling and indicate it was clear to start by saying 'Breech inserted, cowling secure, rear switches on, clear to start.' You then pulled the starter cord, which fired the cartridge. There was a loud bang and with luck the engine would rotate, fire up and start running. If it failed to start you repeated the whole process again.

Taxiing the Chipmunk could be quite challenging. The brakes were controlled by a long lever that stuck up out of the cockpit floor on the left-hand side. If this lever was pulled fully rearwards and locked in position the brakes would be fully applied.

To obtain differential braking the lever was moved a small distance rearwards and locked; application of rudder then applied brake in the same direction, enabling the pilot to steer left or right. The aircraft also had a strong tendency to weather-cock into wind and the control column had to be used appropriately to keep the tail on the ground during taxiing. It was essential to weave continuously whilst taxiing to keep a clear view ahead. Thus a long taxi across the relative wind was a demanding exercise in co-ordination of hands, feet and eyes; safe arrival at the marshalling point was greeted with a sigh of relief.

Once in the air the Chipmunk flew beautifully. It was not a high-performance machine; it took a long time to climb to height and once up there would cruise happily at 90 knots. It had a standard instrument panel with the normal six instruments; the artificial horizon and the direction indicator were air driven so could topple very easily during manoeuvres. The fuel gauges were in the wing upper surface, connected directly to their tanks and rather awkward to read in flight. The flaps were controlled by a large lever on the right-hand side of the cockpit rather similar to a car's hand brake; you had to change hands on the control column to operate them, which could make a final approach interesting.

Stalling and spinning were completely viceless. Aerobatics were a delight but you would lose height steadily during an aerobatic sequence. You could not sustain negative g because of the carburettor fuel feed to the engine, which would cut out if you tried to sustain inverted flight, so slow rolls were challenging. Equally, the engine often stopped during stall turns but always got going again as you accelerated down after the manoeuvre. You had to be careful not to exceed the maximum permitted engine RPM (2675) when accelerating to high speed (a relative concept!) as the propeller was fixed pitch. The maximum permitted speed was 173 knots.

The circuit and landing procedure was straightforward, apart from the change-hands routine to lower the flaps. It was desirable to land in a three-point attitude and the aircraft would bounce or ground loop if you got this wrong. The threshold speeds were very low: 55 knots for a normal approach, 60 knots flapless and 45 knots for a short landing. It was easier to land on grass surfaces than hard runways.

You could always imagine that you were in a World War Two fighter when flying the Chipmunk, but without the associated complexities and handling challenges. In sum, it was a lovely aircraft in which to achieve your first solo. In spite of the terrible smell of vomit in these Chipmunks – most had been used to provide air experience for ATC (Air Training Corps) cadets at some time – the flying made a welcome break from drill and academic studies.

By now academic studies for me meant being a member of the C stream, which involved study for an external degree with the University of London in history, english and war studies. I found war studies and history interesting but english was something of a trial.

At the end of the second term the Leadership (to us Survival) Camp took place. It was held in the wilds of the Scottish Highlands, miles from anywhere, near the source of the River Spey. It involved endless forced marches across the mountains, by day and night, being chased by members of the RAF Regiment, sleeping under canvas and outside, and eating very little. The journey from Grantham station to Newtonmore was an epic in itself, British Rail still being firmly in the steam train era. One or two were re-coursed after this episode. On the way home afterwards I fell asleep at the wheel of my ancient MG saloon and luckily slid gently off the road in Stockbridge, destroying the car and a wall but I suffered no injuries. I had only paid £20 for the car, so it wasn't a great loss.

Back at Cranwell for the summer and autumn terms, life continued much as before, with the improvement in quality of life in the autumn associated with the move from the Junior Entry's Mess up to main the College building. After some 6 hours 10 minutes' dual in the Chipmunk, spread over nearly a year, Master Pilot Ayers was bold enough to send me off solo on 16 October 1961, from Cranwell's North Airfield. That was the end of my Chipmunk flying at Cranwell and I didn't fly a Chipmunk again for twenty-seven years!

In January 1962 proper flying training started on the Jet Provost (JP), which was in service in two versions, the Mk 3 and the Mk 4. The Mk 4 had a considerably more powerful engine and was

considered to be quite a hot ship. We spent half a day down at the flying squadrons learning to fly and half a day on academic or Service studies. Learning to fly and studying a degree course at the same time, as well as surviving as a Flight Cadet, proved to be quite a challenge. There were many times when I felt I had only survived by the skin of my teeth.

I went solo after 9 hours 55 minutes' dual, on 2 February 1962, in Jet Provost Mk 3 fleet number 56. And thereby hangs a tale. Thirty-one years later, when I was Station Commander at RAF Linton on Ouse, the Jet Provost was finally being retired after many years of excellent service. In one of my weekly executive meetings I asked the engineering contract manager, Terry Stone, if it would be possible to retain a Jet Provost as a Gate Guardian for the Station. He confirmed that this was indeed possible so I asked him to pick a suitable airframe that had not already been disposed of, preferably a Mk 3 as this version had been in service the longest. Eventually the selected aircraft was ready for positioning on display and Terry produced a plaque, which detailed the aircraft's service history. I observed that I could well have flown this aircraft as it had been at Cranwell whilst I was there, but that as I had only recorded fleet numbers in my logbook it would be impossible to tell. Terry offered to look through the F700 to see if he could find my signature; I told him not to bother. He then asked to see my logbook. He then announced in triumph that it was the Jet Provost that I had flown my first (jet) solo in – the dates coincided precisely in both the logbook and F700. So finally I knew the aircraft's proper identity – XN 589, now fleet number 46 at Linton. The faithful JP is still there to this day.

The JP was a jet-powered version of the Piston Provost, powered by a Viper turbojet and equipped with retractable landing gear. The Viper had originally been developed as a 'throw away' engine for the Jindivik target drone but had been adapted for normal use in the JP. The JP had side-by-side seating, ejection seats, a UHF radio and a simple DME navigation aid. It represented quite an advance in sophistication when compared with the Piston Provost but the Mk 3 was very underpowered. It was easy to start and taxi with its nosewheel landing gear. The take-off and climb was unexciting, the normal cruising speed was 180 knots and we tended to operate in the height band of 5000 feet

to 20,000 feet. It was fully aerobatic and capable of more advanced manoeuvres than the simple Chipmunk, such as 'noddy' stall turns, proper slow rolls, four- and eight-point rolls, reverse stall turns and sustained inverted flight. It was straightforward to fly in the landing circuit as long as you remembered to raise and lower the landing gear every time around. It was equipped with a fairly good instrument layout with an electrically driven artificial horizon and a gyro magnetic compass. The instruments were grouped in the centre of a fairly wide instrument panel, which meant that you had to look across the cockpit at them from your seat on the left-hand side but you soon got used to this. The Mk 4 version had an uprated Viper engine so was always in demand for aerobatics. It had a much more exciting performance, being capable of achieving speeds of 400 knots and altitudes around 30,000 feet. Neither version was pressurised and they both had the same rather primitive oxygen system, which did not supply oxygen under pressure. During high-level handling sorties in the Mk 4 we were regularly exposed to conditions favourable for decompression sickness and most of us experienced this in some form or other.

The flying syllabus was 180 hours, an extra 20 hours being added to the Cranwell syllabus to compensate for the extra time spent in training by Cranwell cadets compared with our direct-entry colleagues. The syllabus followed a traditional pattern. After an initial spell of general handling we were soon introduced to the circuit and expected to go solo between 10 to 15 hours. Some went sooner, some later. We were then introduced to more off-circuit general handling and aerobatics, with an initial progress check after about 30 hours. Spinning was carried out both dual and solo, the only limitation being that spinning was prohibited with fuel in the tip tanks. Instrument flying followed, with award of an instrument flying grading, a very lowly form of instrument rating that allowed a student to penetrate cloud in a straight line. Medium- and low-level navigation, night flying and formation flying all featured in the syllabus, including land-away cross-country navigation exercises.

For the next eighteen months we alternated between flying and academics during term time, progressing steadily through the syllabus. It was a great relief to spend time down on the

flying squadron, away from the fierce Senior NCOs and Flight Commanders up at the College. Inevitably one or two got the chop from flying; some stayed on as navigators or ground branch, some left for another life. Occasionally there was an accident but these were few and far between and never affected us much.

Lincolnshire had a number of Thor ballistic missile sites, manned and operated by the RAF, which were excellent landmarks for us tyro aviators. I remember well how surprised we were to see all these sites with their full complements of missiles all up and ready during the tense time of the Cuban Missile Crisis, whilst we carried on doing aerobatics overhead them in the autumn of 1962.

The winter of 1962/3 was very severe and had a big effect on our flying activities. There was snow on the ground from December until March and large amounts of it fell in Lincolnshire. There was no snow-clearing equipment at Cranwell, other than cadets wielding shovels and brushes and the occasional snowplough. The airfield at Cranwell was covered with a deep layer of snow, so Wing Commander Flying decided that Barkston Heath seemed a better option for clearing the snow; the entire Cadet Wing was given shovels and set to work clearing the runway. Progress was very slow and at the end of the first day one of the mathematicians amongst us calculated that at this rate of progress it would take until May to clear the runway. Thankfully, this exercise was soon discontinued. Some of the JPs were then dragged out onto Cranwell's snow-covered runway and launched off, sliding about quite dangerously, to land at Coningsby, where there was snow-clearing equipment.

Coningsby was a Vulcan base, which had to be kept open all the time so that the British nuclear deterrent force could be seen to be operational. We then went by bus to Coningsby to fly for quite a while. Strenuous efforts were made by the Squadron Commanders at Coningsby to interest us in the Vulcan force; one look inside a Vulcan convinced me that they were to be avoided at all costs in the future. A final treat at the very end of the flying course was a weekend trip to RAF Wildenrath in Germany, when three aircraft went out on a Friday and returned the next Monday.

* * *

Ancient cars featured strongly in our lives at Cranwell. The Cadets' garage was a decrepit hangar dating from World War One, draughty and without lighting. Rows of cars in varying states of disrepair clustered inside; every Saturday afternoon there was a flurry of activity by their owners attempting to get them into running order for the evening foray into Lincoln, or, for the very brave and confident, Nottingham. There was no MOT test in those days. The variety of types was amazing, including an ancient Lagonda saloon that had had its body removed and replaced by a Vampire T11's nose cone, thereby making it into a giant two-seater sports car – without a hood. I owned no fewer than five cars during my three years at Cranwell – one lasted only three weeks! My favourite, and the longest lasting, was 'Bessie', a 1931 Morris Cowley. She was bright yellow, an open two-seater with a dickey seat at the back. Her maximum speed under favourable conditions was 40 mph. She was the most reliable of the five and I sold her for £30 at the end of my time at Cranwell as I doubted she would ever make it to RAF Valley. Today, if she existed, she would be worth a small fortune.

The first ever RAF Regiment Cadet was involved in a car-stealing ring – without anyone's knowledge. The Cadets' garage provided a perfect cover for his nefarious activities – Cadets changed cars almost weekly and no one took any notice of his acquisitions and disposals. He was caught out when he put one of his many current tax discs on his car of the day, which unfortunately belonged to another – stolen – car. He took it to London for the weekend and parked it illegally; it was spotted by a policeman who noted the discrepancy and one evening he was taken away to jail by two plain-clothes policemen. This was sensational and definitely one in the eye for the RAF Regiment staff who were constantly singing his praises. When the MOT test was introduced in 1963 it swept through the Cadets' garage like the Black Death and many wonderful old cars were destined never to be driven again.

Finally, it all came to an end. After sitting exams for the University of London and obtaining a low-quality pass – third class-degree in History, English and War Studies – I managed to pass the Final Handling Test, flown on 1 July with a Sqn Ldr Foster. Then there was the longed-for logbook entry authorising

the wearing of the Royal Air Force flying badge with effect from 30 July 1963, in accordance with Queen's Regulation 770, after 116 hours' dual and 65 hours' solo. Air Chief Marshal Sir Gus Walker, the C-in-C of Flying Training Command, presented us with our 'Wings' that evening. Next morning we all paraded for the last time as Flight Cadets with Wings on our tunics. We marched up the College steps to the tune of 'Auld Lang Syne' and raced to our rooms to put on our Pilot Officer uniforms. We woke the next morning with hangovers after the Passing Out Ball and moved on into the real Air Force.

CHAPTER THREE

Advanced Flying Training and Operational Conversion – 1963 to 1964

The next stop was No. 4 Flying Training School, RAF Valley, Anglesey, where we were to do our advanced flying training on the Gnat T1. The Gnat T1 was brand new and was still rolling off the production line. The Gnat was built by the Folland Aircraft Company and was designed by W E Petter, who had also designed the Canberra, the Lightning, and also the Westland Whirlwind twin-engined cannon armed fighter, which my father had helped bring into service in 1940. Originally the Gnat was conceived as a small lightweight fighter in an attempt to halt the trend towards ever bigger and heavier fighter aircraft. As such it was ordered by the Finnish Air Force in small numbers and large numbers were built under licence in India, but did not find favour with the RAF. In the early 1960s the RAF needed a new advanced trainer to replace the ageing Vampire T11, which was not considered a suitable lead in for the new generation of combat aircraft coming into service. The Hunter T7 was available but an argument was put forward by Folland's designers that the Hunter could not embody the new Integrated Flight Instrument System known as OR 946, whereas the trainer version of the Gnat that the firm was proposing

would be able to incorporate OR 946, albeit in a modified form. Also, just at the same time the Hunter had beaten the Gnat in the competition to provide a replacement ground attack fighter for the Venom, so almost as a consolation prize the Gnat T1 was ordered to replace the Vampire.

The Gnat was a very small aircraft, only 37 feet long and with a wing span of 24 feet. The student and instructor sat one behind the other and the rear cockpit layout was quite different from the front (student's) cockpit because of the small size of the aircraft. The landing gear also doubled as an airbrake (when partially extended) and retracted into the fuselage, having a very narrow track of only 5 feet. Retracting the landing gear resulted in a major rearward movement of the centre of gravity and an automatic tailplane datum shift was incorporated to compensate for this.

The flying controls were hydraulically operated but there was a manual reversion facility in the event of a hydraulic failure. This could be practised in flight by selecting a hydraulic cock 'off', which cut off hydraulic pressure from the flying controls. Sneaky instructors would turn this off at most inconvenient moments, such as in the middle of your aerobatic sequence. Following a simulated or real hydraulic failure it was essential to 'freeze' the tailplane in the right position, as control in pitch was now provided by very small elevators, which were unlocked from the tailplane by pulling a T-shaped handle in the cockpit. The elevators were so small that they could not provide sufficient control authority for safe flight and landing, so the 'frozen' tail could be moved in the nose-up sense by use of a standby electrical trim system. It could only be moved back to the original frozen position. In manual the datum shift facility did not work so had to be compensated for by the pilot. Control loads in manual were much heavier than in power, so handling following a hydraulic failure could be very challenging, especially if associated with an engine failure as the forced landing pattern was more difficult to fly than the simple Jet Provost's.

The emergency drill following a hydraulic failure, real or simulated, is burnt into every Gnat pilot's brain. Its acronym was STUPRECC. This translated as: 'Speed – below 400 knots/0.85 M, Trim – to ideal sector while regaining level flight, Unlock – elevators, Power – cock off, Raise – guard on standby

trim, Exhaust – tailplane and aileron accumulators, Check – operation of elevators, ailerons and standby trim, Changeover – switches to standby if required.' It was a complicated drill and if you got it wrong there was a good chance of losing control at a critical moment, such as just before touchdown.

The Gnat was powered by an Orpheus turbojet; this was started by an external gas turbine starter trolley, which was almost as big as the aircraft. Landing away at an airfield that did not have these starters was embarrassing! With its very narrow track landing gear the Gnat could be very tricky in cross winds and had a limit of 10 knots crosswind on a wet runway. A brake parachute was also fitted but it was quite small and not very effective. Compared with the rather pedestrian Jet Provost it was a really hot ship, capable of exceeding its maximum IAS (indicated airspeed) limit of 0.9 M below 11,000 feet and 500 knots above. Supersonic flight was easy to achieve from a shallow dive, normally entered from around 40,000 feet. It only carried 2120 lb of fuel internally and so for flying training always had external slipper tanks fitted, which increased fuel capacity to 3063 lb – just enough for an hour's sortie. The Orpheus turbojet delivered 4520 lb static thrust at sea level. It was a reliable engine and we very rarely suffered from malfunctions, despite the salt-laden corrosive environment in which it operated.

Unlike other RAF aircraft the Gnat was not fitted with Martin-Baker ejection seats. Instead, it had lightweight seats made by Folland to an original design by SAAB of Sweden. Their operation was quite different to the Martin-Baker seats; they were much lighter and slimmer, yet they worked very well. Instead of a collection of safety pins, which had to be removed to make the seat live (the Martin-Baker system), there was a simple lever with a large red knob on the end that was in line with the pilot's neck in the safe position, which was moved 90 degrees to the right to make the seat live. It was very simple and effective. If you tried to get airborne with the seat safe, the acceleration on take-off pressed your neck firmly into the red knob, reminding you forcibly to make the seat live!

The OR 946 flight instrument system was a great advance over the traditional instruments in the JP and made instrument flying much easier than in the JP. The view from the front seat was excellent and you could imagine you were riding a witch's broomstick when looking out ahead at the very long pitot probe.

We were the second course to fly the Gnat, so the overall level of knowledge and experience of the aircraft was still fairly low amongst the staff. The general serviceability of the Gnat was not good; it was a very complex aircraft and because of its small size and compact nature, any engineering problems were always difficult to resolve. During its service the Gnat was to suffer from a high loss rate, mainly caused by handling difficulties associated with the longitudinal control system and the general complexity of its systems. Nevertheless, it was very exhilarating to fly. Your first solo was a circuit of Anglesey as fast as possible, which was fantastic fun. The course was some 70 hours long and I found it much more challenging than basic flying training. The syllabus covered the same activities as the basic JP course – general handling, instrument flying, night flying, formation and navigation – with the added sophistication of a flight simulator in which countless complicated emergency drills were practised.

RAF Valley was a remote and bleak place to be based, especially in the autumn and winter. The airfield buildings all dated from the 1940s and were primitive. The Officers' Mess was somewhat newer and a big building programme was being undertaken to upgrade the Station. The grim prospect of a posting to V bombers at the end of the course was ever present as output from RAF Valley went in that direction in those days, particularly if you did not do very well. The incentive to perform to a high standard was therefore very strong. Social life was confined to Anglesey with the occasional epic weekend drives to London. There were few motorways then and the M1 stopped at Birmingham, so a car journey to London was not undertaken lightly. On Sundays no pubs were open in that part of Wales, although there were some dubious 'clubs' where a drink could be found, and the Officers' Mess bar always did a roaring trade.

The senior course (consisting entirely of the Cranwell Entry ahead of ours)decided one day to steal a guided missile which was displayed on a stand outside the Officers' Mess at the neighbouring Army firing range of Ty Croes. They reckoned that they could fit it into the back of a long wheelbase Land Rover, which they borrowed from a local farmer. Equipped with hacksaws and candles to deaden the noise of sawing they bluffed their

way in successfully. They had arranged with one of the building contractors to have a supply of ready-mix concrete and a suitable hole waiting back on the lawn in front of the bar at RAF Valley so that their trophy could be secured in its new home for all to see. Unfortunately, the metal stand holding up the missile proved to be solid, not hollow as they had expected, so sawing through it took very much longer than they had calculated. Amazingly, no one detected them whilst they struggled on. Eventually they got the missile off its stand only to discover it was very heavy and far too long to go in the back of the Land Rover. Nothing daunted, they propped it up on the back of the Land Rover, pointing forward like something on a May Day Parade in Red Square, and succeeded in driving out of the camp without being stopped at the Guardroom! The hole and concrete were ready back at RAF Valley but sadly the missile arrived much later than had been expected.

It was placed in position and when we all awoke in the morning there it was, looking splendid. Naturally, at first light the Army realised their loss and where their rocket had gone – there was no other possible place apart from RAF Valley. They turned up very quickly demanding the return of their property, and despite offers of trips in Gnats and tours of the Station, they removed the missile before the concrete had had time to set, but luckily after photographs had been taken. By way of revenge the Army removed a large wooden propeller from the ante-room wall. As few of us used the ante-room, preferring the bar for socialising, no one noticed it had gone and the Army had to ring up to ask if we wanted it back!

By February 1964 our course had come to an end (not with the same number who had started) and it was time to find out one's posting to the front line. There were the usual lucky few who went to Hunters, three even luckier chaps went off to be the first ab initio Lightning pilots and one or two went to Central Flying School (CFS) to become first tour QFIs. I was lucky, too, as I escaped the V force and was the only one on the course to be posted to Canberras. I was quite happy with this fate – I certainly had not performed well enough to go on to single-seat aircraft and all Canberra squadrons were now based overseas and operated, by and large, at low level. They were all single-pilot aircraft so I was entirely content with my lot.

* * *

There then followed a delightful interlude whilst I awaited a course on the Canberra Operational Conversion Unit. I went as a holding officer to RAF Colerne, just outside Bath, to be attached to a Hastings transport squadron. The Hastings was a lumbering, four-engine tail dragger, which owed its origins to the Handley Page Halifax heavy bomber of the World War Two era. I was told that the only reason it had been equipped with a tailwheel rather than a nosewheel was to enable an Army jeep to be slung under the wing centre section! The wings and engines were I believe identical to the Halifax's. The Hastings was the RAF's main medium-sized tactical freight and troop transport aircraft and despite its antiquated appearance it did an excellent job. It was robust and simple, but tricky to take off and land. It was replaced in service in 1968 by the Hercules but a few soldiered on well into the late 1970s, equipped with a radar and used to train navigators in the art of using an airborne radar set. Appropriately, the flight that did this task was known as 1066 Flight.

Flying the Hastings was a complete change to flying the nimble, diminutive Gnat but, perched up high above the ground in the right-hand seat and acting as second pilot (untrained), I had a most enjoyable six weeks and notched up 42 hours' piston-engine flying time. We trundled around over Salisbury Plain disgorging parachutists and things called SEAC Containers – I was never sure what these were. There was also a gentle meander around the RAF's Mediterranean establishments – Luqa in Malta, Tripoli in Libya, Nicosia in Cyprus – all done at a steady 150 knots. Throughout my six weeks there I never was allowed to attempt a take-off or landing, a wise precaution under the circumstances as the Hastings had quite a reputation for being tricky close to the ground. You also had to be extremely strong, as the control loads were monumental when compared with a Gnat. I did, however, become very skilled in raising and lowering the undercarriage and flaps.

Then it was on to No. 231 OCU (Operational Conversion Unit) at RAF Bassingbourn, just north of Royston in Cambridgeshire. This was a delightful establishment where we were taught to fly that classic aircraft, the Canberra, another of W E Petter's

designs. The OCU was equipped with the T4 version, where two pilots were squeezed into the space originally designed for one, so dual sorties were very chummy affairs. We flew our 'solo' sorties in the B2 version, which was no longer in any front-line squadron. The Canberra was a simple aircraft. The T4 and B2 had early Rolls-Royce Avon engines, which were very prone to compressor stall if mishandled and also prone to icing. The cockpit instrumentation was rather old fashioned, all the fuel was carried in three fuselage tanks and wing tip drop tanks, the flying controls were manually operated and the pilot sat under a goldfish bowl-like canopy, which could not be opened but gave an adequate view forwards and sideways, but none rearwards.

The aircraft had a good performance, and could operate up to 45,000 feet without difficulty but it got pretty cold at that altitude. It was limited to a maximum speed of 450 knots at low level, a speed it could exceed quite easily. At high level it suffered from compressibility effects with its straight, rather thick, wing and was limited to 0.8 M. Its flaps were very simple, down only with no intermediate setting, so they were only used for landing. It had a large bomb bay with hydraulically operated doors.

Inevitably, with its twin engines, much time was spent practising flying on one engine. This was an activity that could easily lead to trouble. Engine failure shortly after take-off resulted in a marked yaw and roll towards the failed engine, which had to be promptly controlled by opposite rudder and aileron. At low speeds the rudder loads were very heavy and the minimum speed that you could control the aircraft depended on your physical ability to hold on full rudder deflection. The taller and stronger brethren could hold the lowest speeds. One of the flying exercises was to determine your individual critical speed on one engine. This was done by flying at 1500 feet with one engine throttled back, reducing speed steadily with the other engine set to a high power setting.

Shortly before my arrival two instructors were practising this exercise together in a T4. The demonstrating instructor, a big Canadian on exchange duty, was holding a very high power setting at a nice, low speed. Unfortunately the top latch of his ejection seat was not done up properly and the action of him

holding on full rudder pushed the seat up the rails to the point when it fired, throwing him out of the aircraft. This left an astonished non-flying instructor with the task of recovering the out of control Canberra and landing it, with a hole in the canopy, at the nearest airfield. The Canadian luckily survived this dramatic experience.

Single-engine circuits and landings were hard work and once flap had been selected you were committed to land. Roller landings were only permitted in the T4 with a QFI as the early Avons were tricky to accelerate evenly once throttled back on touchdown. The B2 had very primitive ejection seats that needed a minimum of 200 knots and 1000 feet to work, whereas the T4's seats were the standard 90-knot/ground-level seats like the Jet Provost's. Compared with the Gnat the Canberra felt somewhat old fashioned but it was a gentle aircraft that only bit if you took liberties with it, particularly on one engine.

I was crewed up with a navigator of vast experience, and girth, Flight Lieutenant Vic Avery, whose wisdom and common sense I valued enormously. He had flown Canberras before and I'm sure he monitored my youthful impetuosity and inexperience with great care and he kept me out of trouble on many occasions. The course consisted of general handling, including lots of practice engine failures and single-engine circuits; instrument flying, navigation at high and low level, night flying, a bit of formation and some basic aerobatics. These were used as a lead in to the Low Altitude Bombing System, or LABS, manoeuvre, which the operational aircraft used for nuclear weapon delivery. Just one visit was made to a weapons range for a session of medium-level bombing, a delivery mode that was not used on the front line any more. All told, it was an undemanding and gentlemanly course that allowed plenty of time off to go sailing. London was only one hour's drive away – what a change from Anglesey – and Cambridge a mere fifteen minutes' away. I enjoyed my time at Bassingbourn.

The course was 83 hours' of flying and when completed Vic and I were posted to No. 16 Squadron, RAF Laarbruch, in Germany close to the Dutch border. Training was now positively over and operational service on the front line now beckoned. I certainly hadn't been a star during training but I had survived reasonably well and the prospect of a nice tour

abroad loomed before me, flying a classic aircraft. Before going out to Germany, I remember going to the SBAC Air Show at Farnborough and being very impressed by the brand new Blackburn Buccaneer Mk 2 – little realising then how much I would one day be involved with this splendid aircraft.

CHAPTER FOUR

The First Tour
– 1964 to 1966

No. 16 Squadron was a famous RAF unit, formed originally at St Omer in 1915. Its motto was *Operta Aperta*, meaning 'hidden things will be revealed'. It was an Army Co-operation squadron for most of the inter-war years and the beginning of World War Two, then became a reconnaissance squadron equipped with Mustangs and Spitfires. After the war it remained based in Germany and flew Vampires and Venoms before being equipped with the Canberra B(I)8. Its role as a light bomber squadron was primarily nuclear strike, with a secondary role of conventional ground attack by day and night.

The Canberra B(I)8 was a two-seat version of the aircraft, specifically designed for ground attack and intruder missions. Unlike the original Canberra, the pilot now sat behind and above the navigator in a redesigned cockpit with a fighter-type bubble canopy, which, for some inexplicable reason, could not be opened. Thus it became extremely hot inside until one got airborne and the cockpit conditioning started to work.

The navigator lived in a sort of tunnel, ahead of and below the pilot. He had a small chart table for high-level navigation and a couch in the nose to lie on for low-level navigation, looking out through a transparent nose with two small side windows. He had no ejection seat and relied on a manually operated para-

chute for escape, through the side entrance door. Most of our flying was at low level, but his chances of escape in an emergency at low level were slim. The pilot did have an ejection seat, but when I arrived on 16 Squadron it was still one of the earliest types with a limited operating envelope. During my tour it was replaced by a more modern seat with a ground capability at 90 knots.

The B(I)8 was equipped with more powerful Avon engines than the earlier B2 and carried considerably more fuel in integral tanks in the wings in addition to the three tanks in the fuselage. Wing tip tanks could also be fitted but there was a fairly low airspeed limit associated with them that inhibited any weapons delivery training so generally they were only used on long-range transit sorties. The cockpit layout was quite different and much improved on the B2 and T4. The aircraft had a simple fixed gunsight but no bombsight so traditional medium-level bomb delivery from straight and level flight was not possible. The rest of the systems were the same as the B2.

The two navigation aids fitted were a DECCA navigation system and a Doppler system called Blue Silk. DECCA used a series of ground stations to transmit signals that were displayed in the aircraft and transferred by the navigator to a chart, which was over-printed with a series of parabolic lines. It was a very accurate system but there was only a limited number of DECCA chains in existence, mainly in Europe. The Doppler Blue Silk was moderately accurate and displayed ground speed, drift and track; wind velocity could be derived from it. There was also a facility to drive a roller map from the Blue Silk, but this involved extensive preparation of long strips of map, which were quite narrow and thus limited in value. It was easy to disappear off the side of the map if you diverted off track. The roller map was a bit of a gimmick and was hardly ever used.

The B(I)8 had only two radios, a standard multi-frequency UHF set and a ten-channel preset VHF radio. It also had an Instrument Landing System (ILS), but surprisingly no radio compass. Thus our ability to navigate accurately outside the confines of the UK and Germany was limited. Overall, the B(I)8 was a big improvement on previous marks of Canberra, at least for the pilot. It was very nice to fly albeit rather heavy on the controls, and when on one engine could be more demanding than earlier models because of its increased weight and thrust. It

was strange to be able to throw this large aircraft around doing what were essentially aerobatic manoeuvres from low level. Fatigue consumption was a constant worry, but it was a straight-forward aircraft with a proven record of reliability.

The general pattern of flying in RAF Germany was a mixture of navigation exercises at high and low level over Germany and the UK, with regular weapons sorties to the Ranges. The whole of Germany was divided into a series of low-flying areas linked by link routes in which the minimum height was 250 feet – outside the areas and link routes the minimum height was 500 feet, so it was one vast play area. The UK low-flying system was also a series of areas and link routes but low flying outside these was not permitted. Running down the centre of Germany was the border with East Germany with its associated Air Defence Identification Zone. Penetration of the ADIZ was not permitted and it was also protected by a Buffer Zone. Flight in the Buffer Zone was permitted but with care; if a 'Brass Monkeys' call was transmitted on the 'Guard' frequency any aircraft in the Buffer Zone hearing it was required immediately to turn west. One took great care when navigating near the border! The main weapons range was situated at Nordhorn, on the Dutch border in the north-west of Germany, but others were also available in the UK – Tain, Wainfleet – and for a while there was a French range we could use called Suippes.

The B(I)8's weapons were simple. For our primary nuclear strike role we used a tactical nuclear weapon of American origin. It filled the entire bomb bay. It was closely guarded by the Americans, who would only release it for actual use on the word of their President. There were therefore many American weapon custodians and guards at Laarbruch. The only delivery method was called Low Altitude Bombing System (LABS), an American system that had been developed to allow the delivery aircraft to approach at high speed and low level. The weapon was tossed forwards by the action of the aircraft pulling up into a loft manoeuvre. Once the weapon had been released the aircraft would escape by continuing the loft manoeuvre into a roll of the top of the loop and departing in the opposite direction as fast as possible.

There were two delivery modes, Normal or Alternate. In the

Normal mode you approached at low level at 434 knots, having previously selected an Initial Point (IP). A time to run before initiating the pull up manoeuvre was calculated, taking into account the head or tailwind component. As you overflew the IP, you pressed the trigger, which initiated a timer. Once the timer ran out, the LABS display gave you a pitch demand, which you followed, pulling about 3½ g. At 60 degrees of pitch the weapon was released, to fly onward for about 3 miles; you continued to pull over into a roll off the top of a loop and (hopefully) escaped in the opposite direction. In the Alternate mode, you flew to the target, then pressed the trigger. You then pulled up into your LABS manoeuvre but this time the weapon was released at 120 degrees of pitch. It flew upwards, then descended down onto the target whilst you again (hopefully) escaped after completing the roll off the top of the loop.

There was a switch in the pilot's cockpit, the Normal/ Alternate switch, which selected the angle of pitch for weapon release. Needless to say, it was vital for this to be in the right position. Many a practice bomb was released inadvertently into Germany with the switch at Normal for an Alternate attack, and vice versa. Luckily our practice bombs were very small.

The LABS manoeuvre itself was quite an exciting thing to do in a fairly large aircraft from low level. You could get into real trouble if you pulled up too slackly, or allowed the nose to drop too much at the completion of the roll out at the end of the manoeuvre, as the Canberra would decelerate or accelerate very quickly. The accuracy of this type of attack was surprisingly good, given all the variables that affected it. We used to put bombs within 200 yards of the target on a regular basis, which was quite sufficient for an atom bomb.

In addition to the bombing ranges in Europe we also went regularly to Libya, where the weather was always much better, to carry out concentrated LABS work ups. There were two ranges, one at RAF El Adem, a remote base near Tobruk in east Libya, and another at a place called Tarhuna, a few miles south of Idris, where there was also an RAF Detachment.

LABS was our everyday bread and butter, because in those days NATO policy was for massive retaliation in the event of a Soviet incursion into West Germany. We would have 'gone nuclear' straight away. Most of our pre-planned targets were in Poland and the Baltic states, but there was also an option to

deliver a nuclear weapon direct into the battlefield if called on to do so – a process called Selective Release. The ubiquitous 25-lb practice bomb was used to simulate a nuclear weapon and the B(I)8 could carry four, two on a carrier on each wing weapon pylon. Very occasionally clearance was given for a 'Shape' to be released. The 'Shape' was a concrete version of the real thing; it weighed the same and had the exact same profile but was filled with concrete rather than a nuclear warhead.

I recall being taken to Nordhorn Range within days of my arrival at Laarbruch to witness delivery of a Shape as the culmination of a Taceval Exercise. It was a gloomy day. The crew had been briefed to deliver the Shape in the Alternate mode so that those on the ground could see the whole event from the Range tower. Sure enough, right on time, the Canberra appeared out of the murk, bomb doors open, at high speed. It pulled up over the target but to everyone's amazement the huge Shape left the aircraft at about 60 degrees of pitch – the Normal/Alternate switch had been left in the wrong position! The Shape disappeared into Germany, never to be seen again. We returned to Laarbruch, glad that we had not been involved other than as spectators!

The first task for any new aircrew arriving from the OCU at Bassingbourn was to convert onto the B(I)8, then become familiar with flying in Germany. Once this aircraft and theatre conversion was complete there followed an intensive work up in the nuclear strike role; this often took some time because of poor weather and I spent two sessions at El Adem and Tarhuna during the winter of 1964/5 where the weather permitted the necessary minimum number of LABS bombing sorties to be completed. Once this work up was finished a new crew could go into QRA.

Quick Reaction Alert (QRA) had to be maintained for 365 days a year. This involved having two Canberras loaded with nuclear weapons and ready to start, at 15 minutes' notice to get airborne. Two crews, with the associated ground crews, RAF police guards, American weapon custodians and guards lived in the QRA Compound, which was close to the main runway threshold and surrounded by a high security fence. As I remember it, one spent two weeks on QRA, 24 hours on, 24 hours off. You often flew normal training sorties during your 24 hours off.

Life in the 'Pen', as it was known, followed a predictable routine. Each day the aircraft had to be checked out, you had to study and be fully familiar with your route and target, and of course you had to be able to get airborne within 15 minutes of the hooter sounding, which meant living permanently in flying kit. We used regularly to be brought up to 10 minutes' readiness, which meant being strapped in and ready to start, but we never got to the point where the engines were started.

Being on QRA was very boring, it seemed inconceivable that we would ever really be launched; if we had been, there would have been nothing to come back to. We became quite good at cooking exotic meals and playing various games. At that time there was no British TV available, only the BBC World Service. We also used to leave the occasional 'spoof' map lying around showing how we were planning to drop our nukes on America, to get the American custodians all excited.

Would we ever have been launched in the event of an outbreak of hostilities in Europe? It is very difficult to say. Doubtless the need for US and British permission would have been time consuming and difficult in times of tension. Not long after I left 16 Squadron, the Soviet Union put down a popular uprising in Czechoslovakia; tension increased considerably and QRA was doubled up. However, nobody had much idea what was going on because of the jamming of communications with Czechoslovakia, so in the end nothing more happened. It is interesting that after the Canberra was withdrawn from service and replaced by a combination of Phantom, Buccaneer, Jaguar and finally Tornado aircraft, nuclear QRA, with British weapons, was maintained virtually to the end of the RAF's time in Germany.

RAF Laarbruch was built in the early 1950s, right on the Dutch border. The remains of the Siegfried defence line, built by the Germans as the first line of defence for the Reich, ran through the area covered by the airfield; many of the trenches and old fortifications were still evident. There was a single runway and two parallel taxiways, which were available as standby emergency runways. In 1964 there were only two squadrons in residence, 16 and 31 (a Canberra PR unit), although there was room for another two. We lived in barrack blocks in single rooms, which were smaller than those I had lived in at Cranwell.

The reason for this was that the man in charge of building the airfield had charged for a full-size, standard NATO base, but had built Laarbruch to a smaller specification all round. He then pocketed the extra cash and put it into a Swiss bank account, which doubtless paid for a comfortable retirement once he had been released from jail. We had to live with the consequences: smaller rooms; a runway that was a little too short and too narrow; a ring road around the airfield that was only wide enough for one way traffic; a fence that kept people in rather than out. The list was endless. Nevertheless, our quality of life was excellent. Drink was very cheap in the Officers' Mess – it was cheaper to put vodka in one's car windscreen wash than buy anti-freeze stuff at a garage. Petrol was bought through a rationing system that gave us extremely preferential prices compared with the Germans and cars could be bought without incurring purchase tax. Compared with our colleagues in the UK we were very well off.

The secondary role of the Canberra B(I)8, the one that it had originally been designed for, was to provide long-range ground attack using conventional weapons by day or night. As this role was not part of the RAF's contribution to NATO, it was only practised twice a year on conventional weapons practice camps, usually lasting a month, and held overseas at Akrotiri in Cyprus or Luqa in Malta. Our conventional armoury was very primitive and dated from the World War Two era. A gun pack containing four 20-mm cannon was fitted into the rear half of the bomb bay; each gun had a maximum of 500 rounds of ammunition which gave a very long firing time. The sighting system was a very simple ring and bead type gunsight, which could not be depressed or deflected to take wind effect into account. The front half of the bomb bay could carry sixteen 4.5-inch flares, most of which had been made in the late 1930s. These were to illuminate targets at night. A grand total of two 1000-lb bombs could be carried, one on each wing pylon. The only method of delivery was from a shallow-dive attack, again using the primitive gunsight. Although it was theoretically possible to fit three 1000-lb bombs in the front half of the bomb bay, they would not fall clear if delivered in a dive attack, as the Canberra did not have explosive release units to push the bombs out. There was no facility to deliver bombs from level flight as we did not

have a bombsight. Thus the front half of the bomb bay was always used for flares.

Our attempts at gunnery were fairly accurate from 10-degree dive attacks and some good scores could be obtained. Shallow dive bombing from a 30-degree dive attack was somewhat 'hit and miss' as the target virtually disappeared under the nose at the release point. Our ability to hit targets at night under the fitful light of the ancient 4.5-inch flares was minimal. Nevertheless, we all enjoyed conventional weapon delivery enormously, although we did not get many opportunities to practise. Events in the Far East were to change this during my tour on 16 Squadron.

In January 1965, after I had been on the squadron for four months, the squadron was stood down from its Quick Reaction Alert (QRA) commitment so that it could deploy to the Far East, in the conventional role. The British were involved in a little local difficulty between the newly emergent ex-colonies that had become Malaysia and Indonesia. This became known as the 'Indonesian Confrontation'. Most of the action took place on the ground, high in the jungled mountain border areas of Borneo. But after (rumour had it) a Russian-built 'Badger' bomber had flown down the runway at Kuching with its bomb doors open and other mildly tiresome provocations, the whole thing showed some promise of becoming moderately entertaining in the air. Despite the size of the RAF's Far East Air Force, which had eighteen operational squadrons, further detachments were sent out to Malaya and Singapore from the UK, Germany and Cyprus. Australia and New Zealand also sent operational squadrons.

No. 16 Squadron was deployed to an up country bare base airfield called Kuantan – about half way up the east coast of Malaya. As I was still the most junior member of the squadron I was given to the tender mercies of RAF Transport Command for my journey to Malaya. I was bumped off the Britannia at RAF Muharraq (Bahrain) in favour of a more senior officer, so I spent four days there, of which I only have a hazy recollection before the next transport aircraft – a Comet – came through. Most of the time was spent in the Mess bar playing a form of cricket with the resident members of 8 and 208 Squadrons, the Middle East Air Force Hunter Wing. The 'batsman' threw an empty beer can into

a rapidly rotating ceiling fan – there was no air conditioning in those days; if the can was subsequently caught by one of the 'fielders' he was declared out and had to buy a round.

Kuantan had a 2000-yard runway, a dispersal area but no taxiway and no permanent buildings or facilities other than a single-storey wooden terminal building with a small veranda on top for Air Traffic Control, to serve the Malaysian Airlines Dakota that flew in every other day. The nearest diversion airfield was in Singapore, 160 miles away. There was only a single telephone line to communicate with the outside world, an operation made more difficult by the fact that you had to talk to a Chinese telephonist to get connected to anyone outside. Communications security was non-existent.

There wasn't much space between the runway and the jungle but what there was, was filled by a variety of leaky tents dating from World War Two in which we lived, slept, ate and briefed. Sanitation was provided by some cold water taps and a local gentleman, who would arrive every morning driving a tractor towing a bomb trolley carrying clean Elsans and buckets, which he removed again in the evening. We were soon convinced that the real (secret) reason behind our presence at Kuantan was to carry out the field trial of the 'Closet, chemical lightweight tropical', or Elsan. It failed. The seat cracked under the weight of anyone over 8 stone. The crack opened up when you sat down, which was fine – but when you stood up. . .ouch! There were a few strategically positioned slit trenches, which made excellent baths since they filled up with rain every afternoon when the duty storm arrived. These were invisible to the uninitiated when full (before they put the sand bags round them). Having politely directed some visiting senior staff officer through the pouring rain to his tent, young officers would watch his retreating bush jacket and 'Dollar Brolly' (an exquisitely intricate piece of engineering in wood, string and oiled paper), with collective bated breath, praying that he would find one of the trenches on his way there.

There were also some rather elderly 20-mm Oerlikon anti-aircraft guns, which had been dug out of Singapore Naval Dockyard, scattered about to provide airfield defence. All lesser mortals (ie non-aircrew) were 'trained' in the use of these guns in the event of an air raid. But to cock the bloody thing you had to strap your heaviest man in the harness, and the rest of the

team had to swing on his legs, grunting and swearing, in order to compress the biggest spring I have ever seen. By the time the gun was finally loaded and ready to fire the enemy bomber pilot would be back home addressing his after flight Nasi Goreng.

Food was provided from a single cookhouse, made of wooden frames, canvas and the odd bit of aluminium sheet. The quality of the food, all purchased locally, was surprisingly good. Unfortunately the cookhouse burnt down during a visit from the Command Fire Officer, giving him a graphic demonstration of our fire-fighting ability, and its replacement was never quite as good.

Flying operations were delightfully straightforward. There were a couple of air traffic controllers, a mobile DF and a radio, but that was all. A mobile air defence radar was flown up at one point during our detachment, but I don't recall it ever offering much of a service. Eventually it was taken away. Our version of the Canberra had navigation aids that were optimised for use in Germany and there were no spare parts for them in the Far East. Consequently, after about two weeks we were dependent solely on our trusty navigators, trusty stopwatches and some in-different, untrustworthy maps for our navigational accuracy around a fairly hostile environment. Apart from the occasional burst tyre and bird strike our safety record was incident free, apart from one heart-stopping moment when a crew experienced a double engine surge in the circuit at night, caused by rain water ingress into the fuel system. They were downwind in the inky black when it occurred and the runway was already occupied by another aircraft backtracking for take-off. Luckily our plucky crew managed to recover one engine and arrived on finals just as the runway became clear. Remember, the navigator had no ejection seat in this mark of Canberra.

We were tasked to provide long-range day and night dive bombing and strafing with 1000-lb bombs and 20-mm cannon, illuminating targets at night with our ancient 4.5-inch flares. The likely targets were mainly airfields on the island of Java. The only weapons range where we were allowed to practise the night delivery profiles was China Rock Range, but because of its proximity to the Jahor Baharu coastline and jungle area where Indonesian paratroops were reported to have infiltrated, the Range Safety Officer and his party were evacuated every night,

so we used the 'Clear Range' procedure for weapon delivery. This meant that the responsibility for ensuring that it was safe to drop weapons rested with the aircrew of the delivery aircraft.

On the first night of flare dropping and gunnery on China Rock our most experienced crew were sent off to try out the procedures. They duly scattered numerous flares over what they thought was the weapons range but never succeeded in identifying the target, due to a combination of lack of aircraft nav aids and the absence of the Range Safety Officer. They must have been some way off the target because their flares' parachutes all ended up in the jungle on the mainland, causing a major security alert as the locals thought that some very small Indonesian guerrillas, or some supplies for infiltrators, had been delivered. The Headquarters of the Far East Air Force was not amused!

Night flying from Kuantan was challenging. In that airfield lighting was provided by a very feeble and unreliable set of electric lights supplemented by gooseneck flares, a galvanised watering can that had a huge paraffin-fed wick. The goosenecks were much brighter than the electric lights but there were only enough of them to put down one side of the runway. This made night approaches particularly interesting if you had forgotten on which side of the runway the goosenecks were.

The squadron's only moment of glory came one morning when we were tasked to strafe an area of jungle where the aforementioned Indonesian infiltrators were reputed to be hiding. Given that it was daylight the area was attacked successfully. What result this had we never did discover, but Indonesian infiltration of the mainland petered out over the subsequent months.

Off-duty amusements were simple. Every afternoon a 3-ton lorry would set off for the local beach – Paradise Beach – which was idyllic and unspoilt. It has now been developed into a Club Med holiday complex. The local town of Kuantan was a classic example of a Malay trading community unchanged since the Edwardian era. Great logs of timber were rolled into the waters of the muddy river, to be loaded by hand onto sail-powered cargo vessels, which then transported them down the coast to Singapore. There was a busy market full of live animals, any goods you could imagine and exotic tropical smells. The architecture was straight out of the nineteenth century and there was not a skyscraper in sight; now the town is a mass of high-rise development. There was one small hotel called the Nan Yang,

which was entered through a pair of swing doors that looked as if were straight out of a Wild West film set. The Kuantan Massage Parlour provided the services one would expect; the only other place of entertainment was the Kuantan Club. This was straight out of a Somerset Maughan novel. It had an air of seedy colonial gentility and was full of stale cigar smoke in which the dwindling number of ex-pat planters met to bemoan their passing sway – whilst swaying over a large whisky 'stengah'. There was an open-air cinema screen on the airfield's domestic site where scratchy old films were occasionally shown. Every so often an aircraft was allowed to go away to Singapore for the weekend where the crew enjoyed the delights of civilisation, air conditioning and Bugis Street.

Eventually it was time to go back to Laarbruch. I was No. 2 to the Boss for the return flight, which was to route via Butterworth, Gan, Bahrain, Akrotiri and Luqa. Gan was a tiny coral atoll in the Indian Ocean with a single runway from one end to the other and no diversion airfield within hundreds of miles. The long flight from Butterworth involved trying to climb above the intertropical convergence zone, an area of thick high cloud and vicious thunderstorms – an unpleasant experience. It was a great relief to see Gan, and a greater one to turn off the single runway without any drama.

During the leg to Bahrain the Boss announced that his section was diverting to Masirah, a very remote RAF staging post on an island on the south-east tip of the Oman. There seemed no obvious reason for this but as I was still a very inexperienced No. 2 I did not think to question this decision. After clearing the itinerant donkeys and camels from Masirah's runway by a series of low passes we landed. I asked the Boss's navigator why we had diverted to this barren outpost of the Empire when all had seemed to be going well. He replied 'Because this is where you can buy the best desert boots in the world and the Boss and I need a new pair.' It seemed a fair decision. We rejoined the rest of the squadron at Bahrain after flying over a very inhospitable-looking Oman, played some more beer can cricket, then flew uneventfully over Iran and Turkey to Akrotiri, Luqa and finally Laarbruch, where we arrived as a nine-ship formation, all without much in the way of nav aids. It was overall a great experience.

Somehow, looking back on it all, it looks disgracefully 'gash' from a modern professional standpoint. But the lack of good communications and nav aids, and living in a welter of confusion, made everyone conscious of basic principles. It induced in people a level of alert scepticism, such that they could always successfully 'cuff' it when the grand plan went awry. Not bad training for war – and not a management plan, budget holder, accountant or business consultant in sight! Just before we left we commissioned some Selangor pewter beer tankards to commemorate our Far East experience. Mine is inscribed simply 'JP [for Junior Pilot] XVI, Kuantan '65'. It is still in regular use.

In retrospect, it seems extraordinary that our conventional capability was so primitive. The Canberra B(I)8 carried the same weapon load as a World War Two ground attack fighter, the only improvement being the ability to carry considerably more rounds of ammunition. Weapon aiming was very basic and the ability to attack targets at night with any accuracy was minimal. The development costs of the V force and the nuclear deterrent had probably starved other more conventional tactical elements of the RAF of any improvements. This situation was only remedied with the cancellation of TSR2, the transfer of responsibility for the nuclear deterrent to the Royal Navy and the introduction of tactical aircraft such as the Harrier, Jaguar, Phantom and Buccaneer into the RAF.

After this experience of the Far East and a semi-operational environment, life back at Laarbruch seemed rather mundane. The squadron soon settled down back into its normal routine, QRA was resumed and trips around the Mediterranean RAF bases resumed, along with bombing detachments to Libya. The only real bit of excitement that I recall was on a visit to Gibraltar in the summer of 1965, when I was intercepted in the visual circuit pattern by a Spanish Air Force F86 Sabre fighter, which followed me around the Rock in close formation, without doing anything else aggressive. As the Spanish were putting more and more pressure on Gibraltar at this time it was a slightly unnerving incident and I was glad to get on the ground safely.

The squadron had an excellent conventional weapons detachment to Akrotiri, Cyprus, in January 1966. I recall being the Range Safety Officer at Larnaca Range (now the civil airport), and having great difficulty in keeping the local Turkish popula-

tion off the range. They would gather in large crowds and rush onto the range area to collect the brass shell cases, which were ejected from each aircraft as it fired its cannon. They were so keen to get these shell cases that they would chase the aircraft as it fired and try to catch the cases as they fell to the ground. Injury was frequent and inevitably we would be blamed for the consequences. We therefore resorted to firing flares at them from our Very pistols in an attempt to keep them away until after the aircraft had ceased firing. This tactic proved to be moderately successful.

On the squadron's return to Laarbruch at the end of January 1966, I discovered that the Royal Navy were seeking volunteers from the RAF to fly Sea Vixen and Buccaneer aircraft with the Fleet Air Arm, as there was a shortage of RN pilots. At this time the government was in the process of threatening to abolish conventional aircraft carriers so this seemed like an excellent opportunity to experience a form of aviation that looked as if it would soon be extinct. I therefore applied to fly Buccaneers in the strike role. The rest of the squadron thought I was mad, but it also offered another escape route from the possibility of a posting to the V Force, where many Canberra pilots were sent for their second tour.

I was delighted to discover that my application was accepted and I was to report to RNAS Lossiemouth, in the north of Scotland, in July 1966 for a swept wing conversion course on the Hunter before starting the Buccaneer Operational Flying Course. During my twenty months on 16 Squadron I accumulated a total of 526 hours on the Canberra, I was lucky enough to have been all round the Middle East and experienced an operational detachment to the Far East. It was a good background with which to go off on loan service to the Senior Service, where the highest standards would doubtless be expected. So I packed my bits and pieces into a Canberra and delivered them to Lossiemouth. I then hitched my Mirror dinghy to the back of my Triumph Spitfire sports car, and set off on the long journey from Germany to the north of Scotland, looking forward to something completely different but with happy memories of my first tour.

The Fleet Air Arm – 1966 to 1968

Royal Naval Air Station Lossiemouth was a very different place to RAF Laarbruch. Situated in wonderful country-side on the shores of the Moray Firth, it was a very busy airfield. It was the original stone frigate – you lived in a cabin in the Wardroom, phone calls from off base were announced as shore telephone calls, the liberty boat (bus) left the gangway (main gate) for Elgin. The floor was the deck and the ceiling the deckhead – all in all a very confusing environment for someone from the RAF but you had to learn quickly if you were to be accepted by the Royal Navy. This was a difficult time in that the government of the day was clearly intent on getting rid of aircraft carriers in favour of land-based RAF aircraft, so relations between the Fleet Air Arm and the RAF were not always harmonious. Thankfully there were no hard feelings between the light and dark blue at my lowly rank level.

I started off by doing a short conversion course on the Hunter with 764 Naval Air Squadron (NAS), which reintroduced me to swept wing handling techniques and naval aviation practices. The two variants of Hunter used by the Fleet Air Arm were the T8 and the GA11. Royal Navy policy was not to waste front-line combat aircraft by making trainer versions, so the ubiquitous Hunter T8 served as the training aircraft for the Scimitar, Sea Vixen and Buccaneer. Compared with the Gnat, the Hunter T8

was a simple aircraft. It was powered by the same version of the Avon engine as the Canberra B(I)8, which gave some 7500 lb thrust at sea level. It carried 3000 lb of internal fuel, nearly always augmented by two 100-gallon drop tanks, which increased the fuel state to 4900 lb (not a great amount but better than the Gnat). Its power controls were very light and easy to use. Manual reversion was much more straightforward than with the Gnat, just rather heavy. None of the Royal Navy's Hunters carried a gun but they could carry practice bombs and rockets. The single-seat GA11 version was essentially a Hunter F4 with the gun pack removed and the same wing as the T8, with the saw tooth leading edge. Both versions had arrestor hooks for use with airfield arrestor cables. A few of the T8s were equipped with the OR 946 Integrated Flight Instrument System, as fitted to the Buccaneer, which Folland had claimed couldn't be fitted in a Hunter! I spent three carefree weeks flying Hunters with 764 NAS relearning some old techniques. Then it was over to 736 NAS, the Buccaneer operational flying training squadron, for conversion to the Buccaneer.

After the relative simplicity of the Canberra, the Buccaneer was altogether a much more complex aircraft. It was designed and manufactured by the Blackburn Aircraft Company and was the company's first ever jet-powered combat aircraft. It was a big beast, with a 44-foot wingspan and a length of 60 feet. Its original role was to deliver a nuclear weapon against Russian capital ships, but it was also a very capable conventional attack aircraft and it could deliver a wide range of weapons. It had to fly at high subsonic speeds at very low level, which it did extremely well, but it also had to fly slowly enough to be launched and recovered from the rather small Royal Navy aircraft carriers, thus it presented quite a challenge to its designers. It was extremely robust in order to cope with the stresses of high-speed, low-level flight, many of the components being milled out of solid billets of aluminium, an entirely new construction technique at that time. It used the 'Area Rule', a design concept that reduced drag at high speed and as a consequence the fuselage had a very distinctive 'Coca-Cola' bottle shape with a large bulge behind the wings. This had the advantage of providing plenty of room for the complex avionics, which were all valve driven. The swept, folding wings were equipped with

sophisticated high lift devices to enable the aircraft to be catapult launched and to fly slowly enough to land back on board a carrier.

The ailerons could be drooped through 25 degrees to act as additional flaps, whilst retaining their differential roll control function. The small flaps on the inboard, non-folding, section of the wing, could be lowered through 45 degrees and the entire wing/aileron/flap area was 'blown' with high pressure air. This was known as Boundary Layer Control, or BLC. It delayed the stalling speed and allowed the approach speed to be reduced to a minimum of 127 knots. It was essential to have BLC on at aileron droop angles beyond 10 degrees or the wing would stall. Unfortunately the action of drooping the ailerons produced a very strong nose down trim change, so, to counteract this, an electrically operated flap on the tailplane was moved through the same angle as the ailerons but in the opposite direction. The entire undersurface of the tailplane was also 'blown'. Synchronisation of aileron droop/tailplane flap was essential; if more than 10 degrees' difference occurred between the two, longitudinal control would be lost. There were displays in the cockpit showing the relative positions of these control surfaces; they looked a bit like a section of round cheese when they moved so inevitably were known as the 'cheeses'. The whole system seemed incredibly complex but it worked very well, provided you made sure that the aileron droop and tailplane flap always stayed synchronised and that the BLC system was on auto.

The Buccaneer carried most of its fuel in eight integral fuselage tanks, connected in pairs; the fuel was fed to the engines by hydraulically driven pumps known as proportioners. These kept the fuel flow from the tanks correct so that the aircraft's centre of gravity remained constant. The Buccaneer was equipped with a fixed air-to-air refuelling probe; the original design was retractable but it proved to be too short so was replaced by a longer, fixed installation.

There was also a hydraulic system that powered the general services such as landing gear, hook, wing folding, the bomb door operation, the airbrake, the wheel brakes and the flaps. This was probably the least reliable system in the aircraft; it operated at 4000 psi so inevitably suffered from numerous leaks. In the event of a leak the system shut itself down, leaving you

with only single selections of essential services. The flying controls were hydraulically powered by separate systems that were very reliable. The aircraft had full auto stabilisation in all three axes and a standby yaw damper. It also had a fairly basic auto pilot with heading, barometric height and Mach number holds.

The two-man crew were accommodated under a long canopy, the Observer being seated higher and slightly off set from the pilot so he had a good view forwards.

The pilot's main instrument display was the OR 946 Integrated Flight Instrument System (IFIS) combined with a mass of more conventional instruments showing fuel state by individual tank, blow pressures, hydraulic pressures, electrical system status and radio altitude. There were also standby flight instruments that displayed airspeed, attitude, heading and height in the event of IFIS failure. The IFIS display of airspeed was not considered accurate enough for deck operations so a two-needle airspeed indicator (ASI) was stuck up on the coaming in the pilot's line of sight to give accurate speed indications for deck landings. Most of the weapons system controls were also in the front cockpit. Right in front of the pilot was the head up display (HUD), known as the Strike Sight, which displayed all the information needed to carry out an automatic or manual attack. Its glass could be lowered flat to improve the view forward, a Godsend when performing deck landings in poor visibility or into the sun.

Another device worthy of mention is the Airstream Direction Detector, or ADD. This was a small probe that stuck out from the side of the fuselage, with a series of slots cut in it. It was free to rotate so aligned itself with the relative airflow, thereby measuring the aircraft's angle of attack at any speed. It was capable of generating audio tones that varied as the angle of attack, and therefore the airspeed, changed. It was calibrated to generate a steady tone at the correct angle of attack/airspeed for final approach, with a high-pitched interrupted tone if the speed was too high and a loud, low interrupted tone if it was too low. It enabled the final approach to be flown entirely with one's head out of the cockpit, there being no need to check one's airspeed by looking at the ASI. It was a marvellous aid to deck launches and landings and also an invaluable warning device that the aircraft was approaching maximum performance.

The Observer had control of the navigation systems and the fire control radar, known as 'Blue Parrot', which was located in the nose. This was a powerful radar designed to detect and lock on to ship targets; it had a range of nearly 200 miles from high altitude. It provided range, bearing and closing speed information to the weapon system computer, enabling automatic toss attacks to be carried out using conventional or nuclear weapons. It also had a very limited mapping capability over land. The aircraft also had a Doppler navigation system called 'Blue Jacket', a device known as a Wide Band Homer that could detect radar transmissions and the usual radio equipment, including a long-range HF transmitter/receiver. Thus the Buccaneer was a very complex aircraft by comparison with the Canberra, but also a very capable and effective weapons system.

The Buccaneer was produced in three versions, the S1, the S2 and the S50, an export version of the S2 built for the South African Air Force. The S1 version was built in relatively small numbers and in 1966 was being steadily replaced by the S2, however, 736 NAS was still equipped mainly with the S1.

The S1's engines were Gyron Juniors, which were rather unreliable and short of thrust. Like all turbojets the Gyron Junior had a variable position intake guide vane system, but it was very sensitive and regularly got into the wrong position for the demanded RPM. There were even Inlet Guide Vane (IGV) position indicators in the cockpit, something I have never seen in any other aircraft. If the IGVs got into the wrong position the engine would stall or flame out, a regular occurrence. When the BLC system was selected extra fuel was applied to the engine in an attempt to offset the large loss of thrust. Cooling valves (Turbine Cooling Valves – TCVs) in the turbine assembly opened to provide a supply of cooling air to the inside of the turbine blades. This cooling air was essential to prevent failure of the turbine at high temperatures. So what with unreliable IGVs and TCVs that were essential with the BLC system, engine handling was complex. Even unblown take-offs were very slow events and in the blown approach configuration the aircraft was distinctly underpowered.

The S1's electrical system was also complicated. It used an air-driven alternator (Air Turbine Alternator – ATA) to provide the majority of AC services, the air being taken from the engines. If

you throttled back excessively in flight the ATA would trip off line as the engine RPM reduced, depriving you of many essential AC services just when you really needed them. Thus operating the Buccaneer S1 was a challenging business and I'm glad I never had to go to sea with it.

The S2 was powered by Rolls-Royce Speys, which had nearly twice the thrust of the Gyron Junior, and were much more reliable, so as a consequence it was a much more sprightly performer. The S2 also had a much better and more reliable electrical system, and was really quite a different aircraft. Unusually, the S1 handled much better than the S2 in spite of its lack of thrust. It could actually achieve a higher maximum speed (whilst consuming fuel at a vast rate) than the S2 because of the small size of its air intakes and it was much less sensitive in pitch at high angles of attack and low speed. Nevertheless the S2 was a vastly superior aircraft, with a tremendous range and weapon-carrying capability. It was trickier to operate from the deck but was clearly a much safer and effective aircraft overall. The Buccaneer was the first jet aircraft designed exclusively for the Royal Navy from the outset rather than being some cast off from industry that the RAF didn't want, so it was very much the star of the Fleet Air Arm in the 1960s.

There were eight of us on our conversion course. The two naval pilots were Robin Cox (until recently Airbus chief pilot with Virgin) and Rory Neilsen, sadly killed later in a winter sports accident. The two naval observers were John Bennet (a chopped pilot) and 'Bodger' Reardon (an ex-Sea Vixen observer). The other four were all RAF, two navigators (Barry Titchen and Norman Roberson) and two pilots, Tim Cockerell (ex-Hunters) and me. I was crewed up with 'Bodger' for the duration of the course, an interesting and enlightening experience.

The course itself was demanding. Initial conversion to the aircraft was a challenge in that there was no dual control version so your first sortie was your first solo, with a QFI in the back seat offering advice on handling, often in no uncertain terms! Once type conversion was complete it was straight into navigation, formation, weapons system handling and weapon delivery sorties on the two local weapons ranges at Tain and Rosehearty. Then came a busy session of practice deck landings on the runway, known as 'MADDLs' (Mirror Assisted Dummy Deck

Landings). The runway was marked out in the same way as a carrier flight deck with a projector sight alongside. However, you could not get the feel of what it really would be like, since whatever you did the runway never moved, was always 8000 feet long and 150 feet wide and never pitched up and down. The target area for landing was roughly the size of a tennis court – not very big. You had to be right on the centre line and accurate to within 1 knot of speed, and you had to fly the glide path with total concentration. You made no attempt to flare; you simply flew the aircraft into the ground in an attempt to move the earth from its orbit. Initially I did not find this new technique easy to grasp. As I was struggling to master MADDLs, HMS *Hermes* sailed into the Moray Firth so we all had to go off and do some real DLP (Deck Landing Practice).

The first time you see an aircraft carrier from the air your immediate reaction is that it is quite impossible to land on it as it is far too small. Nevertheless we were all briefed and awaited our turn at DLP. The exercise did not start too well as one of the naval pilots on the course ahead tightened his final turn excessively, lost control and both he and his observer ejected – successfully. I had the greatest difficulty in mastering the technique until rescued by the RAF QFI on 736 NAS, Graham Smart. He realised I was not coping, took me to the deck first in a Hunter then in a Buccaneer (with him bravely in the back seat), and finally it clicked and I had no further problems. During this session of DLP none of us actually hooked on, so this experience still awaited us. Deck landing in a large aircraft like the Buccaneer on a small Royal Navy carrier was always a very challenging event and it never became a relaxed affair.

There only remained the requirement to experience a catapult (cat) shot. There was a shore catapult installation at the research establishment at Bedford and so three of us went down there to do three cat shots before going to sea. The catapult at Bedford was an amazing device, with a large adjacent boiler house that looked like a Chinese laundry generating the required quantities of steam. You taxied up a ramp onto the catapult itself and were fired off down a disused runway, which had a large barrier like a tennis net to stop you if the catapult didn't give you enough flying speed. Because there was no ship-generated head wind you always got a very fierce kick from this land-based device.

The technique used for launching a Buccaneer was 'hands off'. A tailplane trim setting was calculated, taking into account the aircraft's weight, centre of gravity, configuration and expected end speed after launch. This was set and the theory was that it would rotate the aircraft into the correct attitude for the initial climb without intervention from the pilot. Once positioned on the catapult the aircraft would be tensioned up, with its retractable tail skid resting on the deck. The pilot would apply full power and when happy, lock his left arm behind the throttles to ensure they remained at full power, raise his right hand to accept the launch then place it on his right thigh close to but not holding the control column. The catapult would fire after a short delay. The acceleration was phenomenal (0 to 120 knots in about 1½ seconds) and then everything stopped as you became airborne. It was like being fired into jelly. You then carefully took control by grasping the control column, retracted the landing gear and allowed the aircraft to accelerate to a safe climbing speed, retracting the aileron droop/flap combination in stages. Loss of an engine or boundary layer control air would mean instant ejection. The aircraft was very sensitive in pitch and it was important not to apply a large nose-up control input until a safe speed had been achieved.

There had been a number of incidents when Buccaneer S2s had pitched up rapidly on launch. One aircraft had been lost under these circumstances, so there was much debate as to whether squadron pilots were taking control too soon and inducing pitch up by over rotating. Eventually a very senior naval test pilot was sent to HMS *Victorious* to re-brief the pilots and to demonstrate a launch in the configuration claimed to be the most susceptible to pitch up. An unwilling volunteer was strapped into the back seat and the rest of the squadron aircrew went out to watch the launch. Luckily there were at least three plane guard helicopters in attendance. The aircraft immediately pitched up violently after launch, the crew ejected and were back on board within minutes. The test pilot did have the grace to admit that there was a problem! Changes were made to the launch procedures, the wing tanks' profile was changed so that they generated less lift and a more accurate tailplane indicator was fitted. These changes were successful and launching the Buccaneer S2 became much safer.

Cat shots were always exciting and if something went wrong

the only option was ejection. There was an underwater escape facility fitted to the ejection seat, which, if selected, would release you from the seat and propel you upward if you went into the sea still in the aircraft. However, the canopy had to be jettisoned first and most of us thought that we would come up right under the ship, not a healthy prospect. Few people bothered to have it switched on. On my final cat shot at Bedford I had a full fuel load for the return to Lossiemouth. The cat gave me such a powerful kick that the entire head up display became detached and fell in my lap!

One final exercise had to be completed, a session in the 'Dunker'. For this exercise a facsimile of an aircraft cockpit, with you strapped into it, would be lowered underwater to a depth of about 30 feet. Then you had to escape. This was done in the submarine escape training tower in Gosport. It is quite an interesting and unnerving experience, being lowered into deep water strapped into an aircraft cockpit!

By December 1966 I was deemed ready to join a front-line squadron. I had some 65 hours in the Buccaneer (only 13 in the Mk2), seven deck landings and two cat shots under my belt. I was posted to 801 NAS, HMS *Victorious*, at that time in the Far East. No. 801 was the first squadron to be equipped with the Buccaneer Mk2 and *Victorious* was half way through her commission, so I would be joining an experienced outfit.

The trip out to Singapore was just as slow as the previous one in 1965, however, this time I was going to a completely unknown environment. I remember finally arriving in the naval dockyard, late in the evening after a long, hot journey, and seeing the carrier for the first time. From the dockside she looked enormous. I found my way to the aft gangway, the one used by officers. No one seemed to be expecting me, but I was taken down to the Wardroom in the bowels of the ship, to discover that all the air squadrons were disembarked to the various airfields in Singapore and only ship's officers were currently on board. Nevertheless they filled me up with Horse's Neck (brandy and dry ginger) and eventually a cabin was found for me, even deeper inside the ship. I had no idea where I was and fell asleep, only to wake sometime later urgently needing to have a pee. I stumbled around the passageways and eventually found the heads (lavatories). Much relieved, I then tried to find

my cabin again. I became totally lost, and, clad only in my underpants, had almost given up all hope of ever finding my cabin again when I walked past an open door and recognised my baggage! What a relief.

The next day I was collected by someone from the squadron and taken over to RAF Changi, where the squadron was located, a much more familiar environment. Many of the squadron personnel had returned to the UK for Christmas, but those who remained were having a very pleasant time living in the Fairey Point Officers' Mess, considerably more luxurious than HMS *Victorious*. The Officers' beach club was just around the corner, another fine establishment. The flesh pots of downtown Singapore were only a short taxi ride away and I seem to remember that we all took full advantage of them.

However, re-embarkation day moved ever closer. We spent our time airborne performing lots of 'MADDLs' at Changi by way of preparation. Finally, one morning the ship steamed past us as we sat at the beach club and that afternoon we launched to recover on board. The ship succeeded in finding the only piece of the South China Sea where there was a big swell and after a few hairy attempts to get on board we were all sent back to Changi.

The next morning conditions were much calmer and after three rollers I was told to put my hook down. I will never forget my first arrested landing; the deceleration was amazing but even more alarming was the urgency with which you were marshalled away from the angled flight deck to your parking spot, often with only the sea in view. Having finally shut down and climbed out, I looked around. Normally, after landing at an airfield and getting out, all relative motion has ceased and this is what you expect to see. By now, though, the ship was turning out of wind; I looked up, expecting the world to be still but the horizon was moving rapidly. It was so disorientating that I had to clutch hold of the aircraft ladder to stop myself falling over.

There now followed a period of intensive work-up training for the new members of the ship's crew and the new aircrew. We flew on average about twice a day. Finding one's way around the labyrinth of passageways and compartments was quite a challenge, especially as the older hands seemed to know their

way around with unerring accuracy. I recall one occasion when, trying to remain inconspicuous in the Wardroom one evening, the Squadron Commander collared me to take a message to the operations room in the island. At that time the only way I knew how to get there was to go out onto the flight deck and walk along it to the island. So I set off, in the dark. As I climbed up the access ladder that led to the flight deck, something made me look to my right. There I saw a Sea Vixen on short finals; the other squadron was night flying and the flight deck was very active. Had I not turned to have a look I would have been flattened by it landing on. I retreated to the Wardroom – the message was not delivered. An aircraft carrier was a very dangerous place for the inexperienced.

Life on board soon settled down as we found our way around and got used to the routine. The flying was probably the most exciting and demanding that I have ever experienced. We started the day early, first launch usually being at 0700 hrs, which meant getting up at 0500 hrs, breakfast in the Aircrew Refreshment Buffet (ACRB) at 0530 hrs – always greasy fried eggs – then briefing at 0600 hrs. The aircraft would be ranged on the flight deck in order of launching – normally the Gannet AEW aircraft first, then the Buccaneers and last of all the Sea Vixens.

After start up the aircraft was taxied forward to the catapult and positioned accurately with the use of the Calley gear, inward-rotating rollers that ensured the aircraft was aligned exactly in the centre of the catapult. The hold back, which was a frangible metal link connected to the rear of the aircraft, was then connected to the deck. The aircraft's wings were then spread and the catapult bridle attached; the catapult shuttle was then moved forwards so that the aircraft was then tensioned up on the catapult in the flying attitude. On receipt of the clearance to launch from Flyco, the Flight Deck Officer (FDO) would give the wind up signal; once the pilot signalled that he was happy to launch the FDO would drop his green flag and the catapult would fire after a short pause.

Once airborne and joined up as a formation we would practise a variety of activities. Ship attack profiles, navigation exercises, weapon delivery work, air-to-air refuelling, battle formation and air combat, and strikes on coastal or inland targets all featured regularly. The ship tended to operate either close to Malaya or the Philippines, there being excellent

American facilities in the Philippines, including the enormous naval support facility at Subic Bay.

I was lucky enough to be selected not only to deliver a 'Red Beard' 2000-lb nuclear weapon Shape on a 'Long Toss' attack on Tabones Range in the Philippines, but also to fire Bullpup missiles at Scarborough Shoal, an offshore reef with a wreck that made a suitable target. The 'Red Beard' was the British tactical nuclear weapon of that period, designed as the principal anti-ship weapon for the Buccaneer. It filled the entire bomb bay. The target was a small rocky island and the enormous bomb hit it right in the middle – a very satisfying experience. The Bullpup was a small air-to-surface missile of US origin, with a range of about 3 to 4 miles. It was fired in a shallow dive and controlled by the pilot, using a small control handle. It was a difficult missile to control accurately and much practice was needed on the very simple simulator that we had on board. On one occasion I recovered to the ship after failing to fire a Bullpup owing to bad weather. After landing on, the missile broke free from the aircraft and careered off down the flight deck, narrowly missing various personnel and other aircraft, to fall in the sea ahead of the ship with a big splash. Naturally it was assumed by all that I had failed to make my weapons switches safe and had fired it off by mistake. Luckily the film taken from Flyco, when developed, proved otherwise and I was exonerated.

Recovery to the ship was always a fairly stressful business. First of all you had to find the ship, which was not always where she said she was. You then joined the 'low wait' to await your 'Charlie time', the time you had to arrive on the deck. When called in to 'slot' you joined the circuit, having dumped fuel if necessary to get down to landing weight. The circuit was flown at 600 feet, turning in abeam the ship. You aimed to achieve your final approach speed/angle of attack about half way round the final turn. It was important not to line up on the ship's wake, which always gave a powerful visual distraction. You also had to cope with the funnel smoke, which sometimes was quite thick. The final part of the approach was flown at a constant speed/angle of attack, lined up exactly on the flight deck centre line and using the projector sight for glideslope. It was vital to concentrate utterly on the sight and the centre line, ignoring the rest of the ship's structure. There was no attempt to cushion

the landing at all; the aircraft arrived at a fairly high rate of descent. You knew immediately if you had caught a wire because of the very rapid deceleration. In this case you throttled back immediately, so that the aircraft would be pulled back a short distance at the end of its roll out, thereby allowing the wire to fall clear of the arrestor hook.

Flight deck handlers would move out onto the flight deck as soon as they saw that you had caught a wire, in order to give the signals for taxiing clear as quickly as possible, as there was usually another aircraft 30–40 seconds behind you. The wire needed to be reset and checked before the next aircraft could land – this was done by a man wearing a large glove, which he ran down the length of the wire to check for any broken strands. If any were found that wire would not be reset. It was not uncommon for a recovery to start with all four wires available and to finish with only one.

Meanwhile, you taxied clear as fast as possible, folding the aircraft wings as you went, to be parked towards the bow of the ship. If no deceleration was felt on touchdown you immediately applied full power to go round, accompanied by a shower of red flares and the cry of 'Bolter, bolter' from Flyco. You then rejoined the circuit for another go. Once the ship and her squadrons were fully worked up you would often find the ship still turning onto her designated flying course as you 'slotted', only steadying on the correct course as the first aircraft rolled out on final approach. The desired landing interval by day was 30 seconds. In the event of poor weather a radar approach was used, similar to that on an airfield but without any glideslope information.

For most of my time on board, the Buccaneer was not cleared to fly at night from the ship because of problems associated with the 'hands off' launch technique. Eventually these difficulties were resolved and a full flight clearance was issued. Night flying was much more demanding. The catapult launch was very disorientating, as you were fired off into the dark without any visual references. Night recoveries were always radar approaches, irrespective of the weather. You looked up at 1 mile/300 feet, to see a very dimly lit flight deck. The projector sight was, however, very bright and the centre line was marked by a line of red lights that continued down vertically over the stern, thereby giving a very powerful indication if you were off

centre line – this was known as 'the donkey's plonk'. Day flying from the deck was very exhilarating and I soon came to enjoy its challenge, but nobody really enjoyed night flying off the deck very much.

During my time embarked the ship stayed east of Suez, operating mainly in the Far East. We visited Hong Kong, Subic Bay and Singapore regularly. The ship was getting old by this time and generally seemed to suffer some form of mechanical breakdown on an almost weekly basis, requiring repair work to be done in a major dockyard. During one of these visits to Singapore a group of squadron aircrew drove an ancient minibus up to Thailand on an expedition. Thailand was un-discovered by western tourists at that time and I have memories of a country still very much stuck in the nineteenth century. The railway engines were all powered by steam, using wood for the boiler fires; they were all made in Glasgow in about 1900. I also recall taking another group of squadron ratings on a snorkelling expedition to a Malayan offshore island. We were delivered there by an ancient leaky fishing boat and left to our own devices for three days. There was no one else there. We camped on the beach; it was like a scene from Robinson Crusoe.

In May 1967 it was time for the ship to return to the UK for a major refit. We sailed up the west coast of Malaya (flying all the time) then crossed the Indian Ocean heading towards Aden. The British were in the process of withdrawing from Aden at this time and the security situation in the colony was very tense. There had been numerous terrorist acts and the prospect of a bloodbath during withdrawal was very real. On arrival off Aden the heat was intense and the ship's air conditioning system, never very efficient, failed completely. The ship's engineers decided to flood the flight deck in an attempt to cool down the ship's interior. The only effect this had was to produce incred-ibly hot fog below decks. We all went ashore to find some relief and were entertained in the Officers' Mess, RAF Khormaksar, our bus being guarded by soldiers with loaded machine-guns.

Also in Aden at the time was HMS *Hermes*, the carrier that was to take over our role east of Suez. Thus there was a rare opportunity for two Royal Navy aircraft carriers to operate together for a short time. We spent three or four days flying

around the Aden Protectorate, accompanied by the Hunters from Khormaksar, in a display of airpower that was designed to impress upon the locals our capability to quell any unrest. This culminated in an enormous, unwieldy fifty-five aircraft flypast, consisting of all the serviceable Sea Vixens and Buccaneers from *Victorious* and *Hermes*, together with a large number of Hunters. The Hunters, who were all at the back of this huge gaggle, had a very difficult time staying in position.

We flew round Aden three times then split up to recover to our own aircraft carriers. Not wishing to be outdone, the 'fish heads' down below had taken advantage of this rare opportunity to operate two carriers in close company. They ended up with the two ships in line abreast, some two miles apart, both steaming into wind (what there was of it) to recover their aircraft. Unfortunately, they had put *Hermes*, which had a less angled deck, to the right of *Victorious*. This meant that to put the relative wind down her angled deck she had to steam on a heading that had her steadily closing with *Victorious*. Thus the two carriers got closer and closer and their individual landing patterns began to get completely intertwined, with confusing consequences. It was rumoured afterwards that somebody actually landed on the wrong ship without realising it, only to be rapidly fired off again.

We bade farewell to *Hermes* and steamed up the Red Sea toward the Suez Canal, with canvas swimming baths rigged on the flight deck to cool off in, uncertain as to whether or not we would be able to transit through the canal. The Middle East was in turmoil, with the prospect of a war between Israel and the Arab nations becoming more likely every day. We listened to the BBC World Service with great interest; the alternative route would have been all the way round South Africa. Nevertheless, we did go through the canal, but there were signs of military activity building up on both sides. We watched Egyptian Air Force pilots, who watched us from the bank, as we slowly sailed through. In the Great Bitter Lakes we passed the liner *Oriana*, which caused great excitement because of the large number of young, enthusiastic female passengers. Eventually *Victorious* emerged into the Mediterranean and we all prepared to disembark to the UK after a fast passage towards Gibraltar.

Just twelve hours before launching everything changed. We

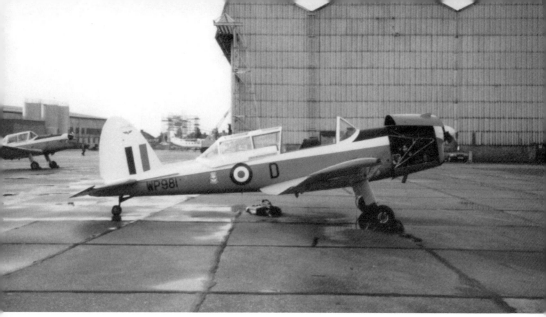

perfect aircraft for a first solo.

Old cars were an essential feature of a Flight Cadet's lifestyle. My 1930 Morris Cowley with the boys aboard.

JP4 formation, Cranwell, 1963.

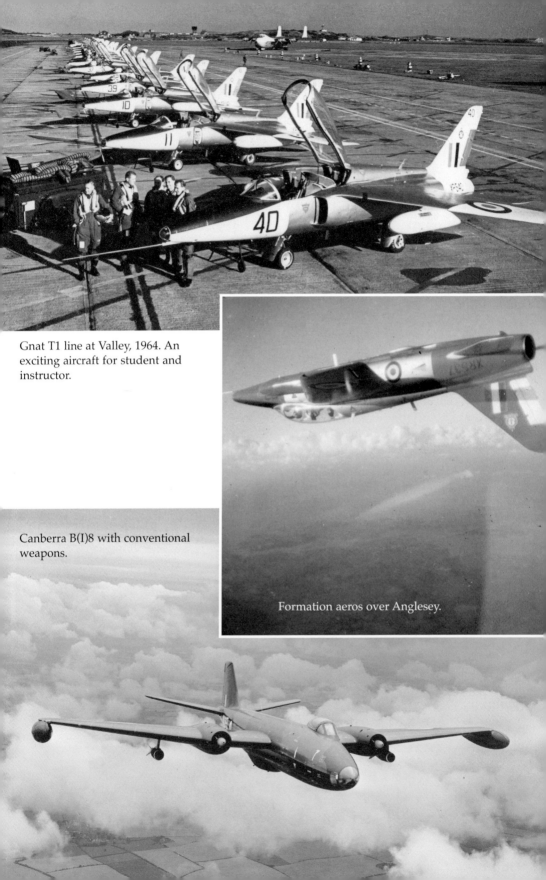

Gnat T1 line at Valley, 1964. An exciting aircraft for student and instructor.

Formation aeros over Anglesey.

Canberra B(I)8 with conventional weapons.

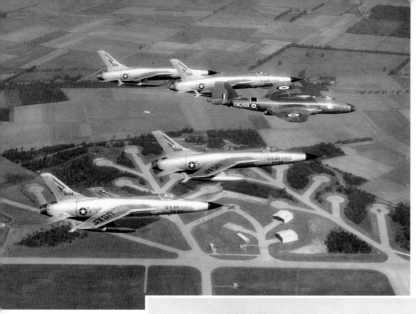

16 Sqn Canberra, with USAF F105s, overflying Laarbruch QRA compound.

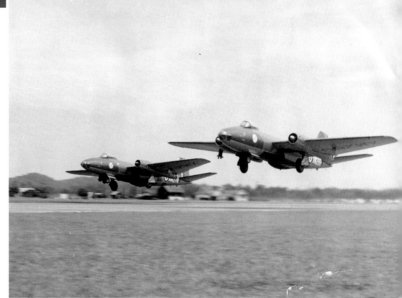

Paris take off, Kuantan, author in No 2 position.

Officer's accommodation, Kuantan, after regular evening storm.

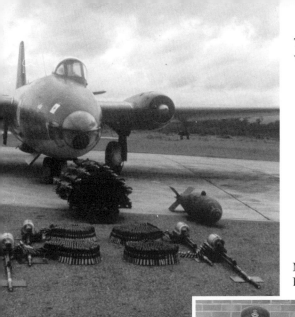

The Canberra's conventional weapons load was rather small for such a large aircraft.

My Buccaneer course colleagues, RNAS Lossiemouth, 1966.

Hunter T8B, the dual control trainer for the Buccaneer.

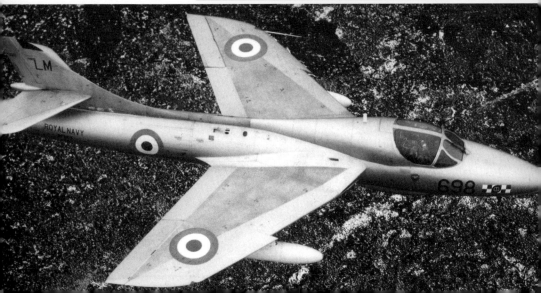

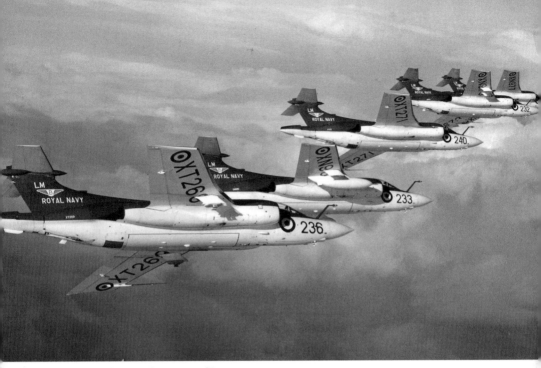

A gaggle of early production Buccaneer S2s.

HMS *Victorious*, leaving Portsmouth.

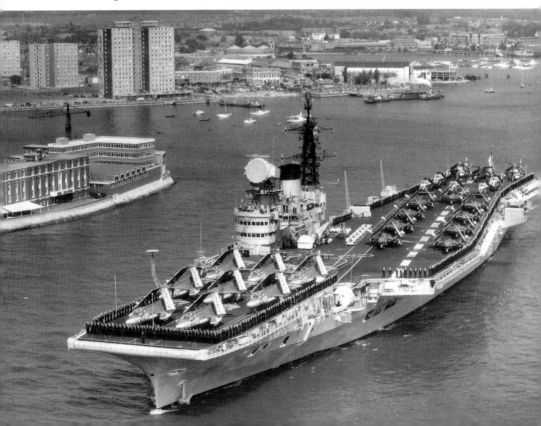

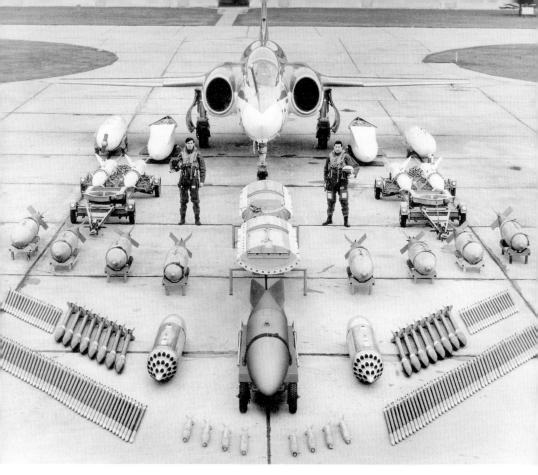

The Buccaneer had a far greater range of weapons than the Canberra.

Safely airborne from *Victorious*'s port catapult.

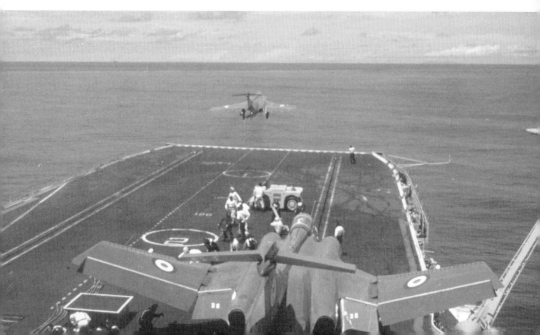

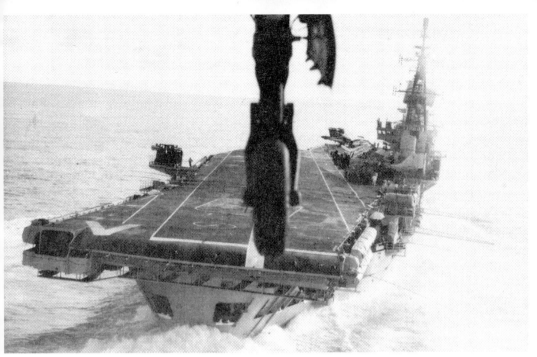

Final approach to 'Vic', as recorded by forward facing F95 camera in Buccaneer's photo-recce pack.

Buccaneer takes a wire.

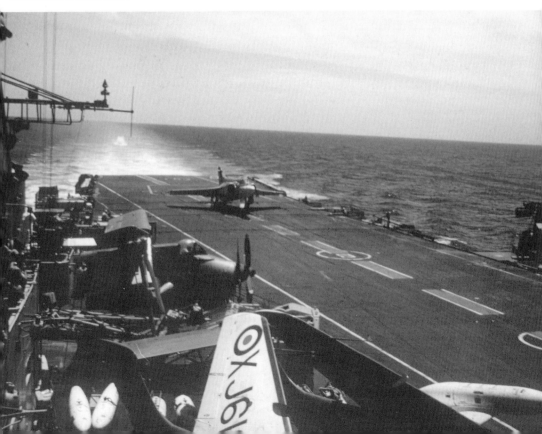

lose a Bullpup missile whilst landing on, April 1967.

Buccaneer firing 2″ rockets, Tain Range.

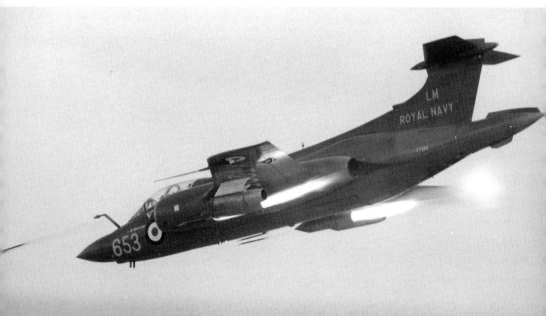

All 9 of 801's Buccaneers airborne.

My ejection seat, showing the underwater assisted escape bladders inflated

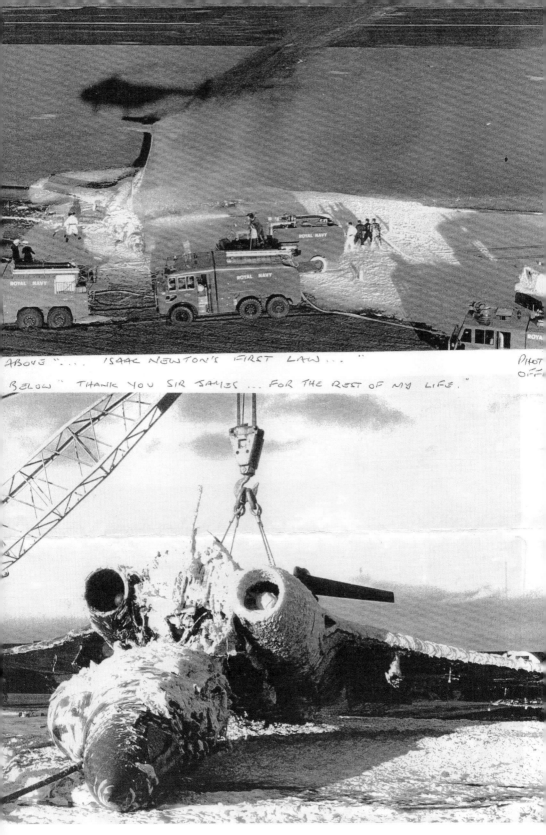

ABOVE "... ISAAC NEWTON'S FIRST LAW ..." PHOT
 OFF

BELOW " THANK YOU SIR JAMES ... FOR THE REST OF MY LIFE."

A dramatic end to a 'Fam1' sortie, my student and I ejected successfully.

A 12 Squadron Buccaneer. This was my personal aircraft on 801 Sqn, now in service with the RAF.

Air to air refuelling
with 12 Sqn.

Recieving my Queen's
Commendation for
Valuable Services in the
Air from the Squadron
and Station Commanders.

Pilots of 79 Sqn, RAF Brawdy, 1976. Author seated behind cockpit.

Hunter of 79 Sqn over Soviet warship, Gibraltar, 1976.

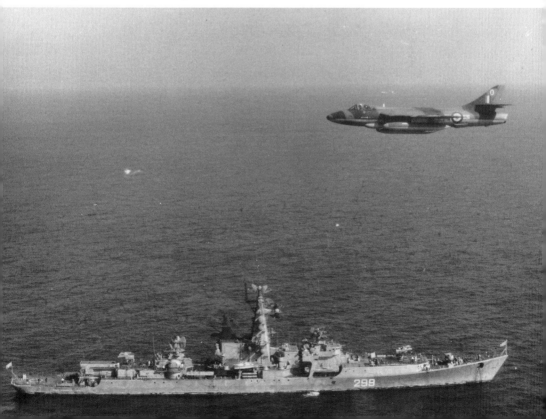

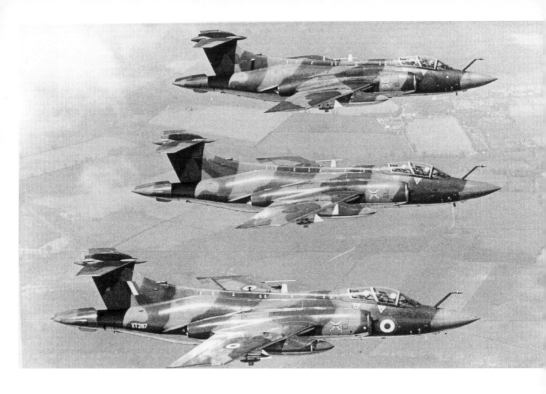

3 Buccaneers of 237 OCU, RAF Honington, 1977.

The 'Silver Wings' flypast, June 1977. No sign of the chaos about to occur.

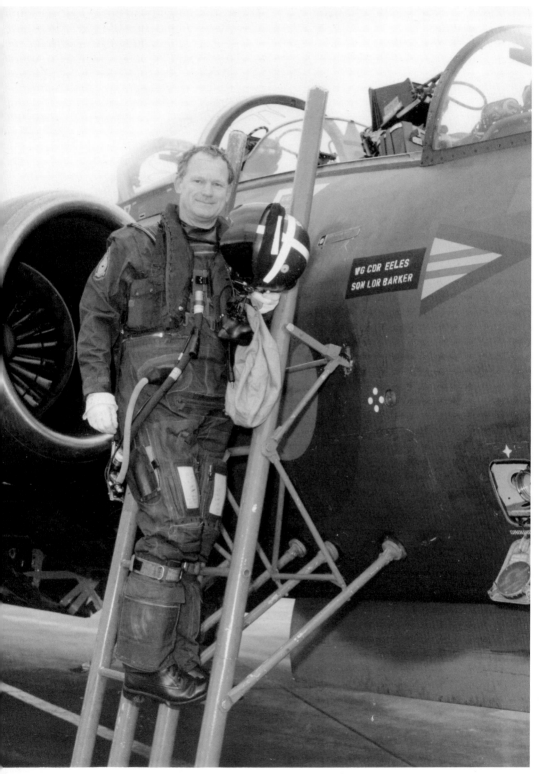

Taking command of 237 OCU, 1984.

Sidewinder firings at Aberporth, 1987.

were to stay in the Med for the time being, operating close to Malta, practising rocket attacks on our splash target and air-to-air refuelling, mainly for the Sea Vixens. No one knew at junior officer level what we might be expected to do if fighting was to break out between Israel and the Arab nations, an event that seemed more likely every day.

Unfortunately there was no Fleet Auxiliary tanker with aviation fuel in the Med, so on the morning of Monday 5 June we steamed into Grand Harbour, Valetta, to off-load a broken Sea Vixen and top up with aviation fuel. We had originally been told we would be remaining in harbour for two days' rest and recreation and a big formal cocktail party had been arranged for the first night at anchor, with the inevitable run ashore afterwards. There was also, as I recall, a rival party ashore, to be given by the local nurses and school teachers. We bachelors all planned to go to the latter event, as it offered much better possibilities after a long stretch afloat.

That morning, as the ship entered harbour, we listened on the Wardroom's radio to the news of the outbreak of hostilities between Israel, Egypt, Jordan and Syria. That evening, as we were all changing into shore rig for the schoolie/nurses' party, there came a pipe over the ship's public address system, announcing that all shore leave was cancelled, but that pre-planned shipboard events would continue. We all changed out of shore rig into cocktail party uniform, when another pipe came, announcing that all shipboard events were now cancelled and that the ship would be sailing at 2200 hrs, etc, etc, with all the going-to-sea routine being trotted out. Groaning, we went back to our cabins to change into normal uniform for supper, when another pipe announced that all previous instructions were cancelled, shore leave was on again, the ship would not be sailing, etc, etc! All this took place in the space of twenty minutes or so.

And so we stayed in Malta for the whole of the seven-day war, doing nothing more aggressive than getting drunk at various parties ashore, whilst being accused by the Arab press of actively assisting the Israelis. Once the war was over we set sail, and a day later we were all launched off to fly back to Lossiemouth via Boscombe Down, where the aircraft were all searched thoroughly by Customs. I flew back in Buccaneer S2 XN 981, with our indefatigable junior engineer, Chris Esplin-Jones (Split Pin) in the back. We suffered a total pressurisation

failure and had no hot air in the cockpit, so it was a very un-comfortable transit across France, followed by a long wait over Boscombe for the mist and ice in the cockpit to clear sufficiently to be able to land. Sadly, as events turned out, that was the end of my embarked flying, although I was not to know it at the time.

HMS *Victorious* arrived at Portsmouth about a week later and I went back on board to collect my bits and pieces. The ship was to stay in dock for a short refit before sailing again on her last commission. Whilst this was taking place 801 Squadron remained shore-based at Lossiemouth. We exchanged some of our aircraft for newer ones painted in the new overall grey paint scheme and carried on flying, waiting for the ship to put to sea again in November. The squadron provided an impressive fire-power demonstration for Exercise *Unison*, when three aircraft dropped their eight 1000-lb HE (high explosive) bombs in shallow dive attacks on Salisbury Plain, in front of a large group of Very Senior Officers. On the weekend before *Victorious* was due to leave the dry dock a fire broke out on 2 Deck when a water-boiling urn shorted out. The ship's fire main was not connected up as the ship was in the dry dock, so by the time the fire was extinguished by the dockyard fire brigade one sailor had died and some serious damage had been done, mainly to the wiring and cable looms. A week later the MoD announced that the ship would not put to sea again because the damage was considered too severe to justify the cost of repair. The Commissioning Party was turned into a Wake and even our farewell flypast of nine Buccaneers was frustrated by bad weather.

I remained with 801 Squadron throughout that winter and spring. The squadron remained at Lossiemouth and continued with operational flying activities, including the first air-to-air refuelling from Victor tankers. I also dropped a number of simulated napalm stores, called firebombs, on Tain Range. However, I do not believe that a real firebomb was ever released for actual service.

In April 1968 the squadron, now allocated to HMS *Hermes*, deployed to RAF El Adem, in Libya, for a major exercise. Our sister squadron, 893 Naval Air Squadron, flying Sea Vixens,

deployed to Cyprus as defenders. We attacked Cyprus from El Adem on a regular basis, to be intercepted by Sea Vixens – it became very routine. The second half of the exercise was spent doing forward air control work in the desert with the army, which was much more fun.

It was just about this time that the Government announced that the RAF would be receiving Buccaneers as a long-awaited replacement for the Canberra, after many other projects had fallen by the wayside.

On return to Lossiemouth after the exercise in Libya, 801 Squadron was to reduce in size to a six-aircraft squadron in order to fit into the smaller *Hermes*. This meant a corresponding reduction in the number of aircrew so my time with the Fleet Air Arm was coming to an end. I flew back from El Adem in XT 269, expecting to have a non-stop transit refuelled *en route* by Victors. Unfortunately the cabin heating failed and the prospect of a six-hour transit at 30,000 feet in sub-zero temperatures was not appealing so we diverted into Malta.

Once on the ground Trevor Ling, my observer, fired up the HF radio and spoke to Lossiemouth explaining our predicament. An engineer was brought to the radio at Lossiemouth and gave instructions on how to fix the problem. I borrowed some tools from the RAF engineers and was busily pulling bits out of the Buccaneer when a group of RAF officers came over to have a look at their 'new' strike aircraft. They were not terribly impressed at what Trevor and I were doing to it!

Once back at Lossiemouth I discovered I was to go on a Qualified Flying Instructor's course at the Central Flying School, RAF Little Rissington. So I packed my bags and said farewell to the Royal Navy, not expecting to go back to them again but having had a wonderful two years with some of the best flying of my life. Embarked flying really was the most demanding aviation experience I have had, so I left sadly, not knowing what the future held.

Learning to Teach
– 1968 to 1969

RAF Little Rissington was the home of the Central Flying School (CFS) and a far cry from the front-line Fleet Air Arm. Neat rows of Jet Provosts, Chipmunks and Varsities were lined up on the flight line. Everything was very prim and proper. The Officers' Mess was a vast building with rows and rows of photographs of previous QFI courses along its corridors. Luckily my course had a large number of kindred spirits who had reluctantly been extracted from the front line, so the prospects for a robust social life were pretty good. Little Rissington was in the heart of the Cotswolds, with Bourton on the Water just down the hill with its many excellent pubs; Cheltenham was only a twenty-minute drive away.

We spent the first few weeks in the ground school learning about aerodynamics, meteorology, flight instruments, flight planning and instructional technique, all rather tedious and uninspiring. We then started flying the Jet Provost and after being checked out began to be taught the art of basic flying instruction. This consisted of being 'given' a typical flying lesson, such as 'effects of controls', by a staff QFI. Then you would practise the 'patter' with a course colleague, then finally 'give it back' to the staff QFI, who then 'gave' you another exercise. Needless to say, the mutual practice sorties did not consist of too much patter, but they were an excellent oppor-

tunity to practise advanced and convoluted aerobatics with one of your mates.

After some 30 hours and an initial handling check, the course was split up, the majority remaining on the Jet Provost and destined for the basic Flying Training Schools at Cranwell, Linton-on-Ouse, Church Fenton, Leeming, Acklington and Syerston. A few went on to the Chipmunk, which was flown by the University Air Squadrons – a very popular posting. A similarly small number went on to the Varsity for multi-engine instruction and only four went on to the Gnat, the advanced fast jet trainer. Just before I arrived at CFS it was hinted that I would be returning to the Buccaneer as a QFI after the course; I was therefore delighted to find myself on the Gnat course with one other RAF colleague and two naval officers.

The Gnat course was completely different from the Jet Provost element of the CFS course. For a start, the flying was undertaken at Kemble instead of from Little Rissington, as the runway at Little Rissington was considered too short for safe Gnat operations. This entailed a journey by ancient minibus every morning, which took about an hour, just about long enough to recover from the previous night's socialising.

The minibus was driven by an equally ancient civilian driver called Charlie. He would spend the entire journey telling us how he had never had an accident in all the years he had driven for the RAF. After many weeks of this torture we were all delighted when one day a wheel fell off the minibus as we descended the hill towards Bourton on the Water. Charlie burst into tears and took no further part in the proceedings. After recovering the wheel from the neighbouring field we escorted Charlie down the road to the Old New Inn in Bourton, where we sought assistance in the form of a restorative drink. Notwithstanding the early hour of the day, the landlord obligingly opened up, thereby putting any prospect of flying out of court, as he insisted that all of us should have a restorative brandy in view of the shock we had experienced. The party developed from then on and we didn't get back to Little Rissington until very late in the day!

Kemble was a sleepy hollow of an airfield deep in the Gloucestershire countryside. The CFS Gnat squadron shared

the accommodation with the Red Arrows who were flying the Gnat at this time. The course itself was much more relaxed and practical than what went on up at Little Rissington.

The rear seat of the Gnat was a very difficult seat to teach from; the view ahead was minimal and many of the controls and instruments in the back were different from the front. Teaching from the back of a Gnat was a specialised art and it was difficult to imagine what it would be like trying to teach a 'real' student, rather than one of your course colleagues or one of the staff instructors. We spent a lot of time transiting to and fro from RAF Valley, either to take advantage of better weather, to use the simulator, or to borrow other aircraft as the Gnat was notoriously unserviceable.

Even walking out to the aircraft could be hazardous. The Red Arrows also flew from Kemble and during the winter months they had little to do – there was no formal work up programme as today. Various team members would come to Kemble and get airborne, float around the circuit until a couple of CFS students began to walk out to their aircraft, and then attempt to blow them over by flying down the flight line as low and fast as possible.

Eventually, by late November 1968 the course was complete and we were all signed up as B2 Qualified Flying Instructors, instructors under probation as we had yet to be exposed to real students. The end of course final guest night was a riotous affair and included participation by live chickens and Morris dancers. The Commandant, Air Commodore Ivor Broom, a wartime pilot of great distinction, joined in the revelry with tremendous gusto. The end of course photo was taken the next morning and was not a pretty sight.

By now my ultimate destination as a QFI back at Lossiemouth on the Buccaneer had been confirmed, but before that occurred I was to go to No. 4 Flying Training School at RAF Valley to gain some instructional experience. Valley had not changed much since I had done my flying training there four years previously. In the winter it was still wet and windy. The only difference was that there was now a squadron of Hunters established to provide additional training capacity, particularly for foreign students, as the Gnat's high level of unserviceability made it very difficult to achieve the training task. I joined the Refresher Flight of 2 Squadron, which spent its time refreshing students

who had already passed the course and who were waiting for subsequent courses, so most of them were pretty competent. This did not really expose me to a genuine student who needed to be taught a new skill, but nevertheless it was a useful experience.

The Gnat continued to suffer from technical problems. On one occasion I was up at Lossiemouth on a land-away navigation exercise; after getting airborne I was instructed to land as soon as possible using minimum control inputs. It subsequently transpired that another aircraft's aileron control cables had snapped in flight so all Gnats were immediately grounded for inspection and repair. After two days of hanging around in a sweaty immersion suit I got fed up and went back to Valley by train, still wearing my immersion suit and clutching my flying helmet. I was a source of constant amusement and inquiry from all the other train passengers on what proved to be a very slow journey.

By the end of April 1969 it was time to move on again, this time back to RNAS Lossiemouth and 736 Naval Air Squadron. I was to be a member of the RAF team of instructors, all of whom had flown the Buccaneer with the Fleet Air Arm. We were to assist in training the first eight courses of RAF aircrew destined to fly the Buccaneer.

Teaching on the Buccaneer – 1969 to 1972

After a long drive from Anglesey to the north of Scotland I arrived back at Lossiemouth late on a Saturday night, expecting to go straight to bed in a deserted Wardroom Mess. I found the mother and father of all parties going on – HMS *Eagle* was in the Moray Firth and many of her crew had gone ashore for the day. When it was time for them to go back on board, a strong wind prevented the ship's boats from running a shuttle service so they were all stuck at Lossiemouth for the night. There was no accommodation and the party was going at full throttle. At some point in the early hours of the morning the Wardroom piano was reduced to its component parts, then very cleverly reconstructed. Next day, during lunchtime drinks after the church service, a senior officer placed his glass of gin and tonic on the piano – it collapsed spectacularly. By this time the perpetrators were all back on board *Eagle* and untouchable.

I joined 736 Naval Air Squadron with two other pilots (Tim Cockerell and Jerry Yates) and three navigators (Barry Dove, Mick Whybro and Dave Laskey) who had all served on Navy Buccaneer squadrons. We were the team responsible for training the first eight courses of RAF aircrew, although in practice we were completely integrated with the naval aircrew on the squadron; we flew equally with RN and RAF students.

Additionally there were about fifty RAF ground crew attached to 736 Naval Air Squadron, commanded by a flight lieutenant engineer officer, John Harvey. Their role was to learn about the aircraft and assist with the maintenance task. Eight old and rather tired Buccaneer S1s were taken out of storage, maintained by the RAF and used for all the RAF flying tasks as there were insufficient numbers of S2s to meet the extra flying generated by the unexpected addition of the RAF training.

My first task was to refresh and qualify as a QFI on the Hunter, our only dual control aircraft, which was used for all early handling sorties and instrument flying. Our Hunters had the Buccaneer's flight instrument system installed on the left-hand side for the student pilot. That apart, it shared no common handling characteristics with the Buccaneer and was much easier to fly. I also became an Instrument Rating Instructor (IRI), which involved a pleasant two-week detachment at RNAS Yeovilton to fly with the Naval Flying Standards Flight. Next, it was time to become checked out as a QFI on the Buccaneer.

The Buccaneer QFI sat in the back seat, devoid of any flying controls and with minimal flight instruments to assist him. The view forward was quite good, especially on the right-hand side, as the seat was higher and off set to the right compared with the front seat. Thus you could monitor the progress of the sortie quite effectively, and provide advice, encouragement and remonstrations to the tyro pilot in the front, but there was no way of controlling the aircraft.

The tyro pilot would complete at least six simulator rides, culminating in a complex emergencies sortie, and three trips in the Hunter. These three trips were very useful in that they gave the QFI a fair idea of his student's ability and competence. Then it was time for the Fam 1, the student's first Buccaneer sortie and also his first solo. Some of these sorties were nerve-racking events for both individuals. The sortie profile included a climb to height for some handling at around 30,000 feet with and without auto stabilisation, a maximum rate descent to 10,000 feet for more handling and basic aerobatics, a descent to low level for a high-speed run, then some practice at flying the aircraft in the landing configuration. Then it was back to the airfield for a long straight-in approach, followed by visual circuits, culminating hopefully in a successful landing. If a major unserviceability occurred at a critical stage in the sortie, such as an engine failure

on take-off or in the circuit, the chances of a successful outcome were remote and totally dependent on the reactions of the student pilot. The S1 version of the Buccaneer was particularly underpowered and not very serviceable so every Fam 1 was an exciting event. Thereafter the QFI did not fly in the back again, handing over to an experienced staff observer/navigator, unless an individual was having particular difficulties on the early sorties.

Apart from Fam 1, the rest of the flying on 736 Naval Air Squadron was fairly routine and typical of an operational conversion outfit. There were still quite a few RN aircrew going through and they enjoyed a longer and more comprehensive course than their RAF colleagues, including air-to-air refuelling, visual and photo recce and DLP. Having experienced an enjoyable tour with the Navy I often felt my loyalty being pulled in two directions; the Navy were faced with a steady run down of its fixed wing activities, which were being taken over by the RAF and they were most unhappy about this. I had much sympathy with them. Relationships remained cordial throughout between RN and RAF staff on 736 Naval Air Squadron, because of our shared experience of carrier operations, but there were many occasions when RAF students got the cold shoulder treatment. John Harvey and his engineers performed marvels in keeping the elderly and unloved S1s going, especially as none of the troops were allowed to live at Lossiemouth and had to commute daily from Kinloss.

Socially the life at Lossiemouth was as good as ever, there were many living in the Wardroom and there was much to do in that remote part of Scotland. I kept a small boat in Hopeman harbour, some five miles down the coast, and sailed it regularly down the Great Glen each summer. The Inchnacardoch Hotel in Fort Augustus was a regular haunt, being run by an ex-Fleet Air Arm pilot, Bill MacDonald, who had a large family of daughters. I was best man to Andy Evans, a navigator who had been with the RN and who married one of the daughters. I spent many happy weekends exploring the far north of Scotland, sailing and skiing in the winter at Aviemore.

The two years of RAF training passed very quickly and generally without major incidents. By December 1970 the last RAF

course had arrived so the end of my association with the Fleet Air Arm was in sight. The main RAF base for the Buccaneer force was at Honington in Suffolk, with further squadrons planned to form at Laarbruch, so all of the RAF staff expected to move on to one or other of these bases.

On 1 December I was scheduled to fly with Flying Officer Ivor Evans on his Fam 1. By this time the S1s were getting decidedly tired. Their Gyron Junior engines, never known for their user-friendly handling characteristics, were extremely difficult to accelerate in a crosswind on the runway. You often had to point directly into wind, brakes on, to persuade the engines to accelerate up to full power, then turn to line up with the runway as you started the take-off roll. The aircraft's acceleration was so sluggish that this evolution never presented any difficulty.

Ominously, on this Fam 1 we had great difficulty getting the port engine to accelerate through the inlet guide vane range before take-off but, with persistence, it finally wound up and off we went. All went well until we returned to the circuit. We ended up too high and close on the first circuit so, at 200 feet, I told Ivor to overshoot and go round again. When he pushed the throttles forward for full power all we got from the port engine was a lot of loud bangs and choking noises and no thrust. With commendable alacrity for a pilot on his first flight on type, Ivor lifted the wheels and got the airbrake in, but with the landing flap down and the blown ailerons and tailplane bleeding large amounts of air from the one good engine, Isaac Newton's First Law soon kicked in. It very rapidly became evident that this sortie was not going to end satisfactorily without the help of Martin-Baker's rocket-assisted deck chair. I had loosened my shoulder harness to see ahead, round the top of Ivor's ejection seat and this was no time to start tightening straps. Shouting EJECT, EJECT, I pulled the firing handle between my legs, and after a big bang I was looking down through my feet at the airfield grass coming up fast. I arrived on terra firma like a sack of spuds thrown from a second floor window.

After establishing that I was alive and that my back hurt, my next priority was to get my SARBE (Search and Rescue Beacon Equipment) going to qualify for the silver tankard that Burndept Electronics (the manufacturers) gave to all aircrew who used their excellent product in a rescue. When an asbestos-suited fireman appeared in my field of vision I told him rudely to go

away as I still hadn't got the beacon working yet. Given that I was sprawled in the middle of Lossiemouth airfield he clearly thought I was delirious, took it gently from me and made soothing noises until the ambulance arrived. Ivor also jumped out successfully.

The hapless Buccaneer flopped on the airfield, narrowly missing some people mending a radar aerial, and slithered to a halt on its belly; the cockpit section broke off and a fire started. The big fire tender, when it finally arrived after getting bogged down in the grass, squirted foam all over it trying to extinguish the fire and shut down the starboard engine, which perversely continued running at full power for a while. A putrid smell drifted away on the wind and gave rise to serious complaints from lunchtime drinkers in the Wardroom. I spent an uncomfortable three weeks lying flat on my back in Dr Gray's Hospital, getting my vertebrae back in place, drinking smuggled whisky and annoying the nurses. Ivor, whose straps were tight, was back flying in a couple of days.

A few years later, by now a married and more responsible officer altogether, I visited the Martin-Baker factory and met that great man Sir James Martin. I think I speak for every ejectee when I say thank you, Sir James, and all at Martin-Baker, for the rest of my life.

Barely a week after my accident, a Buccaneer S1 being flown by two RAF students suffered a massive uncontained engine failure shortly after take-off. The pilot ejected successfully but tragically the navigator was killed because a piece of Perspex from the shattered canopy jammed the ejection seat's release mechanism and he was unable to separate himself from the seat in time. This accident brought Buccaneer S1 flying to a halt for ever. Some of the remaining airframes were delivered to other airfields for use as Gate Guards or for battle damage repair work, the rest went to museums or scrap. I spent the rest of the winter at Lossiemouth recuperating then finally had to leave in March 1971 to continue my instructional duties at the newly formed Buccaneer Operational Conversion Unit, No. 237, based at RAF Honington in Suffolk. I returned to full flying duties after a minor argument with the Station Medical Officer, who insisted that I would be grounded for a year; happily the back specialist at the hospital at Ely overrode his decision.

* * *

RAF Honington was a typical pre-war bomber base set in the Suffolk countryside. It had been closed for a few years before reopening for the RAF's Buccaneer squadrons in 1969. There was only one squadron resident, 12 Squadron, so it was a bit of a sleepy hollow compared with Lossiemouth. Setting up 237 OCU was quite a challenge. I recall having to visit the scrap heap at the recently closed down RAF Stradishall to recover briefing boards for our briefing rooms as Honington seemed unable to provide any. We opened for business in June 1971 and the pattern of activity was almost identical to what had taken place at Lossiemouth. Unfortunately there was no flight simulator at Honington so many journeys were made up north to use the simulator that was still in use at Lossiemouth.

Our early students were a complete mixture, ranging from first tourists with no previous experience through to our future Station Commander and even the Air Officer Commanding. The RAF looked on the Buccaneer as a sort of mini V bomber and much to our horror tried to make us operate it in a similar fashion to a V bomber. Not surprisingly we resisted as we saw the Buccaneer as more of a larger Hunter fighter-bomber. Luckily for us, our new Station Commander, Group Captain Peter Bairsto, known to all as 'the Bear', agreed with the maxi Hunter philosophy and fought hard for this in the corridors of power. The OCU was commanded by an extremely handsome and upper class Wing Commander, Anthony Fraser; his senior flight commander and Chief Flying Instructor (CFI), Squadron Leader David Mulinder, was a man of great character and wit. We soon settled into the business of training RAF aircrew on the Buccaneer and it was not long before some RN aircrew started to appear on the instructional staff.

One night one of the first tour student navigators, David Herriot, and I were programmed to fly in a three-aircraft formation; we were to be the lead aircraft. Unusually it was a busy night at Honington, with a number of visiting aircraft including a twin-engined Andover passenger aircraft that was bringing in a load of visiting VIPs. It was also a very dark night without moonlight or stars.

All went well with the sortie up to the point when I lined up on the runway as a three-aircraft formation for a 30-second stream take-off. I should point out that the Buccaneer, because of its naval ancestory, was not at that time equipped with a landing lamp, as they are superfluous on aircraft carriers. It was

therefore not possible to see anything in the darkness ahead apart from the runway edge lighting.

Brakes off, full power and off we went. Initially all seemed OK. The airspeed indicator began to give readings but, at about 100 knots, the aircraft rapidly decelerated and came to a halt. I still had full power applied and thought at first I had inadvertently put the arrestor hook down but, no, the selector was in the up position and there was no green light showing it to be down. Luckily none of the aircraft behind had started their take-off roll so I called Air Traffic Control with a message that I 'seem to have become stuck on the runway,' or words to that effect. Air Traffic Control naturally assumed that I had inadvertently put the hook down and had engaged the approach end arrestor cable – this had happened before. Doubtless thinking what idiots we were – you could tell from the tone of their voices – they sent a vehicle out to have a look at us. By this time I had throttled back to await developments.

The vehicle approached, stopped a short distance away, then rapidly reversed away. Air Traffic Control, now in a completely different tone of voice, told us to shut down but not to unstrap or attempt to get out until outside help had arrived. Eventually a team appeared from the darkness with an extending set of steps, which they gingerly placed by the cockpit. They then signalled us, from a distance, to get out. When we climbed down we saw that the arrestor cable was wrapped around the nosewheel leg. The whole thing was stretched tight like some giant catapult; it appeared to be about to launch our Buccaneer, backwards, down the runway towards the rest of the formation who were still patiently sitting there.

By now the Bear, who was not noted for tolerance of professional foul-ups, had arrived on the scene. Breathing fire from his nostrils he demanded to know precisely who was to blame for this shambles that had closed his airfield in such a thoughtless fashion, and in the middle of a VIP visit! Of course in the darkness of the night no one had a clue as to how this had happened or how to extract the aircraft from its imminent backwards launch. As the debate and argument continued amongst all parties out there on the runway, the finger of suspicion seemed to be pointing more and more at my student and me. In the hubbub we both agreed it would be safer to make ourselves scarce and to slip away to the bar.

The answer to this saga only became clear the next morning. Lying on the grass beside the runway was found the shattered remains of a metal stand that the fire crews used to hold up the arrestor cable about 3 feet above the runway, to allow them to move the rubber grommets that supported the cable more easily into position. Whilst re-rigging the cable after the arrival of the VIP's Andover the night before, they were hassled by Air Traffic Control to hurry up as my formation was already taxiing. In their haste to get the job done they forgot to remove the stand. I then hit it on take-off and inevitably collected the cable around the nosewheel leg. Amazingly there was little damage to the Buccaneer; it needed a new nosewheel leg and two new under-wing tanks, but that was all. Not long afterwards all RAF Buccaneers were equipped with a landing lamp but whether or not this would have influenced the outcome is impossible to say.

During the autumn of 1971 a change in the rules and regulations allowed single officers to live off base in their own accommodation so Peter Bucke, Peter Huett and I found a pad in the depths of Suffolk, which we started to rent. This move off base caused consternation in the upper echelons of the command structure at Honington but the Bear was told there was nothing he could do to stop it. Hearing of his discomfiture at this turn of events we decided, out of devilment, to invite him to our house-warming party. Imagine our amazement when he accepted! As the day approached we were informed that, unfortunately, he had been summoned to a conference at Strike Command headquarters but that he would send a couple of representatives to stand in for him. These turned out to be his daughter and a friend of hers, Julia Bennett, who lived locally. We were to pick them both up in a local pub, The Dog in Norton, and they would be escorted by another, more suitable, bachelor, Peter Gooding. So that is how I met my future wife, in a pub, being escorted by a man considered far more reliable than I! It was not long before Julia and I announced our engagement.

By the spring of 1972 all six of us who had been RAF instructors on 736 NAS and then 237 OCU had been instructing for three years continuously, so the RAF decided to split us up and send us on our various ways. Barry Dove went off to a ground tour at Bawtry, the Group headquarters; Jerry Yates was posted to

Germany and the newly re-formed 16 Squadron; Dave Laskey and Mick Whybro went off to various courses and Tim Cockerell and I were to go to 12 Squadron at Honington.

Events moved very quickly; my instructional tour ended the day before my wedding on 3 June 1972. Shortly before the wedding, the Duke of Windsor (Edward VIII) died and a period of official Court Mourning was declared. We were then informed by the protocol staffs that if uniform was to be worn at ceremonial events, such as weddings, the wearers would have to wear black arm bands. Thus it was that I, my best man Peter Huett, the Guard of Honour and all Service guests were clad in black armbands at my wedding. There were many remarks about whether this marked mourning for a lost era of bachelor excesses, as typified by the alleged damage caused to the Officers' Mess bar during my stag night!

CHAPTER EIGHT

No. 12 Squadron
– 1972 to 1975

After a three-week honeymoon break in Corfu it was back to
work with a vengeance, on a new squadron that was the
sole RAF Buccaneer front-line squadron based in the UK.
No. 12 Squadron (motto 'Leads the Field') had recently been
taken over by a new squadron commander, Wing Commander
Nigel Walpole, a man of great energy and vision who had
recently been rushed through his operational conversion from a
ground tour.

Whilst Julie and I were enjoying the delights of Corfu in the
spring, 12 Squadron had suffered a fatal accident in which two
aircrew lost their lives, one being the USAF exchange officer.
The circumstances of the accident threw considerable doubt on
the control and supervision of flying on the squadron, especially
as the squadron commander had been a member of the fatal
sortie's formation. Thus I arrived on a Monday morning to find
the squadron in a state of considerable turmoil. It was not long
before the news came that Nigel Walpole was to be relieved of
his command and replaced by Wing Commander Ian
Henderson, a flight commander who had recently left for a
ground tour. He was given an instant promotion to acting rank
and a rapid return to the cockpit. To say that squadron morale at
this time was low is an understatement.

Nigel Walpole's send off was for me a grim event, as I was

Station Duty Officer and had to attempt damage limitation in the Mess, unfortunately not with much success since at the height of the evening's excesses someone invited the Bear over. He came and was not amused. His wrath was directed at me, his representative, the next Monday morning. There was only one thing to do; tell him politely that it had not been sensible for him to come and that if he had stayed away all the mess would have been cleared up without him knowing. After boiling over for a bit he calmed down and seemed to accept this response as fair. However, overall it was not a happy start to a new tour.

No. 12 Squadron's task was to provide a maritime strike/ attack capability for the Supreme Commander Atlantic (SACLANT); its secondary role was nuclear strike in support of the UK National Plan. Ian Henderson's task was to restore the squadron's morale and *esprit de corps*. He was also charged by the Bear to develop proper tactics for multi-aircraft formation attacks on surface ships, a skill that the squadron had never fully got to grips with since it re-formed as a Buccaneer squadron in 1969. There were a number of relatively new squadron members so we all set to with a will. It was hard work.

Looking in my logbook I see that I regularly flew 35 hours a month, a lot of it at night, with many detachments away from Honington. Within weeks of my arrival we were detached to Stornoway in the Hebrides, whilst Lossiemouth's main runway was repaired. It had been badly damaged by a Buccaneer that caught fire during take-off for the big autumn exercise that always took place in the North Sea and Atlantic. We soon found ourselves flying as far south as Gibraltar with the assistance of air-to-air refuelling. Stornoway was a very primitive forward operating base with minimal facilities but the locals were extremely hospitable. We lived in breeze-block huts in communal sleeping areas. There was a field kitchen and a large Mess tent that served as an Officers' Mess. There was a large hangar, which was empty of all facilities and full of seagull excrement. The runway was rather short so a portable arrestor gear was brought in to cater for emergencies. On Sundays we were confined to camp and no flying took place in respect of the strictly observed Sabbath in that part of the world.

During the detachment the Air Officer Commanding No. 1 Group, Air Vice Marshal Horsley, a distinguished wartime

Mosquito pilot, paid us a visit. On arrival he was taken to our Mess tent and given lunch. During the meal he described his sadness at discovering the previous evening that the family cat had been run over and squashed when let out for its evening tiddle. Suitably sympathetic noises and comments were made round the table.

The next item on the programme was a visit downtown to the Procurator Fiscal. The Air Marshal and the Bear travelled in a staff car, preceded by a Land Rover driven by the Stornoway Station Commander, a squadron leader. On reaching the edge of Stornoway a cat ran out in front of the convoy and . . . was squashed. 'Drive on' commanded the Bear. 'Stop!' shouted the Air Marshal. The party then disembarked from their vehicles and the corporal driver, holding the very dead cat by the tail, was instructed by the Air Marshal to find its owner and offer suitable sympathy and remuneration. However, none of the inhabitants of the houses in the immediate area would have anything to do with the dead cat, so, with time pressing, it was thrown over a wall and the convoy set forth again. The Procurator's hospitality with the whisky was generous and the Air Marshal became somewhat happier.

The next event was a fishing expedition leaving Stornoway harbour in a small motor boat that I had been detailed to oversee. Thus two very merry senior officers descended into the boat after leaving the Procurator's lodgings and we chugged out into Loch Stornoway. No fish were caught and as we turned for home at the furthest point from the harbour the engine died. Nothing would persuade it to start again so there was no other option but to row back, naturally against the tide. At least the Bear had the decency to help with the rowing but the Air Marshal sat glumly in the stern, the effects of the Procurator's whisky having worn off. Overall, it was a disastrous afternoon but most amusing to look back on.

Moreover, the disasters continued. At the Squadron Dining-in Night that evening one of the pilots, Rob Williams, foolishly promised to supply the Air Marshal with fresh lobsters the next morning for him to take back to Bawtry. Rob sadly had more to drink that night than he had anticipated and seriously overslept. He was woken from his camp bed next morning and summonsed to the Air Marshal's Hunter. Rob stood in the keening Hebridean gale, clad only in a Paisley pattern dressing

gown and wearing red leather slippers, attempted to explain the lack of lobsters to the Air Marshal, who was already strapped in. We had no more VIP visits after that.

Planning the flying programme on 12 Squadron was originally rather a 'hit and miss' business, with one or other of the numerous squadron leaders getting the task at short notice. With the complications of booking activities well ahead, it was decided to give the programming task to two competent flight lieutenants as a full-time commitment. Thus Bruce Chapple and I became the 12 Squadron programming and planning team, a busy but rewarding task. It also meant that we could take advantage of the good deals when they came along, as long as we were not too obvious about it.

One of these was a BBC TV programme called 'Skywatch'. This was a programme featuring all RAF activities, including a firepower demonstration on Salisbury Plain. No. 12 Squadron's involvement was to provide four aircraft, each firing a full war load of 2-inch rockets with high-explosive heads. This amounted to 144 rockets per aircraft, something that none of us had ever done before. Normally we simply went to the range and fired nine rockets singly in an academic pattern; occasionally we would do a first run attack using an operational profile but merely firing a single rocket. Thus this exercise was a never to be repeated opportunity.

The target was a concrete tower about 20 feet high, surrounded by a group of redundant vehicles. We were told to take our time around the pattern and only fire when completely happy. When the moment came, it was astonishing. The whole of the area in front of the aircraft was obscured in smoke and rocket exhaust flame. There was a powerful stench of cordite in the cockpit and in spite of the fast ripple mode of fire being used it seemed to take for ever for all the rockets to leave their launcher pods. Subsequent viewing of the video of what happened in the target area, which of course we did not see from the cockpit, was awe-inspiring. The concrete tower, which for years had withstood efforts by army artillery to destroy it, crumbled and disappeared. The vehicles were smashed to pieces and hurled about all over the place. Our opinion of the 2-inch rocket, which up to this point had been rather disparaging, suddenly improved by a large amount!

The other weapons available to us were really no different from many years' previous. Our conventional bomb was the 1000-lb high-explosive bomb, which could be fitted with a retard or ballistic tail and air or ground burst fuses, and the 2-inch rocket described above. For night illumination we had the Lepus flare, which was tossed in a ballistic trajectory towards the target before deploying a parachute and igniting. Our conventional attack tactics had to be designed around these weapons. Thus we ended up with large formations of eight aircraft split into two sections of four. One section was responsible for defence suppression, using a toss attack to throw a large number of air burst bombs towards the target in the hope that radar gun laying and missile guidance systems would be knocked off line. The other section would then close for an accurate shallow dive, level retard or rocket attack to finish off the target.

Whether or not this would have worked out successfully for real was uncertain. We spent many hours in the air co-ordinating these attacks and on a good day they worked out well. On a bad day, with poor weather, aircraft snags and poor communications they could be a nightmare. Since they all involved getting very close to the target with no screening from the ship's defences, we all felt very vulnerable.

At night we reduced the aircraft numbers and used the Lepus flare to illuminate the target before carrying out a dive attack, which was quite scary on a dark night. On one occasion I did succeed in sinking the splash target being towed by a frigate, very much to both my and the ship's amazement. Of course we also had the ultimate, nuclear, option but again the delivery aircraft would have been very vulnerable.

During my tour on 12 Squadron some welcome new equipment began to appear. A much improved Radar Warning Receiver was fitted into the tailplane fairing, which, when combined with the old Wide-Band Homer, gave us a much better ability to detect and classify hostile radar transmissions. During 1973 we began to receive the Martel missile system. Martel was an acronym for Missile Anti Radar and Television. It was designed as a defence suppression weapon in its anti-radar mode and a ship sinker in its TV mode. It was quite big, about 12 feet long, and the Buccaneer could carry four anti-radar, three TV missiles or a combination of both. The anti-radar version could

be launched from low level about 20 miles from the target. It would climb to height then dive supersonically on to the target, exploding close to any radar it was locked on to. The TV version was launched at low level about 12 miles from the target. The launch aircraft could then turn away and, through a data link pod, establish a TV and radio command link with the missile, which cruised at about 800 feet and 500 knots. The missile had a TV camera in its nose and the picture was displayed on a TV screen in the navigator's cockpit. The navigator could control the missile through a small control column and guide it with great accuracy into the target ship once it came in view. That, at least, was the theory. The TV missile was thus limited to daylight and reasonably good weather but, combined with its anti-radar version, it did at last gives us a reasonable stand-off attack capability.

We were involved in the trial firings in Aberporth Range off the Welsh coast. On one occasion it was decided to combine a Martel trial firing with a trial to test whether a Phantom's radar could pick up a missile like Martel, which was similar in size to a number of Soviet cruise missiles. There was a layer of cloud on the day from 1500 feet to 2500 feet so the Martel would be below this whilst the Phantom would be above. The missile was duly fired and set off towards the target; the Phantom was head on to it and cruising at 3000 feet. The Phantom's navigator soon locked on to the Martel. Unfortunately, as soon as the Buccaneer's navigator selected the terminal phase of the attack his TV screen went blank and he lost all control of his Martel. Shortly afterwards the Martel shot out of the cloud cover going vertically upwards, narrowly missing the Phantom on both its upward and subsequent downward trajectory. It was decided not to repeat this trial again!

Eventually, an American active electronic countermeasures pod began to appear, giving us the ability to jam hostile radars. By the mid-1970s, therefore, the Buccaneer was able to detect maritime threats, jam them, then carry out accurate stand-off attacks with missiles and close-in attacks with bombs and rockets.

Many of our detachments were to Malta, Gibraltar and Cyprus, mainly for various exercises with the Royal Navy. I participated in a firepower demonstration in Cyprus when the first public

demonstration of the BL755 cluster bomb took place, delivered from a Buccaneer flown by the Bear.

Cyprus was invaded by the Turks in 1974; when this occurred I was on leave and for the first and only time in my career I was recalled from leave. I was one of the last to get back to Honington and the first four crews were already walking to their aircraft to set off for Cyprus when I got into the squadron late that evening. They never got airborne and we spent the next three days hanging around in expectation of going. Ultimately we were stood down and never went.

However, there was an amusing sequel to this. One of our aircraft was in Engineering Wing undergoing a minor servicing. The Engineering Wing staff, with commendable enthusiasm, worked day and night to get the aircraft serviceable quickly and it was soon delivered to the squadron. What we did not know was that the Engineering Wing staff had prepared it for an over-seas deployment 'by the book', which involved fitting in the bomb door a full set of aircraft access steps, intake blanks, ground locks and engineering manuals, a considerable load. We on the squadron were unaware of this load and as normally the bomb door was not rotated very often, so it remained inside but unknown. A few days later we were involved in a demonstra-tion to members of the Royal College of Defence Studies (very important people), who were embarked on a destroyer in the North Sea. After carrying out our demo co-ordinated attack we re-formed for a low fast flypast over the ship. The formation leader, the Boss, briefed that we should all open our bomb doors just as we approached the ship, as this action made a wonderful noise. Imagine my surprise when I saw his door open and the ladders, locks, intake blanks and manuals all fell out. Luckily, given their poor ballistic qualities, they fell into the sea well short of the destroyer but the Navy and College staff and students were equally astonished. I understand that there was a tense exchange of signals between the Royal Navy and RAF Honington on the incident.

After nearly three busy years with 12 Squadron the RAF's posting people caught up with me again and it was time to move on. For a short while a ground tour seemed possible and too awful to contemplate, but then commonsense prevailed and I was posted to the Tactical Weapons Unit, flying Hunters, based at RAF Brawdy far in the west of Wales.

In the New Year's Honours List of 1975 I was delighted to discover that I had been awarded a Queen's Commendation for Valuable Services in the Air, presumably for three years' of undetected crime. This was presented to me on the occasion of the Squadron's 70th Anniversary celebrations. So in March 1975 I left Honington, 12 Squadron and the Buccaneer for the wild west of Wales.

Hunters in Wales
– 1975 to 1976

RAF Brawdy was situated at the most westerly end of Pembrokeshire. Apart from a small section of Ireland, the next dry land was the eastern coast of the USA. Brawdy had been a Royal Naval Air Station but the Navy had withdrawn in 1972 leaving the airfield empty, apart from a secret US Navy facility, which was the terminal of a submarine listening system used to detect the passage of submarines transiting the North Atlantic. Thus there was an urgent need to reopen the airfield to full-time operations so that the US Navy facility could be properly supported. No. 229 OCU, happily based at RAF Chivenor in Devon and flying Hunters, eventually drew the short straw. Renamed the Tactical Weapons Unit (TWU), it reluctantly moved to Brawdy from Chivenor in October 1974.

Brawdy was a very different airfield to operate Hunters from compared with Chivenor. The weather was very unpredictable and difficult to forecast; the nearest diversion airfields, St Athan and Valley, were a long distance away and not always available; the only navigation aid was an old DME (Distance Measuring Equipment) beacon that rarely worked; the F6 and T7 Hunters were always short of fuel and the living accommodation was primitive by RAF standards. Nearly all the aircrew longed to be back at Chivenor in glorious Devon rather than be at this windswept outpost. Thus it was not the happiest of units

that I arrived on after an incredibly long car journey from Honington one wet Sunday evening.

The TWU was divided into three squadrons, 63, 79 and 234, all having reserve status and strong traditions as fighter squadrons. There was a large fleet of Hunters consisting of T7s, F6s and FGA9s. There were also three Meteors for target towing and a couple of Jet Provosts for the Joint Forward Air Control Unit. The TWU's task was to provide tactical flying training and weaponry for pilots graduating from advanced flying training who were destined to move on to Harrier, Jaguar, Lightning, Buccaneer and Phantom Operational Conversion Units. It also provided short refresher courses for senior officers returning to flying duties and for newly arrived staff pilots; this job was done by 79 Squadron. The TWU's war role was to provide short-range day air defence for the main fighter bases of Leuchars, Binbrook, Coningsby and Wattisham; additionally a permanent detachment of three Hunters was maintained at Gibraltar to provide air defence for the Rock and to deter Spanish interference with inbound and outbound air traffic.

I joined 79 Squadron for the short conversion course. Initially this was not too challenging as I was already a current Hunter pilot. Things got more interesting when the weapons phase started and I was reintroduced to air-to-ground gunnery, much more effective with the Hunter's 30-mm Aden cannon than it had been with the old Canberra 20-mm Hispano. We also fired 68-mm SNEB rockets in shallow dive attacks, very similar to the Buccaneer's 2-inch rockets, and dropped practice bombs from shallow dives. This latter event was a purely academic routine, there being no real bomb in the RAF inventory that the Hunter could deliver. The delights of air combat were also experienced but sadly not air–to-air firing, which was reserved for long course students or senior officers going back to the air defence world.

At the end of the short course I was delighted to be posted to 79 Squadron as it certainly seemed to enjoy the best quality of life. Dealing with senior officers returning to flying appointments was an entertaining business. Most were excellent and enthusiastic pilots only too keen to scrub off the rust of a ground tour and get on with the flying but there were exceptions. Some of the American exchange officers had great difficulty in coping

with what for them was a primitive aircraft, dreadful weather and a lack of understanding of RAF operating procedures and language. Some RAF pilots had been too long on the ground and didn't make it through the course and were returned to a less demanding environment.

When the weather was good the flying was superb, with the whole of Wales, Devon and Cornwall as our playground. Sorties in the F6 and T7 were always short of fuel; the Hunter's fuel gauges had the regrettable characteristic of over reading when flying fast at low level. The F6 and FGA9 had two bingo lights, directly connected to float switches, which illuminated at 650 lb a side and reset the gauges to the correct reading. This was always a disconcerting event, especially if it occurred in the middle of Wales during a bounced low-level simulated attack profile sortie. For some reason the T7 didn't have bingo lights, so T7 pilots lived in ignorance of their true fuel state. At least the FGA9, with its 230-gallon external tanks, had a bit of an advantage over the F6s and T7s with their 100-gallon external tanks.

Brawdy had two runways. One was quite a bit shorter than the other, and neither orientated into the prevailing westerly wind. The F6 had no brake parachute so could sometimes be challenging to stop. There was one memorable occasion when an F6 went into the barrier on the main runway, followed quickly by another going into the barrier on the secondary runway, leaving five Hunters still airborne and very short of fuel. They were told to divert to St Athan in poor weather, dropping their tanks in St Brides Bay on the way. Two aircraft never got there, ending up even further away at Cardiff by mistake, taxiing in on fumes.

We bombarded Pembrey Range ceaselessly, with practice bombs, rockets and 30-mm cannon. The weapons system in the Hunter was primitive and the vital switches to operate it seemed to differ between individual aircraft; thus a fair number of drop tanks also got dropped into Pembrey inadvertently. Air-to-air firing was conducted against a banner towed at 200 knots behind a Meteor or a Hunter. It was often said that if the Russians had attacked the UK using banners at 200 knots we would have slaughtered them, but high-speed aircraft targets would have been altogether much more challenging.

* * *

Despite its remoteness the county of Dyfed, or Pembrokeshire, as its inhabitants insisted on calling it, was a delightful area when it wasn't raining. The coastline was dramatic and there was a very English feel about the whole area. It was also known as Little England Beyond Wales. In the local village of Little Haven there was a superb pub, The Swan, run by an ex-79 Squadron World War Two pilot, George Nelson Edwards. The squadron naturally gravitated to this establishment. There were no Married Quarters at the airfield apart from the Station Commander's, OC Ops Wing's, OC Eng Wing's and the US Navy Commander's. The rest of us lived in Quarters in the town of Haverfordwest, some 12 miles from the airfield but only 5 miles from Little Haven.

Julie and I did not sell our house in Suffolk, but rented it out to Americans, so lived happily in a rather stark quarter in what looked just like a council estate. During the first summer in Wales our first daughter, Joanna Katherine, was born in the Haverfordwest hospital. Thus she is qualified to play rugby for Wales; she has never shown any inclination to do so. I kept a small boat in a yacht club near Milford Haven; the sailing was excellent. The summer of 1975 was a very good one, with long periods of sunshine and little rain. The two Australian girls who worked in the petrol station at Newgale, at the bottom of the hill near Brawdy, were even spotted once sunbathing topless on the roof of their garage by an eagle-eyed pilot in the circuit at Brawdy. This quickly caused the circuit to become very over-crowded!

No. 79 Squadron's operating base in the event of hostilities would have been RAF Wattisham in Suffolk, not very far from our home. Wattisham was a fighter base with a resident Lightning squadron and Phantom squadron. We much looked forward to deployments there on exercise, which occurred about twice a year. We operated our Hunters from the premises of the Anglia Gliding Club, very much in Battle of Britain style, carrying out day Combat Air Patrols about 20 to 30 miles up threat from the airfield. If we intercepted an incoming raid this usually resulted in a high-speed chase at low level, which ended up over the airfield, much to the delight of the ground crews and indeed ourselves. As soon as it got dark we packed up and went down to the Red Lion in Bildeston whilst the Lightning and

Phantom boys carried on with the war. Night flying was not one of our activities.

On one occasion, however, it became evident early on in the exercise that the OC Ops Wing wanted to exercise his *Scramble for Survival* Plan, and the only time he was going to be able to do this was after dark. The more astute of us ensured that, as twilight approached, we found our aircraft to be unserviceable. Thus it was that as dusk fell there were only two Hunters on the Operational Readiness Platform, one being flown by the Boss, George Glasgow, the other by Bo Plummer, a very experienced instructor. They were surrounded by Lightnings and Phantoms and felt somewhat overawed. *The Scramble for Survival* Plan required aircraft to get airborne, climb to an altitude determined by its position in the take-off order, establish a holding pattern over the Coltishall TACAN (Tactical Air Navigation Aid) beacon and then recover to Wattisham on reaching maximum landing fuel for an ILS approach. All this was to be done silently and without the use of radio except in emergency. It is important to understand that the Hunter had neither TACAN nor ILS.

Eventually the scramble was activated, well after sunset. Struggling to find the internal cockpit lighting our two heroes got airborne and optimistically set off towards where they thought they should go. A few minutes later there was a startled transmission from one of the Phantoms to the effect that there was an aircraft going round the holding pattern the wrong way. . . . Now it takes a long time for a Hunter with full 230 gallon tanks to burn down to landing weight and Bo Plummer's aircraft had full tanks. He went round and round the pattern until ready to recover, then let down in the general direction of Wattisham. Imagine his surprise when he broke cloud and found himself well out over the sea with no land in sight. He sensibly turned onto a westerly heading and soon picked up the lights of Great Yarmouth, and from then on it was a straightforward recovery to Wattisham. However, we were told we would not have to participate in a *Scramble for Survival* again!

Another activity of a more serious nature was the Gibraltar Detachment. The border between Spain and Gibraltar was closed in 1965 by the Spanish authorities and no aircraft inbound to Gibraltar was allowed to enter Spanish airspace, which was extremely close to Gibraltar. The Spaniards had made the arrival

and departure procedures as difficult as possible and, as they claimed sovereignty over Gibraltar, theoretically it was possible that they might attempt to harass or intercept any inbound or outbound aircraft. Therefore, to defend Gibraltar's airspace and to protect both civil and military aircraft using Gibraltar, there was a permanent detachment of three Hunters and three pilots. The aircraft remained out at Gibraltar for long periods but the pilots spent only three weeks at a time, being drawn from all three squadrons at Brawdy.

We had a fairly relaxed routine, flying once or twice a day at the most, usually only when there was an inbound or outbound aircraft. At other times when aircraft were expected, we simply sat in the crewroom at some form of readiness – it was all quite relaxed as the Spanish Air Force had not tried to interfere for a long time. When airborne we used to check out the adjacent Soviet Navy anchorages for any new naval vessels, carry out a bit of air combat, support any of our own Royal Navy's warships and cooperate with any visiting detachments, often Buccaneers.

The airfield was challenging to operate from. The runway was only 6000 feet long and began and ended in the sea. There was no barrier so the brake 'chutes were essential. The Rock would produce some very difficult turbulence and cross winds in certain wind directions, which sometimes prevented flying altogether.

The social life in the evenings and at weekends was pretty hectic and it was with relief that one welcomed one's replacement off the aircraft and headed back to the UK after three weeks. During one of my 'Gib Dets' I received a phone call from the Station Commander at Brawdy informing me that I had been selected for promotion to squadron leader on the next promotion list. After recovering from the shock, I realised that this would probably mean the end of my tour on 79 Squadron. Sure enough, not long after getting back to Brawdy I learnt that I was to move on, not to a ground tour, as I had thought, but back again to Honington and No. 237 OCU, as Chief Flying Instructor.

I made the most of my last few months on 79 Squadron, which culminated in a wonderful two days at the International Air Tattoo held at Greenham Common, which celebrated twenty-five years of the Hunter. There was a superb line-up of Hunters, with the first, all red, prototype WB 188 in the centre. I had the

honour to meet and chat to Sir Douglas Bader and managed to scrounge a short flight in the Battle of Britain Memorial Flight Lancaster, an unforgettable experience. Then it was back to Brawdy for the last time, to pack up the house, boat, etc, and return to the flat countryside of Suffolk, our house and back again to the Buccaneer.

CHAPTER TEN

Chief Flying Instructor, Staff College and Strike Command – 1976 to 1982

After a short refresher to re-familiarise me with my old friend the Buccaneer I took over as CFI in December 1976 from Peter Norris, who I had first met on the CFS course at Little Rissington where he was going through the same QFI course. I remember trying to sell him to a female customer one evening in the Old New Inn in Bourton on the Water, in an attempt to raise some cash to buy beer. By now he was clearly going to the top in the RAF.

The OCU was now a busy place. There were two squadrons based at Honington (12 and 208), two based at Laarbruch (15 and 16), and the last RN squadron (809) was still in commission and based at Honington when not at sea in *Ark Royal*. There was an RN Unit, loosely attached to the OCU, that looked after RN training and affairs when *Ark Royal* was at sea. Thus there was a constant stream of aircrew, both new and experienced, to put through the course. No.237 OCU had a reputation for being a hard outfit to get through, particularly for aircrew who had come from the V force. However, with no dual control version we had to insist on high standards and we were no harder on our students than the RN had been on 736 Squadron.

It seemed that many expected an easier ride than they got and so complained when they found the going tough.

My opposite number as Senior Nav Instructor was Dick Moore, a Cranwell contemporary who had gone on to Hunters after Valley but who had unfortunately lost an eye when a bird came through the canopy of his Hunter. He had retrained as a navigator and was a very good one. Our Boss was Wing Commander Arnie Parr, who was a hard taskmaster. Inevitably I spent a lot of time in the Hunter, with the associated Fam 1s in the Buccaneer, but as a Flight Commander there was now the chance to pinch one or two of the more enjoyable trips, such as the 'Bounce' for strike progression sorties. The pressure to produce trained crews was relentless and the conditions for doing so were far less suitable than they had been at Lossiemouth.

Limited availability of weapons ranges and poor weather were the two principal limiting factors that bedevilled our activities. Our safety record was remarkably good. We had one fatal accident involving our naval pilot. When away in Norway for a weekend overseas training flight, he decided to undertake some illegal low flying up a fiord on his way home, despite the protestations of his RAF navigator. He flew into high-tension cables and lost control; both ejected but only the navigator survived. The pilot drowned.

Another less traumatic but nevertheless dramatic incident occurred when a student crew set off on a routine sortie to the Wash bombing ranges. The Buccaneer's pre-take-off checks included a check by the pilot that the canopy was both closed and locked – the locking action being a separate selection to closing. The navigator observed that the aircraft was very noisy as they transited over Norfolk at 250 feet and 420 knots, but this got no reaction from the pilot, so the first clue that all was not well was missed. Once out over the sea the pilot accelerated to 550 knots to trim the aircraft out at his attack speed. He then turned towards the range. At this point the canopy, which the pilot had failed to lock in his pre-take-off checks, finally gave up and was ripped off the aircraft, embedding itself deep into the fin. The cockpit was filled with dust and a 550-knot breeze; the poor navigator could not move or speak but the pilot, protected by the front windscreen, was a bit better off. They slowed down, put out a distress call then elected to return all the way to

Honington. I was the duty instructor at the time. I was summoned to the Air Traffic Control tower and eventually the aircraft came into view, escorted by a passing Jaguar. It presented an amazing sight, as the canopy was a substantial piece of equipment, stuck half way into the fin. Apparently this highly unusual configuration did not significantly affect the aircraft's handling characteristics!

During this tour one of my Cranwell cadet contemporaries, Alastair Mathie, who had been with us at Brawdy, was based in France with an *Armée de L'Air* Jaguar squadron. He also kept his Auster at the local flying club. One day he telephoned to say that he and his wife Dot were flying back to England in the Auster. Could they land at the old airfield at Great Ashfield and stay with us for the night?

Naturally I replied yes and contacted the Bury St Edmunds police to let them know that our old airfield would be having a visitor. In due course the Auster arrived, Dot retired to the kitchen with Julie, and Alastair and I repaired to The Dog at Norton, as Alastair was desperate for a pint of proper English real ale. Meanwhile, an observant local had spotted the Auster's arrival and had walked up to the airfield to have a look, as it was rumoured that criminals had been using the airfield for refugee and drug smuggling from the continent. Ignoring the large British registration letters of G AIFG, he spotted the notice that Alastair had put on delicate parts of the airframe in French, reading *'Ne poussez pas ici'* (to dissuade Frenchmen at the flying club). The local assumed the aircraft was foreign and up to no good so he rushed home and alerted the police – sadly not the police that I had contacted but the police station at Stowmarket.

Meanwhile, in The Dog one pint had extended to three or four. Eventually back at home the ladies were disturbed by a knock on the door – it was the police, looking for Alastair and seeking an explanation! They were redirected to the Dog where eventually they were pacified. By now it was clear that driving home was not an option so the kind police offered us a lift home, which we gladly accepted. We arrived home with sirens blaring and blue lights flashing – at our insistence! The ladies were not impressed.

The summer of 1977 marked the twenty-fifth anniversary of the Queen's accession to the throne so it was decided to use twenty-

five RAF aircraft in the flypast over Buckingham Palace at the end of the Trooping of the Colour Parade. The formation was to comprise two Vulcans, two Victors, two Buccaneers, two Lightnings, four Jaguars, four Phantoms and nine of the Red Arrow's Gnats. This disparate collection of aircraft, with widely differing performances and fuel states, was to be led by a Vulcan whose captain had virtually no experience of formation flying, let alone leading mixed formations over London at low level. I was to fly one of the Buccaneers in formation with the lead Vulcan. The whole unwieldy formation was to fly at 240 knots, a ridiculously low speed for the fast jets but chosen for time-keeping purposes; the V bombers were limited to remain below 300 knots at low level.

The forecast on the day was for deteriorating weather over London but the pressure was on to be there. We all formed up over Southwold and set off towards London, flying at about 1000 feet above ground level. All went well at first, but as we approached the suburbs the cloud base started to get lower and lower. Bear in mind that with the lead Vulcan at 1000 feet, and the rest all stepped down behind him, the Red Arrows right at the back were down at about 600 feet over the buildings of the East End. It was a hairy ride as it was getting turbulent. By the middle of London the cloud base was down to 1000 feet and the lead Vulcan was at 800 feet, putting the Reds down to around 400 feet.

Just after passing over the Palace all mayhem broke loose. The rearmost Victor, with two Phantoms on each side, got too close to the Victor ahead and pushed down to avoid collision, thereby putting itself right in the face of the nine Gnats. At the same moment the leading Vulcan went into thick cloud. The Reds broke away, descended as low as they dared and raced off over west London back to their home base at Kemble. The Jaguars, Lightnings and Phantoms, by now in cloud, all broke away from their V bombers, engaged afterburners and split up, climbing for safety in the middle of the busy London Control Zone. My No. 2 and I managed to stick on the wing of our Vulcan as it stumbled up through the thick turbulent cloud; the cloud was so dense that I could only see a small portion of the Vulcan's enormous wing. It was the most frightening situation I had been in for a long time, especially as we were flying so slowly. We had no idea what had happened to the rest of the formation. Eventually we broke out of cloud somewhere well to the north of London,

only to see the Vulcan that had originally been behind us out ahead by a mile or so. Somehow it had overtaken us in cloud – how close it had come we will never know. We recovered back to Honington thankful that we had survived and I swore never to get involved in flypasts over London again, a commitment I was subsequently unable to honour. The photo taken from the ground as we flew over the Palace does not show the chaos that was about to occur.

During this tour the RN finally finished their Buccaneer flying in 1978 and our small RN Unit was disbanded. The 809 Squadron aircraft were handed back to the RAF, repainted in RAF colours and eventually another RAF squadron was expected to form at Honington. This was to be 216 Squadron, a unit that had previously only ever flown transport aircraft. Coincidental with this unit's re-formation was the introduction of another new weapon system into the inventory, the Pavespike laser designation pod and the laser-guided bomb. The introduction of this equipment did not affect our activities on 237 OCU at this time but it would do in the future.

In 1977 the first RAF participation in the USAF's Red Flag exercise took place, again a first for the Buccaneer. We sent our Qualified Weapons Instructor course along on the first Red Flag, along with an instructor crew. The Americans were astonished at the way in which the British operated their aircraft and were somewhat mortified to find out that our tactics of flying at high speed and ultra low level were extremely successful when compared with their more restrained approach.

In 1979, as my time on 237 OCU was coming to an end, the first fatal accident involving structural failure of a Buccaneer wing occurred. In this incident the latch pin, which held the folding section of the wing in place, failed on a German-based aircraft with fatal consequences. All latch pins were replaced and the fleet was soon flying again, but not for long. In January 1980 there was another fatal accident during a Red Flag exercise; in this case the wing failed in the inner non-folding section owing to metal fatigue. The whole fleet was grounded with little prospect of an early return to flying status. Thus it was not too hard a pill to swallow when I left Honington for the now inevitable desk jobs; at least it was to be via a year at the RAF Staff College, Bracknell.

* * *

This promised to be an interesting and demanding year, both intellectually and socially, so we packed up the house again and went off to school in Berkshire. Staff College was indeed an interesting year away from flying. At the end of the course it was time for postings; by this time my old Station Commander, the Bear, had been promoted to Air Marshal and was looking for a Personal Staff Officer (PSO). Thus it was that I was posted to Headquarters Strike Command, RAF High Wycombe, as PSO to the Deputy Commander in Chief. The next eighteen months were a frantic whirlwind of activity. There was no ADC to take up the load of running the Air Marshal's residence and social programme, so this work had to be dovetailed with all the outer office work. There was also no flying, apart from as a passenger with the Air Marshal.

The Falklands War took place in the middle of this tour; it was strange to be a bystander whilst the action unfolded, but being present whilst the most senior of the RAF's Commanders debated what to do. It became increasingly obvious from the intelligence reports that the Argentines were going to invade the Falklands, but the inaction from the government, who must have been given the same intelligence, was difficult to understand. In the end we won, but it was a close run thing; I heard the news in a VC 10 over Greenland as we returned from a visit to the USAF in Omaha, Nebraska.

Overall it was a tough tour, which I did not enjoy, but thankfully there was the occasional amusing incident, but they were few and far between. Two I recall both involved the Commander in Chief, Air Chief Marshal Sir Keith Williamson, whose residence was some distance away from the Headquarters. One evening, whilst watching the evening TV news, my phone rang; it was the Bear, claiming that he had heard intruders prowling in his garden. He demanded that I summon the RAF Police to investigate; why he could not have done this himself I still do not know. I duly telephoned the police guard post and told them to go to the DC-in-C's residence immediately to investigate intruders. Unfortunately the sleepy police corporal thought I said 'the C-in-C's residence' and sent his gallant team off into the Buckinghamshire countryside, where eventually they awoke a very surprised Air Chief Marshal who sent them away with a flea in their ears. Meanwhile I received a series of increasingly

enraged phone calls from the Bear demanding to know where the police had got to. Eventually whoever it was disappeared from his garden and peace returned – until the next morning!

The second incident occurred one morning in February. We were supposed to go to Honington for the official opening of the Tornado Weapons Conversion Unit, the Bear having decided to present a large silver bowl as a prize for the best student on the course. Unfortunately, over night there was a really heavy snow fall of about two feet depth; as a consequence all the roads around High Wycombe were virtually impassable. Thus our plan to drive to RAF Northolt in order to fly to Honington seemed doomed to failure. However, the C-in-C had the use of the only four-wheel drive vehicle in the High Wycombe MT Section, a rather ancient Land Rover that was provided to get him from his residence to the Headquarters in inclement weather. After the C-in-C's arrival that morning – in the afore-said Land Rover – the Bear stole the keys. Without telling the C-in-C or any of his staff we set off for Northolt, me sitting in the back under the canvas tilt, clutching the silver bowl and two RAF swords, clad in a greatcoat, with the Bear and his Cpl driver in the front.

The journey to Northolt normally took about thirty-five minutes; today, because of the snow and appalling traffic congestion, it took two and a half very cold hours. This was before the days of mobile phones so we were out of contact with the Headquarters for the whole journey. The C-in-C, wanting to go home for lunch, discovered his transport had been hijacked and not surprisingly flew into a rage. When we arrived at Northolt, we were met by a very agitated Station Commander, who announced that the C-in-C wished to speak to the Bear *very urgently*.

The Bear disappeared into the terminal building, only to emerge a few moments later looking grim. We returned to High Wycombe in a frosty silence. As we drove up the hill towards the Headquarters, the Bear suddenly announced that he was feeling indisposed and that he would be going directly back to his residence. I was charged with returning the Land Rover to its rightful owner, the C-in-C! Luckily, after an initial explosion, the C-in-C realised that I was merely an innocent bystander in the plot so did not blame me, but I believe he and the Bear had an icy exchange of views when they met the next morning!

* * *

One of the consequences of the Falklands War was a considerable turbulence in personnel, with the need for people to be sent down south to run the new establishment in the Falkland Islands. In September 1982 I discovered I was to move again, this time with the acting rank of wing commander, to a completely new world at the Headquarters of Support Command, at Brampton in Cambridgeshire. It was another ground tour, but with the distinct chance of flying two new aircraft. I was to be the staff officer responsible for all aspects of fast jet advanced flying training on the Hawk at Valley and multi-engine advanced flying training at Finningley. So I said my farewells to the Bear and Strike Command, went down to Brawdy for a week's familiarisation with the Hawk and then moved into quarters at RAF Brampton.

Hawk, Jetstream and (Again) Buccaneer – 1982 to 1987

The Hawk was a great little aircraft, agile and responsive, but positively a trainer rather than a front-line aircraft like the Hunter. I found out that I was responsible for all the activities at RAF Valley, where all Support Command's Hawk flying, apart from the Red Arrows, took place. This meant I had to make regular visits to Anglesey and naturally that involved flying whenever possible. It was great to get back in the cockpit again. Valley had not changed much since my earlier time there with the Gnat, however, with the excellent serviceability of the Hawk it was a very busy place. The Hawk had a far greater endurance than the Gnat so more ambitious sorties were possible. The view from the back seat was excellent; you were hardly aware of the pilot in front of you, a far cry from the cramped and limited view from the back of a Gnat. I soon settled into the routine of the staff work associated with Valley, which was much more pleasant than running around looking after an Air Marshal.

The other part of the work covered multi-engine flying training on the Jetstream, a twin turbo-prop trainer aircraft originally designed as a light commuter airliner. The Jetstream

had an inauspicious start to its career as a trainer in the RAF, culminating in its withdrawal from service and being placed in storage, but by 1982 it was back in service again and working properly. It was a completely different sort of flying to what I had been used to and it was my first experience of using a turbo prop. I went 'solo', but with another pilot in the right-hand seat, and so collected another type in my logbook. The Jetstream aspect of my tour provided some interesting variety and enter-tainment. Weekend support for the Red Arrows was one activity that I enjoyed, as there were few volunteers to fly around the UK in pursuit of the team, carrying spares and a few ground crew.

At this time there was a proposal to bring Ground Launched Cruise Missiles into the UK, based at Greenham Common in Berkshire. This generated a furious response from the Campaign for Nuclear Disarmament and the peace camp full of horrible women that grew up outside the gates became notorious in the national press. I found myself assisting a Group Captain in devising a plan for the security of the site, so in order to circum-navigate the monstrous regiment of women at the front gate we used our own Jetstream to fly in and out.

One consequence of this work was that we were privy to the highly classified information as to when the first missiles were due to be flown in to the site from the USA. This was informa-tion that the peace campers would have loved to have had, as they were threatening to invade the site when it happened. Imagine our consternation when the date was revealed in a national Sunday newspaper; had we been lax with our security? As it turned out we were blameless, as the information had been leaked to the paper by a London-based female civil servant, but we did sweat for a bit.

Late in the autumn of 1983, after only a year at Brampton, I got a phone call from the Bear advising me that I had been selected to command 237 OCU, but not to tell anyone yet as it was still to be confirmed. When the news came out officially I was delighted. My boss was furious but there was nothing he could do. I then caught mumps – not nice at the age of forty-one! Thus my second ground tour came to an end after only eighteen, months in which I had become qualified on two new aircraft and had clocked up quite a number of flying hours.

* * *

By early 1984 the Buccaneer Force had changed considerably from what it had been when I left it in early 1980. After the wing failure accident in the USA the number of serviceable aircraft had reduced significantly and there were only enough for two front-line squadrons and an OCU. The two squadrons based in Germany had been disbanded and re-formed as Tornado squadrons. The two remaining squadrons, 12 and 208, were now both based at Lossiemouth and were committed specifically to the maritime attack role. The OCU was still located at Honington but was due to move in late 1984 to join the squadrons at Lossiemouth.

I started my refresher flying in May 1984 and almost immediately became involved with a Board of Inquiry into a fatal accident that occurred at Lossiemouth on 208 Squadron. This was a particularly unhappy affair, which made a deep impression on me, particularly in respect of the need for squadron members to have trust in their commanding officer, such that they felt able to discuss their personal problems with him when need be. Overall, it was a very messy business but we managed to avoid the next of kin suffering unnecessary hurt.

Once that was over I completed my refresher and took over the unit from the indefatigable Wing Commander David Mulinder in September. No sooner had I taken command, when arrangements for us to move north really began to gather pace. There was going to be a considerable amount of domestic upheaval for all concerned; we were going to have to leave our house and move to a married quarter that was pretty much identical to the local council houses! Our squadron accommodation was also going through a major renovation but was the same building that had been used by 736 Squadron when Lossiemouth was a naval airfield – it was good to be back in the old building doing the same thing again!

One thing I will never forget was our Dining Out from Honington. The boys constructed a large Buccaneer out of cardboard, about 8 feet long, equipped with a rocket-launching tube under each wing. A long electrical cable connected the launching tubes to a 12-volt car battery. An initial trial firing in the empty squadron building was truly spectacular, with the rockets exploding violently on impact with the wall. The initial reaction was that it was too dangerous to use it in the Officers' Mess, but,

after a few beers before the event, the boys changed their mind. It was duly suspended from the ceiling of the dining room, with the car battery hidden beneath the table. Despite the attempts of the Mess Staff to have it removed, it survived and we all sat down to dine with it hanging menacingly over us.

On my left was the Boss of the Tornado Weapons Conversion Unit. He asked what the Buccaneer was going to do – I explained that it would be pulled along the rail from which it was suspended and that it would dump a large amount of talcum powder on whoever was below – which happened to be him. He was not amused and we didn't converse very much for the rest of the evening. On my right was OC Ops Wing. He too asked what the Buccaneer would do – I told him to get down under the table as soon as I had completed my speech – good advice, as it turned out.

When my turn came to speak, I made an appropriately rabble-rousing speech vilifying the Tornado and extolling the virtues of the Buccaneer. When I finished speaking the switch was thrown on the battery. There was a suitably theatrical pause, which convinced the diners that it wasn't going to work, then the rockets went off. They spread all over the dining room, exploding loudly wherever they hit. How no one was injured I will never know. About three or four hit the door leading to the kitchens, which was severely damaged as a consequence. Behind the door was a lady carrying a large tray of glasses from the dishwasher to the cupboards; when the rockets struck she dropped the entire tray load and screamed loudly, thereby enhancing the whole effect of the event. The whole dining room erupted with a standing ovation, which was a most gratifying and fitting way to end the Buccaneer's association with RAF Honington.

The rest of the evening has disappeared from my memory in an alcoholic haze, but inscribed in my logbook is the following statement, written by the Station Commander, Group Captain Peter Harding:

As 237 OCU is relocated at RAF Lossiemouth, the Buccaneer era comes to an end at Honington after 15 years. My best wishes to you and 237 for a successful time at Lossiemouth , thank you for all your help both in the air and on the ground during a trouble-free move North. We

shall remember the Guest Night for ever, the scars will not remain for quite so long.

Running 237 OCU at Lossiemouth was a great pleasure. The weather was very good, we had weapons ranges right on our doorstep, the vast low-flying area in the north of Scotland was always available and I had an excellent team of instructors and ground crew. We were only training crews for 12 and 208 Squadrons, who were both resident with us at Lossiemouth. The airfield was a busy place as in addition to the three Buccaneer squadrons there was the Jaguar OCU, a detachment of 22 Squadron flying search and rescue Sea Kings and last but by no means least 8 Squadron with its mighty Shackletons. Friday nights in the Officers' Mess Bar were noisy and exciting.

Although all the Buccaneer squadrons belonged to 18 Group, the maritime element of Strike Command, 237 OCU was given an interesting and unique war role, which had nothing to do with maritime operations. When the Buccaneer squadrons were withdrawn from RAF Germany in 1984 there was no unit in that theatre of operations that could undertake airborne laser designation for aircraft carrying laser-guided bombs. A number of important operational plans required the use of airborne laser designation, so as 237 OCU had a number of navigators who were very experienced in overland Buccaneer operations, it was given the task of supporting the Jaguar and Tornado squadrons in Germany in war time. This required regular visits to Laarbruch to work with the resident squadrons. Not surprisingly, HQ 18 Group were not particularly enthusiastic about this activity as it would have liked to have had all Buccaneers assigned to maritime operations. However, we were determined to carry on with this work, ably supported in HQ 2 ATAF by Group Captain Nigel Walpole, who had once been an OC 12 Squadron, and was a great enthusiast for our overland capabilities. It also gave the squadron a unique ethos, which was much preferable to simply supporting the other two squadrons at Lossiemouth.

The technique we used for low-level overland laser designation was as follows. Two Buccaneers, loaded with a Pavespike designator pod, a Sidewinder AAM, an underwing tank, an electronic countermeasures (ECM) jamming pod and four 1000-lb bombs

with retard tails (in the bomb door), would get airborne either with the laser bomb-armed aircraft, or would *rendezvous* once airborne. Each Buccaneer would formate with a section of bombers. The Tornado crews initially doubted whether the Buccaneers could keep up with them, especially in the event of an abort from low level due to bad weather; but we soon disproved this notion!

During the final approach run to the target it was essential for the Buccaneer pilot to identify the target and place his HUD aiming mark on it so that the navigator, who before take-off had aligned his laser designator aiming symbol (displayed on his TV screen) with the pilot's HUD aiming mark, could also identify the target on his head down screen. Once the navigator had done this he called 'happy', thereby allowing his pilot to manoeuvre, at up to 4 g, away from the target. This was usually achieved at a range of between 5 to 2 miles from the target, depending on the size of the target and the visibility.

The Pavespike pod could only be carried on the Buccaneer's port inner wing pylon, so all turns away from the target had to be to the right, to allow the pod's head to stay in line of sight with the target for the maximum amount of time. It was essential for the navigator to continue to track the target manually with his pod. This was no easy feat at 4 g, with his head down peering into a TV screen, controlling his marker with a primitive thumb-operated control.

Weapon release from the bombers was indicated either by a call of 'bombs gone' or a tone transmission on the radio. The subsequent timing of firing the laser was absolutely critical; firing too soon would result in a big undershoot as the bomb tried to guide direct to the target, but firing too late would result in an overshoot. Nevertheless, despite these difficulties and the lack of range facilities to conduct live firing practice (only Garve Island Range, near Cape Wrath, could be used and it was only available for very limited periods) the results achieved were very impressive.

The Buccaneer was the only RAF aircraft capable of providing stand-off airborne laser designation from 1979 (when Pavespike was first introduced) until 1991, when the TIALD pod finally came into service on the Tornado. Should the formation be engaged *en route* the Buccaneers were well able to defend themselves, with their Sidewinder AAM, chaff packets (loaded into

the airbrake), the ECM pod and the four retard 1000-lb bombs, which could be used as a 'last ditch' defence against a fighter carrying out an attack from astern. It is interesting to note that the Buccaneer's major operational contribution to the Gulf War of 1991 was as airborne laser designators, albeit from high level rather than the low-level scenario for which we practised so much.

A by-product of this activity was the opportunity to become involved in the NATO squadron exchange scheme. A Dutch F16 squadron (322), based at Leeuwarden, was equipped to carry Laser Guided Bombs (LGBs) and with the assistance of Nigel Walpole we organised a squadron exchange with them. The Dutch were very keen to toss some of their LGBs at Garve Island, the Cape Wrath weapons range, as there was nowhere in Holland where they could do this. We were naturally going to provide the laser designation for them, thereby giving a graphic demonstration of true NATO interoperability.

Two Buccaneers and two F16s set off for Garve. The weather was good and I had an expert Pavespike operator, Norman Browne, as my navigator. The live toss bombing exercise was a great success with all the F16s' bombs guiding well and impacting on target. Norman even managed to organise an HF radio link to Nigel Walpole in his office in Germany to tell him of our success. So far, so good.

The plan was then to fly across the 'moon country' in the north of Scotland, escorted by the two F16s, to be bounced by a third F16. The 'bounce' duly turned up. Our two Buccaneers accelerated off leaving the three Dutchmen to indulge in a bit of air combat. Half an hour later we were sat in the debrief, watching the Pavespike videos, when a broadcast from Air Traffic Control announced that an F16 was returning to the circuit with engine handling problems . . . it was our bounce aircraft, which had got airborne somewhat later than us. A few moments later Air Traffic announced that the aircraft had landed safely and we went back to our debrief.

Suddenly, the door to the briefing room burst open revealing an incandescant F16 pilot, gibbering away in what can only be described as Double Dutch. All the remaining Dutchmen immediately leapt to their feet and rushed out upstairs to their detachment office, slamming the door shut behind them. Sounds

of considerable altercation came from behind the closed door. At this point my Warrant Officer, Jack Sim, sidled up to me. 'I think you had better come out to the flight line and have a look at this F16' he said. The F16 had a thin wisp of vapour coming out of its jet pipe. Closer inspection revealed that the entire back end of the aircraft was riddled with 20-mm bullet holes. 'Get it into the hangar as quick as you can' I said to Jack.

By now the Dutch had calmed down somewhat and were able to offer an explanation. After leaving the bombing range one of the pilots had failed to put his master armament switch to safe. Dutch F16s always flew with a full load of 20-mm ball ammunition, apparently to keep the Centre of Gravity within limits. Our pilot found himself in a position to claim a shot at the F16 ahead of him. He selected air to air, pressed the trigger to film his opponent, and because his master arm switch was still live the gun fired. Luckily he was only tracking the rear of the aircraft ahead, not the cockpit as is normal. However, seeing that nothing appeared amiss with his opponent, he decided to say nothing and carried on with the fight! His opponent, unaware of what had happened, carried on with his sortie and only became aware that something was not quite right when he rejoined the circuit. The Dutch decided to lock up their miscreant pilot in the detachment office for the rest of the day/night.

I went to see the Station Commander, Group Captain Bruce Latton, to brief him on the affair. His immediate and understandable reaction was that we should tell someone; I urged caution. After all, the incident took place over moon country and was unlikely to have been witnessed by anyone. The Dutch were doubtless going to take care of their culprit in their own way. If anyone brought in a dead sheep riddled with 20-mm ammunition, or even a dead human, we could always claim that the incident was under investigation. Eventually the Station Commander agreed; we left it to the Dutch to sort out. The culprit was flown back to Holland the next day in handcuffs and the F16 underwent an engine change in our hangar.

No one from moon country complained and the incident was quietly forgotten. However, I could not resist mentioning at the final Dining In Night for the Dutchmen, that when the RAF shot themselves down they did it properly. (Earlier in the year a Phantom shot down a Jaguar recovering into Bruggen.) Our next

squadron exchange was with a Portuguese Air Force squadron and was an altogether much more restrained affair.

A once in a lifetime opportunity occurred in 1986 when I was given permission to display the Hunter T7 at a number of air displays and unit events during the summer. I embarked on a work up programme that saw my minimum height for aerobatics steadily come down from the usual 5000 feet above ground to a minimum of 500 feet for aerobatics and 200 feet for level passes. The work up was greatly assisted by having a trusty navigator beside me – in most cases Bob Poots – who was a great help providing lookout to the right, timing and reminders of next manoeuvre, height and speeds. Finally the day came for the check out by the AOC; the first attempt failed due to the cockpit being full of water after an overnight rain storm, which drenched everything during the pre display inverted flight check. The second go was successful.

Bob and I subsequently displayed at a number of events, including the Lossiemouth Air Day, the St Mawgan, St Athan and Abingdon Air Shows and a number of lesser events. It was great fun and the beautifully mannered Hunter never let us down. No. 237 OCU even put up a five-aircraft Hunter formation team for the Lossiemouth Air Day. After a few passes in different formations I broke off for my solo. It was probably the last time a military Hunter team displayed in the UK.

We were encouraged to get to know the other squadrons and their work so I decided to learn about flying the Shackleton with 8 Squadron. This was something quite different. I needed two cushions behind me and two underneath me to reach the controls and see out. The aircraft was a great heavy brute to fly; it had to be landed on three points or it would bounce down the runway with increasing severity. Piston engine handling was a complete mystery to me at that time. Nevertheless I was launched off 'solo' by day and collected a first pilot day qualification in my logbook.

Eventually the good life of flying, skiing, sailing and exploring Scotland was bound to come to an end. Much to my amazement and delight a posting came through to CFS at RAF Scampton as Officer Commanding Examining Wing, another flying tour as the chief trapper! Two flying tours as a wing

commander was almost too good to be true but I had the posting notice in my hand and could hardly believe my luck. I was sad to leave Lossiemouth as I would almost certainly not fly the Buccaneer again. After over 2000 hours on type, plus over 1000 hours on the Hunter in associated flying, it was a wrench to get out of such a fine aircraft probably for the last time. I retained a war role appointment back on 237 OCU but the chances of using it to fly the Buccaneer again were very remote. So yet again we packed our bags and set off down to Lincolnshire, the first time I had been based there since leaving Cranwell in 1963, twenty-four years previously.

CHAPTER TWELVE

CFS Examining Wing, Brampton and Linton-on-Ouse – 1987 to 1994

My responsibilities as OC Examining Wing covered a very wide parish, ranging from quality control of the flying clubs that provided flying scholarships for seventeen-year-old schoolchildren, to standards of instruction at OCUs and on front-line squadrons. There was so much to get involved with that choices had to be made. As I had a fast jet background I started with a Hawk conversion course to gain an instructional qualification, then I moved to the Jetstream for a similar qualification. Then a familiarisation with the piston-engined Bulldog followed. Then one with the Jet Provost, some twenty-four years after my initial flying training. The rotary wing instructional business was also one of my responsibilities; this allowed me to go on a senior officer's acquaint course on the Gazelle helicopter, lasting only a week. However, despite the short time available I managed to go solo, something I enjoyed more than anything I had previously experienced in aviation. At the other end of the scale were the gliders used by the Air Training Corps, one powered by a small engine, the others pure sailplanes –

another delightful aviation experience that I was privileged to experience.

There were also many trips abroad at the invitation of foreign air forces. After an often long flight and arriving in unfamiliar territory, one was presented with the Pilot's Notes of an aircraft previously never flown, and expected next morning to perform as an examiner, with all the authority of the Royal Air Force Central Flying School. In my two years at CFS I flew in the Oman, Jordan, Kenya, Switzerland, Singapore and Dubai; I flew a variety of unusual aircraft including the F5, Macchi 326 and 329, SF 260 Warrior, Defender, Skyvan, S211, Hawk 61 and a microlight called the Skywalker.

Flying in the Oman with the Sultan of Oman's Air Force (SOAF), now called the Royal Air Force of Oman, was particularly memorable. In the short space of ten days I flew the Defender and Skyvan for the first time and renewed my acquaintance with both the single- and two-seat Hunter.

One afternoon a group of RAF and SOAF aircrew climbed aboard two Skyvans, flew over the Jebel Akhdar to the empty desert, selected a suitably smooth-looking bit of terrain and landed. We then proceeded to fill a large number of empty beer tins with petrol from jerrycans, place a wick in the tins' openings, then lay them out on the desert floor to outline a runway. Whilst the sun went down we sat under the wings of the Skyvans, eating a delicious curry that had been brought out in 'hot locks'. Once it was dark we lit the wicks in the beer cans, started up the aircraft, got airborne and flew a few circuits on our beer can- illuminated desert strip until the flames finally went out. Then we returned to base in time for a last beer before the Mess bar closed. Wonderful!

It was also quite sobering to land on a primitive strip right up on the border with Yemen. We would taxi back slowly to the take-off point whilst dropping off passengers and freight 'on the move', then get airborne again whilst watching the Yemeni ZSU23/4 anti-aircraft gun batteries just over the border, and very close to the strip, tracking our every move.

Flying in Jordan was another unusual experience. The airfield that was the F5 base was called H5, situated not too far from the Iraqi border. The two-seat F5 had a very poor view from the back seat so we were asked not to attempt any landings, to save us the embarrassment of a rear-end strike on the runway.

Needless to say one of the pilots that I flew with allowed the rear end to contact the runway and the damage, in the shape of two seriously scraped jet pipes that were no longer circular, was obvious. That individual didn't fly with us again but next morning the aircraft was back on the flight line, the damage having been beaten out with a hide-face hammer.

We were provided with a very ancient refrigerator in our sparse accommodation for our beer supply, but it did not have an electric plug attached. Our host simply stuffed the two wires into a wall socket to make it work. After a shower and whilst still damp I tried to open the door to extract a beer, only to be blown across the room by a large electric shock as the whole refrigerator was live. We removed the wire from the socket by tying a bootlace to it and pulling it out. Our post flying beers remained at room temperature from then onwards.

Back in the UK I expanded my fast jet experience to include the Phantom FGR2. I achieved this with just two flights at the Phantom OCU at Leuchars, courtesy of the Boss, Dave Roume. I found the Phantom to be technically very similar to the Buccaneer. It had a much greater performance but was much twitchier at high speed and at low level.

I quite unexpectedly gained a first pilot (night) qualification in the mighty Shackleton. This came about as a result of a phone call from Wg Cdr Dave Hencken, who commanded the Shackleton squadron. He explained that he had been posted to Brussels but if he arrived with a current QFI category he would be able to instruct at the local flying club. Could I help? I said yes, a trip in a Jet Provost would be sufficient. However, he asked that if he could send me solo at night in the Shackleton would that do? I said yes, wonderful, but when? He replied that he would be shortly on his way to Coningsby and to meet him there at 8 pm. There was now no way I could get out of this so I set off across Lincolnshire in my car and sure enough, when I got to Coningsby in the dusk there was the Shackleton waiting for me.

After four or five rather shaky night circuits and landings in the great beast I said to Dave that I was quite happy to sign his logbook there and then. He, however, insisted on sending me off on my own, with a rather reluctant co-pilot in the right-hand seat and a bunch of probably terrified rear crew down the back,

for the required four circuits and landings. It was now completely dark and the sensation was exactly the same as it would have been flying a Lancaster in World War Two – blue flames from the Griffons' exhausts, the pneumatic brakes hissing and squealing, ancient flight instruments dimly lit in red light. It was an unforgettable experience. Luckily I completed the sortie without damaging anything, achieving four good three-point landings and taxiing back successfully (quite a challenge with pneumatic brakes). I signed Dave's logbook, he signed mine and we went our separate ways. As I drove back to Scampton in the dark I realised it was the anniversary of the Dambusters' raid. Local legend had it that the ghost of Guy Gibson's dog Nigger was seen running round Scampton on this occasion – so I hurried back home as quickly as possible but saw nothing!

Another interesting aspect of the job was the requirement to fly with the Red Arrows once a year during their pre-season work up to check that they could handle emergencies correctly and safely whilst in formation displays. This was exciting if somewhat nerve-racking work, especially as the Team were going through a period when they suffered a number of accidents.

The RAF's new basic trainer, the Tucano, also made its appearance for the first time at Scampton in 1988. Powered by a turbo prop and with seats one behind the other, it represented a complete change from the Jet Provost that it was replacing. The cockpit was supposed to be virtually the same as the Hawk's, thereby easing transition from one aircraft to another. The Tucano was quite a sprightly performer up to 240 knots but it ran out of steam at that point. The engine control system was complex and not very reliable and the build quality left much to be desired initially. It was an interesting challenge bringing into service such a different type of trainer; many people regretted the passing of the simple and reliable Jet Provost. In spite of being hyped as having jet-like handling qualities, the Tucano was not jet-like at all. Nevertheless it was nice to have another aircraft in my logbook, especially a brand-new one.

The two and a half years at Scampton simply raced by and toward the end of 1989 it looked like another move was on the

cards. This time it had to be a ground tour and so it was, albeit with a promotion to Group Captain. As a final fling, in early December 1989 we took a Jetstream full of CFS staff to Berlin for a long weekend, sending our wives on ahead by civil airliner. The Berlin Wall had just come down and the collapse of the East German regime was under way; it was going to be an interesting visit. We had to refuel on the way at RAF Wildenrath in order to arrive at Berlin with sufficient fuel for a return to Hanover. I taxied the Jetstream out to the holding point, parked and applied the handbrake, which was exactly the same style as those fitted to early 1950s Ford Popular cars.

After receiving our airways clearance I attempted to release the parking brake, but to no avail. It was stuck firmly on. Sqn Ldr Fred Da Costa, my large and very strong co-pilot and Jetstream expert, was also unable to release it. Visions of our unsupervised wives spending huge sums of money in Berlin, whilst we languished unserviceable at Wildenrath for the weekend, floated before our eyes. A member of the Wildenrath Visiting Aircraft Flight was summoned to the aircraft. He could not, or would not, offer any advice or assistance. At this point Fred removed from his flying suit an enormous Swiss Army penknife. He ordered the ground crew to undo the screws that held on the panel into which the handbrake lever disappeared. This was done, somewhat reluctantly, and our visiting assistant disappeared. Fred then pulled out the split pin that connected the handbrake lever to the operating cables of the handbrake, thereby releasing the handbrake, allowing us to proceed. It was a strange sensation, accelerating down the runway with the handbrake lever still firmly on!

We had a most interesting weekend in Berlin, watching the Berlin Wall being destroyed and realising that we were witnessing the probable end of the Cold War era. We returned the Jetstream to Finningley, explaining briefly the handbrake saga and leaving before we were asked any more questions.

I returned to RAF Brampton as Group Captain Flying Training, an appointment that held responsibility for all the flying training activity within what was then called RAF Support Command. Given my recent wide experience of flying within the Command it was a logical and sensible move. I had a large office in the corner of the Headquarters building with a good view of

the helipad. I had a large staff of officers ranging from flight lieutenant up to wing commander working for me and, by and large, the work was interesting.

There were forays out of the office to the flying training stations, which always involved flying, especially as I had been current at Scampton in all the Command's training aircraft. Shortly after my arrival the man from the Jetstream office came in to talk about some unauthorised tampering with a Jetstream handbrake that had occurred on an overseas training flight – luckily I was able to tell him I knew all about it and had the matter in hand!

Just down the road at Cambridge Airport, Cambridge University Air Squadron were short of a QFI. Cambridge Airport was on the way home so I was kindly taken on as a part-time instructor, flying there whenever I could get a morning or afternoon away from the office.

After my experience over London in 1977 I had hoped never to become involved with this sort of flypast ever again, but not long after arriving at Brampton I was detailed off to organise the airborne element of the Queen Mother's ninetieth birthday celebrations that were to take place on Horse Guards Parade in the centre of London. The event was a celebration, not a military parade with fixed timings. The organiser, a gentleman called Major Parker, was insistent that the flypast should take place at the correct time but he was unable to tell me what that time would be. However, there would be a two-minute 'window' in which all flypast participants would be required to pass in front of the Queen Mother.

The elements of the flypast were the outfits that had the Queen Mother as patron, namely the Army Air Corps Historic Flight, the Royal Navy Historic Flight, the Battle of Britain Memorial Flight and the Central Flying School. Thus there was a wide range of aircraft performance to cope with, ranging from the 90 knots of the Army Air Corps Historic Flight, through the 180 knots of the Battle of Britain Memorial Flight to the 360 knots of the nine Central Flying School Hawks. This presented me with a big planning challenge, especially as there was only the two-minute window available. Clearly it was essential to have an idea as to how the celebration was progressing in order to know when to send the various aircraft with their wide range of

speeds out of their holding patterns to achieve their overhead time. The Army kindly offered the use of a Clansman radio set, reputedly man portable, for a man on the ground to communicate directly with the formations.

I decided we would have to try this piece of kit out 'in situ', so the Army provided a Lynx helicopter, which flew me and one of my squadron leaders into the Honourable Artillery Company's landing site in the City. We then took a taxi to Horse Guards, lugging the extremely heavy Clansman radio with us. On arriving at Horse Guards, which was thronged with tourists, we set up the radio. We attempted to talk to our Lynx, which was now hovering just overhead. We were completely unsuccessful in achieving two-way communication, much to the tourists' amusement, so we retired back to the helicopter landing site to think again.

Then my squadron leader had a brilliant idea. Mobile phones were becoming quite common by this time, so he suggested that he should position himself on the parade ground, equipped with a mobile phone and in constant communication with RAF Northolt Air Traffic Control. All the flypast aircraft would also be on Northolt's radar frequency, so we could get an almost instant update on what was going on at Horse Guards. This plan worked out very well.

I hitched a ride in the leading Hawk because I wanted to be there in case there were problems on the day. In the event all went well, and all the aircraft made it into the two-minute window. Unfortunately we were all slightly early and overflew the celebration whilst the bands were playing 'Land of Hope and Glory'; not what the gallant Major had planned but very appropriate nonetheless. Evidently the crowd loved it.

The Hawk formation landed at RAF Abingdon and arrived at the bar just in time to watch the event on the 10 o'clock news.

Some nine months after starting at Brampton the situation in the Middle East deteriorated rapidly with the Iraqi invasion of Kuwait and it was soon clear that a medium-scale war was going to be inevitable. In December 1990 I was told to put together a plan that involved moving medical teams around the UK in our Jetstream and Domine training aircraft to meet incoming aircraft with battle casualties on board who needed to be categorised and sent on to appropriate hospitals and treatment centres. We

were told to expect a jumbo jet-sized aircraft in every hour within twenty-four hours of the outbreak of hostilities – anywhere within the UK. This was going to be quite a challenge to meet and would have involved the cessation of all multi-engine pilot training and all navigator training.

In the end the plan was never activated because of the very long air campaign, followed by a very short land campaign, which produced minimal casualties. However, I did get involved in some support flying activity associated with the Gulf War. Once hostilities commenced there was a need to fly staff from the Joint Air Reconnaissance and Intelligence Centre (JARIC), also located at Brampton, out to Ramstein Air Base in Germany to collect intelligence material and then return them speedily to JARIC. We used a Jetstream for this task, flying out of and returning to Wyton, which was just up the road from Brampton.

This was yet another chance to grab a bit of flying as many of these tasks were flown in the evenings. The two spooks would sit in the back of the Jetstream, then disappear on arrival at Ramstein. Sometimes we would only be on the ground for fifteen minutes, sometimes for more than two hours, before they returned clutching bags, which they held onto tightly.

On one occasion the whole of the south-east of England became covered in fog when we returned. We failed to get into Wyton (it was now approaching midnight), but Marham was still open and we managed to scrape in there. The Station Commander, Group Captain Jock Stirrup (later to become Chief of the Air Staff) kindly offered us a car to run us all back to Brampton, which the co-pilot and I gladly accepted. The spooks refused the offer and waited for their own special transport to come and collect them. Clearly whatever they had collected from Ramstein was very valuable!

The war was won in fairly quick time and life at the Headquarters slipped back into its usual routine, although an impending planned move of all staffs down to Innsworth began to attract our attention.

Luckily fate intervened again in the form of yet another posting back to flying, this time as Station Commander of RAF Linton-on-Ouse and Officer Commanding No. 1 Flying Training School. So after a mere twenty-two months at Brampton I was on the

move again, this time to Yorkshire after a quick Jet Provost refresher course at CFS. Linton-on-Ouse had always had a wonderful reputation as a first class Station and it certainly lived up to its name. It was built during the RAF's expansion in the 1930s, so was a well-founded establishment with substantial buildings. The Station Commander's residence, Whitley House, was a large detached house with a huge garden that we were swallowed up in.

In addition to the airfield at Linton, I was also responsible for the operation of no fewer than three other airfields used as relief landing grounds – Church Fenton, Topcliffe and Dishforth. The Royal Navy Elementary Flying Training Squadron (RNEFTS) was based at Topcliffe so my connections with the Fleet Air Arm were happily re-established. No. 1 Flying Training School was equipped with two types of Jet Provost, the elderly Mk 3a and the slightly younger Mk 5a. RNEFTS flew the Bulldog and it was not long before the first Tucano arrived from Church Fenton to replace the Jet Provosts. Finally there was a Volunteer Gliding School that operated on the weekends flying the Vigilant motor glider. Thus a wide variety of flying was available, further enhanced when the Chipmunks of the Air Experience Flight (AEF) normally based up the road at Leeming deployed to Linton for their summer camp flying.

Needless to say I sampled all types, but not as frequently as I would have liked as there was much to do as Station Commander. Indeed, there was so much going on that it is difficult to single out individual events of note; just a few come to mind in no particular order. There was the changeover at RNEFTS, when a civilian contractor (Hunting) took over the operation with civilian aircraft – the Slingsby Firefly – and a predominantly civilian team of instructors. The Navy put on a tremendous final decommissioning parade and cocktail party but were justifiably enraged to discover that the new contractor had taken down the RNEFTS sign on the hangar and replaced it with its own before the event. The whole experience was a nightmare of non co-operation from the Hunting's manager, which nearly resulted in my Chief Instructor and me resigning; not a happy business at all and what a contrast to what had gone before.

In contrast there was the honour of reading the Lesson in York Minster in the Battle of Britain Service and taking the salute at

the Battle of Britain Parade in York, when the Station exercised its Freedom of the City by marching past. Unusually there were German officers taking part in the Parade – they were students on RNEFTS. Then there was the monthly 'Gentleman's Walk' in which a select group of worthies would disappear into the Dales or North York Moors for a day's walking in any weather, always stopping for lunch in one of the numerous excellent Yorkshire pubs.

Despite a distinct lack of long-term funding for the Station we managed to build a large new extension to the Officers' Mess, demolish the dreadful pre-war airmen's married quarters and build some very nice new ones. Eventually the Jet Provosts were retired and had to be flown away to their new homes, but not before we held a big 'Farewell JP' party. Despite horrible weather on the day we managed to put up a big formation in the form of the letters JP, plus a solo aerobatic display. We also managed to get two Piston Provosts to come, plus a large number of those associated with the aircraft during its long RAF service. The day finished with a Happy Hour and Guest Night, with the inevitable headaches the next morning.

Eventually only one JP 3 remained, languishing in the corner of a hangar. I asked the engineers why it was still here – the answer was that the purchaser's cheque had still not been cleared. Eventually the new owner arrived to take his Jet Provost away. He paid for a full fuel load and staggered off the short runway, just missing the trees at the end.

The interesting sequel was that a short time later he had the canopy and right-hand seat removed for some maintenance reason. When the seat was reinstalled the top latch, which secured the seat to the aircraft, was not done up properly. The explosive parts of the ejection seat had been removed but the mechanical parts and parachute were all in working order. He then offered his brother a trip, which was accepted. His brother strapped into the right-hand seat incorrectly, omitting to do up two vital straps. Once airborne he was offered some aerobatics. Again he accepted. During a roll some negative g was experienced and the seat, not properly secured, fell out through the canopy. Its occupant was then released from the seat, which unfortunately remained attached to the parachute. Our hero, with some presence of mind, then pulled the parachute rip cord, opening the parachute. Then the entire parachute and seat

combination slid up his body (the straps were not done up) until he was suspended by the neck – luckily for him this occurred so close to the ground that he landed in a heap before he was strangled. The other brother, meanwhile, was aghast when his sibling shot out of the Jet Provost, and, convinced he was dead, took some time to compose himself sufficiently to go back and land. It is interesting to note that at the time of writing (2007) there are still many of our Jet Provosts flying under civilian ownership.

Another interesting little diversion came in the form of a hot air balloon flight. A local balloon operator asked for permission to land at any of our four airfields if they happened to appear conveniently in front of him on one of his flights. I was quite happy to allow him to do so, provided I could see for myself the nature of his activities. Thus an invitation arrived to join one of his flights over the Yorkshire Dales, complete with a champagne reception at the end of the flight. The whole business of inflating the balloon, climbing aboard before it shot off, then drifting in the wind in a wickerwork basket whilst looking vertically down at the scenery and hearing every sound from down below was a new and amazing experience. It was quite unlike flying a conventional aircraft. It was an expensive way of flying but luckily I got my one trip for free.

I recall one unusual incident in the autumn of 1993 when we were staying in our Suffolk house for the weekend. The house is very close to, if not actually on, the extended centre line of runway 29 at the Mildenhall USAF base, about 15 miles away. KC 135 tankers and other heavy US aircraft regularly flew over whilst positioning for an approach. During the night I was woken by a very strange-sounding aircraft passing overhead; the engine noise was a pulsing sound quite unlike anything I'd heard before. I lay in bed, half awake, wondering whether I had dreamt it, when I heard another similar sound approaching. I jumped out of bed and looked out of the window but could see nothing in the pitch black. I ran to the other side of the house and saw a faint flashing light disappearing towards Mildenhall. The time was 02.20 on the Sunday morning.

On return to Linton I related the story to OC Ops Wing, who responded by saying that he knew the senior RAF officer at Mildenhall very well, and that he would ask him what the

aircraft were. A few minutes later he rang me to say that Mildenhall had declared that no traffic had recovered there between 1800 hrs on Saturday and 1000 hrs on Sunday. My response was 'Nonsense, two strange aircraft definitely went in early Sunday morning.' OC Ops had another go at Mildenhall, only to be told firmly by his RAF colleague to stop making inquiries at once. So what were they?

At that time there were many rumours of a new stealthy aircraft called Aurora that had been developed to replace the SR71. A few weeks before my experience there had been an unexplained incident at Boscombe Down apparently involving an emergency landing by an unknown US aircraft, after which it was covered in tarpaulins and removed with great secrecy by an American C5 transport aircraft. In the aviation magazines there was great speculation about Aurora, with a few claimed sightings, and descriptions of a pulsing engine noise. By all accounts the project was unsuccessful, as stories soon dried up and no further sightings were recorded. It's my guess that two of these mystery aircraft were recovered into Mildenhall that night, again in great secrecy. I was just lucky enough to be woken up by them.

In April 1994 the Buccaneer was finally retired from service, having been in service with both the RN and the RAF for more than thirty years. A massive weekend party was held at Lossiemouth to say goodbye to this marvellous old warhorse, attended by just about everyone who had ever been involved with the Buccaneer as air or ground crew. One of the outcomes of this weekend was the formation of the Buccaneer Aircrew Association. I found myself nominated as Deputy Chairman and Newsletter Editor. The Association continues to thrive with over 450 members, regular social events including the infamous 'Buccaneer Blitz', held every year in London. The Association even owns its own Buccaneer, rescued from the scrapman's torch and currently displayed in the Yorkshire Air Museum along with many of the weapons used in its operational life.

Eventually, after a six-month extension in post, all good things had to come to an end and it was time to hand over command to another old friend, David Milne- Smith. There was the inevitable round of parties, farewells, presentations and a final Dining Out

Night. At the same time I was frantically negotiating my next tour, which would inevitably be my last in full-time service. After a couple of false starts I ended up with a posting to the MoD in the Defence Exports Services Organisation, my sole posting to the MoD in thirty-seven years of service in the RAF. So it was a sad farewell to Linton and Yorkshire and a move back down to our Suffolk home.

MoD, 5 Air Experience Flight and Cambridge University Air Squadron – 1994 to 2004

My first priority was to join No. 5 Air Experience Flight (AEF) at Cambridge Airport, to fly Chipmunks under the redoubtable leadership of Sqn Ldr Ced Hughes. Once this had been achieved I could think about the next tour, which was to be my last as a full-time RAF officer.

However, before this started I suddenly found myself being briefed in the Foreign Office and the MoD on a task that involved travelling to the Gulf state of Qatar, at the request of the Qatari Minister for Defence, to conduct a review of Qatar's defence forces and to make recommendations for the future size and role of these forces. Working with me would be a Royal Navy Captain and an Army Colonel. We only had three weeks to carry out this task due to a lack of funding to pay for a longer stay!

After the withdrawal of the British from the Gulf in the 1970s Qatar had fallen very much under French influence. Most of the Air Force's equipment was French and the ruling elite of Qatar had been actively encouraged by France to remain within the

French sphere of influence. By 1994, however, this relationship was beginning to go sour and the Qataris were now looking to the United Kingdom for advice and assistance. Qatar also had access to potentially one of the largest natural gas fields in the world in its territorial waters.

On arrival we were ushered into the presence of the Minister of State for Defence Affairs, a member of the ruling Al Thani family, who was a rather wild character. He clearly enjoyed extreme sub aqua diving and offered my RN colleague some opportunities, which the Captain tactfully turned down. My task was to deal with the air arm. It was too small really to justify the title of Air Force. It soon became apparent that its leader and his immediate circle were still very much under French influence and resented my appearance in their midst. Getting any help from them was a struggle, whereas my naval colleague had no problems at all, as the head of the Qatari naval arm had been through Dartmouth and was longing for a return to British values! A large number of Pakistanis were also included in the air arm, both as aircrew and engineers. They, too, were deeply suspicious of my activities. Thus I had a particularly difficult three weeks, whereas my naval and army colleagues clearly enjoyed themselves.

Eventually, we presented our findings and recommendations to the Minister and presented him with our only official gift, a rather tacky MoD crest. We, on the other hand, were each given a very expensive watch! We returned to the UK uncertain as to what would be the outcome of our visit. Time was to prove that Qatar moved very positively into the US/UK orbit, with major coalition operations being conducted from there in subsequent years. Our recommendation that a new airfield for sole military use be built was taken up and the Qatari air arm ordered Hawk aircraft to replace its French Alpha Jets, so perhaps we did achieve something.

On my return from Qatar and after a short interlude working at RAF Innsworth, I found myself behind a desk in the Ministry of Defence, working in the Defence Exports Services Organisation as the Assistant Military Deputy (Air), a very grand title for a rather routine job. At least it was possible to escape early on a Friday, take the train to Cambridge and fly the Chipmunk all afternoon or on the weekend. The job did have its compensa-

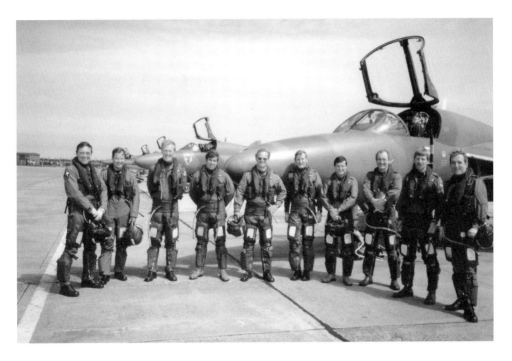

The 237 OCU Hunter display team pilots, Lossiemouth Air Day, 1986.

The 237 OCU Hunter team in action.

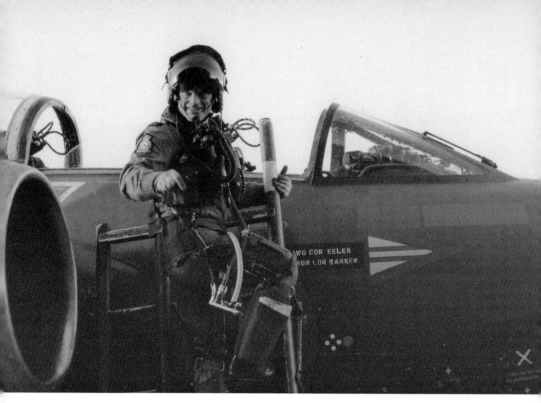

End of sortie and achievement of 2000 hrs Buccaneer flying.

CFS Exam Wing visit to Jordan, 1989. Flying the F5.

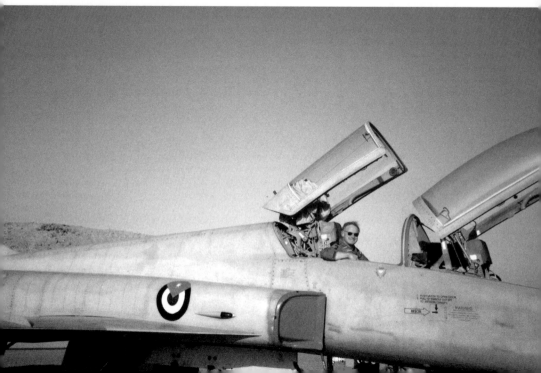

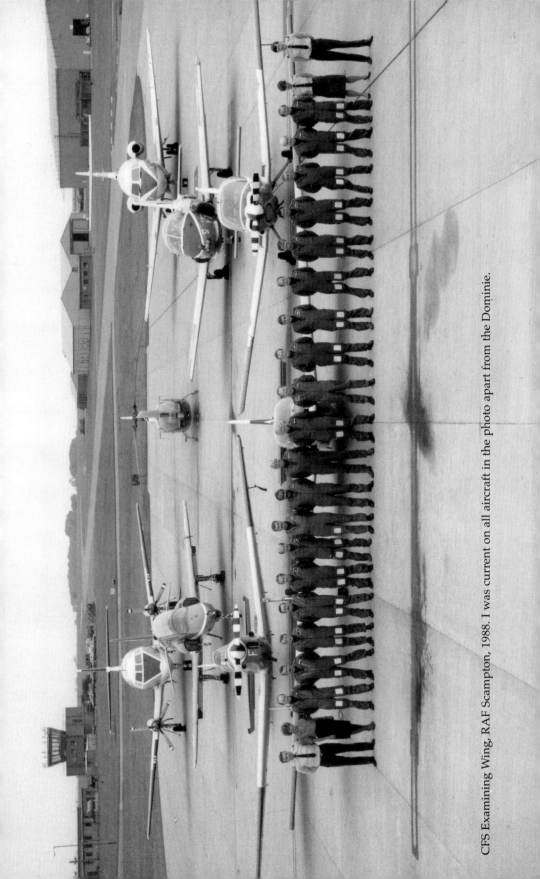

CFS Examining Wing, RAF Scampton, 1988. I was current on all aircraft in the photo apart from the Dominie.

Preparing a flarepath of beer cans, Oman. Prior to desert strip night work, 1988.

CFS ExamWing visit, Singapore, 1989. Flying the uncomfortable SF260.

FS Exam Wing visit Dubai, 1989. Flying a micro light.

FS Exam Wing visit Kenya, 1989. Hawks at Mombasa airport.

I had to check out gliding instructors. Gliding at Syerston.

CFS, 1989. Flying the Bulldog.

Taking over RAF Linton on Ouse, January 1992.

My staff at Linton.

Flying the Lord Mayor of York, Linton, 1992.

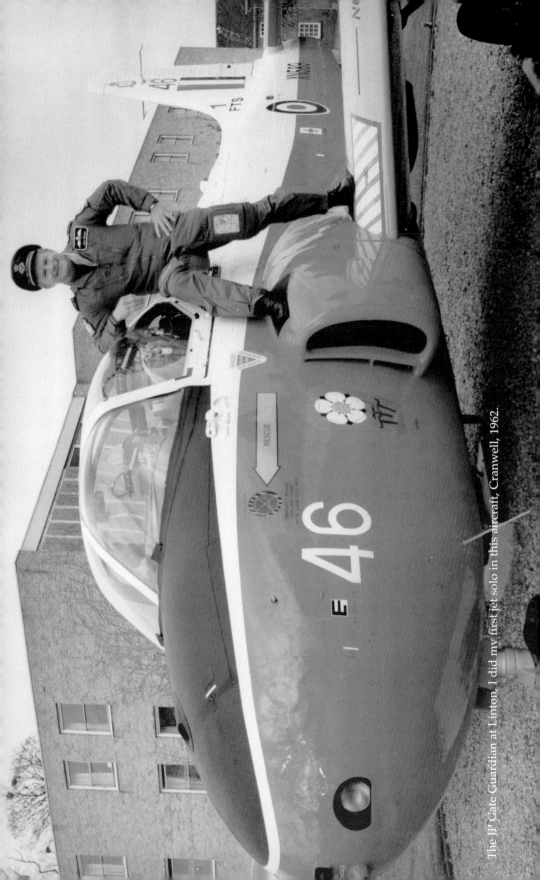

The JP Gate Guardian at Linton. I did my first jet solo in this aircraft, Cranwell, 1962.

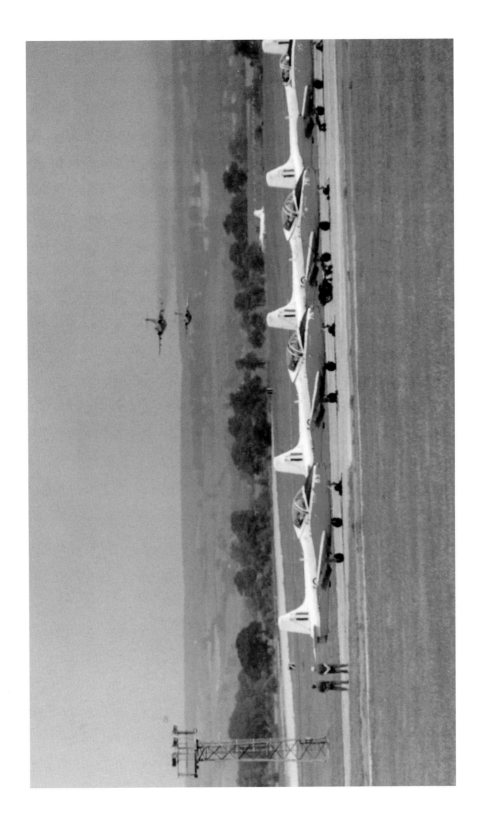

JPs on the flight line, Linton, with low fly past from 2 Buccaneers.

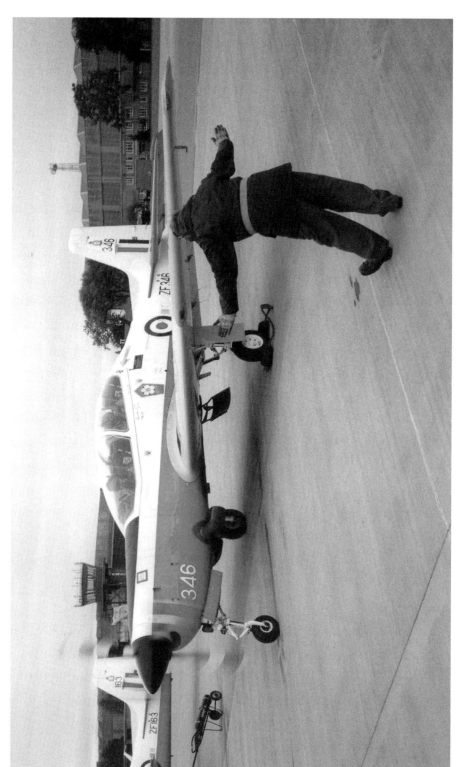

The Tucano replaced the JP at Linton in 1992.

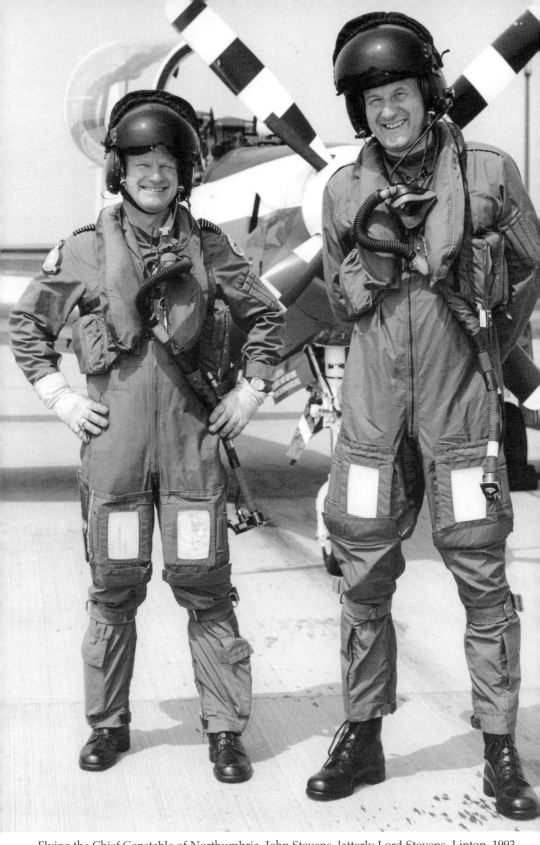

Flying the Chief Constable of Northumbria, John Stevens, latterly Lord Stevens, Linton, 1993.

he hot air balloon trip, 1994. Author far left in the basket.

me of the Buccaneer Aircrew Association with their Buccaneer, Elvington, 1996. Author 2nd right, ck row.

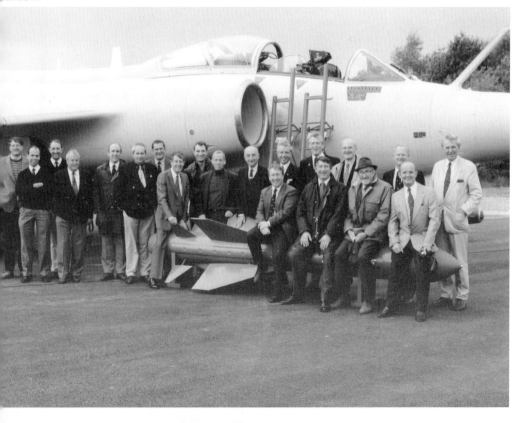

Tutors of CUAS, RAF Wyton, 2000.

Tutor formation celebrating 100 years of powered flight, 3 Dec 2003.

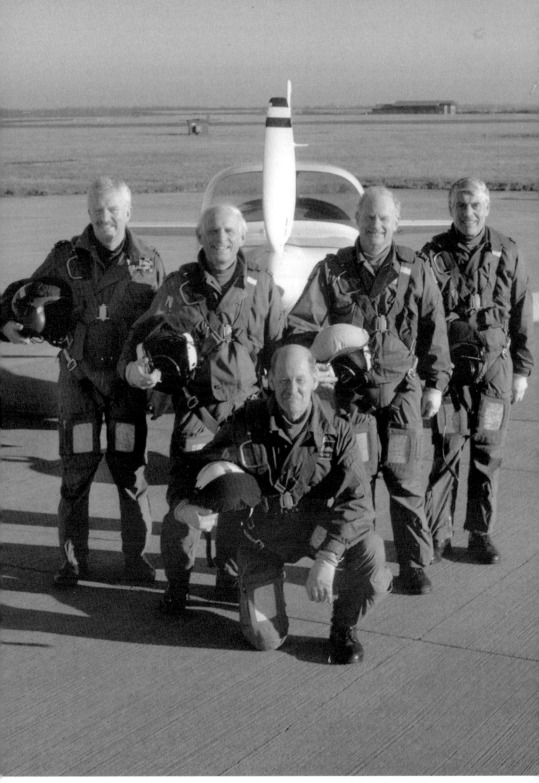

Tutor formation pilots, 3 Dec 2003. Each one has more than 1000 hrs Tutor flying time. Author 2nd right, back row.

Flying the Auster at Great Ashfield.

Author at the controls, Auster.

tions in the form of many overseas trips to sort out problems with British products in places such as Korea, Oman and Indonesia, also attending major overseas trade shows and organising tours by the Red Arrows in support of British Industry. The Paris Air Show and Farnborough also featured regularly. Back in London there was a regular involvement with the Air Attaché circuit with its numerous social events. During this tour I had what was to prove to be my last trip in a fast jet during a visit to Valley, although I did not know it at the time.

Time passed quickly and it soon became apparent that the dreaded fifty-fifth birthday was approaching. There was still a need to earn money and retirement from the RAF was about to occur. A job within the aircraft industry was always a possibility but did not really appeal. I scanned the newspapers looking for possibilities and even had a couple of interviews but with no result.

Then, out of the blue, came a totally new and thoroughly appealing possibility. The RAF was going through one of its regular manning crises and was getting short of pilots on the front line. Too many were leaving and the need to remove those remaining from the front line to become flying instructors was making matters worse. The solution was to offer employment to those leaving the Service as Full Time Reservists, on specific contracts at specific locations, as Flight Lieutenant flying instructors. There would be one of these creatures on each University Air Squadron. I was now current again on the Bulldog, as the Chipmunk had now left the AEFs, so I applied for the post of Full Time Reservist QFI on Cambridge University Air Squadron (CUAS), which also flew from Cambridge Airport. This time the interview was successful and I got the job. With great delight I left the MoD as a Group Captain on a Friday, was dined out in great style in the RAF Club, went home and cut my rank tabs in half and went back to work the next Monday as a Flight Lieutenant. The initial contract was for four years.

After a short QFI Refresher course at Cranwell I reported to the oldest University Air Squadron in the world at Cambridge Airport to be plunged immediately into the mad house of Freshers' Fair where our new recruits were to be found. For two years the squadron remained at Cambridge Airport, an ideal location for the majority of our students, as it was only a short

cycle ride from the University area. It was also only a forty-minute drive for me from home.

In 1999 the squadron won the de Havilland Trophy in the regional competition but already the signs of a major change were on the horizon. A decision to replace the Bulldog had finally been made; the new aircraft was to be the Grob 115E, named Tutor, supplied and serviced by a civil contractor. The aircraft was owned by the contractor, not the MoD, and would be civil registered. This meant restrictions on many traditional flying activities, such as low flying below 500 feet. The squadron was also required to move from Cambridge Airport to RAF Wyton, an airfield that had been closed since 1995, which was to be reactivated as the base airfield for Cambridge University Air Squadron and University of London Air Squadron. It was some 15 miles away from Cambridge, in the wrong direction for me, and quite a challenge for students without cars to get to.

We were the first squadron to be re-equipped with the Tutor, an event that was coincident with the move to Wyton. The 'new' accommodation at Wyton had been lying derelict for four years, there was no running water, no lavatories, the windows were frosted over so you could not see out and the CAA refused to license the hangar for use as it had no heating. It was clearly going to be a struggle to get the place sorted out. The airfield was, however, ideal for light aircraft operations, surrounded by open countryside (unlike Cambridge) with good access to un-restricted airspace. It took just over two years to get everything finished, including new mini hangars inside the main hangar for aircraft servicing, a decent-sized aircraft parking area, adequate Air Traffic Control and reactivation of the secondary runway.

The Tutor was a very different type of trainer when compared with the Bulldog. It was built of carbon fibre and had a very extensive avionics fit, including an embedded Global Positioning System (GPS) that would even allow instrument approaches to be flown without any external equipment apart from a small radio box in the Air Traffic Control Tower. It handled very benignly apart from in cross-wind landings, the main landing gear having no form of damping. After some eighteen months of operations it was discovered that the aircraft was not certified to fly in cloud. A long and difficult period followed whilst this problem was resolved; after modi-

fication the restriction was lifted, only to be replaced by another that prevented many traditional aerobatic manoeuvres being flown because they had not been specifically cleared for the aircraft.

All told, it was a frustrating period but it didn't seem to upset the students very much. Life on the squadron generally carried on much as before, with plenty of sailing and skiing expeditions and many social activities in the wonderful Town Headquarters in Cambridge. A wide variety of students came through the squadron. Quite a few opted for a career in the RAF as a result of their experience, whilst others disappeared into civilian life with a small taste of military flying, but they all enjoyed their time on CUAS.

For most of my time on CUAS I was the CFI, which involved arranging the daily term-time flying programmes, running the vacation flying camps and organising the annual summer camp away at some other airfield. We went to Coltishall twice, Woodvale and St Athan until our Headquarters at Cranwell decided that University Air Squadrons didn't need to go away for the summer any more, probably because they realised that we were having too much fun when away from home base.

I also renewed my Instrument Rating Examiner qualification, was responsible for squadron history (including organising the 75th Anniversary celebrations) and was the Squadron Adventurous Training Officer. It was a busy time but most enjoyable, apart from the 60-mile each-way commute every day. I eventually got rid of the CFI task, only to be made Chief Ground Instructor. The title seemed to indicate that there were other ground instructors, but no, I was the only one. This involved organising all the ground training activities, as well as continuing to fly full time.

December 2003 marked the 100th anniversary of the first powered controlled flight, so the two UAS at Wyton put up a formation of five Tutors to mark this auspicious occasion. The aircraft were flown entirely by full-time reservist QFIs, all of whom had over 1000 hours' flying time on the Tutor, and whose combined total of flying hours and years of RAF service amounted to 34,000 hours and 190 years. Two of us, Syd Morris and I, had flown together in a fifty-five aircraft formation over Aden thirty-six years previously. During my time on CUAS I was presented with a small memento to mark my forty years as

a qualified military pilot, something not many aviators can claim to have achieved.

During my time with CUAS a slightly spooky event occurred at home. In 1940 my father commanded 263 Squadron from June to December. It was the first squadron to be equipped with the Westland Whirlwind, the RAF's first single-seat, twin-engine fighter. In the 1980s Air Vice-Marshal Ken Hayr, who had been a Flight Cadet when my father was Commandant at Cranwell in the 1950s, was Air Officer Commanding No. 11 Group, the only fighter group in the RAF at that time. Ken Hayr used to invite small groups of veterans from the Fighter Command of the 1940s to his Headquarters for an informal lunch, after which each veteran would be presented with a model of the aircraft he flew in 1940. My father was invited to one of these lunch parties, and Ken Hayr duly presented him with a lovely model of a Whirlwind, which I subsequently inherited when my father died in 1992.

The Whirlwind model lived in my study, on a bookshelf about two and a half feet above floor level. Meanwhile Ken Hayr retired from the RAF and became a display pilot on the air show circuit, flying a variety of aircraft. In particular, he displayed a Vampire T11 trainer. During the Biggin Hill Air Show of 2002 Ken was tragically killed when he lost control of the Vampire he was flying when he encountered powerful jet wake from the Sea Vixen ahead of him at too low an altitude to eject. The next morning I found the shattered remains of the Whirlwind model in the garden; our golden retriever dog, just over a year old, had removed it from the shelf, taken it outside and chewed it to bits. There were a number of other models he could easily have chosen, but it was the one given by Ken Hayr to my father. The dog has never touched another model again despite there being many within reach. It was really quite a strange affair.

Another element of aviation came into my life at this time when I was asked to join a volunteer team of pilots who formed the Flying Control Committee at the Imperial War Museum, Duxford. We were all highly experienced military aviators with some display flying background. Our role was to ensure that the rules governing display flying were adhered to during displays at Duxford, to advise and assist the organisers and to ensure that

those who broke the rules or who flew dangerously were dealt with appropriately. This was a sensitive and sometimes difficult task as those who flew varied enormously in skill levels and in their attitude to discipline in the air. It required a delicate and diplomatic touch. The bonus was the privilege of mixing with many pilots flying unique and exotic aircraft, most dating from the 1940s to 1950s, and having a free ringside seat at all Duxford's superb air displays.

Unfortunately, when something goes badly wrong there is usually insufficient time to do anything about it. During the 'Flying Legends' Display of 2003 the RN Historic Flight Firefly was being flown by a relatively inexperienced pilot. This was the very same aircraft that we had brought back to the UK in HMS *Victorious* way back in the summer of 1967, so I had a particular interest in it. The aircraft was being flown downwind, just outside the airfield boundary, to reposition for its next pass. I was watching it from the roof of the Control Tower. It pulled up into a Derry wing-over and immediately flicked into a spin, which was clearly irrecoverable from such a low height. Clearly the pilot had entered the manoeuvre with insufficient energy and it was all over in seconds. The aircraft crashed into a field of wheat, just missing houses in Duxford village, instantly killing both crew in full view of the capacity crowd. There was nothing any of us could have done. However, had we been made aware of the pilot's lack of display experience we might have been able to make him remove that manoeuvre from his display routine, but unfortunately we had not been given his display sequence. After this tragedy the Committee was given access to all display sequences before flying started. So far, there have been no further accidents and I hope it stays that way.

It became clear in 2004 that contracts for Full Time Reservists were not going to be renewed when they expired. Thus for me the end of full-time military aviation became a reality. I was dined out of the squadron in great style in November 2004 after forty-four years of full-time service in the RAF and over 8000 hours of flying in twenty-eight different military aircraft types. However, this was not quite the end of the story. I joined No. 5 Air Experience Flight in the lowly rank of Flying Officer RAF Volunteer Reserve (Training), to fly members of the Air Training Corps and Combined Cadet Force on air experience trips. This

involves a trip to RAF Wyton once a week, to fly the Tutor on short twenty-minute sorties. It is very enjoyable and a delightful way to wind down slowly to the time when ultimately I shall have to hand in my flying suit and helmet for the last time. Sometimes the cadets ask me how long I have been flying as a pilot. When I respond with 'more than forty years' they are usually stunned into silence, such a long time being inconceivable to a twenty-first century teenager. I just hope some of them will have the luck to have as much fun as I have had.

CHAPTER FOURTEEN

The Good, the Bad and the Ugly

So, after more than forty-seven years and over 8000 hours of military flying, in a wide range of very different types, which was the best, the most effective, the easiest, the most difficult, the strangest, the worst and the least memorable?

Two of the best for me were the Chipmunk and the Hunter F6. At opposite ends of the performance spectrum, they both were very good to look at, particularly the Hunter. Both had beautifully responsive and well balanced handling qualities, they were easy to fly but demanding to fly well. Both had cockpits with a distinctive smell and neither was particularly comfortable, but sortie lengths in each were usually quite short. The Chipmunk could be very tricky in a cross wind and the Hunter could bite if you exceeded 0.85 M with any flap selected. The Hunter could also use up fuel very quickly. In spite of the countless forced landings practised in each, neither ever gave me the slightest hint of an unserviceable engine. Both were absolute classics from the best manufacturers of British aircraft, Hawkers and de Havilland.

The most effective was without doubt the Buccaneer. It had enormous character and some very quirky handling characteristics but was perfect for the role for which it was designed – low-level strike, attack and reconnaissance. Throughout its service life it was regularly modified to carry a wide range of

weapons, although most regrettably the avionics hardly changed from the day it entered service with the RN. The list of weapons it was able to deliver is amazing: the 'Red Beard' tactical nuclear weapon; the WE 177 nuclear weapon; 1000-lb and 540-lb bombs; 2-inch RP, Gloworm RP; SNEB RP; Lepus flares; Bullpup ASM; MARTEL TV and AR ASM; Sea Eagle ASM; Sidewinder AIM 9B, 9G and 9L; laser-guided 1000-lb bombs; and numerous types of practice bomb. From 1978 until 1991 it was the only RAF aircraft able to provide laser designation for laser-guided bombs with video recording. It performed outstandingly well in both the maritime and overland theatres, based both at sea and ashore. In the twilight of its service it flew with great effectiveness in the first Gulf war, designating and delivering laser-guided bombs from high level, a role that had never been envisaged on its entry into service in the 1960s.

The easiest to fly was the Jet Provost 3. Its handling character-istics were extremely docile and it was virtually unbreakable. The Viper engine gave it only a modest performance, which allowed the tyro pilot plenty of time to cope with his new and unfamiliar environment. In many ways it was perhaps too easy to fly, generating a false sense of confidence, which rapidly evaporated when confronted with an aircraft with a more robust performance. The Jet Provost 3 was often referred to as 'the constant thrust, variable noise machine', an apt epithet.

The most difficult aircraft I ever had the pleasure of flying was without doubt the Shackleton AEW2. It was huge and ungainly to manoeuvre on the ground, its tail wheel configuration making it basically unstable. Excessive use of the pneumatically operated brakes resulted in a loss of pneumatic pressure, which then required a lengthy recharging process. In the air it was heavy and slow to respond to control inputs, requiring much anticipation. Landing was always very challenging, particularly in a cross wind. Anything other than a perfect three-point touch-down would result in a series of kangaroo-like bounces that became increasingly difficult to control. It was very noisy inside and has doubtless deafened many aircrew who flew it for lengthy periods. Flying the Shackleton filled me with admiration for those young men who flew Lancasters during World War Two, as single pilots with relatively few flying hours, on long, hazardous bombing missions over Germany at night. I suspect that the Hastings would fall into the same category as the

Shackleton, but as all I ever did was to raise and lower the landing gear, I am not qualified to comment further!

The prize for the strangest goes to the Short Skyvan, flown in the Oman. It looked like a freight container that had wings bolted on, together with some wheels to facilitate movement on the ground. It was, nevertheless, ideal for flying all sorts of unusual people, animals and freight around the harsh environment of the Oman. It was robust, simple and straightforward to fly.

As for the worst, for me it was the Jetstream T1. Designed by the famous firm of Handley Page as a small commuter airliner, it was intended to fly between regional airports at a constant speed and height, and this it did very well. It was never suited to the role of pilot training, with the constant take-offs and landings, the regular explorations of the flight envelope at medium and low levels and the general hard wear and tear of training flying. The engines were far too complex, controlled by a myriad of micro-switches. It was difficult to land and very noisy inside. The view from the flight deck, whilst adequate for take-off, transit along an airway and landing, was not really good enough for lookout in a busy circuit or during general handling. It was far from ideal as a multi-engine pilot training aircraft. However, it fulfilled this role from the late 1970s until 2003 without loss, other than its pilots' hearing. Since the formation of the RAF in 1918 there had always been a Handley Page aircraft in RAF service, until 2003, when the Jetstream was finally retired, although some soldier on with the RN as crew trainers.

The least memorable candidate comes from the motley collection of civil aircraft I have been able to fly over the last forty odd years. It is the Premier AX3 microlight, a device I had a couple of trips in whilst serving at RAF Brampton as Group Captain Flying Training. We were looking into the possibility of using microlights to provide air experience for Air Cadets and the Premier AX3 was offered for trial as a potential vehicle for this. It was flimsy, very underpowered and generally uninspiring. I flew in it from Wyton to Scampton and back again but it would have been quicker to have gone by car.

Record of Service

Sep 1960 to Jul 1963	RAF College Cranwell (officer and flying training)
Aug 1963 to Feb 1964	4 FTS RAF Valley (flying training)
Feb 1964 to Apr 1964	36 Squadron RAF Colerne (holding post)
Apr 1964 to Jul 1964	231 OCU RAF Bassingbourn (operational conversion)
Aug 1964 to Jul 1966	16 Squadron RAF Laarbruch (squadron pilot)
Jul 1966 to Nov 1966	736 NAS RNAS Lossiemouth (operational conversion)
Dec 1966 to Jul 1968	801 NAS HMS *Victorious*/RNAS Lossiemouth (squadron pilot)
Aug 1968 to Dec 1968	244 QFI Course RAF Little Rissington (flying instructor course)
Jan 1969 to May 1969	4 FTS RAF Valley (flying instructor)
Jun 1969 to Mar 1971	736 NAS RNAS Lossiemouth (flying instructor)
Apr 1971 to Jun 1972	237 OCU RAF Honington (flying instructor)

Jul 1972 to Mar 1975	12 Squadron RAF Honington (squadron pilot and training officer)
Apr 1975 to Sep 1977	79 Squadron RAF Brawdy (Flight Commander and flying instructor)
Sep 1977 to Dec 1979	237 OCU RAF Honington (Chief Flying Instructor)
Jan 1980 to Dec 1980	RAF Staff College Bracknell (student)
Jan 1981 to Oct 1982	RAF Strike Command, High Wycombe (Personal Staff Officer to Deputy C-in-C)
Oct 1982 to Mar 1984	RAF Support Command, Brampton (air staff officer)
Apr 1984 to Jun 1987	237 OCU RAF Honington, RAF Lossiemouth (Officer Commanding)
Jul 1987 to Dec 1989	CFS RAF Scampton (Officer Commanding CFS Examining Wing)
Jan 1990 to Dec 1991	RAF Support Command, Brampton (Group Captain Flying Training)
Jan 1992 to Jul 1994	RAF Linton-on-Ouse (Station Commander)
Aug 1994 to Feb 1995	RAF Personnel and Training Command, Innsworth (Project Officer, future flying training)
Mar 1995 to Sep 1997	MoD, DESO (Assistant Military Deputy, Air)
Sep1997 to Nov 2004	Cambridge University Air Squadron, Cambridge Airport and RAF Wyton (Chief Flying Instructor, Chief Ground Instructor)
Dec 2004 to Sep 2007	5 AEF RAF Wyton (pilot)

Pilot Qualifications, Military Aircraft

JET

FIRST PILOT, DAY/NIGHT

Jet Provost T3, 3A, 4, 5A
Gnat T1
Canberra B 2, T4, B(I)8
Hunter F6, F(GA) 9, GA 11,T7, 7A, 8, 8B, 8C
Buccaneer S1, 2
Hawk T1, 61

FIRST PILOT DAY

Phantom FGR 2
F5F
S 211
Macchi MB 326, 329

TURBO PROP

FIRST PILOT DAY/NIGHT

Jetstream T1

Skyvan
Tucano T 1

FIRST PILOT DAY

Jetstream T3

PISTON

FIRST PILOT DAY/NIGHT

Bulldog T1
Shackleton AEW 2

FIRST PILOT DAY

Chipmunk T 10
SF 260 Warrior
Firefly T 67 M
G 115 E Tutor
Defender

SECOND PILOT

Hastings C 1, 2

GLIDERS

FIRST PILOT DAY

Venture T1
Viking T1
Valiant ASW 19
Vanguard T1
Vigilant T1

HELICOPTER

FIRST PILOT DAY

Gazelle HT 3

ANNEX 3

Flying Hours

Buccaneer	2185
Hunter	1416
Canberra	600
JP	400
Hawk	323
Gnat	195
Tucano	226
Jetstream	110
Tutor	1400
Bulldog	752
Chipmunk	135
Multi-engine piston, rotary, glider and miscellaneous types	508

Civilian Aircraft Flown as First Pilot

Auster

RV 8

Robin

Cessna 150

Hornet Moth

Luton Minor

CFM Shadow

Fournier RF3

Andreasson B4

Premier AX3

Luscombe Silvaire

Flying the Buccaneer, a Pilot's Perspective

Written for the Japanese magazine *Famous Airplanes of the World* and reproduced with its permission.

first became involved with the Buccaneer in July 1966, when I arrived at the Royal Naval Air Station Lossiemouth in the north of Scotland, to embark on an exchange tour of duty as an RAF pilot with the Fleet Air Arm of the Royal Navy. After two years of flying with 801 Naval Air Squadron embarked on the aircraft carriers HMS *Victorious* and *Hermes*, I became a flying instructor and returned to serve on the operational training unit, 736 Naval Air Squadron. This involved the somewhat alarming business of flying in the observer's seat, with no flying controls, to assist a pilot on his first ever flight in a Buccaneer. By 1971 the Buccaneer had been brought into service with the Royal Air Force and I spent another year on 237 Operational Conversion Unit, the RAF Buccaneer training squadron, as an instructor. I then spent three years on 12 Squadron, the first RAF Buccaneer squadron, as the training officer and squadron pilot. During this time many new weapons and tactics were introduced, including the Martel air to surface missile system. I was awarded the Queen's Commendation for Valuable Services in the Air at the end of this assignment. In 1977 I returned to 237 Operational Conversion Unit as a Flight Commander and Chief Flying Instructor, again teaching the art of flying the Buccaneer. After this assignment I remained on ground duties until 1984, when I returned to command 237

Operational Conversion Unit, moving it from its base in the east of England back to Lossiemouth in Scotland. I relinquished command in 1987. Overall I was associated with the Buccaneer for 21 years and flew over 2000 hrs in the aircraft. I also flew over 1000 hrs in the dual control Hawker Hunter, which was used as a trainer for the Buccaneer.

The first version of the Buccaneer, the S1, was powered by de Havilland Gyron Junior turbo jets, each gave a static thrust of 7100 lb, barely adequate for such a large and heavy aircraft. By mid 1966 the S1 version was being steadily replaced in service by the S2, which was powered by Rolls-Royce Spey turbo fans, rated to give 11,500 lb of thrust. I learnt to fly on the S1 before moving on to the S2, which was used by the operational squadrons.

Before flying the Buccaneer at least two weeks were spent in the Ground Training School, learning how the aircraft's complex systems worked. Considerable time was also spent in the Flight Simulator. The first Simulator was fairly rudimentary, with no motion or visual capability, but it did allow the pilot and his observer/navigator to practise normal and emergency procedures in a fairly realistic environment. Later Simulators for the S2 version had more sophisticated facilities including motion, a visual system and the ability to carry out weapon attack profiles. There was no dual control facility in the Buccaneer, so a number of Hawker Hunter trainers, equipped with the Buccaneer flight instrument system, were used to introduce trainee pilots to the flying techniques used in the Buccaneer, although in no way did they replicate the Buccaneer's flying characteristics.

The first thing you noticed as you walked out to a Buccaneer was its size – it was a big aircraft, weighing in at around 20 tons, 64 feet long and with a wingspan of 44 feet. It was quite a climb up into the cockpit, which was fitted with Martin-Baker Mk6 MSB ejection seats. Early Naval aircraft had an underwater ejection system fitted to the seat; this used compressed air to release the occupant's harness, inflate his lifejacket and propel him to the surface if the aircraft landed in the sea with the aircrew still in it. It was initiated by a water depth sensor. The introduction of a rocket pack to the seat in 1970 gave it a 'zero/zero' capability so the underwater escape facility was no longer needed. Cockpit instrumentation was somewhat haphazard. The excellent OR946 Integrated Flight Instrument

System (IFIS), driven by a Master Reference Gyro and an Air Data Computer, was rather overshadowed by the proliferation of other random instruments; these seemed to increase every time a modification was embodied. For example, the IFIS airspeed display, a strip indication, was not considered accurate enough or suitably positioned for speed assessment during carrier operations, so a two-needle conventional airspeed indicator was fitted on the top of the left instrument panel to give the pilot an accurate 'heads up' airspeed display. By the end of the aircraft's life the cockpit could best be described as an ergonomic slum. In front of the pilot was the Strike Sight, a simple head up display, which used a sight glass that could be folded down to improve forward visibility. The aircraft also had a very effective windscreen clearance hot air jet and a wiper/washer (just like your car), both essential for operations over the sea. The Buccaneer had a complex flying control system. In addition to conventional ailerons, flaps, rudder and all moving tailplane, there were two innovative high lift devices that enabled the Buccaneer to be launched from and landed back on the rather small Royal Navy aircraft carriers. The ailerons could be drooped to a maximum of 25 degrees, to act as additional flaps. This produced a very strong nose down change of trim, which was counteracted by an electrically operated flap on the rear of the tailplane that moved upwards through the same amount as the ailerons drooped, thus restoring longitudinal control. A boundary layer control system ejected high pressure air, bled from the engines, over the wing leading edge, the top surfaces of the flaps and ailerons and the under surface of the tailplane. The combination of aileron droop, tailplane flap and the boundary layer control system (BLC) reduced the minimum speed achievable from 155 kts to 130 kts, thus enabling catapult launch and arrested landings on aircraft carriers.

The twin Speys, or Gyron Juniors in a Mk1, were started by using an external low pressure air starter, there being no on-board starter system, something to be borne in mind when operating away from home base. Once the engines were running and the various systems had been checked, taxiing was straight-forward, there being ample power and authority from the brakes and nose wheel steering. The facility to fold the wings was very useful when manoeuvring in confined spaces, and

allowed more than one aircraft to be positioned within a Hardened Aircraft Shelter.

Catapult launch from a carrier was carried out with hands off the control column. A tailplane angle was calculated and set so that the aircraft would rotate a small amount on leaving the deck; mainplane flap/aileron droop/tailplane flap was set to its maximum deflection of 45/25/25 with the Boundary Layer Control (BLC) system on. The aircraft was physically connected to the carrier deck by a frangible metal link known as the 'hold back'. This would prevent the aircraft from moving with full power applied but would break when the catapult was fired, thereby releasing the aircraft and allowing it to accelerate under the thrust of the catapult. After the hold back had been connected, the catapult bridle was attached and the catapult shuttle was moved forwards, thereby rotating the aircraft into the nose up launch attitude. Once 'tensioned up' in the launch attitude full power was applied under the direction of the Flight Deck Officer. When ready to launch the pilot would brace his left arm to ensure full power remained applied, raise his right hand to indicate he was ready to go to the Flight Deck Officer, then place his hand on his right thigh adjacent to, but not holding, the control column. Acceleration down the catapult was very brisk – about 4 to 5 g – and once airborne the pilot would take control whilst being careful not to induce a high pitch rate, as the Buccaneer was unstable in pitch at low speed. After retracting the landing gear and cleaning up the flap and droop in stages, the S2 accelerated quickly to its normal operating speed of 420–480 kts, whilst the S1 took considerably longer.

Take-offs from runways were carried out unblown with flap/droop set to 15/10/10, unless aircraft weight or runway length required a blown take-off, when flap/droop was set to 30/20/20. The Buccaneer S1 was slow to accelerate, even when unblown, and needed a long runway, but the Buccaneer S2 accelerated quickly and had a much shorter take-off run. Take-offs in close formation presented no difficulty.

Once airborne, both versions of the Buccaneer were a delight to handle when in their element of high speed at low level, however, the S1 was rather underpowered. Control forces were well balanced and light. The S1's rate of climb was poor, but the S2 gained altitude very quickly. It was unusual to go above

35,000 feet in either version but 40,000 feet could be reached in a light aircraft. The maximum permitted speed was 580 kts or 0.95 M, which could be maintained for ages and easily exceeded. Because of the need to fit the Buccaneer inside the limited head-room of aircraft carrier hangar decks the fin was relatively short, so the aircraft was unstable in yaw, particularly at high speeds. A three axis auto stabilisation system, with a standby yaw damper, was used at all times. There was also an autopilot facility that provided airspeed, heading and height holds, a useful facility on long transit flights. Aerobatic manoeuvres such as aileron rolls, barrel rolls and roll off the top of loops were permitted but full loops were not. The aircraft could suffer from inertia coupling if certain handling limitations were ignored. The Gyron Junior turbo jets in the S1 were very prone to compressor stall, particu-larly at high angles of attack, so required careful handling. Loss of engine thrust in a Buccaneer S1 was major emergency, particularly in the high drag landing configuration, as the aircraft had a very limited performance on one engine. The Spey turbo fans in the Buccaneer S2 were much more reliable. Single engine flight in the S2 presented no problems.

The Buccaneer could carry a wide range of conventional weapons and could also deliver a tactical nuclear bomb. At first this was a weapon named Red Beard; it was a large device that completely filled the bomb bay and it could only be delivered from a toss manoeuvre. It was replaced in 1971 by a smaller weapon, the WE177; two of these could be carried and they could be delivered from a low level approach in a laydown mode in addition to a toss attack. High explosive and nuclear bombs could be delivered from toss attacks initiated from a high speed, low level approach. The observer/navigator would use his radar to identify and lock on to a target. The pilot would follow the steering demands displayed in his Strike Sight, pulling up into a 3–4 g toss profile about 3 miles from the target. Dive bombing and level attacks were also possible with high explosive bombs and rocket projectiles. The Buccaneer also carried a number of different air to surface missiles, such as Bullpup, TV and AR Martel and Sea Eagle, and for self defence a Sidewinder air to air missile, at first the AIM9B but later this was superseded by the AIM9G and 9L. Toss attack profiles were initiated at 540 kts, dive and level attack profiles were flown in the 450–500 kt range. The very wide range of weapons available

made for challenging and exciting flying; the Buccaneer was an excellent weapons platform, being stable and responsive in the speed range of 350–550 kts. The rotating weapons door could be opened at speeds up to 550 kts and did not affect aircraft handling in any way.

Both versions of the Buccaneer were equipped for air to air refuelling through a fixed probe, slightly offset to the right in front of the pilot. The first Buccaneer S1s had a retractable probe but this never proved to be satisfactory. Air to air refuelling was carried out at the relatively slow speed of 250–280 kts. The Buccaneer could carry a Flight Refuelling Mk.20 air to air re-fuelling pod under the right wing and this facility was regularly used by the RN squadrons. The RAF squadrons tended to use Victor and VC10 tanker aircraft and only limited use was made of the Buccaneer's pod. The probe was well positioned and re-fuelling in flight fairly straightforward provided there was no turbulence. The technique used was to position the aircraft about 10 metres behind the hose and then to fly steadily towards the basket up the extended line of the hose with an overtaking speed of about 5 kts, adding just a little power as the probe engaged the basket to ensure a positive contact. Once in contact it was necessary to push the hose further into the pod to initiate fuel flow. When refuelling was completed the aircraft would withdraw slowly down the line of the hose until the basket disengaged from the probe. It was important not to look at, but through, the basket during approach and withdrawal in order to reduce the tendency to over control in pitch and generate a pilot induced oscillation.

When speed was reduced below 300 kts for recovery the Buccaneer became much more difficult to fly accurately. There was an aileron gear change facility that allowed greater aileron deflection for the amount of control column movement which could be used below 300 kts. Approaches to both airfields and aircraft carriers were normally flown in the 45/25/25 BLC on configuration, airbrake fully extended, with the final approach being flown at a constant speed for a no flare landing. With 25 degrees of aileron droop extended there was significant adverse aileron yaw generated in turns by the down going aileron but this could be easily resolved by a coordinated use of the rudder. The excellent Airstream Direction Detector (ADD) gave both audio and visual indication of angle of attack/airspeed,

allowing the pilot to keep his eyesight out of the cockpit – essential for accurate deck landings. The basic final approach speed (blown) was 127 kts, considerably lower than similar fast jets. It increased to 155 kts unblown. Single engine approaches could be flown either blown at 30/20/20 – essential if landing on a carrier – or unblown at 45/10/10, the usual option for an airfield landing. There was no asymmetric handling problem and the S2 could overshoot on one engine from the threshold providing the fuel state was reduced to a minimum. Single engine touch and go landings in the configuration 30/20/20 BLC on were regularly practised by pilots prior to embarkation to cater for missing a wire on a single engine approach to the carrier. Arrested landings afloat involved a very rapid deceleration; once stopped it was essential to raise the hook, fold the wings and vacate the flight deck quickly to enable subsequent aircraft to land without delay. On airfields arrested landings were carried out in the event of aircraft hydraulic failures; these were straightforward and gave a much slower deceleration. Aborted take-offs could also use the airfield arrestor system to bring the aircraft to a halt.

As previously mentioned, there was no dual control version of the Buccaneer so a pilot's first flight was always a rather stressful event. Another pilot instructor would accompany him in the observer's seat, giving verbal instructions and encouragement but without any chance of taking over control if the student pilot made serious errors. This system worked effectively and I carried out many first flights from the observer's seat without incident as an instructor until one day when I was with a young pilot in a Buccaneer S1. On his first approach to the runway he allowed the aircraft to get too high and so I instructed him to overshoot and try again. As he applied full power the left engine failed. With only one engine working the aircraft would not maintain height and speed, so at an altitude of about 150 feet and at a very low speed I ordered an ejection, I pulled the lower handle of the seat and was fired out of the aircraft. The student pilot followed shortly afterwards and we both landed safely on the airfield. I unfortunately damaged my back badly. The Buccaneer crashed on the airfield and caught fire, giving the airfield rescue services a wonderful opportunity to exercise their skills for real.

In conclusion, the Buccaneer was a challenging aircraft to fly,

with its complex systems and its unique and innovative high lift devices and flying controls. All those lucky enough to fly it were highly enthusiastic about it. After 8000 hrs of military flying on many different types I still feel that my 2185 hrs on the Buccaneer, both at sea and shore based, with the Royal Navy and the Royal Air Force, were the most demanding and exciting of my flying career.

Acronyms

AAM	Air to Air Missile
AAR	Air to Air Refuelling
ACRB	Aircrew Refreshment Buffet
ADD	Airstream Direction Detector
ADIZ	Air Defence Identification Zone
AEF	Air Experience Flight
ASM	Air to Surface Missile
ATA	Air Turbine Alternator
BLC	Boundary Layer Control
CFI	Chief Flying Instructor
CFS	Central Flying School
DLP	Deck Landing Practice
FDO	Flight Deck Officer
FRA	First Run Attack
HDU	Head Up Display
IFIS	Integrated Flight Instrument System
IGV	Inlet Guide Vane
IRI	Instrument Rating Instructor
ILS	Instrument Landing System
LABS	Low Altitude Bombing System
LGB	Laser Guided Bomb
MADDL	Mirror Assisted Dummy Deck Landing
NAS	Naval Air Squadron
OCU	Operational Conversion Unit
PSO	Personal Staff Officer

QFI	Qualified Flying Instructor
QRA	Quick Reaction Alert
RNAS	Royal Naval Air Station
RNEFTS	Royal Navy Elementary Flying Training Squadron
RP	Rocket Projectile
RPM	Revolutions Per Minute
TACAN	Tactical Air Navigation Aid
TCV	Turbine Cooling Valve
TWU	Tactical Weapons Unit
UAS	University Air Squadron

Index

ACKNOWLEDGEMENTS

THE VAST MAJORITY of the first-person quotes from Kneale used within the text come from interviews conducted by the author in 2002–3. Additional quotes come from the following sources: First and foremost, a superlative and invaluable series of interviews conducted by Julian Petley and Kim Newman, variously published as 'The Manxman' in *Monthly Film Bulletin* (March 1989) and 'Quatermass and the Pen' in *Video Watchdog* (Issue 47, September/October 1998).

Several quotes concerning Kneale's Isle of Man days come from an interview for Manx Radio conducted by Roy McMillan (February 2003). Assorted others concerning his TV career come from an on-stage Q&A conducted by Julian Petley at Manchester's Cornerhouse (October 2001) and interviews conducted by BBC4 for their documentary *The Kneale Tapes* (October 2003).

Other research sources include: Various *Radio Times* listings and articles; *Tomato Cain and Other Stories* (Collins, 1949); *The BBC Children's Hour Annual* for 1954 (Burke, 1953); Kneale's articles for *Sight and Sound* ('Not Quite So Intimate', Spring 1959) and *Punch* ('Speech by the Minister of Power, 1973', November 30, 1960); the script-books of the BBC Quatermass serials (first published by Penguin, 1959/60, and reprinted with new introductions by Arrow, 1979); *The Television Playwrights* (Michael Joseph, 1960, ed. Michael Barry); the Folio Society's MR James short story collection (1973), edited and with a new introduction by Kneale; the short story adaptations collection *Unnatural Causes* (Javelin, 1986); Andrew Pixley's exhaustive, authoritative archive articles on the television Quatermass serials for *TV Zone* magazine — in, respectively, issues 106 (September 1998), 109 (December 1998), 110 (January 1999), and 161 (April 2003), also *Nineteen Eighty-Four* (issue 159, February 2003) and *The Year of the Sex Olympic* (issue 162, May 2003); the excellent programme compiled by David Prothero for the weekend event at Chapter in Cardiff (July 1999); interviews with Kneale from the *Independent* ('Don't Mention the Q Word' by Kevin Jackson, November 30, 1991); Paul Wells' interview 'Apocalypse Then!' in *British Science Fiction Cinema* (Routledge, 1999, ed. IQ Hunter); Julian Petley's interview for *Primetime* (issue 9, Winter 1984/5) and Kevin Davies' interview shot for the Sci-Fi Channel (1996); interviews with Judith Kerr for BBC Radio 4's *Women's Hour* (2003) and *Desert Island Discs* (2004); *Hammer House of Horror* by Howard Maxford (BT Batsford, 1996); *Hammer Films: The Bray Studio Years* by Wayne Kinsey (Reynolds & Hearn, 2002); *English Gothic: A Century of Horror Cinema* by Jonathan Rigby (Reynolds & Hearn, 2002); *Ten Years of Terror: British Horror Films of the 1970s*, edited by Harvey Fenton and David Flint (FAB Press, 2001); *Danse Macabre* by Stephen King (Macdonald Futura, 1981); *The Intimate Screen: Early British Television Drama* by Jason Jacobs (Clarendon Press, 2000); *British Television Drama: a History* by Lez Cooke (BFI, 2003); Kneale's own private script collection.

I'd like to thank: In particular, all the interviewees for their kindness in sparing the time to talk. For assistance along the way, my gratitude goes to: Darrell Buxton, Mark Campbell, Ted Whitehead, Malcolm Chapman, Gina Gilberto, Peter Anghelides, Cheryl Vosper Christian, Ian Dawn, Frank Spink and John Das at BBC4, Manchester Central Library, the Yahoo Kneale internet group (movies.groups.yahoo.com/group/kneale/), and the Mausoleum Club website (www.the-mausoleum-club.org.uk).

For support and advice: Andy Willis, Garry Watson, Michael Hayden, David Butler, Toby Hadoke, Matthew Holness — fine fellows all; the estimable Mark Aldridge; everyone at Manchester's Cornerhouse — especially Linda Pariser and Lorraine Mahoney. Special mentions for the late Dave Prothero, with respect; and David Kerekes for having faith and patience in the project.

Most of all, though, to Nigel Kneale and Judith Kerr, without whose kindness, assistance and talent, there would be, needless to say, no book at all.

Finally, this book is for Catherine and Michael, with much love and gratitude.

2003. Both facilities virtually debuted in the original BBC *Quatermass* serials, and have now gone forever. Meanwhile one of the BBC's current senior drama executives is Laura Mackie, the daughter of Kneale's ex-Script Unit colleague, Phillip Mackie. Arguably, Kneale's style of writing — focussing on ideas and plot rather than character — is out of favour in the current climate, where much TV drama is taken up with gritty character-driven star vehicles for ex-soap stars. Perhaps, too, the distance he kept from his writing — shying away from autobiographical fiction, and exercising, for instance, a fascination with the uncanny, in which he doesn't believe — might leave modern viewers a little cold. But Kneale wrote for another time, and much of his work has a strength and power that today's television schedules sorely misses. Perhaps the broadcasting environment will change in due course, but Kneale is quite content to put his career behind him.

In fact, the veteran writer is surprisingly optimistic about the future of broadcasting and storytelling. "It's wonderful to find so many people now who know so much more about how to make a film, and the sort of film they'd like to make," he remarks. "The technical and expert interest is quite wonderful, I find. And the whole business of storing old films and keeping them and showing respect to them — well, it's a bit wobbly, because some areas are better than others, but the aim is good where it exists at all."

He cheerfully acknowledges the sheer span of his writing career. "I suppose in a way I've seen through quite an exciting time, when things changed from the beginning of television to almost the extinction of it. What the next stage will be I wouldn't dare guess. It may replace everything, from books to films. It's lying in wait for us now..."

As Kneale says, "In twenty years' time, I won't be around, but there will be people who enjoy making stories on a medium yet to be invented and enjoying it, and doing it in their own way."

For a writer who dealt so often with speculation, Kneale's career is itself littered with 'what ifs.' What if he'd pursued a literary career after the success of his short stories? What if his working relationship with the BBC hadn't deteriorated into frustration and ill-feeling? What if he'd fully established himself as a film screenwriter during the 1960s, or his original feature ideas had made it into production in the 1980s? And that's not to mention the tantalising promise of the flotilla of unmade original scripts he wrote, from *The Big Big Giggle* to *Batavia*.

And yet Kneale himself doesn't take the whole business too seriously. He certainly wouldn't consider his greatest achievement in life to be writing *Quatermass*, *The Road* or *The Stone Tape*. Rather, it's his long, happy marriage to a woman he loves, and being father to two children he adores. In that respect, it's hard not to feel that he's got his priorities exactly right. The writing was just something he did while he had to stay out of the sun. It just so happened that what he wrote was remarkably skilled, imaginative and innovative.

"I always pushed my luck, I think," Kneale says with a smile.

writer in his homeland.

The Nazis had systematically destroyed much of Kerr's writing, but in recent times dedicated parties have been unearthing such work. One such journalist searched for Kerr's work in the university of Wroclaw, formerly Breslau. "In the archive, he found all the newspaper articles that had been written over five years," Kneale says. "It's the most astonishing thing. He took them back to Berlin, and said, 'Would anybody be interested in this?' and one man, an entrepreneurial publisher, said, 'Let me have them.' Within three months they had sold 70,000 copies in hardback! If only the man who wrote it all had been alive... They're now published in superb editions, and secondary sub-publications and in different languages — not English, because they're untranslatable, but to local German, Polish and so on. Marvellous things, but all I can do with them is admire them on the mantelpiece!"

INDEED, THE CONTINUED success of Kneale's family is quite astonishing. His wife Judith continues to write and illustrate best-selling children's books. After sixteen volumes, she even killed of her most famous creation, in the 2003 title *Goodbye Mog*. Between them, the *Mog* books and her fictionalised childhood autobiographies have been published all over the world, and translated into almost ever language imaginable. Total sales number into the millions. Their daughter Tacy has moved into special effects puppeteering, a lifelong fascination for her (and a curious echo of her father decorating a pair of leather gloves with foliage to pass as an alien creature in Westminster Abbey long ago.) Tacy's recent credits include the blockbusting *Harry Potter* film series.

Their son Matthew, meanwhile, is himself an author of great repute. His fourth novel, *English Passengers* — a historical, seafaring tale, touching on old Manx smuggling and the slave trade — was shortlisted for the Booker Prize in 2000, and won the prestigious Whitbread Prize the same year. While working on new fiction, Matthew has relocated to Italy, and become a father to two young children, and thereby Kneale's first grandchildren.

Kneale hasn't returned to the Isle of Man since a trip with Matthew during the nineties, but his links with the island have not been lost. His brother Bryan continues to be involved with art and culture there. It's been proposed that the writer should feature on one of a series of stamps celebrating famous Manx figures, and a Manx radio station staged a new production of Kneale's first ever script, the disaster docu-drama *The Long Stairs*, with local amateur actors. In fact, the island is now developing a reputation as an ideal location for filmmakers. The 1998 hit *Waking Ned*, supposedly set in Ireland, was made entirely in locations on the Isle of Man. The Manx government actually offers financial incentives to film production companies, and it's becoming a favourite destination for such enterprises. The spawning ground of a British cinema veteran is, therefore, drawing the British film industry back.

THE LANDSCAPE OF BROADCASTING has changed almost beyond recognition since Kneale began working in it in 1948. Today, there is a whole raft of channels on offer to viewers at all times (although it's debatable exactly how many are worth watching). The BBC closed its in-house Radiophonic Workshop unit in 1999, and their Visual Effects department followed suit in

1936. He's in Berlin, the year of the Berlin Olympics. Then you have to find out what he's doing there."

Therefore, Quatermass' journey begins in pre-war Britain, and hinges on a disaster. "He's experimenting with the sort of rocket ships they had in the 1930s, through short distances in the air and down again," Kneale says. "It's very primitive, but that's what he would have done, if he'd been experimenting in about 1936. He has a catastrophic accident with one of these things — and his young wife is killed by it. Then he is blamed - 'what are you playing with this ridiculous rocket thing for?'"

The British authorities close down Quatermass' experiments and cut off his funding, leaving the gifted scientist extremely vulnerable. "He's in a state of shock, terrible depression and shame, and in that state of mourning he is approached by people from Germany, and invited over to go and join them, and attend the Berlin Olympics to cheer him up. Of course, Von Braun at that point had just been appointed to be in charge of their rocket programme..."

With Quatermass thus ensconsed in Nazi Germany, and uneasily enlisted into their rocket research programme, he would become aware of the Nazis grander plans. "What were the Germans really looking for? More than anything at that time, the Nazis really believed deeply in total superstition and magic. They had theories which were grounds for the belief that they were in fact descended from spiritual matter. That totally pleased all the people like Hitler and Goebbels and Goerring, 'that's us! That's where we came from!' So Quatermass could be there in Germany, and he could rumble this. Now, where do you go..?"

This proposed prequel has been on the starting blocks for some time, although a script has yet to be written. "I had the idea in about 1999, and discussed it with my agent," Kneale says. "He was a bit gloomy about it. Then later on I could see why he was, and I could see exactly how it could be fixed, except I haven't written it. It's just a matter of doing it. I can do the title all right. It would be *Quatermass in the Third Reich*."

Kneale fully accepts the problems that such a production might face in the current broadcasting climate. "I'm not sure in what form it'd be done," he admits. "You could do it as a series like the old *Quatermass*es, but they don't use that kind of formula now much. It could be done as a two-parter or a four-parter or as single length for a film. It's just who'd show any fraction of interest and how much money they've got to do it with. I'd like to do it, though, just for the hell of it."

It seems the idea was tentatively put forward to the BBC, who demurred. The sheer cost of the piece — with a period setting and an imaginative content — is not in its favour. "It might be unproduceable," Kneale agrees. "Berlin in 1936. Well, there isn't much of it left. But it you stayed indoors... and then you begin to think of a story that way. It occurs in walled rooms, and you use it cunningly, it is still possible to write the story..."

THE KNEALES have weathered many ups and downs in recent years. Sadly, Judith's brother Michael, a hugely well-regarded QC, died in 2002. (Michael had even published his own childhood autobiography, *As Far As I Remember*.) On a happier note, Judith's father, Alfred Kerr, is once again a celebrated

logically — but not to allow that to confine or hinder the viewers' enjoyment of the story. We also wanted to convey the prescience of the original work."

The final confrontation was relocated from Westminister Abbey to the Tate Modern Museum (a nod, perhaps, to inaugural Quatermass star Reginald Tate), but hedges its bets by showing no monster whatsoever. Instead, Quatermass simply addresses the darkness around him. After two hour's tension and build-up, though, the climax is weakened as a result. Nevertheless, the compelling quality of Kneale's original scripts still shone through, and the production marked the first BBC TV production of his work for thirty-one years, albeit not of new material. (Perhaps surprisingly, there were few slip-ups during the live broadcast - just one fluffed line, and one near-fall.)

Kneale himself was decidedly underwhelmed by the project, though. "It was a stunt, wasn't it?" he opines. "And not a good stunt. They found themselves doing what somebody had thought a live show was like — and it wasn't like that!" In particular, Kneale was unimpressed by what became of his original screenplay. "They were just slashing their way through, taking my script and chopping great lumps out of it. And not the fault of the actors, who were decent people and had obviously done a lot of work. They were making it as real as possible. Mark Gatiss' performance was totally believable. The others were limited by the fact that there was no script left. Strangely, my accountant liked it. It must have cheered him up."

On the other hand, the BBC themselves were well pleased with the piece, as Richard Fell asserts: "I think it was successful. It carried off the tension and adrenaline and suspense of the story, and the feedback from the audi-ence has been unprecedented for a BBC4 programme." Indeed, it drew an impressive audience of around half-a-million viewers, considerable ratings for a non-terrestrial channel and BBC4's highest in a year. (Curiously, exactly three weeks after the broadcast, one-time Quatermass Sir John Mills died at the age of ninety-seven — leaving Jason Flemyng as the last surviving actor to have played the role.)

In the years since his last produced work, there is just one writing project that Kneale has been developing — entirely, at this stage, for his own amuse-ment. In many ways, it draws on the same source as the *Kavanagh QC* story, the rise of the Nazis, and the genuine horror of World War II. It's a subject that looms large in Kneale's life. "It all connects back to my wife's life, which I'm always very conscious of, her real life, far away from the Isle of Man, escaping from Germany by one day."

And yet, the new project blends those events with Kneale's most famous fictional creation, the luckless rocket scientist Bernard Quatermass. The obsta-cle, of course, is that, at the end of his last appearance, Kneale had killed the character off. There is a solution, however. "Quatermass, through the various versions we've had, goes from the age of somewhere in his fifties to somewhere in his nineties, and then blows himself up," Kneale explains. "That's him. That's his life. So the only way I can ever resurrect him is with a prequel.

The concept of the prequel has been percolating in Kneale's imagination for some time. "The only sensible thing is to put him back in time, to the 1930s, when he would have been in his late twenties. So, he's a young man with his life before him. You have to put it in a date that makes sense, and that is

the 21st Century was, it was felt, an appropriate way to draw proceedings together.

The project was the brainchild of Richard Fell, head of the BBC's experimental Fictionlab unit. As Fell explains, "It was my idea, having been a long-time fan of Nigel's work. *Quatermass*, *The Year of the Sex Olympics* and my own particular favourite, *The Road*, are all classics of television drama — some sadly no longer with us. But it's now becoming an accepted idea that classic television, like theatre of film, can be revived and adapted for a contemporary audience." Indeed, according to Fell, the seeds of such a venture had been sown some time earlier. "I made a BBC film called *Surrealissimo* with Mark Gatiss a number of years ago, and during the making of that we discovered we were both fans. We discussed the idea of reviving a Kneale piece then. When BBC4 announced they were doing a 'TV on Trial' season, I thought it was a great opportunity to resurrect the idea. There was no intention, or pre-knowledge, about the DVD box-set — just happy accident."

An impressive team was assembled to realise the idea. Fell adapted Kneale's original six-part drama into one two-hour piece, as well as acting as executive producer. The appointed director was Sam Miller, a veteran of the likes of BBC2's popular drama *This Life*, with feature film experience under his belt. Many were surprised at the casting of a 'young' Quatermass, established film actor Jason Flemyng, but his restrained, authoritative performance was agreeable and satisfying. Andy Tiernan essayed a troubled, edgy Victor Carroon, and prominent Kneale fan Mark Gatiss bagged the role of Quatermass' anxious assistant, Paterson. (As Gatiss himself wryly claimed, "I made it clear that if I wasn't involved in this production, it wasn't going to happen — let's put it that way!"). Appearing as Gordon Briscoe was rising TV star David Tennant, in the same week that he was first mooted as the next Doctor Who. Extensive rehearsals were held for the piece in a London church hall, but the live performance itself was staged at a disused Ministry of Defence base in Surrey. With different areas of the base dressed as sets. Between scenes, the actors were ferried from set to set on golf buggies, and pre-recorded links were inserted to bridge the gaps.

Kneale himself signed on as consultant to the project, and, after initial meetings, received weekly phone calls from the production team to keep him updated. "Nigel gave us notes on the script," Fell says, "and we had long discussions about the characters and their motivations — some of which we used and some of which we didn't. He was incredibly helpful in discussing the meaning of the film — why and how he had written it and the pitfalls he had encountered. His co-operation was incredibly useful."

Broadcast live on Saturday, April 2, the end result was, arguably, more 'interesting' than entirely 'successful'. The claustrophobic atmosphere of the early scenes set around the mission control centre dissipates rather as Carroon escapes to roam London. Unexpectedly, the tone is of 'timelessness' rather than an outright update. There are few obvious trappings of 2005, whereas the costumes and design often seem to suggest the 1950s. "The timeless approach was our intention from the beginning," Fell admits. "Indeed, one of the things that attract me to Nigel's work is its timeless quality and relevance. We wanted the viewers to have some sense of its origins — both linguistically and techno-

Quatermass and the Pit that was mooted at the very end of the Nineties. It was assigned to director Alex Proyas, then best known for the Gothic comic-book film *The Crow*. Proyas enlisted the assistance of scriptwriter David S Goyer, with whom he'd collaborated on the paranoid fantasy *Dark City*. Goyer scripted the new adaptation, which he called simply *Legacy*. This time, the story would be set in modern day America, and there would not even be room for Professor Quatermass himself. Goyer's script centres on the remarkable concepts of the source material. The suggestion that Man has been influenced by Martian visitors, which becomes clear when a mysterious object in unearthed. The tone, though, is relentlessly dark and foreboding — not to mention somewhat unsubtle.

Plans were drawn up for Proyas to direct from Goyer's script, and shoot in Australian studio space — then a vogueishly affordable option. But Kneale was extremely dismayed when he read *Legacy*, and endeavoured to have the production stopped. "It was atrocious," Kneale asserts. "They'd turned it into a bogey picture." In any event, the film was never made.

More remakes of existing Kneale scripts were said to be in the pipeline. There continues to be interest in the film rights to the *Quatermass* serials and the likes of *The Stone Tape*, although none has yet come to fruition. The BBC even briefly considered adapting the *Quatermass* serials for radio in 2002. The Corporation was also approached with a view to producing a fresh television production of *The Road* at around the same time, but sadly these plans came to nothing.

Nor was this first time a remake of *The Road* was mooted. According to Julian Petley, similar efforts had been made in the early nineties. "When Mark Shivas was producing drama at the BBC, I said to him, 'You really ought to think about trying to remake some of the stuff that the BBC has destroyed, and in particular Nigel Kneale's *The Road*'," Petley says. "I sent him a copy of the script, and he showed it to one of his script editors without telling her who it was by. He just said, 'What do you think of this?' Apparently, she said, 'This is the greatest thing I've ever read!' And yet, still no-one has remade it, which I think is extraordinary!"

The Spring of 2005 saw a fresh flurry of Kneale-related activity. In April, BBC Worldwide released a 'Quatermass collection' DVD box-set, comprising the original TV versions of *Quatermass II*, *Quatermass and the Pit*, and the two extant episodes of *The Quatermass Experiment*. The tapes were remastered by the BBC's semi-official 'Restoration Team', achieving impressive results on a very tight budget. The package also came with an extensive booklet detailing the production of the serials, written by archive TV expert Andrew Pixley. (At around the same time, the DVD rights to Kneale's anthology series *Beasts* were also acquired.)

Simultaneous with the appearance of the box-set, BBC4 staged a season around the theme of television nostalgia. The season, 'TV on Trial', was an assessment of television quality down the decades, screening archive programmes and allowing viewers to decide which era was the best. (In the final vote, the 1970s won out.) Needing a climactic centrepiece for the project, it was decided to restage *The Quatermass Experiment* as a live TV drama — the BBC's first such undertaking in twenty years. This juxtaposing of fifties TV drama with

lost rocket — again, a direct nod to Kneale's serial, rather than the Hammer remake. "I went back into the teleplay and I found things that had been omitted from the movie that I thought were worthwhile, and I put them back in," O'Bannon explains. "The movie opens with something that was a real cliché scene in the 1950s in a horror movie. A teenage couple is necking in their convertible when the rocket crashes. Real cliché. And in so doing they omitted a really lengthy scene from the teleplay, which took place in Quatemass' mission control in which they're all walking around very worriedly waiting for this rocket to return. I went back to that."

For O'Bannon, the relocation of the story to America was a mixed blessing. "There are certain things that are lost", he argues. "One of the very good things about the film version is the way it makes use of that post-war situation in Britain. You can still feel the rubble almost of the war. There's a grim quality, of cratered buildings and tight circumstances, that infuses that film. I think that's one of its virtues, and all of that had to go."

Instead, O'Bannon sets the crashing of Quatermass' rocket in Atlanta, Georgia, the home of the Centre for Disease Control (CDC). The decision was driven by a desire to update the original scene where the mutating Carroon breaks into a chemist's and frenziedly consumes every chemical it contains. "I transformed that scene," O'Bannon says. "Instead of keeping it a pharmacy or chemists, I had him break into the CDC's Biosafety 4 lab — the highest level of contamination — and eat all of the specimens. Since I was doing that, by simple logic I had the thing crash in Atlanta."

After the initial crash, Geoffrey Quatermass speeds to the scene. "Quatermass comes whipping across the ocean in his own private jet," O'Bannon explains, "because he's the head of Quatermass Aerospace who have manufactured a line of various high performance aeroplanes, and the jet is, of course, of their own manufacture." O'Bannon's script even opts for Kneale's original climax, with the massive Carroon creature — having taken up residence in a nuclear dismantling building before it spores — responding to Quatermass' pleas to the lingering shred of humanity within it.

O'Bannon decided to run his handiwork by the original writer himself. "I communicated with Mr Kneale," he explains. "I wrote him a letter, and I sent him a copy of the screenplay to get his comments on it. He sent a reply and he was very friendly and courteous." Kneale, in turn, was very taken with the deft, smart new script. "Dan sent me a copy, which was fine. He'd Americanised it, of course, but there was nothing wrong with that. I'd seen things he'd done, *Alien* and so on, and I thought he was pretty good. I found he'd used my original ending, which I was very pleased with." O'Bannon was delighted to receive such positive feedback. "I'm very flattered that Kneale feels that way," he says. "Maybe he was simply pleased that I took the effort to work from his original, rather than simply tossing it to the winds and ignoring it, which is what is done so often with adaptations."

Sadly, the project capsized before it got past the stage of the first-draft script. "It was fun," O'Bannon says, "but then the Warners deal collapsed for reasons that were never explained to me."

BY CONTRAST, Kneale was not remotely enamoured by a radical remake of

This antagonism can be traced back to when Skeggs managed to seize control of the company. "Skeggs was the office junior, and through bankruptcy he became the boss," Kneale explains. "Hammer went bust and they closed it all. It fell into the hands of their two accountants, and Skeggs raised a bank loan to bring it back to life. Hammer Films rise again, and he would be the great producer — an upraised clerk."

Skeggs tried to negotiate with the major American studios, to strike deals to remake the Hammer back catalogue, but found it less easy that he'd hoped. "He was acting the big producer, but he never produced anything. He got in so many tangles with things he'd sold and half-sold. Then they'd discovered he'd didn't have the rights to something and they had to scrap the contract that they'd half-signed."

In due course, Skeggs sold the Hammer back catalogue on to PR mogul Charles Saatchi. "Saatchi was a fan of Hammer's films when he was a small boy. He said to Skeggs, 'Wouldn't it be nice to remake all the old Hammer films? I'll buy the rights from you, the lot, for a tidy sum.' Skeggs said yes. And that's the end of the awful, awful Hammer Films story..."

In effect, this meant that various attempts were made to launch remakes of the *Quatermass* stories. The first, in 1993, was a surprisingly faithful new version of the original TV serial (rather than Hammer's film), planned by Richard Donner's production company for Warners. The script came courtesy of a long time *Quatermass* fan, *Alien* writer Dan O'Bannon. "Dick Donner's company had acquired the rights to do remakes of Hammer's films," O'Bannon says. "I was asked if I wanted to try writing one of them, and immediately jumped on *The Quatermass Experiment*. I said I'd like to try to do an update of that." Perhaps sadly, the script never went into production. "Nothing came of it," O'Bannon admits. "About the time I was finishing writing the script, somehow or other the whole deal collapsed. I don't know what went wrong, but I did manage to finish the screenplay. As a reference I worked from a videotape of *The Creeping Unknown* and from a copy of the teleplay, as a matter of fact I used that same Penguin edition I'd bought as a child. I worked to incorporate what I thought were the best moments of both." O'Bannon even had a suggestion to make about casting. "I was going to recommend that they get Sean Connery to play Quatermass. I had him in mind as I was writing it."

O'Bannon's tale concerns one Dr Geoffrey Quatermass, a middle-aged aerospace tycoon — according to the stage directions, 'a cross between Howard Hughes and George Patton'. With experimental rocket groups a thing of the past, the enterprises of the 1993 Quatermass are driven by commercial concerns, as well as a fierce, questing curiosity. The script is a faithful modernisation of the television original, stylish and fast-paced. The familiar characters from the forty year old serial — Victor Carroon, Judith Carroon, Gordon Briscoe and Colin Marsh — are present and correct, with even their names intact. Even the new Quatermass character is, we learn, the 'son of British rocket pioneer Bernard Quatermass'. "I had a little fun with that, a few in-jokes," O'Bannon admits. "Of course, if you think about it, logically it's impossibly bizarre that his son happens to have exactly the same experience that his father's had forty years before. I just didn't touch on that!"

The script opens with Quatermass team nervously awaiting news from their

Kneale's work has had on them. Comics writer Grant Morrison was too young to have seen the original TV *Quatermass* serials, but grew up adoring the film adaptations. "They were the ones that really impacted on me. I just thought they got better and better," Morrison says. "They started off good and then get *really* good. *Quatermass and the Pit* is just one of the best stories ever. I think Kneale came up with some real archetypal science fiction myths, the notion of the buried spaceship and the alien life-form coming back from space along with the crew. All these things have been used again and again and again but they're really primal stories and Nigel Kneale did a lot of them first."

Morrison gladly attests to the influence Kneale has had on his own work. "All that stuff was definitely a really big input for me," he says. "The idea that every story had a brilliant concept and started out from something really original was a big inspiration. Every one of them builds off this really simple, brilliant idea: we are descended from the Martians, we are food for aliens... every one of them's just a great little concept. It's a mythical quality for me. The stories are so tiny, but I feel they're myths for the age of science. That's what he's created. People have been riffing off him for a long time. There's something eternal about *Quatermass*."

American scriptwriter Dan O'Bannon reckons Kneale;s writing owes its strength to "a haunting imagination. That's the way I would see it. A strong sense of imagination, plus a certain quality about it that hooks your mind or feelings, and a gift for character that's unusual in science fiction."

Most of all, Julian Petley values Kneale's "imagination — getting TV drama away from literary adaptation. He's got a breadth and a depth of vision which I think is unusual. There's a slightly dystopian vision in Nigel, I think. There's a theme of a distrust of youth, which I find interesting. It must have been very unfashionable at the time he was doing things like *The Chopper* and *Bam! Pow! Zapp!*. But it's not just thematic. I think it's the care with which he draws characters; the way he places them in their surroundings. It's making the unbelievable believable, which I think is a tremendously difficult thing to do. That's where his great originality lies. He's got tremendous breadth of interest, too... and apart from that, he's a nice guy!"

Kim Newman considers that Kneale "just has more ideas than anyone else. Not only that, but he always roots this stuff in a solid sense of society and character. I always believe his people. And he's very good on specifics; he writes British stuff. It would be absurd to remake *Quatermass and the Pit* set in New York. It just doesn't work." That's not to say, though, that this was never a possibility.

THE POWER of the *Quatermass* serials continues to be felt. Their plots are regularly plagiarised by everything from the Johnny Depp film vehicle *The Astronaut's Wife* to the ITV drama *The Uninvited* and the BBC series *Strange*. Meanwhile, Kneale fan Stephen Gallagher has created the ITV series *The Eleventh Hour*, the main character of which, Professor Alan Hood, is by Gallagher's own admission a would-be Professor Quatermass for the twenty-first century. The rights to the *Quatermass* serials themselves lay among the embers of Hammer Studios, which had become the property of one Roy Skeggs, a former employee of the studio who Kneale darkly refers to as "the awful remnant."

the workman says, 'Thing like that would had to have been suckled...' They just make your hair stand on end. He just had this amazing economy, rooted, I think, in his Manxishness, this facility for real language, which is breathtaking at times."

Gatiss points out Kneale's great skill for writing within established genres, and yet subverting them for his own ends. "It can't be a coincidence that most of his stuff is in fantasy of horror and sci-fi," Gatiss argues."I think the great thing is that within that, it's always about people; always people's stories. At every stage where he runs up against what would be the sci-fi cliché he turns it on its head. Really he invented that. His ear for real dialogue, especially dialect, I think is just incomparable. Comparisons to HG Wells are not odious. He is a genuine seer. I think it's quite remarkable the extent to which he predicted the disintegration of broadcasting and society. I do think that if he'd chosen something more straight, if I can use that word, he would be up there with Dennis Potter in the popular imagination, but he stuck to his guns. I think it's a fascinating way of trying to communicate his thoughts and beliefs and stories. I think it's a shame that it's probably forever going to have some slightly anoraky context. Shame on the BBC and the world for not recognising him more!"

Gatiss and Dyson confess that they too have referenced Kneale in their own television work, but more through stray lines and in-jokes that outright parody. "With the *League*, his influence is much more the quality of his writing," Dyson explains. "There are certain things that have found their way in. If not quotes, they're in the spirit of." Gatiss is, in fact, one of Kneale's most high-profile admirers, and has been active in his support for the venerable writer. In his capacity as a modern TV writer and performer, he has tried to launch several documentaries celebrating Kneale's work. Back in 1992, before *The League of Gentlemen* brought him to public attention, Gatiss paid his respects to *Quatermass* in an unexpected manner. He was commissioned to write an original novel for Virgin Publishing, part of a series of new adventures of *Doctor Who*, the TV version having been axed by the BBC. Gatiss' story, *Nightshade*, has the time-travelling Doctor land on Earth in 1968, and encountering an elderly actor, Edmund Trevithick, who had starred as the intrepid Professor Nightshade on British television many years ago. To his horror, Trevithick seems to be bedevilled for real by the fictional alien foes he faced on screen.

"Obviously, *Nightshade* was a complete homage to Nigel Kneale," Gatiss admits. "When I started out, I envisaged it as like a Christmas ghost story or something, a *Stone Tape*-like thing. Originally I think it was going to be much more like *Doctor Who*, but then I thought, with the setting and everything, it has to be *Quatermass*. It was certainly never intended as a *Quatermass* rip-off; I just wanted to play with all the things that really appealed to me about it." Gatiss peppered the *Nightshade* novel with *Quatermass* parallels. "There were a lot of things like the references to Trevithick's daughter getting killed on an autobahn [a similar event is recounted in Kneale's 1979 *Quatermass* novel], things like that. At the time I had an original Betamax copy of *Quatermass* and I was obsessed with it!"

WRITERS IN MANY fields are only too happy to confess to the influence

however unexpectedly. "The school bully in *Queer as Folk* was called Christian Hobbs, because *Quatermass and the Pit* taught me that Hobb is another word for the Devil!" Davies reveals. "I always liked that!" Davies' drama *The Second Coming*, about Jesus returning to Earth in the present day — features a key scene wherein a hijacked football stadium, full of religious zealots and surrounded by armed police, is struck by a mysterious beam of light. Davies admits that Kneale's ITV *Quatermass* serial may have unconsciously shaped the scene. "Maybe I've been channelling Kneale for years," Davies suggests. "Do I owe him money?" (With some irony, Davies is now responsible for the return of *Doctor Who* to Saturday night BBC1.)

The popular *League of Gentlemen* comedy team are also acknowledged fans of Nigel Kneale. The *League*'s Jeremy Dyson is outspoken in his admiration for Kneale's work. "What he did was so potent," Dyson says, "particularly those *Quatermass* serials. To have those so early in your career, it's a bit like the Beatles, isn't it? Television's never going to have that impact ever again. But imagine feeling that, that the whole country was coming to a hold to watch what you did. In a way that's something I don't think he's had credit for: he invented modern television. What he was doing, I think, was taking the popular cinema and realising that you could do that kind of thing on television. Nobody had done that before."

Dyson recognises Kneale's particular gifts as a writer. "It's a fierce intelligence, and a particular sensibility for the uncanny, for want of another word. It's realising that you link one to the other and you've got something tremendously powerful. He's one of those few writers who's ideas-driven, and yet still is engaging. Because he can do character as well, although you wouldn't think of him primarily as someone who writes character. His characters are always strong."

"I think the thing that's most impressive is just the intelligence of it — and yet it's intelligence combined with this popular touch," Dyson suggests. "It's a very rare thing, in that he was always only interested in a mass audience. There was nothing elitist about his work. He wanted to communicate to as many people as possible, and yet he talked up to them. He took highly intelligent concepts and placed them bang at the heart of what he was doing. I think whether you're writing in that genre or not, that's something to aspire to."

Dyson's writing partner, *League of Gentlemen* star Mark Gatiss, feels just as strongly about Kneale. "I remember seeing on a documentary that he has the original *Quatermass Experiment* rubber glove monster," Gatiss says. "The idea that it was just perishing in a bag, when it should be in the Smithsonian as far as I'm concerned, is just extraordinary. I really do believe this and I think it's an absolute scandal. It's not too much to say that he invented popular television. *Quatermass* arrived like a rocket into the schedules. When you consider the incredible blandness of television drama at that time, and there it was: the first really kind of mass audience thriller. It's outrageous that he's never had more recognition, I think."

Gatiss is an unabashed admirer of Kneale's writing style. "It's those quiet moments — like the old character in the pub in *Quatermass II* who says, 'I courted a girl from Winnerden Flats. Married her...' I adore those," Gatiss says. "It's just brilliantly written and completely real. Similarly, in *Baby*, when

GOW DTY AASH

THE MANX HAVE MANY SAYINGS, from ''S'giare y Jough na'n Skeeal' (the drink is shorter than the story) to 'Laa er-Meshtey as Laa er Ushtey' (a day on the drink, then a day on the water). Another, 'Gow Dty Aash', can be translated variously as 'have a break' or 'take your rest'. It's fair to say that our subject deserved his rest by the end of the nineties. Few people can lay claim to a fifty year career in television. The medium itself had only just turned sixty. Certainly, barely a handful of TV professionals have been as influential as Nigel Kneale. Once he'd stepped back from his career, Kneale was free to celebrate what he'd achieved — or rather, he was free to be celebrated by others.

As new generations discover his work, more admirers are keen to laud Kneale as a pioneering, vastly original talent. In recent times his work has become more accessible, too. His film work for Hammer is now available on DVD, as are many of his extant TV dramas. For several of these releases, Kneale has provided audio commentaries, discussing the productions. The DVD format allows for such material to be released lavishly and affordably (and, as observers like Kim Newman have pointed out, in many ways it's the digital recording medium that the researches of *The Stone Tape* were trying so hard to find).

There have been personal appearances, too. Despite some moments of ill-health, Kneale has managed to attended some notable public screenings of his work — a full weekend retrospective at Chapter Cinema in Cardiff in 1999, a well-attended celebration at Cornerhouse art centre in Manchester in 2001, and a career-spanning discussion, under the title *My Son, Quatermass,* at London's ICA in 2003. There have also been assorted memorable screenings at London's National Film Theatre over the years, the success of which figured in the British Film Institute's decision to release *The Stone Tape* on DVD. "That release was very, very successful, and one of the reasons that tipped us off was we knew we'd had good audiences for it," the BFI's Dick Fiddy admits. "We knew there was a lot on interest in it out there."

MANY MAJOR PLAYERS in the modern British TV industry regard Kneale as an underrated, pioneering genius. Scriptwriter Russell T Davies holds Kneale in high esteem. "I think he bloody believes everything he's writing," Davies insists. "The emotions seem absolutely real. And there's a massive seriousness of intent, dressed up with wonderful storytelling. His skill as a writer went far beyond the outlandish. He could map small, human intimacies with equal imagination and precision. But in amongst all the smoke and mirrors of monsters and aliens, there's not one — not a single one —invented to be just scary; every single creation has got something to say about the state of the world and mankind. What a combination! — honesty, invention and ambition."

Davies has made his name with major TV drama successes such as *Bob and Rose* and *Queer as Folk*, and references to Kneale's work have crept in,

going to do one, let's do it about something that really matters, and for me the worst and most important thing that's ever happened is the Holocaust. That'd be worth doing.' Very reluctantly they agreed to do it, because they were very frightened of the subject. They thought it would be treading on all sorts of toes. I said, I know its sensitive stuff! That's the reason for doing it!"

Kneale had, of course, spent much of his adult life happily married to Judith Kerr, a German Jew whose family had only narrowly escaped an unthinkable fate at the hands of the Nazis. The late Rudolph Cartier had fled Vienna for similar reasons. Throughout his career, much to his own distaste, Kneale has been pigeonholed as a 'horror' writer, which he disputes. "Real horror," he asserts, "would be something else. It would be Auschwitz."

Ancient History, Kneale's script for *Kavanagh QC*, sees James Kavanagh pitted against one Alexander Beck, a seemingly harmless family doctor, who is being tried as a Nazi war criminal. Assorted witnesses present very different portraits of Beck. To some, he is a kind, helpful man, whereas others give testimony to the abominable experiments he conducted at the concentration camp in Dachau. It's a supremely well-written, thought provoking piece of modern TV drama, with a depth and power rarely seen in mainstream television. Kneale clearly understands the complex themes involved, and handles them masterfully. It's also a restatement of the writer's recurrent preoccupations: something old and buried surfacing in the present day with a disruptive effect, and the power of beliefs. Unlikely as it seems to draw a line of descent from *Quatermass* and *The Stone Tape* to Kneale's Nazi war crimes drama, they are all identifiably the work of the same writer. It's a sombre work, and whereas most of Kneale's work is driven by ideas, very powerful and personal emotions are at the heart of *Ancient History*.

The episode was made as part of third series of *Kavanagh QC*, and directed by Tristram Powell, with well-known character actor Frederick Treves as Beck, and Warren Mitchel as Avram Rypin. It was broadcast on March 17, 1997. "It was very well directed by Tristam Powell, who was equally devoted to it," Kneale says. "People were a bit awed by Warren Mitchell. They thought, 'he's so funny he might just make it accidentally funny.' But he didn't, he did it beautifully. He was very good indeed. It was fine. It took it about as seriously as it could be."

A month after the episode was broadcast, Kneale turned seventy-five years of age. It wasn't pre-mediated or intentional, but, in effect, he retired from writing thereafter.

the existing archive material, the dramatised framing scenes, and occasional narration courtesy of Kneale himself, contextualising the *Quatermass* serials with life in fifties Britain. "Somebody had the idea that, at that time, I had reacted to various things happening in Europe or the world and that's where it all came from; that events such as the Hungarian revolution had sparked thoughts. Well, it didn't — but that's what they had in mind!"

Kneale was happier with the casting, though. Emma Gregory played Mandy, a journalist who arrives unannounced at Quatermass' home to quiz him about yesteryear. As the Professor himself, the BBC brought in Andrew Keir, who'd made such an impact in the role back in Hammer's *Quatermass and the Pit* film. Keir was unsettled by the shifting shape of the piece, though. "Andrew was very concerned that it should be done properly," Kneale recalls. "He was offended by just being used as a link man. But he was very patient and very good."

The result is rather a mish-mash. The linking scenes that Kneale wrote for the elderly Quatermass never really get chance to come to life, and the clips are sometimes jarring. (As Keir had starred in none of the original BBC serials, whatever footage was used had to avoid any actual dialogue from Bernard Quatermass, as the part was played by other actors.) Intriguingly, the final scenes refer to a broken-down society and Quatermass' search for his granddaughter, implying that they take place just prior to the events of the concluding *Quatermass* TV serial.

However artificial, Kneale's narration sections are the most compelling part of the radio production. The familiar *Quatermass* theme, Holst's Mars The Bringer Of War is used throughout, and the strident, alarming tone of the music, coupled with Kneale's recollections of fifties fear and paranoia, is effective and evocative. A relatively minor enterprise, comprising just five fifteen minute instalments, *The Quatermass Memoirs* made little impact on the writer himself. "It was typical radio. That's why I did it, really," he says. "God knows, it wasn't a very important sort if thing, just a way of using up their tape time." The experience did nothing to reconcile the BBC and the writer. "The BBC just didn't care tuppence about what they were doing, because they really don't know what they're doing, certainly not in radio." Tragcally, the production proved to be Andrew Keir's last acting job. "Andrew died the following year, which was very sad. He must have been pretty ill when this nonsense was going on."

IN HIS MID SEVENTIES, Kneale was less and less eager to take on writing work, and didn't balk at turning offers down. That was his initial reaction to being asked to write for *Kavanagh QC*. A Carlton TV series, it had been conceived by Ted Childs as a new vehicle for John Thaw — the venerable *Inspector Morse* had finished its regular run, although new 'specials' continued to appear. As James Kavanagh, Thaw played a well-regarded criminal advocate whose time was divided between the courtroom and his eventful home life.

At first, Kneale was supremely nonplussed. "I was asked to write a story for them, but I thought it wasn't really very important, and not worth writing," he admits. "I thought it was tedious, and obsessed with legality." When Carlton persisted, Kneale found inspiration in a subject close to home. "I said, 'if we're

than the standard derring-do's which generally populated *Sharpe*.

Needless to say, at the age of seventy-three, Kneale was in no rush to attend to the location filming, which took place out in the Crimea. He was generally pleased with the result, although there was one disappointment. "The final scenes, that I had clearly written as occurring at night, were shot in the day, because they couldn't shoot at night," he reveals. "There was no electricity out there for big lighting. But it was done really rather well, actually. It had good people, and I enjoyed doing it."

Directed by Tom Clegg, and produced, like *The Woman in Black* and *Stanley and the Women* before it, by Chris Burt, the feature length *Sharpe's Gold* was first broadcast on April 12, 1995. In the years since, the series has been sold extensively abroad, and released on home video. It is, if nothing else, one of the most accessible pieces of Kneale's work, in every respect.

Whether by accident or design, much of Kneale's work that followed *Sharpe* had a powerfully reflective quality. In 1995, Kneale scripted an TV series adaptation of *A Small Person Far Away*, the novel his wife Judith had written to conclude the trilogy of childhood memoirs, as started in *When Hitler Stole Pink Rabbit*. The adaptation was offered to independent franchise Granada, but they declined it. Instead, Kneale turned to memoirs of his own younger days — albeit in a less overt fashion. It would involve a pretty remarkable reunion.

It had been over twenty years since Kneale had written for the BBC. Nor had there been any approach to do so, although the writer himself wasn't bothered. "The more I worked for ITV, the less I could work with the BBC," he recalls. "They were given to taking offence. But I just wanted to write scripts: I didn't care who did them, as long as there were talented people involved." In 1996, BBC Radio 3, aimed at an older audience than the other national BBC stations, was staging a celebration of the 1950s. Of course, *Quatermass* had been a key moment in popular culture in fifties Britain, and so it was decided to make a brief series looking back at Kneale's seminal serials. The writer himself was approached, and became directly involved in the resulting series, *The Quatermass Memoirs*. His previous work for radio had been the play *You Must Listen* — back in 1952.

Kneale collaborated with the series' producer, Paul Quinn — "a bright creature," he remembers fondly — in piecing the programmes together. As per the title, the idea was to blend in new dramatic scenes of the Professor reminiscing with flashbacks to his adventures. ("I'd already killed him off, so it was a retrospective," Kneale observes delightedly.) It was hoped to use archive material from the original serials for the 'flashbacks', but problems arose. Kneale recalls, "The producer said, 'It's all in the BBC archives, *The Quatermass Experiment*, *Quatermass II* and *Quatermass and the Pit*. I'll find it, and we'll just do the linkage bits, the framing, and then I'll get all of this good stuff out of the archive.' Then, when he came to do it, there wasn't any. Incredibly none of it was any good. Nobody had ever bothered to look."

Regrettable, only the first two episodes of *The Quatermass Experiment* were ever recorded for posterity, and the sound quality of that and the *Quatermass II* telerecordings weren't always of a high enough standard for broadcast.

Rethinking the programmes, it was decided to weave together three strands,

script for it," Kneale explains. "It lasted just one week in the cinemas, and sunk, and was never heard of again…"

OVER THE ATLANTIC, a new TV series, *The X-Files*, was fast becoming a cultural phenomenon. It followed a pair of shadowy FBI agents, Mulder and Scully, investigating all manner of unearthly, supernatural goings-on. The makers were clearly admirers of Kneale's work. Quite apart from the unintentional similarity to Kneale's own unmade *Push the Dark Do*or, the series shares many approaches and concerns with *Quatermass*, *The Creature* and *The Stone Tape*. Indeed, Kneale received a call from the *X-Files* production team, asking if he'd be interested in writing for the show. "A creature rang up at a very early stage, when they just started," Kneale remembers. "I said no. That was that. I said, this is

Sharpe's Gold, the most mainstream of Kneale's recent work.

the worst kind of science fiction — for me, anyway. It's stuff I wouldn't write, and there were too many hands in it." Nor was the writer impressed by the series' leads. "I said, 'you've got two non-actors there, and I'm not keen to write for them!'"

Meanwhile, British television received a double blow on June 7, 1994, when two of its most estimable talents died on the very same day. Dennis Potter's death received a great deal of media coverage, somewhat overshadowing the other. Sadly, at the age of ninety, Rudolph Cartier had died too.

Things were changing over at ITV. A new franchise, Carlton, staged a takeover of Central. Ted Childs opted to give up his post at the Drama department, but stayed on at Carlton in a freelance capacity. As executive producer, Childs launched a successful new series, *Sharpe*, in 1993. Like *Inspector Morse*, the source was a sequence of popular novels. Set during the Napoleonic Wars, the series depicts the adventures of the spirited, wayward Major Richard Sharpe (played by Yorkshire-born actor Sean Bean). Although meant as little more than entertaining hokum, *Sharpe* was a lavish production, shot on location in Turkey and the Crimea, and attracted several major actors and writers.

Kneale was asked to contribute a script adapted from Bernard Cornwell's original novel *Sharpe's Gold*. "It was just straightforward," Kneale says. "I wasn't doing anything else at the time, so I said yes and did it. I knew they were well done, and interesting." Nonetheless, ever inventive — and wary of writing around other people's ideas — Kneale quickly abandoned the source novel. "I didn't use much of it," he admits. "I used the first ten pages, I think. Then I had an idea which would be more fun to do. It was all about magic by the time I was through with it." Kneale's episode is certainly more interesting

on a deserted coast; the coast there was deserted at the time it all happened. That would have been a complication, getting stuff in from Sydney, or at the very least Perth, to shoot every day. Not an easy one."

As an economic measure, Kneale was asked to rework the existing scripts, and reduce the running time. "It was written for six parts and they said 'well, let's make it in four, because it'll be cheaper,'" Kneale says. "So I remember doing this, rendering it down to four. We had to leave quite a lot out, but it was possible." It was to no avail. "They couldn't raise Dutch and German money on that either," the writer recalls. The union of Central and Grundy faltered, and the necessary hefty budget simply couldn't be found. "In fact, doing something like *Neighbours* is much more Grundy's class of stuff," Kneale suggests. "In the end, it was cheaper just not to make it." Ted Childs suggests that the subject of the serial contributed to its downfall. "ITV considered the theme too bleak for popular television," Childs admits, "and the project was shelved."

There had been abandoned projects before, of course, but Kneale had expended a great deal of time and energy on *Batavia*, over the course of researching, writing and reworking the scripts. History, indeed, was a subject that held great fascination for Kneale, but only rarely has his produced work dealt with it. Just like the historical, seafaring *Crow* before it, *Batavia* capsized.

THERE WERE MORE offers of film work, but these bore little fruit. American producer Jon Davidson, formerly an associate of John Landis during Kneale's spell in Hollywood in the early eighties, had since had great success with the film *RoboCop*, a blend of violent action and satire. Davidson approached Kneale to come up with ideas for an original script, but the assignment never got further that the discussion stage. Closer to home, the British production company Zenith asked Kneale to script a remake of the 1950 British thriller *So Long at The Fair*, concerning a girl whose brother vanishes seemingly without trace at the 1889 Paris Exposition. The script, updating the tale to the present day, was written by Kneale in full. "It had been a film with Dirk Bogarde and Jean Simmons," he says. "It did look a bit dated — fine in many ways, but dated — and there was a feeling that it was time to do another one. They just wanted to use the central idea, and update all the mechanics around it. It just didn't get made, that's all." Kneale dealt with the project's directors, but the project was dropped before it progressed further than a script.

Another fully-written adaptation was of James Herbert's novel *Haunted*, concerning a debunker of all matters supernatural who is invited to an apparently ghost-infested house. Kneale's old associate Lewis Gilbert was directing the production, but dithered with Kneale's version of the script. "Lewis had a book by James Herbert, the *Rats* man," Kneale says. "It wasn't very exciting or very new, but Lewis had rather taken to it. He already had a very good script, I thought, written by somebody else, and had decided against it and not made it. He decided against the one I did as well. I didn't greatly miss it. I thought I'd got it, and it would have worked, but in a fit of vanity, Lewis decided to do it a different way. Too bad." When Gilbert eventually made the film in 1995, Kneale's work had been abandoned and an entirely new script written by Gilbert with Tim Prager and Bob Kellett. "In the end, Lewis changed all the casting and got two American youths, who I think were very cheap, to do a

AT THIS POINT, Kneale was struck with a story idea that he felt would make an excellent TV serial — this time, one that he would originate. The inspiration, though, was an actual historic episode. In 1629, a Dutch ship, the Batavia, had been making its maiden voyage for the East India Company to Java, when it was shipwrecked off the coast of Western Australia, near what is now Perth. The survivors were hardly home and dry. One of the ship's officers, Jeronimus Cornelisz, set himself up as the group's charismatic, influential leader, but proved to be a borderline psychopath. "They got under the total influence and control of a sort of madman," Kneale explains, "a religious maniac creature who wanted

Stanley and the Women.

to found them as a sort of colony of like thinkers to himself, and did in fact go a long way to doing it." In effect, the group became a pseudo-religious cult, and in due course, a massacre broke out amongst rival factions which precious few survived.

Kneale proposed the idea for a drama about these events to Ted Childs, who was suitably enthused, and commissioned it as a six-part serial for Central. "Tom did a great job," Childs says, "basing his script on the only real source work, accounts compiled in the seventeenth century." The serial, called simply *Batavia*, was due to go into production in 1992. The chief hurdle the project faced was the sheer expense involved. The scripts required filming on board a period ship, and an extensive location shoot in Australia. Clearly, Central would need to bring in partners and co-funders.

Not surprisingly, the first place they looked for such partners was Australia itself. "The people in Central TV thought this would be an exciting one for them," Kneale says, "but they wanted the Australian company, Grundy, to come in on it, and provide money and facilities because it was part of Australian history."

Grundy, then best known as the makers of lightweight Antipodian soap opera *Neighbours*, despatched an executive to England to discuss the project. "The boss of Grundy was brought over here, and they put on a splendid lunch for him," Kneale recalls. "He listened to it all, and he said, 'well, we can't afford to do it on our own. We need money from other companies, such as the Dutch, or possibly German.' So he went off and set about stirring that up."

Raising funding from the co-production proved to be difficult. In the meantime, Kneale's full scripts were sitting waiting. "It was completely written and all set," Kneale says. "As soon as you get a big ship, though, you've got complications of every sort. I'd been through that many years before with Lewis Gilbert on *HMS Defiant*, so I could see that this wouldn't be easy. It was certainly workable, but they would need the cast and facilities setting up

I talked to Kingsley about it and said, 'How can we get away with that one?'" Steve's delusions about a global Jewish conspiracy simply weren't suitable in a popular TV context, and the two writers discussed the problem. "Kingsley said, 'It doesn't matter what he says, because he's mad.' I said, 'We know he's mad, but at the same time you put that onto the screen and you're going to have the Holocaust men knocking on your door.'" Amis was forced to agree.

Instead, Kneale proposed a new obsession for Steve, that Hell is situated in the Sun and that a race of beings had fled there from the Earth in Biblical times — but were about to make a catastrophic return. "I'd hatched that idea a long time ago," Kneale says, "that if you were going to situate Hell somewhere, it would be in the sun". Kneale put the idea to Amis. "I said, 'I'll change it into what I do know about, that he's a fantasist about things from outer space doing bad, instead of Jews.' Kingsley said, 'Well... I don't mind.' And I said, 'It is important, because this character's going to stick out a mile in the production. If you want to introduce a linking character with a mad fantasy, you're going to turn that character into a very important part of the story."

The part of Steve was played by Sam West, a relative newcomer from an acting background. "It was Sam's first big part. He was too young to have done very much. His talented parents were Timothy West and Prunella Scales, super people, and very, very good actors indeed. Sam had inherited all the talent, and portrayed the part excellently." Elsewhere in the cast, Geraldine James, Sheila Gish and Penny Downie portrayed Stanley's phalanx of women. "There were a lot of ladies in it, which pleased John Thaw!" Kneale says. "He tended to rather like picking his female leads, and he was very good at it. He knew the ones he would get on with best." On the other hand, Thaw never quite hit it off with Kingsley Amis himself.

Although not vintage Kneale, *Stanley and the Women*, as directed by David Tucker, was a great showcase for the writer's exceptional skills as an adapter, and it was clear that, with the team at Central, Kneale was still adept at working on modern TV drama. Kneale found himself involved in the media launch for the series. "I remember this press conference that Central ran," he says. "They'd invited the cast, of course, and they invited Kingsley Amis. All the publicity seemed to have turned around into an argument about whether Mr Thaw was happy with such an anti-feminist sort of tract." With the attention elsewhere, Kneale drifted away. "I found Kingsley sitting by himself at a table and not being taken the slightest notice of in a different room. So I sat down and we had some tea while this nonsense was going on."

The four episodes of *Stanley and the Wom*en aired on ITV from November 28, 1991. Both the scriptwriter and the novelist were satisfied with the result. "It was perfectly well-done, and it all worked," Kneale says. "Kingsley was the first to admit it, he went along with it completely and was very happy with the end product. Then when he was writing in the *Sunday Times* he said that it had been his favourite version of any of his novels, which was very nice of him!"

* Kneale remembers the possibility being mooted of him writing an episode of *Inspector Morse*. "Yes, it was," Kneale says, "but I didn't do it. It was just talk."

However, when Central bought the TV adaptation rights, it was a condition of the deal that it should not be in conflict with the stage version. As a result, it was shown once and released for a brief period on video, after which it effectively disappeared. "They put in — and from their point it was absolutely right — that it should not be shown on television in competition with the stage version," Kneale confirms. "Nobody lost anything. The two were so unlike. The whole idea, apart from the title, was completely different. It was interesting that they could be so different, but they were, and they're both quite successful." It's unfortunate, though, that, as a consequence, yet another of Kneale's most impressive television pieces is largely unavailable.

ON A HAPPIER NOTE, Kneale had, by now, firmly established himself with Ted Childs at Central Drama, as part of a pool of freelancers. At the time, Central were riding high on the success of the upmarket crime drama *Inspector Morse*, which had been running since 1987. Childs had been inspired to develop a sophisticated whodunnit series by the popularity of BBC1's *Miss Marple*. As a result, Childs bought the rights to author Colin Dexter's *Inspector Morse* sequence of novels, featuring the pint-swigging detective at work among Oxford's dreaming spires.* Central found their Morse in well-loved Salford-born actor John Thaw. Keen to nurture their relationship with Thaw, Ted Childs was on the look out for potential new vehicles for their star. To that end, Central bought the rights to Kingsley Amis' 1984 novel *Stanley and the Women*. John Thaw would star as the eponymous Stanley Duke, whose seemingly idyllic and successful life is belied by his labyrinthine relationships with the opposite sex, and his son Steve's descent into paranoid schizophrenia. The result would be a blackly comic drama. Chris Burt, who'd produced *The Woman in Black*, was assigned to produce, and Childs and Burt knew exactly who to commission as adapter.

Kneale had long been an admirer of Amis' work, and it seems the feeling was mutual. "Way back in the sixties, when the Penguin versions of the *Quatermass* stories came out, Kingsley had given them very glowing reviews," Kneale recalls. "I'd never met him at the time, but we had a kind of contact." The offer of the *Stanley and the Women* project greatly appealed to the scriptwriter. "It's a very decent book, which I liked, so I agreed."

In practice, it wasn't the easiest book to adapt. Many of the characters were intentionally contentious, and the views they espouse aren't the usual mainstream TV fare. Stanley's dealings with the fairer sex, presented in the first person, had a generous dash of misogyny to them, and the plot's structure has its flaws. In planning to rework the material, Kneale decided to deal with the original author direct. "I think Kingsley had sort of lost interest towards the end of the story," Kneale says. "He just wrapped it up. So I tackled him about this. I said, 'We can do much more with the ending. I'd rather like to do a completely changed structure on that.' He was slightly taken aback, but he agreed."

Another major stumbling block was the character of Stanley's troubled son Steve. "He's a schizophrenic youth who imagines all sorts of things that do not relate to reality," Kneale explains. "It's a big element in the book. He has a fixation that it's the Jews who are causing everything to be as awful as it is.

who looks out for Kidd. The drama aired on the night of Christmas Eve 1989, but was rather lost amongst the assorted ITV regions. "The film was not well scheduled," Ted Childs opines, "and did not achieve as many accolades as it deserved — a common complaint from ITV producers!" And yet, there was no denying the strength of the work itself. "I thought Tom did a great job," Childs says. "I was very pleased with the quality of performance and standard of production value that Chris Burt and Herbert Wise achieved."

Kneale concurs. "It's pretty good, actually," he admits. "It was perfectly well done — good acting and direction. It's a very creepy thing. It's about a haunted causeway, in effect. The haunted house itself is right at the end of the causeway, and not a lot happens in it except that lights go out and things like that. But the causeway itself — in thick mist, which meant a smoke machine working overtime — was really creepy. You were blinded by what was ostensibly fog. You could hear an awful rendering of an accident, of people falling into the water where they would drown, and that really worked."

For author Stephen Gallagher, *The Woman in Black* rates amongst Kneale's very best work. "He took a novel that was essentially a slight pastiche of Victorian horror and turned it into a solid and cinematic piece of drama," Gallagher argues. Writer Jeremy Dyson agrees. "The book is very, very conventional pastiche," says Dyson. "Nicely done, but it doesn't really affect you in the same way because you're at a distance from it, and the technique is very self conscious. His adaptation is something completely different. He just gets to the essence of the story and it gets you in the gut. Credit to Herbert Wise, but you know, it begins with the script. What he's done with the structure, paring it down. His brilliant touches as well, like the wax cylinder; just the atmosphere of it. There's all this craft has gone into making that work."

Writer and performer Mark Gatiss is similarly fulsome in his praise of Kneale's adaptation. "It's marvellous," Gatiss says. "For a late piece of work in his career, it's just immaculate. It has everything that you associate with him, I think. He knows how to frighten people, but in a very literate way. All those little moments. My favourite line is when Adrian Rawlins is talking to Bernard Hepton on the train. Rawlins says, 'I'm a solicitor dealing with Eel Marsh House, and I expect to be going in and out of the house quite a bit.' And Hepton just says, 'Do you now.' Wow! — very much opening a crack onto a larger truth. It's fantastic economy. The atmosphere and the writing are just wonderful."

Despite its strong reputation, the TV version of *The Woman in Black* has rarely been seen since its initial broadcast. Not, thankfully, because the tapes were wiped, as TV companies had long since grasped the benefits of storing extensive archives. Rather, it's because a rival adaptation of the book has stolen much of the thunder. Playwright Stephen Mallatrat scripted a stage version which debuted at the Fortune Theatre in London's West End in February 1989, and still to this day remains there. "It was more or less simultaneously done as a stage play, which is still running, incredibly," Kneale says. "I went to see it out of curiosity. They'd done a decent job on it, but it was extraordinary that they did it in an entirely different way from our film. For one thing I had a whole village to play with, and they had a bare stage and a cast of two. That way you can save a lot of money!"

with the story, you have to work hard at it and pick out the right bits and make it go, but it's not the same as having made up the story," he says. "Susan Hill's original book was very decent. I was putting in things that aren't even thought of in the book, like a wife and family." In fact, Kneale's telling of *The Woman in Black* transforms the source novel into a skilled descent into unease and terror, often by altering the whole shape of the tale. Writer Kim Newman points out that Kneale is sometimes guilty of double standards in this respect. "One of the things that's interesting about Nigel," Newman observes, "is that he's often adapted other people's material, all the way back to George Orwell and John Osborne. But for someone who's complained about how his own work is treated, sometimes he's quite free in the way he treats other writers' work. He was very offended at the notion of Susan Hill using the name Kipps from HG Wells as the hero of *The Woman in Black*, and so he decided not to use it and to change the hero's name to Kidd. I'm sure if somebody thought that Quatermass was a silly name and changed it, he'd be furious!"

In adapting the novel, Kneale expertly shapes *The Woman in Black* to suit his own concerns. In classic Kneale style, Kidd has the latest technology at his fingertips: full electric lighting in the house, and a recording cylinder machine. But the march of progress is foiled by a lurking malevolence from the past. Just as voices have been recorded onto the cylinders, the tragic events on the causeway — the violent death by drowning of a child — has been imprinted onto the area itself, to replay over and over again, not unlike the ceaseless haunting in *The Stone Tape*.

Herbert Wise, who'd previously directed *Ladies Night*, reunited with Kneale to make the new piece, casting Adrian Rawlins as Kidd and Clare Holman, who'd appeared in *Ladies Night*, as his wife Stella. Veteran character actor Bernard Hepton appeared as Sam Toovey, a pillar of the community

Scenes from *The Woman in Black*.

tually notching up visits to eighty-two countries over seven continents. After graduation, he'd spend a year living in Japan, honing his skills as an author. His first novel, *Whore Banquets*, was published in 1987. The following year, it won Matthew a Somerset Maugham award — by curious coincidence, the same writers' scheme that had enabled his father to visit Italy almost forty years before. All in all, Kneale's talents as a parent had proved to be quite as remarkable as his ability for writing.

It would have been little surprise if, at this point, Kneale had elected to retire from writing, having reached an appropriate age to do so. Instead, he continued to be offered work, and continued to enjoy new challenges, and so pressed on. Certainly, his reputation and influence grew as new generations began to discover his work.

In 1988, the BBC tapped into the lucrative home video market by releasing the *Quatermass and the Pit* serial on VHS, with the original six episodes edited into a compilation format, complete with an interlude halfway through. A handful of scenes were trimmed or cut altogether, on advice from the writer. The video packaging states, 'BBC Video gratefully acknowledges the kind assistance of Nigel Kneale in the preparation of this 178 minute video edition.' "The BBC issued a tape, which I was in on, to the extent of vetting it slightly and saying, 'We could tweak that out,'" explains Kneale.

Despite the modest success of the release, it was decided against following it up with a *Quatermass II* tape. The serial existed in full in the BBC archive, but the recording technology used at the time it was made was rather crude, and at the time Kneale was unhappy with the result. The influence of *Quatermass* lived on, though. In 1989, the BBC axed the ailing *Doctor Who*, which had been on air for twenty-seven continuous seasons. Curiously, one of the final stories, 1988's *Remembrance of the Daleks*, pays homage back to the series' roots when a character is heard to refer to 'Bernard' and the 'British Rocket Group', as though such things are part and parcel of the fictional *Doctor Who* world. Even in its last days, the programme acknowledged the debt it owed to the adventures of Professor Quatermass.

BACK IN 1983, author Susan Hill had written a short novel called *The Woman in Black*, an homage to the classic ghost story tradition. It features a young turn-of-the-century solicitor, Arthur Kipps — his very name a sly reference to HG Wells' celebrated hero — who is despatched to the coastal village of Crythin Gifford to settle the estate of a deceased, friendless widow, Mrs Drablow, and discovers her restless spirit is restlessly haunting her property.

In 1989, Ted Childs, in his capacity as Central TV's Controller of Drama, found himself casting about for potential new projects. "I was looking around for suitable books we could adapt as television films," Childs recalls. "Producer Chris Burt suggested the Susan Hill novel." Childs secured the rights to adapt the story for television, and knew of an ideal writer for the project. "I believed Tom Kneale would be a good choice as adaptor, given his understanding of the dark side of human nature", Childs says.

Thus Kneale was commissioned to adapt *The Woman in Black* for Central. The resulting script was a masterpiece, one of his finest realised adaptations — although the writer is disingenuous on the subject. "If someone lands you

a masterwork, but they saw Kneale re-established as a TV writer, and more striking work would follow.

IN THE MANY YEARS since Kneale had begun his scriptwriting career, attitudes and approaches to the industry had changed immensely. In times gone by, Kneale was happiest writing in pencil in his workroom, listening to classical music. ("Eventually," he admits, "I found it easier to be quiet!") His manuscript could then be sent away to be typed up. In due course, Kneale had adapted to using an electric typewriter, but the eighties had made computer word processing technology prevalent for professional writers. Kneale wasn't enamoured of these developments. "I always hated computers, partly because I came to all that too late," he says. "I always felt they were like an alien force — like writing against a rival whom I didn't like much. I've a sneaking suspicion that they're bad for writers. I feel that myself, that they corrupt the freedom to think. I don't trust them. I've got a computer, and they're alright for letters or for articles, but for serious fiction I hate them."

Neither was Kneale taken with the increasing use of inflexible scriptwriting concepts such as the three-act structure. "The only stages for me would be getting down a particular set of ideas," he says. "I would never break up a story. The Americans do, it's all Act One, Act Two, Act Three. They think of a film script as like a stage script, which surprised me very much when I first encountered it. They'd say, 'Look, we think Act Three is a bit saggy in the end: we've gotta do something with that.' But that's why I always like to get the end set first, so I know there is an ending. Even if I change it, there's one to fall back on."

Still, Kneale's writing technique itself remained unaltered. "The important thing for me was always to be absolutely certain of the story," he explains. "There are very successful writers, lots of them, who can just start with a few sentences not knowing how it'll turn out, saying, 'Let my characters come alive, that'll make the story, and someday I'll reach the end.' That's a perfectly legitimate way of doing it. I always need to know the end. For example, the thing about old Quatermass was that he never actually was that important in the stories. He had to be there as an anchorman, but the stories were often mainly about the secondary characters as it develops, they carried the load of the drama. Partly, maybe, those were younger characters and could take it better. You develop your own practical way of going about it as you go on writing them."

KNEALE'S ENTIRE FAMILY were being kept busy at the time. His wife Judith was continuing to delight generations of young readers with new titles about Mog the Cat, and their children were establishing successful careers of their own. Their daughter Tacy, having graduated from drama school, had appeared in several productions at the National Theatre. In the late eighties, she took roles in popular TV shows of the day such as *Boon* and *Casualty*, as well as the 1989 film *Scandal* about the sixties Profumo affair.

Kneale's son Matthew, on the other hand, was following in his parents' footsteps by becoming a professional writer. Matthew had studied modern history at Oxford University, and developed a eager taste for travelling, even-

no women, except when they're forced, more or less through penury, to accept women as members. They were only there once a fortnight."

This uneasy arrangement quickly comes to grief. "One of the more put-down members [James Tripp, played by Ronald Pickup] has invited his wife [Evelyn, played by Fiona Walker] on an overnight stay, and kills her for shame at her presence," Kneale explains. "And he's treated with acclaim by all the other members. They're all very pleased. In fact, he hasn't killed her. He's just practically killed her, and she manages to crawl out of the place and is picked up by a set of police women, the rape detail — a newly established section of the Metropolitan police, which has not actually ever been brought into being, and perhaps should be. On this occasion, they got the entire heap of members of this awful gent's club. They invade the premises and totally demolish it."

A low-key return to the medium of TV drama, perhaps, but *Ladies Night*, first broadcast on December 6, 1986, is deftly written and well made by director Herbert Wise — himself a television veteran, having helmed many productions, not least the BBC's acclaimed 1976 serial *I, Claudius*. A spin-off publication by Javelin Books allowed the series' writers, Kneale included, to retell their tales in short story form. Although it was an adaptation, it was the first short story Kneale had written since his *Tomato Cain* collection thirty-seven years earlier. The writer was pleased with the project, and happy to do more.

His next piece, *Gentry*, was perhaps less of a success. Made under the aegis of Ted Childs and Nick Palmer at Central as a one-off ITV play, its concept was thoroughly contemporary: the nefarious activities of the property market. "Again it was purely a thing that was going on at that time — a great deal of buying and selling of houses," Kneale recalls. "Taking awful, dead, broken-down districts where you could buy a house for way below its value so that you could practically rebuild it and sell it off for a high value. The people doing that were the gentry." Kneale's drama built a conflict from this scenario. "This was the case of a considerably dodgy solicitor whose managed to get a house of this sort in the East End very cheaply by abstracting money from a client's account to buy it with," Kneale explains. "Having bought it, he discovered belatedly, and under pressure, that it's been a haunt of criminals and in fact there was a dead body in the bath. The criminals come back to claim money they've secreted in the house, so, confrontation."

Directed by Roy Battersby, and broadcast on July 31, 1988, the end result is perhaps a little overwrought and ordinary by Kneale's usual standards, but the writer, at least, was satisfied. "It was very well done — well acted, though they were choked on brick dust trying to uncover the loot." Alongside Duncan Preston as Gerald and Phoebe Nicholls as Susannah, a well-known musician-turned-actor was cast as the chief criminal, Colin. "Oh dear," Kneale remarks. "To my surprise and delight, they found they'd got a hero from the pop industry, Roger Daltrey [lead singer of The Who]. In fact, he was not at all bad. He'd done very little acting, but he was fine."

Both *Ladies Night* and *Gentry* have their merits, but neither brought out the best in Kneale. His usual preoccupations, of the old in conflict with the new, were present and correct — in the former, the time-honoured beliefs of a gentlemen's club at odds the standards of modern world: in the latter, renovation work unearthing a sinister secret from the past. Neither play was

ously, the choice of guinea-pig was *Doctor Who*, which was moved from its well-established Saturday night slot to two weekday evenings as of January 1982, and enjoyed a ratings boost for its troubles. However, there were other implications of the decision to launch a soap. The BBC Drama department budgeted strictly to produce a certain number of hours of new drama per year. The new soap would eat up one hour of that allocation a week. As a result, fifty-two hours would have to be trimmed from the annual drama output. In the event, the main casualty was the venerable *Play for Today* strand. The strand was axed as of August 28, 1984, although new one-off plays, minus the *Play for Today* banner, were broadcast in a similar slot up until the following February. In fact, the much-trumpeted BBC1 soap, *Eastenders*, made its debut on February 19, 1985, just a fortnight after the final TV play. In committing to production of *Eastenders*, the BBC had dealt a severe blow to the original drama output. New strands were launched — *Screen One* for BBC1, *Screen Two* for BBC2 — but these were costly, occasional pieces mostly shot on film. The heyday of BBC studio drama, the environment that had nurtured talents such as Kneale, Dennis Potter and Jack Rosenthal, was over.

One of the architects of the BBC1 soap was Michael Grade, formerly the Director of Programmes at LWT when *Kinvig* had been made (and grandson of ATV boss Lew Grade). In 1984, Grade was appointed Controller of BBC1. There had been more changes over at ITV. Ted Childs, once the producer of the sprawling ITV *Quatermass* project for Euston Films, had been appointed Controller of Drama at Central Television. It proved useful for Kneale to have an ally at a productive ITV company.

There had been another, more subtle change to the broadcasting climate, too. During the late seventies and early eighties, the post-*Star Wars* boom for science fiction and all things fantastical had doubtless helped *Kinvig* and the final *Quatermass* to get commissioned. By the late eighties, the boom was well and truly over, and as a consequence of the resulting backlash, British telefantasy was scarcer than ever before. Kneale was unlikely to get his more speculative style of drama onto the nation's screens. Gritty and realistic was becoming the order of the day.

This, then, was the broadcasting medium into which Kneale was pitched in 1986. His return to television came about when Nick Palmer, former producer of *Murrain* and *Beasts*, was assembling writers for *Unnatural Causes*, a TV anthology of seven 'psychodramas' for Central. Amongst names such as Beryl Bainbridge, *Sapphire and Steel* creator PJ Hammond, Lynda la Plante, and Paula Milne, Palmer asked Kneale to contribute. He readily agreed.

The kernel of the idea for the new drama had been percolating for some time. "I'd never written one about a gentlemen's club," Kneale says. "I don't belong to one and never did. Once or twice I went to something like the Saville, and was treated to a meal there. I'd got a fairly vivid impression of the Saville and the Garrick and those places." Kneale's play, *Ladies Night*, would concern the casual misogyny of such institutions, and the concessions they are forced to make in the modern day. "It was a bit of sharp mockery. It was about these awful people who ran this hideous club which had been founded on the basis of shooting wild animals. The place is liberally decorated with effigies, stuffed bears and things, and the whole place smelt of decay and horror. There were

CENTRAL LOCATION

KNEALE HAD BEEN WORKING in British television since the 1950s, just as the industry was first becoming organised and established. By the late 1980s, it had changed almost beyond recognition. Television had literally become part of the furniture, a staple of the nation's leisure time from the young to the old. And yet it was becoming a target for all sorts of pressures. The likes of Mary Whitehouse saw it as a potentially destructive influence, allowing programmes with sexual or violent content into the homes of vulnerable viewers. For similar reasons, political parties kept a close eye on any bias within the medium's output. The sometimes outdated BBC faced a struggle to remain a vital part of the television landscape, particularly as searching questions were being asked about the necessity and wisdom of the national licence fee that provided the Corporation's funding.

One tidal change was the introduction of a fourth terrestrial channel, the independent Channel 4, in 1982. It was intended as a cutting edge minority interest alternative to ITV. Plans were afoot to introduce satellite and cable channels to Britain soon after. When the regional ITV franchises were re-negotiated, some companies lost out, and a major new company, Central, was formed to serve the Midlands. In November 1983, the two main channels, BBC1 and ITV, increased their broadcasting hours by launching early morning 'breakfast' programming. As viewer choice expanded, broadcasters faced a fight for audiences.

The BBC had always been set against the notion of having an ongoing soap opera. ITV had *Coronation Street*, a weekly audience winner since it began in 1960, but the BBC refused to commit to such blatant ratings bait. It had frequently dabbled with the form, though: a mid-fifties venture, *The Grove Family*, was a veritable ratings winner. During the sixties, BBC TV made *Compact*, based around the offices of a women's magazine, as well as football drama *United*. Similar successes during the 1970s included *The Brothers*, focussing on a family haulage firm and long-running hospital saga *Angels*. During the early eighties, the much-ridiculed sea-bound melodrama *Triangle* arrived — and evaporated from screens after three years. Indeed, the limitation of all the above was that they aired for just a limited run of episodes each year, and ended after a brief number of series, rather than becoming ongoing anchors in the schedule. During the eighties, as the ratings war was ramped up, the BBC realised that it might need its own regular soap opera. Imported hits such as *Dallas* and *Dynasty* were all well and good, but there were great advantages to be had in manufacturing their own.

The BBC therefore commissioned the team behind the popular *Angels* — producer Julia Smith and script editor Tony Holland — to develop a new regular soap, to be launched on BBC1 in 1985. In the meantime, there was a test run to see if BBC audiences would adapt to a twice-weekly drama. Curi-

world, and the events, of today. They gain from the contrast."

As with *The Stone Tape*, the team would be using the very latest technology against the supernatural and the unknown. Like *Beasts*, the idea was to cover a whole range of styles and approaches, from comic to terrifying. Kneale planned out a first series of seven episodes: one, *Flints*, told of mysterious occurrences as a nuclear airbase. Another, *'Perchance 'Twill Walk Again'*, was more light-hearted, with Collister investigating the ghost of an actor appearing unbidden in Shakespeare productions — a nod to Kneale's days at RADA and the RSC. A third episode, *The Newing Time*, was a economical reworking of the plot from Kneale's abortive film script *Laghangar*.

Clearly, there was great promise in the series' concept, but once again a lack of finances brought the project down. "It was just two or three of these creatures — an English company — enquiring whether we could set up a series," Kneale recalls. "I had a meal with them a couple of times. They were perfectly nice, but really didn't have their hearts in it, and didn't know what they were doing, I think. The man who had the money drifted off somewhere else and it just faded." By pure coincidence, the central premise of *Push the Dark Door* proved to be extremely timely. In due course, Hollywood seized on the notion of a team researching the precise nature of death for the film *Flatliners*, and the hit American TV series of the early nineties, *The X Files*, followed another shadowy group attempting to explore the unexplained.

And yet, all in all, this busy period of writing work for Kneale hadn't borne much fruit. By 1986 he'd had nothing made for television for five years — the longest such absence since his career had begun — and just one film he'd written had made it to the screen, with such disappointing results that he'd had his name removed from it. He chose to return to the medium he knew best — only to find it had changed greatly since he'd been away.

and *Doig's Dark Age* — only got as far an being outlined in treatment form, like the Kenneth Tynan project *The Hummer* before them. Others, such as *Laghangar* and *The Towers of Taranness*, were scripted in full. *Laghangar* is the tale of an accidental visit to an isolated village community with sinister, supernatural beliefs, and the dark methods the inhabitants use to extend their lives. In tone, it's in perhaps akin to the earlier *Quatermass II*, or even the cult British classic *The Wicker Man*, of which Kneale is something of an admirer.

The Towers of Taranness is an altogether different proposal. "It's about the ultimate secret weapon," Kneale explains, "which is tried out on a tiny seaside village in Cornwall, a fishing village where they cook speciality food. The trouble is, all the fish seen to have died. There aren't any to catch. The main character is someone who had a huge success with a rather pop novel about teenage tearaways. He's spent four years writing another one, but thought he would get a bit classier. It turns out as imitation Tolkein. He doesn't quite know why he did it. Neither he nor any of the other people in the village know the reasons."

In fact, the unknown cause is the mind-altering secret weapon, which works directly on the brain. "It causes people to have strange imaginings: they have awful dreams and hallucinations. In fact, it's this thing being switched on and off." The effects in the struggling author are remarkable. His follow-up novel, the titular *Towers of Taranness*, is a wash-out, a riot of fantastical nonsense — illustrated in the script with scenes of sub-*Lord of the Rings* silliness. "I had a bit of fun doing the extracts from bad Tolkein! Of course, in the end his book is a dud, and the publishers don't want to publish it. They can see it's just a bad imitation. They say, 'you should write another one like the first one,' so he's sent back to start on that, and things go from bad to worse."

The writer declares himself underwhelmed with the resulting script, though. "It's alright, but it's a bit obvious. It really wasn't good enough." Along with the other film ideas Kneale conceived in this period, *The Towers of Taranness* was mooted as a potential film project, but when no offers were forthcoming, it was quietly shelved.

ANOTHER OUTPOURING of imagination was involved in Kneale's *Push the Dark Door*, intended as a series for an embryonic British cable TV station in 1985. This was another bold leap, at a time when non-terrestrial television in the UK was in its absolute infancy. What Kneale proposed was a contemporary blending of *The Stone Tape* with the anthology approach of *Tomato Cain* and *Beasts*. The series would follow TV journalist Dave Collister and his team, Hattie Jonas and Jix Perryman. In the opening episode, Collister and company would investigate a haunting in a block of flats, and find themselves called to meet Leo Blackstone, the vastly rich president of the international Blackstone Corporation. Blackstone himself is approaching the end of his life, and chooses to divert his fortune to funding an investigation into the very nature of life, death — and the afterlife. Thereafter, individual episodes see Collister, Jonas and Perryman reporting hauntings and other phenomena, all the while answering to the cynical, ailing Blackstone. "Death is a door," wrote Kneale in the pitch document. "This series is based on a rich man's attempt to force it open. There is fantasy in the stories, but they are set solidly in the

very good director," Kneale acknowledges. "Even Mr Donlevy flourished under his hand. In those days, Donlevy seemed to be a very clever actor. I doubt if that was so, but Sturges made him seem so."

Other favourites of Kneale include the *Quatermass*-worshipping wunderkind Steven Spielberg. "Spielberg's sort of beyond criticism, isn't he? I think he's a superb director," Kneale says. "He's done some absolutely wonderful stuff. I would go and see anything he made eagerly. He's a wonderful director — from the very first thing he did, *Duel*. Beautiful. The sheer economy of it is admirable. Even *Jaws*, which is more commercial, but has the same ferocious economy, is very, very good. He has imagination, and a lot of it, and great skill."

Kneale's all-time favourite director, though, is the neurotic comic auteur

French poster art for *Halloween 3: Season of the Witch*.

Woody Allen. "Woody is a genius," Kneale declares. "He never did anything that was purely a dud. He can get a bit carried away with grandeur occasionally. *Radio Days* was, I think, the best thing of his. He can get quite remarkable results for very little. Woody's a great man. He's fine." On the other hand, modern British filmmaking is less to Kneale's tastes. "Mike Leigh, for example, is not for me," he says. "A lot of people can admire his work, and that's OK, that's for them. I'd rather see Woody Allen!"

DESPITE THE FACT that Kneale's Hollywood interlude had been largely frustrating, it had offered the writer a new opportunity. Previously, he'd written a whole host of film scripts, but they had all been adaptations — even if only of his own TV work. *The Creature from the Black Lagoon* was a remake, but Kneale's script had been very free with the details of its B picture source. On the other hand, just as he'd insisted, Kneale's script for *Halloween III* was entirely original, his first such work for the cinema. It would have been a perfect departure for the writer, to begin working on a broader, international canvas. Instead, this new direction was still-born.

Nevertheless, during the period of the mid-eighties, Kneale was inspired to work on several other original film ideas, none of which were made. It might seem extraordinary that a writer could pour his energies into unsolicited work in this manner, but then, by this time, Kneale had no need to act as a family breadwinner. His children had grown up and left home, and his wife was an enormously successful author in her own right. He was free to follow inspiration whenever it came.

Some of these film ideas — with titles such as *The Housekeeper, Number 19*

theless been quick to pay homage to Kneale in his work. His 1987 film *Prince of Darkness* — in which a group of scientists attempt to deal with a mysterious canister in the basement of a church, which is found to contain the sprit of the Devil — is heavily indebted to *Quatermass and the Pit*. By way of admission, Carpenter, who directed from his own script, credited the writer as one 'Martin Quatermass' (or should that be 'Martian?'). One character is even shown wearing a sweater bearing the legend 'Kneale University'. Carpenter's *In the Mouth of Madness*, from 1995, is largely an homage to the director's beloved HP Lovecraft, but also features a 'Hobb's Lane'. (Coincidentally, the film stars Antipodean actor Sam Neill — whose real first name happens to be Nigel.)

With no little irony, Kneale's *Creature from the Black Lagoon* script passed from hand to hand throughout the eighties as various potential directors were attached to the remake project. For a time, Joe Dante was in the frame to direct. By the early Nineties, the project had been passed on — to John Carpenter. "I read Kneale's script," Carpenter admits, "but elected not to use any of it. The project never got made". The relationship between Carpenter and Kneale is far from clear-cut, but Carpenter graciously expresses "deepest thanks to the man who invented *Quatermass*".

Kneale himself remains proud of his work on the *Halloween III* script, but dismissive of what was made of it. "I saw the finished film, without much enthusiasm. It was dreadful, as I knew it would be. A terrible thing. There was some good acting, but they'd killed it between them. So that was the last time I worked in Hollywood, really."

THE IDEA OF MOVING into the role of both writer and director never appealed to Kneale. "Absolutely not, no," he insists. "It's a different thing, a different kind of thinking. Getting side-tracked into wanting to direct as well as writing is just wrong, I think. They don't relate. They're nothing to do with each other. You write a script and somebody else comes and takes it away. It's no good just reproducing things that I had in my mind as director. That would be just a waste of everybody's time. It's adding his invention on top of what's already there. Then it starts to get really good."

A keen cinema-goer over the years, Kneale has strong opinions on many leading directors. He admires the work of Hitchcock, but only "up to a point — a limited point," he says. "Hitchcock made some very bad pictures and some very good ones. Like other directors at the time, he chugged along. On form he was very good. But this sort of Hitchcock worship that I was shocked to find went on in LA at Universal Studios… he wasn't *that* good. He hadn't written those stories. He didn't write, but he behaved as if he'd written everything in them. This idea of the McGuffin, which meant that the story doesn't really led anywhere and isn't about anything, but to hell with that — here it is. He could shoot beautifully and inventively, with great humour, but sometimes it seemed to die and he could be absolutely awful. Like *The Birds*, which had some good things and some quite appalling things, including the dreadful Miss Tippi Hedren. That takes Hitchcock right down, for me."

Kneale's favourite directors include Billy Wilder — "Wilder's wonderful, just terribly good" — and Francois Truffaut. He also adores the work of Preston Sturges, a former employer of the dreaded Brian Donlevy. "Sturges was a very,

doing that," he points out. "But I didn't want this to have my name. It didn't make any odds anyway. Your name still gets stuck on it as something to wave around, but I didn't really want to think about that in the end. You don't, you know. You just want to put it behind you."

"I was disappointed Kneale took his name off the credits," admits Carpenter, "but then, it was not entirely unexpected". In the event director Tommy Lee Wallace is given full on-screen credit for the screenplay. The film itself is an interesting failure at best. It's pretty clear that there's a tension between the ideas it contains and the way they're realised. In practise, though, it sits relatively easily into the slasher video culture of its day. Carpenter himself asserts, "I like *Halloween III*. It was hated at the time, but I felt it had a lot of cool things going for it". Although their working relationship soured swiftly, Carpenter still clearly holds Kneale in the highest esteem, calling him "a pioneer in science fiction. His ideas and style were enormously influential to an entire generation of fans and filmmakers. He was able to portray a sense of dread, unease and evil that echoed some of the best work of HP Lovecraft. I'm still influenced by Kneale. I wish I had his inventive imagination".

Kim Newman feels the much-maligned *Halloween III* is worth defending. "I think it's an interesting film, and it represents Nigel's work not entirely contemptuously," Newman says. "There are bits and pieces that are exactly as he wrote. There are things that are much more elegant in his version, but his script does need work. The ending [with Challis captured by Corcoran] is rather weak. It's a different rather weak ending from that one that they have in the film."

One of Carpenter's main objections to Kneale's initial drafts of the script was what he calls "an anti-Irish tone," but as Newman points out, that's a whole thorny issue in itself. "The thing that's really impossible to explain to any Americans is that Nigel isn't English," Newman says. "Americans have a vague notion of the difference between English and Irish — maybe even English and Scots — but the difference between English and Manx is something that's too arcane to them. Actually, I think the fact that the villains in *Halloween III* are Irish is one of the distinctive things about it. The use of creepy folksy Irishness is unusual, and I don't think racist at all. Apart from anything else, the film strikes me as being much more unsympathetic in general to Americans. I think *Halloween III* would be funnier if it had *more* stuff about the Irish in it... because, after all, it's not about proper Irish people: it's about those horrible fake Irish-Americans, people who've never been to Ireland but still put on the accent..."

Newman argues that Kneale's treatment of individual groups, be they Irish, British or American, is largely consistent throughout his work. "It's been observed that Nigel's work sometimes seems to have a contempt, as it were, for the common man," Newman points out. "If you compare the horrible American family who get killed in *Halloween III* with the horrible British family who get killed in *Quatermass II*, it's exactly the same, isn't it? They're lower middle-class, crass, and stupid. Maybe it's because Nigel is rather a pessimistic writer. Certainly there's a dislike of bureaucracy that runs through all his work, too. He has a fairly disenchanted view of most groups of people!"

In the years since the making of *Halloween III*, John Carpenter has never-

lace had been at school with him, way back in a town called Bowling Green, in Kentucky. He'd not been a director but a set designer."

In short, Kneale, a veteran scriptwriter — if new to modern big-budget projects — was charged with rewriting his draft script alongside a novice director. In collaboration with Wallace, Kneale turned in a substantially pared-down second version, but soon lost heart in the project. "It became clear very quickly that Kneale had no intention of reworking what he considered to be a final draft", says Carpenter. "More alarmingly, he expressed a disdain for horror fans and youth culture in general". With hindsight, it's easy to conclude that Kneale was unlikely to fit easily into the world of Eighties horror filmmaking, which rarely credited its audience with much grasp of subtlety. "I asked [Carpenter's co-producer] Debra Hill if she could sell something like *Psycho* today," Kneale remembers, "and she said, 'No, the kids wouldn't wear it. You've got to shock them every two or three minutes with any irrelevant thing, it doesn't matter what.'"

Gradually, the script drifted further and further away from Kneale's original concept. The measured, rich tone of the first draft, intended to have a cumulative effect of unease, gave way to overt scares and violence. The ambition of the piece was pared right down, and the characters simplified. Much of the humour was excised, and the creepy, confrontational ending that Kneale proposed was reworked into something more action-based and clear-cut. (Curiously, a favoured Kneale device — the presence of an ancient stone circle — was injected here by other hands, and was totally absent from his original script. In the finished film, though, it is established that each Silver Shamrock logo contained a sliver from a standing stone.)

Seeing his script extensively reworked by Carpenter and Wallace, Kneale decided to leave the project. "After a few sessions, I left it to them," he admits. "When I saw what they were up to, I said, 'Take my name off it.' They were not just cutting it, but putting tatty bogie stuff in — slashing eyeballs and all that kind of awful crap. Between them they chopped all my best material out. Mine had been a jolly good script, very creepy indeed, without any slashing of eyeballs. It was more expensive, being longer, so we didn't make it. It was lot better than the unwatchable thing they made."

Removing his writer's credit on the film proved easier said than done, though. "When it came to that, I dropped them a line saying, 'Just take my name off it,'" Kneale recalls. "They said, 'We'll refer you to the Writers' Guild of America. A very hard lady came on the line. She said, 'You want to take your name *off* a film?' I said, 'Yes, off this one I do.' And she said, 'People don't, you know. None of our members would take their name off anything. They want to get their names *on* things!' I could see that point!"

Nor was that the end of the matter. "She said, 'You must send me a cable to confirm this unusual request'. So I rang up the London cable office and said, 'I wanted to take my name off a film.' The person who was taking it down said, 'Ah, a John Carpenter movie!' I said, 'Yes it is.' And he said, 'But I like John Carpenter movies...!'"

There's a good reason why filmmakers lobby to be credited on their work. Kneale decided to do the opposite as a point of principle, but there was a downside. "What it means is, you lose all the residuals, and people don't like

ties, estranged from his wife and children. Challis is called upon to examine an extremely disturbed patient who's been brought into the hospital. The patient, Grimbridge, is capable only of agitatedly muttering the word "samhain". Under hypnosis, Grimbridge becomes the focus of frenzied poltergeist activity — a la *Quatermass and the Pit* — and dies in terror.

Investigating Grimbridge's fate further, in the company of the man's grieving daughter, Challis follows a lead to the isolated Sun Hills community, a self-contained Irish society working at the Silver Shamrock factory. Corcoran holds sway like a king in Sun Hills, and is eagerly drumming up business in the lead up to Halloween. Challis discovers the secret of Silver Shamrock. Each logo on their masks and toys is designed to react to a signal in a pre-prepared advert for the company, and deliver a fatal energy burst to the owners. A devotee of ancient Keltic practices, Corcoran plans mass murder on Halloween, for no other reason than "mischief". Challis endeavours to stop the plan, but as the final scene ends, the deadly broadcast is going ahead.

The expansive, subtle script that Kneale wrote for *Halloween III* fits easily into the larger body of his work. The fascination with belief, and the conflict of science and the supernatural, were familiar concerns. The Sun Hills community, and the paranoia and secrecy surrounding the Silver Shamrock factory, seem to share genes with *Quatermass II*'s Winnerden Flats, and the emphasis on the destructive power of television was familiar from *The Year of the Sex Olympics*. The tone veers from the dreamlike to the nightmarish, and it contains lashings of Kneale's trademark black humour. It's also totally character driven, with Challis' home-life sketched in. At times — when Challis gatecrashes a Silver Shamrock factory visit — it seems like an adult echo of *Charlie and the Chocolate Factory*. Elsewhere, Corcoran's grip on the community, and the archaic beliefs he fosters within them, bears some comparison to the British horror film *The Wicker Man*. As a whole it's a spellbinding, gentle unsettling piece of work. "I wrote what I thought was one of my best scripts," Kneale asserts. "If they'd done it the way I wrote it, it would have been a good film, no question."

Once the script was submitted, problems arose. "I thought Kneale's first draft was adequate, but that's what a first draft usually is. I felt it needed work", says Carpenter.

From Kneale's point of view, he was being overlooked. "By then, John was getting deeper and deeper into his remake of *The Thing*, having money troubles and problems of every sort," the writer says. "It must have been very expensive, on special effects particularly. It ate up resources. So I found he was cooling on mine, purely because he hadn't any time to spend on it. He said, 'I'm sure it'll be too expensive and I've got troubles with expenses, so let's watch that.' I took it away and cut it down to about half, which would have been cheaper to make."

There were more changes behind the scenes, too. Director Joe Dante left the project. "He had bigger projects waiting", says Carpenter (not least his first major hit, *Gremlins*, and later, the *Quatermass*-referencing *Gremlins 2*.) Carpenter's choice of replacement didn't fill Kneale with much enthusiasm. "An old buddy of his, Tommy Lee Wallace, was going to direct it. Carpenter's a funny man. It's a very American thing that crops up, but Tommy Lee Wal-

rival 3D film on the starting blocks; a third instalment of the *Jaws* franchise. "They didn't make it for an internal reason. There were two groups, one in Hollywood, one in New York, and the New York men were determined to spend this budget on a 3D film," Kneale explains. "It was some madman's idea, and of course New York must have been more powerful, so the thing I'd written was just put aside. This happened an awful lot!" And so, as *The Creature from the Black Lagoon* was shelved, the entirely underwhelming *Jaws 3D* went into production instead.

WHILE KNEALE WAS OCCUPIED at Universal Studios, Joe Dante suggested John Carpenter arrange to meet him about another potential script. "While I was there, I encountered John Carpenter," Kneale recalls. "All the others said, 'you've got to meet John, he's great.'" Since the success of *Halloween*, Carpenter had made a big budget ghost story *The Fog*. At the point when he met Kneale, Carpenter was preparing his own reworking of a fifties sci-fi classic. "John was just about to do a remake of *The Thing*. I'd seen the original and thought it was dire. I met him in Victoria Station: it was very weird place — a restaurant that had been made to look like a replica of Victoria Station in London. They'd got all sorts of stuff brought over from London to be nailed up on the walls. Weird, but quite successful, and a bit trendy. It was smack next to Universal Studios where I had been working anyway."

Carpenter had Kneale in mind to pen a continuation of the *Halloween* franchise. A lacklustre first sequel, *Halloween 2*, had directly followed on from the story of the first, but with little impact. Carpenter had scripted it alongside his producing partner, Debra Hill, with a newcomer, Rick Rosenthal, as director. For a third film, fresh ideas were needed. "John said, 'Why don't we do a movie together? What about another *Halloween*?' I said, 'Ohhh no, thank you, it's either got to be my story or I don't do it.' He said OK. I told him one and he said, 'Let's do it, fine,' so I wrote it."

Also present at the meeting was Joe Dante, then attached to the *Halloween III* project as director. In 1980, Dante had, like Landis, directed a modern werewolf film, *The Howling*, with which Kneale was rather taken. "Kneale pitched us the idea", says Carpenter, "and we both liked it, as we were unabashed fans of Kneale and *Quatermass*".

Carpenter, however, insists that the notion of starting the series afresh came from him. "My idea was to depart from [established main character] Michael Myers and go into different territory, tell new stories," he says. "I felt there was no more narrative strength in the original tale." (The franchise owners clearly don't agree, as Michael Myers has featured in a further eight *Halloween* sequels since.) Kneale himself confesses that he was unaware of the first two *Halloween* films until he was shown them by Carpenter himself. "I hadn't actually seen them, but they ran them for me," he says. "It was pretty ordinary, rough stuff. I could do better than that."

The resultant screenplay focussed squarely on the Halloween festival itself, whereas the previous films in the series had merely used the date as an atmospheric setting. In Kneale's script, Conal Corcoran, a charismatic industrialist of Irish descent, is manufacturing dirt-cheap, best-selling Halloween masks, through his toy company, Silver Shamrock. John Challis is a doctor in his thir-

seen one, but I did then. Jack Arnold was a nice man, who loved England. In fact, I discovered he'd made several films in London. The idea was that he and I should get together, as ancients of the film industry, or the science fiction side anyway." According to Kneale, Arnold "had been kept at Universal as a kind of pensioner, and he wasn't a well man. John Landis wanted to stir him into action again."

Kneale was sufficiently intrigued to fly out to Los Angeles along with his wife Judith, at the invitation of John Davidson. Kneale found he got along well with Landis. "He was Hollywood through and through. He'd been born there, which is rare," Kneale says. "They're mostly people who've moved into that area, but John was a pure Hollywood production! His wife [Deborah Nadoolman] came from New York, and had become a Hollywood lady. She'd worked with Spielberg. She was a costume designer mainly, and she'd done a lot of work on *Raiders of the Lost Ark*. Very nice — not the sort of uppity creatures you find now. She was just a nice mumsy lady, and John was a very nice man. I got to know them quite a bit over there."

Flattered by the attentions of this group of likeable and well-informed film-makers, Kneale agreed to pen a script for the *Black Lagoon* project. There were great plans for the venture. Make-up specialist Rick Baker, who'd worked with Landis on *An American Werewolf in London*, was eager to create a modern monster. A stunt man who could stay underwater for as long as ten minutes at one time — a positive boon in the circumstances — was attached to the production. Kneale, Arnold and Landis had a host of meetings, many at Arnold's Hollywood home, and one, for research purposes, at San Diego Zoo.

Kneale's premise for the script was a marked departure from the 1954 original, though. In the wake, perhaps, of *Kinvig*, the writer was keen to inject a good deal of comedy into proceedings. To that end, he proposed that the film should feature not one creature, but two. In other words, a double act. "I said, let's do a 'George and Lennie'," Kneale recalls, "and they got what I meant instantly."

For the uninitiated, George Milton and Lennie Small are the heroes of John Steinbeck's much-loved 1937 novel *Of Mice and Men*. George is sharp and short, whereas his friend Lennie is a towering simpleton whose strength and temper draws them into tragedy. For this new project, therefore, Kneale conceived of one unwittingly destructive, troublesome monster, and another that, despite its bestial nature, tries to calm and protect the other. Kneale called the least horrifying monster Horriblis. Together, the two creatures would lumber out of their lagoon home, and face the might of the US Navy, with as many comic results as thrills and chills. In conception, it was, Kneale admits, "a world away from the original. I tried to put believable characters in it, and make it a modern story — fast, cynical, funny, and, where it needed to be, horrific."

"So I thought up a story and they all said, 'yes, that's lovely, you must do it,'" Kneale says. "I wrote it mostly back home in London, and it was a good one. It would have been very good, if they'd made it." Trouble first surfaced when it was decided to make the film in 3D, as the original version had been. Curiously, the gimmick was enjoying a brief renaissance in early eighties Hollywood. The knock-on effect, though, was that the budget sky-rocketed to accommodate the special shooting costs. At the same time, Universal also had a

CARPENTER WAS ONE OF the brightest hopes of the next generation of Hollywood filmmaking talent. A keen scholar of film history (in particular, a fan of Howard Hawks and John Ford), he had directed 1976's *Assault on Precinct 13*, a brutal and claustrophobic account of a besieged police station, intentionally drawing heavily on *Rio Bravo*. He then went on to write and direct a low-budget thriller entitled *Halloween* and the result was a massive hit. One of the most profitable independent films ever released until the time of *The Blair Witch Project*. It was also the progenitor to a host of clones, often gruesome and violent, which formed the eighties wave of 'slasher' movies.

"I first came across Nigel Kneale's work in a movie theatre", Carpenter says. "I saw *The Creeping Unknown* [*The Quatermass Experiment*] in 1956. It had an enormous, enormous impact on me — and it continues to be one of my all-time favourite science fiction movies. A year later I saw *Enemy from Space* [*Quatermass II*]. Again, same impact. And, to be fair, director Val Guest entered my consciousness as one of the creators of these brilliant films along with Nigel Kneale." Carpenter's exposure to Kneale's writing is perhaps surprising, given that much of it had aired on British television and was them wiped but his influence did begin to filter through. "I was unfamiliar with the TV work of Kneale until much later — I'd guess the mid to late sixties," Carpenter recalls, "but I read the published teleplays of all three *Quatermass* serials. I was impressed by the ideas that Kneale conceived, as well as his style of writing." As Carpenter's career took off, it wasn't long before he and Kneale would cross paths.

IT'S A TRIBUTE to the curiously hardy nature of Kneale's writing that, as he approached a pensionable age, with a long career in television behind him (and a good deal of film experience too), he was discovered by a new wave of film-directing fans making a mark on Hollywood. The first to make contact was John Landis, a director now more famous for comedies including *The Blues Brothers* and *Trading Places*. In 1981, he had made *An American Werewolf in London*, a stylish horror-comedy that, for once, managed to be both genuinely funny and genuinely scary. It's clearly indebted to the horror films of Universal and Hammer (witness the classic 'local pub on the moors' where the drinkers fall silent when strangers enter). It's striking also that throughout, from the title down, the project bears an Anglophile stamp. (The credits famously dedicate the venture to the marriage of Charles Windsor and Diana Spencer.)

Following the film's success, director Landis, along with a producer friend, John Davison, had been trying to interest Universal Studios in remaking one of their most legendary properties, the 1954 B picture *The Creature from the Black Lagoon*. Landis was a champion of Jack Arnold, the original film's director, whose career had since run aground. He proposed that, as executive producer, he could oversee a remake of the film with Arnold returning as director, working from an entirely new script. As the scriptwriter, Landis approached another, albeit rather reluctant, veteran of fifties genre cinema.

"A magazine had written up great screeds about Arnold's *Creature* and my *Quatermass*, and Landis probably read it from beginning to end and associated us," Kneale remarks. "John had this notion, along with one or two others, that I could help them do another *Creature* film. I'd never actually

the reader's troosers broon'... If you like, *The Pond* is a cautionary tale about cruelty to animals — particularly good for kids, I thought."

Throughout the eighties, Salford-born author Stephen Gallagher was making a name for himself with novels including *Oktober*, *Chimera* and *Valley of Lights*. Gallagher happily attests to the influence Kneale had on his own writing. "Absolutely — particularly in that fascinating friction you get between the everyday and the extraordinary, existing side by side," Gallagher says. "Kneale didn't depict fantastical worlds. He brought out the latent fantastical in the world we all know. Where I think he's truly important is in the way that he made a kind of science fiction that was both world class *and* firmly rooted in British culture. There's a direct line of descent from Wells' fighting machines wailing on Primrose Hill to the demonic forced released at Hobbs End." For Gallagher, the most powerful quality in Kneale's work is "the value of The Story. The Tale, the unique piece of narrative with a central driving idea that makes you sit up and listen, and want to know how it ends."

Despite this tumult of acclaim, Kneale himself has always been supremely wary of the horror genre. All too aware of the substandard writing that it can attract, the writer has always distanced himself from the field, regardless of the vast influence he's had upon it. "It's a world I know nothing about," Kneale admits. "I'm a bit careful and I have nothing whatever to do with it." Understandably, he's unwilling to be pigeonholed, or creatively restricted, by labels such as 'horror'. "If you happen across a great theme that has a disturbing element in it that makes you wonder — great, fine," he says. "But if someone said to you, 'what do you do for a living?' 'I'm a horror writer...' Jesus Christ! To want to be thought of like that I find, well, horrific! I just don't connect in any way with that."

Nevertheless, arguably the biggest name in horror fiction during the Eighties was Stephen King, another acknowledged Nigel Kneale fan. King celebrated his forebears in his non-fiction 1991 book *Danse Macabre*, in which he spotlights his own personal favourite horror films and writers from between 1950 and 1980. King devotes several pages waxing lyrical about Hammer's *Quatermass Experiment* film, albeit as much in appreciation of Val Guest's 'sombre, atmospheric' direction as of Kneale's remarkable concepts. In addition, in the book's appendices, King lists one hundred fantasy-cum-horror films of note, and includes *Enemy from Space* (the US-retitled *Quatermass 2*) — and a similar list of books includes Kneale's *Tomato Cain*. Many observers have also noted a strong resemblance between King's 1987 novel *The Tommyknockers* — about an alien spacecraft found buried deep in woodland, and the influence it exerts on the people of the nearby town — and *Quatermass and the Pit*. Writer Kim Newman certainly detects the influence. "Stephen King has taken many stratagems from Nigel," argues Newman. "He has paid homage. I mean, *The Tommyknockers* is *Quatermass and the Pit* written backwards, isn't it..?"

One of the best-selling authors of his day, many of King's novels have been adapted for the big screen by major directors. Stanley Kubrick freely adapted from King's source novel for *The Shining*, whilst Brian DePalma directed a film version of *Carrie*, and one John Carpenter — one of the leading lights of the Eighties horror film boom — brought King's *Christine* to the screen.

from the third *Quatermass* film was this idea of finding a wrecked alien space-craft, and investigating inside of it, and finding the remains of the creatures. In my original screenplay when they land on that planet, they find a crashed alien ship and they go inside and find the remains of an alien creature. In the movie they just sort of crushed two scenes together, but in my version it was two separate scenes. They find this wrecked alien spacecraft, and they deduce that this alien creature was killed by something. Then subsequently they discover an indigenous pyramid and they go into that and find the eggs. In the script, that was probably one of the more specific things I was thinking about from Kneale's work."

What's more, *Alien*'s space travellers go on to discover an area covered in unearthly eggs, wreathed in smoke. When Kane, played by John Hurt, leans in too close to one such egg, it splits open, and something unseen leaps onto his face, leaving him possessed by the predatory alien life-form. It's remark-ably similar to the space-born pods of *Quatermass II*, which infect those who come across them. Subsequently, when the Nostromo takes off with Kane on board (playing host to an infant life-form), the crew are picked off by the hostile creature that they've unwittingly let on board. It's the same scenario that sets *The Quatermass Experiment* in motion. There, it's unseen. In *Alien*, the episode is played out to become the whole film. Significantly, the proposed original ending of *Alien* sees the creature killing the last survivor, Ripley, and imitating her voice to contact Earth authorities and announce its intended arrival. In other words, it works as a futuristic 'prequel' of sorts to *The Qua-termass Experiment*. *Alien* is extremely atmospheric and effective; to date, it's spawned three direct sequels and a spin-off film. The debt the film owes to *Quatermass* is clear, and O'Bannon, as we'll see, would cross paths with Kneale more directly in due course.

RATHER UNEXPECTEDLY, then, Kneale was the toast of a new generation of young American writers and directors. In particular, there was something of a renaissance of 'horror' fiction and moviemaking. Just as Kneale exerted a palpable influence on the 'telefantasy' boom of the sixties and seventies, so too the progenitors of eighties horror were fulsome in their praise for his work. Liverpudlian writer Clive Barker had grown up adoring Kneale's TV work. Another big name in the horror field, award-winning author Ramsey Campbell, has long held Kneale's writing in the highest esteem. "I think it's the abundance of ideas — the genius for structure, and a great seriousness about what is genuinely frightening," Campbell explains. "He does tap into contemporary fears and uses fantasy to shine a light upon them. And also his observation of human behaviour — a great ear for dialogue. When you've got all those put together, you've got a very considerable talent. Without him I'm quite sure I wouldn't be the writer I am now."

During the early eighties, Campbell took the opportunity to present Kneale's work to a new audience. "I used one of his short stories, *The Pond*, in an anthol-ogy I was editing called *The Gruesome Book*. It was meant for kids, although God knows the cover was pretty gruesome! It was for Piccolo Books, the junior end of Pan. The Scottish lady who was the editor there, who asked me to do a horror book for them, memorably said that the idea of the book was 'to turn

of Nigel Kneale in his youth. "I was about ten or eleven years old when I saw a version of *The Quatermass Experiment*," O'Bannon says. "I was living down in the Ozarks, Boothill and Missouri. We went to the drive-in theatre there quite often. The version we saw was under the title of *The Creeping Unknown*, which isn't much of a title, but the film was absolutely riveting. It made a deep impression on me. That was my first familiarity with anything of his work. A few years later, I was living in St Louis and I came across a Penguin edition of the teleplay of *The Quatermass Experiment*. I read it with great interest and learned that it had originally been a teleplay and who Nigel Kneale was."

O'Bannon was very taken with the aptitude of the older writer across the Atlantic. "As a fan of thrillers and science fiction horror films and such, there were certain methods and techniques that Kneale had used in *The Quatermass Experiment* that I thought were powerfully effective," O'Bannon asserts. "Not too many years later, after *Five Million Years to Earth*, the film version of *Quatermass and the Pit*, was released, I myself was writing a science fiction horror film and I worked very hard to understand and to emulate some of what Nigel Kneale had done."

The film O'Bannon wrote, *Alien*, was one of the key sci-fi films that followed in the slipstream of *Star Wars*. It's often credited as minting a new sub-genre in cinema, the sci-fi horror film. Of course, those that remember as far back as Hammer's *Quatermass* adaptations might take issue with that and clearly, the makers of *Alien* remembered them too. O'Bannon stresses that the influence Kneale had on his writing was subtle rather than overt. "As happy as I am to steal from my predecessors, there simply wasn't much that I could steal specifically from the *Quatermass* films. I stole more openly from films like *The Thing* and *Forbidden Planet*, but with Kneale there wasn't much specific I could lift. It was more a feel or a tone or a quality."

O Bannon elucidates. "There's a moment in *Five Million Years to Earth* with James Donald as the archaeologist, Roney. I can't remember the exact words of dialogue but it amounts to a type of slow take. He's enthusing over his archaeological find, and suddenly he pauses and realises just how old it is, and he says, 'Why, good Lord, so it was — !' A kind of a delayed take, which is, of course, familiar to comedy, but this was a delayed take used for the effect of suspense. I don't know that I actually succeeded in getting any of those moments through into films like *Alien*, largely because I wasn't directing them. But there was a certain attitude that's impossible to explain in words, behind Kneale's suspense techniques, that I tried to infuse *Alien* and other films with."

Nevertheless, O'Bannon's tribute to the science fiction classics of his childhood unconsciously shares several key plot devices with the *Quatermass* serials. *Alien* depicts the spaceship Nostromo landing on an unidentified, deserted planet, answering a distress signal. On investigating, the crew find an abandoned spacecraft containing the ossified remains of an alien being. This owes a debt to a strikingly similar scene in Italian filmmaker Mario Bava's visually impressive *Planet of the Vampires*. But it also bears strong echoes of *Quatermass and the Pit*'s Martian spaceship.

According to O'Bannon, this reference was even stronger in his original, greatly rewritten script. "One of the things that made a big impression on me

makers such as William Friedkin, Martin Scorsese and Francis Ford Coppolla who had grown up with cinema as a staple part of their cultural life. They duly went on to make their own films, at once heavily indebted to classic cinema, as well as being popular and influential in their own right. Film course graduates George Lucas and Steven Spielberg were marginally younger than the first wave of 'movie brats,' and the two were firm friends. Their particular tastes, both in what they watched and in what they made, leaned towards fantasy and science fiction films. Eventually, with films including *Star Wars*, *Jaws*, *American Graffiti* and *Close Encounters of the Third Kind*, Spielberg and Lucas had, between them, trumped their elders, at least at the Box Office.

In 1981, the two filmmakers collaborated on the consciously old-fashioned adventure movie *Raiders of the Lost Ark*, with Lucas producing and Spielberg directing. The brainchild of two young Hollywood titans was always destined to be a success, and indeed it went on to join other Lucas and Spielberg films as an all-time blockbusting hit. In essence, *Raiders* draws on the all-action Saturday morning serials produced by Republic Pictures during the 1930s.

There was another influence, though, which surfaces in the film's cataclysmic finale. Despite his best efforts, Indiana Jones has let the biblical Ark of the Covenant fall into the hands of a Nazi contingent, acting on the orders of Hitler. The Ark is opened in the presence of Jones and a phalanx of film cameras, recording the event for posterity. But the unearthly force unleashed from the Ark causes havoc, obliterating the Nazi onlookers and destroying the recording equipment. The whole scene is an homage to the conclusion of *Quatermass and the Pit*, where the opening of the Martian spacecraft has a similar effect. Specifically, Indiana Jones is heard to implore his companion not to look at the resultant eerie apparition, and in close-up, an antagonistic Nazi officer is shown with his face melting away. (In Kneale's serial, Quatermass tells his friends to look away from the spirit-like 'Hob', and his nemesis Colonel Breen suffers the exact same fate.)

Spielberg has never gone on record about the debt *Raiders* owes *Quatermass* — it may have initially come from Lucas instead, or else one of the many writers who work on the film script during its development. Nevertheless, Spielberg is known to have harboured a boyhood love of Hammer's *Quatermass* films (in particular, the US-titled *Enemy from Space*, aka *Quatermass II*). As such, this scene stands as the most commercially successful film director of all time very publicly tipping his hat in the direction of *Quatermass* and Nigel Kneale. The next year, 1981, saw the release of *Poltergeist*, a tale of a suburban home being gripped by terrifying supernatural phenomena, and the team of researchers who arrive to apply the latest technology to combating it. While overtly indebted to the classic American anthology series *The Twilight Zone*, the premise uncannily similar to both *The Stone Tape* and Kneale's short story *Minuke*. Nor is such an influence impossible, given that young filmmakers of the day were so aware of Kneale's work. Although directed by *Texas Chainsaw Massacre* alumnus Tobe Hooper, the script of *Poltergeist* was originally the work of one Steven Spielberg.

NOR WAS SPEILBERG alone in his admiration. Another up-and coming Hollywood talent was screenwriter Dan O'Bannon, who had discovered the work

favour of being able to write for *Doctor Who*! — with no idea that he'd already turned it down." Kneale had, of course, vehemently declined an offer to write for the series at its inception back in 1963. "Nobody there said to me, 'Oh, we approached Nigel Kneale already, and he doesn't want write for *Doctor Who*. He thinks it's rotten. He thinks people shouldn't be scaring children.' Nobody told me any of that. So there I was in 1980 picking up the phone with a brilliant idea of ringing Nigel Kneale that somebody's already had!"

Nevertheless, Bidmead went ahead with putting the proposal to Kneale. "He said he didn't like doing other people's stuff; that he didn't want to jump onto a tired old bandwagon that he been rattling along for twenty years and that if he was going to do something it was going to be something new. That was a revelation to me. I thought, 'God, this is television, surely everybody wants to do television? This is the world famous *Doctor Who*! It's going out round the world!' Nigel Kneale was the first discovery for me that not everybody thought *Doctor Who* was wonderful!"

Bidmead was certainly disheartened by Kneale's response. "It was very disappointing to put down the phone and have this guy, this hero of mine… but then I found that same attitude in a series of other writers that I rang up after that. But eventually we did get some scripts on the shelf."

Among the new writers that Bidmead did manage to draft into *Doctor Who* was upcoming scriptwriter and novelist Stephen Gallagher. Gallagher had no idea that Kneale had been approached to write for the series at the same time. "I have mixed feelings about that," Gallagher says. "It's like hearing that Elvis nearly sang with The Searchers."

There was never much chance of Kneale helping to rejuvenate the long-running BBC series that he'd always disliked. But then, what he did instead was perhaps just as unlikely. Having just turned sixty, he went back to Hollywood.

BACK AT THE DAWN of the eighties, Kneale received a call from an old friend. Kenneth Tynan, now installed in Hollywood, was looking for potential film projects, and recalled the 'poltergeist' feature he and Kneale had once devised for Ealing Studios. Tynan asked Kneale to revive the idea, and write it up as a brief film treatment. The writer obliged, and gave the treatment the peculiar title *The Hummer*. Set in contemporary Britain, It features a pubescent boy, Paul Oram, who is a cause for concern to his schoolteachers. Deeply introverted, Paul has spells of compulsively drawing and smearing paint into odd, unsettling patterns, whilst humming distractedly to himself. It becomes clear that Paul has no control over his actions at these times. When Paul's mother is killed, the behaviour seems to cease, but in due course it returns to possess and eventually destroy him. It's akin perhaps to *The Exorcist* in its handling of inexplicable phenomena in a modern setting. Sadly, the project got nowhere, for the simple reason that Tynan died of lung cancer on July 26, 1980. The treatment was forgotten — but before the long, the major American studios would be offering other opportunities to Kneale.

HOLLYWOOD WAS A THOROUGHLY exciting place to be in the early eighties. The seventies had seen the rise of a new generation of ambitious young film-

HOLLYWOOD
(SLiGHT RETURN)

TODAY, CHRIS BIDMEAD is a leading British IT journalist, who's written for several major UK computer publications. He's had several strings to his bow over the years. During the sixties and seventies, he was a member of the BBC's Drama Repertory Company, performing in radio plays on a regular basis. "When I was doing plays for the BBC rep, we got tons and tons of scripts, and did three plays a week. Most of them weren't very good, and the cast got fed up with me saying the scripts are rotten, and said 'well, why don't you go and write something?' — so I did."

Sure enough, Bidmead began to make a name for himself as a writer, initially in the field of radio drama. In late 1979, he found himself applying for a permanent BBC post, namely, as Script Editor of *Doctor Who*.

Enthused at the prospect of changing the tone of the high-profile show, by ridding it of overt silliness and re-emphasising the scientific concepts at its core, Bidmead set to work. "When I got this weird job, I moved into the office, and there was just one script on the shelf. It was a great fat thing. It was almost unreadable. The first day of shooting, for whatever it was we were going to shoot, was something like six weeks off — and I had this empty office and no scripts! So I thought, well, obviously, we go for the guv'nor first of all. So I picked up the phone and I rang Nigel Kneale."

Bidmead had vivid memories of watching the original *Quatermass* serials, and had grown up adoring Kneale's work. "*Quatermass* had hit me like a ton of bricks while I was still at school. I mean, we didn't even have a telly," he recalls. "If you wanted to go and see Nigel Kneale's original *Quatermass Experiment* on the telly each week, you had to find a friend who'd got a television set and make an appointment, and go and sit down and watch it with him. It was a totally different occasion from watching television in the daytime."

As with many aspiring writers of his generation, Kneale's work was a formative influence on Bidmead. "Bernard Quatermass was a real scientist. That's what made the whole stories work. You started from the basis of the science, and that's what made it all credible. Nigel Kneale's definitely a formative entity for me. He was outstanding. Here was a writer who had something to say, and had a very, very driving and novel way of saying it. Kneale was taking off from the everyday into a world of amazing, frightening fantasy and the fact that it was very much character-led was terrible important."

So it was that, in his new, official BBC capacity, Bidmead contacted the writer he'd admired for so long. "This was a great chance to connect to my heroes," he says. "There was I sitting in the office with no scripts and I think, right, here's my chance to ring up my hero, Nigel Kneale, and extend to him this wonderful

unfortunate, foolish main characters. Simply put, *Kinvig* isn't nearly as funny as it should be, and the canned laughter track it acquired grates enormously. For all the qualities in its favour — the richly comic scenario, Kneale's usual inventiveness, and the talented actors — the series misses the clarity and depth of Kneale's best drama writing. The central concept is strong, but perhaps it might have worked best as a one-off comic play. It certainly includes many key Kneale preoccupations such as the extraordinary impinging on the everyday, the rational colliding with an unshakeable, deep-seated belief in the irrational.

Whatever the reason, *Kinvig* didn't win many admirers, and failed to last beyond its first run. "We had a very good time, everybody in it," Kneale remembers, "and they thought about doing a second series, but it gradually crept in that they weren't going to do one." The writer had, in fact, prepared outlines for another series of the show, but to no avail. The sitcom, though, is a notoriously unpredictable beast. Curiously, two other TV comedies of note began their first series in 1981. *Hitch-Hiker's Guide to the Galaxy* transferred to television with mixed results, and failed to progress to a second series (albeit largely because of a disagreement between writer Douglas Adams and the BBC). On the other hand, *Only Fools and Horses*, a BBC sitcom about a family of London market traders, very narrowly escaped cancellation after its original run, and went on to become one of the Corporation's best-loved, longest-running comedies. Later, in 1988, BBC2 launched *Red Dwarf*, a confection of sci-fi spoof and sitcom that became another enduring hit. *Kinvig*, though, sadly had missed the mark.

**Scenes from the Kneale
sitcom, *Kinvig*.**

No matter, though. Soon after work on the series finished, Kneale found he had young admirers in high places across the Atlantic.

Kneale's unfamiliarity with writing sitcom showed through, and although, given time, it may have developed into something more satisfying, it was never fit to rank alongside his best drama.

That's not to say the series was without admirers, though. "One fan I was told about by my agent was [much-despised BBC Director General during the 1990s] Mr John Birt, who was then working at LWT," the writer reveals. "He had loved it. Maybe that was a bad sign!"

Birt wasn't alone in his opinion, though. At that time, TV historian Dick Fiddy was just developing his interest in the medium, as well as working as an aspiring comedy writer. The prospect of *Kinvig*, therefore, was a mouthwatering one for him. "It wasn't until I did some research and started reading about the area and watching a lot of stuff that I suddenly realised that Nigel Kneale had been involved in a lot of the things that I'd really liked," Fiddy says. "I remember anxiously awaiting *Kinvig* because, by that time, I would have been very aware of Kneale and his past. Also, as a fan of sitcom, and that rare hybrid, a sci-fi sitcom, I can remember being very anxious to see it."

In fact, Fiddy greatly appreciated the merits of the show. "I liked it a lot," he says. "I'd have to say a lot of that was to do with a very amiable central performance from Tony Haygarth. I thought he was absolutely terrific. And I thought it was clever the way that it toyed with the idea that it could have been reality or it could have been all in his head. I quite liked that gentle dig at those sorts of sci-fi nuts or conspiracy nuts. It wasn't perfect by any means, but it certainly wasn't as bad as its been painted as being. It's like all these things, if you just have one series, you can never really see its potential and where it would have gone."

For Fiddy, *Kinvig* isn't even the great departure in Kneale writing that some see it as. "It's actually a very typical Kneale idea, inasmuch as it's about the people," he argues. "It's about Kinvig himself. It's about what he perceives and how he is. It's a very humanistic piece. I think most of his great stuff is. It's really not about the ideas of mad sci-fi; those are just on the periphery. Kinvig's fixation with that is almost like an escape from his humdrum life. If Kneale's going to do something like that, that's exactly where he's going come from."

In some respects *Kinvig* is just as groundbreaking as the rest of Kneale's output. It's certainly a tribute to his sense of adventure that he was prepared to tackle an entirely different, and well-established, form of TV writing, the sitcom. It's also by far the most neglected of the six original TV series that Kneale wrote. Perhaps the difficulty with it — aside from the problematic fantasy element — was that it didn't much conform to standard sitcom set-up. The greatest sitcom characters — Basil Fawlty, Rigbsy, Norman Stanley Fletcher, the Steptoes — are relatively easy to identify with. Their frustrations and faults make them familiar and likeable, in that viewers love to hate them. Despite the strength of the performances, Des Kinvig and Jim are distant characters who are difficult to love. A manic hotel owner, or a dubious landlord, are fairly common archetypes, but socially inadequate UFO-logists are, by their very nature, less easy to encounter in day-to-day life.

Indeed, the comedy in *Kinvig* — unlike the writer's usual sense of humour — is often broad and obvious, and the writer shows little sympathy for his

in it for a second. It was an amusement for two idle people." The name Kinvig, despite its hint of the extraterrestrial, was, in fact, a traditional Manx surname.

Despite best intentions and high hopes, though, *Kinvig* began to come apart at the seams. The central concept — that Kinvig's imaginings are clearly not real, although he's convinced they are — perhaps invited a little too much ambiguity for the sitcom format. LWT began to grow cold about the series. "Initially, there was a lot of enthusiasm in the South Bank for doing it," Kneale insists. "The trouble was, having shot it perfectly well, it was shown with a lack of enthusiasm all round the country. Their hearts weren't in it, not really. They'd started with enormous enthusiasm and it stayed funny, for me, right until the end. But there was this thing which crept in of saying, 'is this really meant to be a send up of science fiction' — which of course it was — 'or are we meant to believe that all these outer space people really exist?' Never, never, not at all. But there was a sense of, 'well, we're not sure are we?' about them, which is bad, and I think had an undermining effect on some of the cast, who didn't know quite what they were being asked to do. They would have cheerfully and skilfully sent the whole thing up rotten. But a certain weakness crept in at the top end, and Michael Grade, who was then the boss of LWT, I don't think liked it, which is always a fatal thing to happen to any show."

The seven episodes of *Kinvig* were shown at various times around the ITV regions during September and October 1981, but for the most part the show was consigned to a late-night slot where a mainstream audience would never find it. Another possible audience, Kneale's more enthusiastic fans, hated the series precisely because it sought to mock them. "When they done it I heard all sorts of damnation had broken out, that people thought they were being mocked," Kneale says. "Well, indeed they were!" In truth, though, *Kinvig* was a lesser work.

Scenes from ITV's *Quatermass*.

own dismay. The return of *Quatermass* had caused a flurry of fresh interest in the writer, as many of the younger fans were too young to have seen Kneale's celebrated earlier work. The reissued *Quatermass* scriptbooks introduced the classic serials to the new generation of admirers — although the Euston serial itself had left them with a sense of anti-climax. As Kneale was exposed to the more exasperating aspects of fandom, notably the Brighton convention, he felt compelled to disown the telefantasy fans who worshipped him. Their untamed enthusiasm had backfired, and Kneale was about to use it for comic effect.

In fact, the mainstream popularity of science fiction, spearheaded by the blockbusting success of *Star Wars*, had already been cross-pollinated with comedy, but rarely with any success. The uninspired 1978 BBC series *Come Back Mrs Noah*, starring sitcom veteran Mollie Sugden as a housewife of the future stranded on a space station, had few apologists. More satisfying was *The Hitch-Hiker's Guide to the Galaxy*, the first series of which aired on BBC Radio 4 in March 1978. Douglas Adams' inspired space-hopping comedy spawned a popular series of books and a TV version. Later, the writers of *The Goodies* launched their own space-bound comedy, *Astronauts*, in October 1981, the week after Kneale's new sitcom came off air, but it too failed to establish itself with audiences. There was certainly scope for a well-written blend of sci-fi and sitcom on television.

Kneale's idea was about a pair of simple-minded layabouts, the foolish Des Kinvig and the even-more-foolish Jim Piper — descendants, perhaps, of Peter Cook and Dudley Moore's legendary *Pete and Dud* act. Des runs a ramshackle electrical repair shop, in the company of his wife Netta and their over-friendly dog Cuddly. Jim is unemployed — if not unemployable — and devotes his time to researching conspiracy theories and arcane beliefs. His greatest conviction is that aliens have been visiting the earth in their UFOs for many a year. Des simply humours him, but begins to fantasise that an attractive customer, Miss Griffin, is a masquerading alien from the planet Mercury. Over time, Des loses grip on whether his fantasy is actual reality, and engages Jim to help him find out more about the supposed alien visitors.

Clearly, there was rich comic potential in the scenario. The double act of Des and Jim, with their risible belief that the most normal events have an extraterrestrial cause, become the figures of fun inspired Kneale's experiences with British sci-fi fans. (There was an element of barbed satire, too. Miss Griffin was an employee of the bureaucratic BBC — that is, Bingleton Borough Council.) The series, named *Kinvig*, was snapped up by LWT, Thames' weekend-only sister station based on London's South Bank, and Kneale wasted no time in planning and writing a first run of seven episodes.

To star as Des Kinvig, LWT secured the services of Tony Haygarth, familiar to audiences from the police sitcom *Rosie*. His oppo, Jim, was played by distinctive character actor Colin Jeavons. The deft double act they developed won Kneale's warm approval. "They had some very nice and very capable funny people in it," the writer agrees. "Colin Jeavons, a clever actor, was delighted with the chance of playing a loon who really believed in flying saucers, who believed in everything: if you showed him something he believed in it. Tony Haygarth played the cooler customer who led this clown along and enjoyed doing it. They were old pals but one believed in it all and the other didn't believe

hated that. I knew he'd read it, but he didn't say anything. It got too near the bone, I think."

The eventual television reading was broadcast on the night of December 23, 1978. The reader, with some irony, was Liverpool-born actor Tom Baker — then the current star of *Doctor Who*, a new episode of which had aired earlier the same evening. Rather to his own surprise, Kneale was taken with Baker's telling of the tale. "It was simply read on air, and he read it extremely well," Kneale confirms. "It was a fairly sinister story, although it was absolutely true, and Baker got that without any striving or anything. He just did it and got it right. The whole thing has its own surprising style. He's not a natural story reader, but it isn't a natural, ordinary story."

Kneale himself had nothing to do with the production — the existing text of the story was simply told complete — but it became, in effect, his last ever credit for BBC television. It had a curious poetry to it. Just as his first contact with the Corporation, thirty years before, had been readings of *Tomato Cain* for the radio, so an era was ended with the broadcast of another story from the same volume.

WHAT KNEALE DID NEXT wasn't at all predictable. After the dystopian bleakness of *Quatermass*, he chose to go to the other extreme. "I wanted to do a funny one," he admits. "It was nothing terribly new. I'd used comic writing from the beginning. That's how I'd started at the BBC." Indeed, the early fifties children's puppet shows *Vegetable Village* and *Mr and Mrs Mumbo* had given Kneale an early opportunity to flex his comic muscles. But that was long ago, and while he'd always deployed a wry sense of humour, in even his most serious work, he was certainly not known primarily as a comic writer. In fact, though, his own taste in comedy ran the gamut from Woody Allen to Preston Sturges, and he was a fan of TV sitcoms. "When it was good, certainly. And there were some good people," he asserts. "I mean, I don't think you can ever top *Steptoe and Son*. For me, that's about as good as you can get."

The unlikely springboard for Kneale's TV sitcom came from his first and last experience of a Sci-fi convention. "I remember there'd been one of these stunts in Brighton, a science fiction fan get-together," he says. "I'd never struck one of those before. I was invited down, and I was horrified by the fans. They were the craziest lot of people I'd ever encountered. They were dreadful. The whole thing consisted of just dancing about in masks, giggling and having too much to drink. I was just disgusted. I said, never again."

Yet the comic potential of such obsessives began to dawn on the writer. "It struck me that the sort of people who enjoyed that awful business were the sort of people who were prepared to believe in flying saucers and ghosts and all the rest of it — and really believe it, too. So I thought, alright, I'll write a series about people so silly that they could really believe in all this nonsense, and that was my set-up."

The profusion of 'telefantasy' shows in the Seventies had attracted a generation of young enthusiasts, and as they grew older, these fans got organised. Home-made fan magazines and 'appreciation societies' sprung up all over Britain, as well as professional publications such as *Starburst*. In fan circles, Kneale was regarded as the forefather of British telefantasy — much to his

thing I remember as a kid was when John Mills [looking into the sky after the another group of Planet People have been obliterated] says 'it looks like vomit.' Wonderful!" Meanwhile, Dyson is astonished at Kneale's foresightedness. "Every day we wake up and say, 'it's the Tittupy Bumpity Show!'" he says. "It's the most prescient piece of British television science fiction there's ever been, I think! We are now living the Tittupy Bumpity Show, every night on television…"

With some irony, the serial gained average ratings of around eleven million viewers — almost exactly the same figure as *Quatermass and the Pit* had achieved twenty years before. After the elaborate procedure of writing two versions of the script, though, the feature film cut never really saw the light of day. "Euston were never very sure of it," Kneale suggests. "Although they'd spent a lot of money on it, they never seemed quite certain of what to do with it. I said I've got it down to about two hours. I'd been chopping out all sorts of more interesting stuff — certainly any funny bits. The serial wasn't perfect but it was a bit more sort of comfortable. I got it down to the right length but the trouble with it was it never really looked like a feature film. It looked like something that had been chopped down. It was never meant to look like that. They never did show it in the event, because it looked sort of lame. When they offered it to American distributors, there was a turndown."

The protracted making of the entire project had been a draining experience. After the onslaught, having resurrected, and then killed off, his most famous creation, Kneale began to consider his next move. As ever, he decided to tackle something very different indeed.

AS THE EUSTON VENTURE had been in progress, Kneale had received one final BBC credit, for a far more modest enterprise, without having to lift a finger. Producer Tony Harrison had been preparing a series of unadorned late night story readings for BBC1 over the 1978 Christmas period. The umbrella theme for the strand was 'childhood'. Among them Harrison chose *The Photograph*, one of Kneale's unsettling *Tomato Cain* stories. In fact, it had its roots in Kneale family history. "It was an interesting story. It was actually based on a real event, about my father when he was about five years old," the writer reveals. "They all had pretty primitive views about doctoring. He must have got a really nasty old fatal-type illness: an appendicitis that went wild and burst. This poor little creature was obviously dreadfully ill, and his mother was a hard case, and said that she ought to have a souvenir of him before he died. His grown up sister — who emigrated to America and who loved him until her death — she was on his side. The mother didn't really care but she wanted to have a picture of him, and she hauled him off to the only local photographer she could get hold of and had him sat up in a chair and photographed. Then he was sent home to die. But he didn't. In fact he lived to being about seventy, but there had been that weird episode about which he was rather sensitive."

Kneale's father never discussed the incident directly with his son. "I wrote the story and it was published, but he didn't want to talk about it," Kneale says. "I think it had been a thing that had hurt for a long time. Not just the physical hurt, which of course there was, but that this should have been done to him, that he should have been treated as a kind of prop. He must have

was the return of the professor, and the return of the channel, all at the same time. I was so excited that I even bought the novelisation." On seeing the serial, though, Davies was aware of its failings. "As Snoopy once said, anticipation far exceeded the actual event. But that's true of anything, really, so don't blame Nigel Kneale! I didn't really like that whole hippy-stone-circle angle — or maybe it just wasn't well realised — and I'm not sure I followed all of the plot. Or maybe I was just too hormonal. I think I wanted monsters. Actually, I bet a lot of the public wanted monsters, to be blunt. But for all that, I loved the ending and Quatermass's death."

Earth's dark ancestral forces awaken to a summons from beyond the stars...

JOHN MILLS in Nigel Kneale's THE **QUATERMASS CONCLUSION**

Starring JOHN MILLS as Professor Quatermass
Also starring SIMON MacCORKINDALE and BARBARA KELLERMANN
Brewster Mason and Margaret Tyzack with Ralph Arliss

For academic Julian Petley, the serial was found wanting. "I don't think it holds up very well," Petley suggests. "I think there's a lot wrong with that. It may be the direction. As Nigel himself says, it's all a bit too sedate and gentile. You don't really quite believe in these people. John Mills is good, but there's something about it that doesn't really ring true. It's a bit artificial. It's that placing of the extraordinary within the ordinary which gives Nigel's work its power, and I think within the last *Quatermass* it's all kind of extraordinary; there is no ordinary. I think also the fake Stonehenge doesn't really help, and I don't think Piers Haggard is the most wonderful of directors. There's just something about it that doesn't work, which is a shame."

Despite some reservations, writer and broadcaster CP Lee was impressed with what Kneale had achieved. "While it didn't have the same impact on me as *Quatermass and the Pit* — I was hoping it would, but it didn't — once again he was demonstrating an ability to tap into something before it happened, which might be Kneale's problem. But still very, very good." Lee also remarks on the implications of the Planet People, and the murderous, Charles Manson-esque Kickalong. "The ideas are much concerned with the counter culture and the alternative society. It's fascinating, because Manson in the early seventies was the great bugaboo and was all over the media. It's interesting that he would pick up on that, or want a character to be in that style."

Writer Grant Morrison had grown fonder of the serial over the years since it was made. "I remember being a bit disappointed at the time, but I've seen it since and I really like it," Morrison says. "When it first came on, it just didn't do it for me, because I was so enmeshed in the earlier ones, but I've grown to like it. It's just got a brilliant central concept. It's just so depressing, the sky filled with flakes of human bodies. That was horrible."

Mark Gatiss and Jeremy Dyson cheerfully attest to the impact the Euston serial had on them. "I was obsessed with it for ages," Gatiss admits. "The

as they had to wait yet longer for the long-mooted serial. Completed by the end of 1978, it was due to be broadcast in September 1979, a high-profile treat as part of ITV's new season. By the Summer, massive advertising hoardings appeared around London announcing 'Earth's dark ancestral forces awaken to a summons from beyond the stars. The legend returns on ITV — Wednesdays at 9pm throughout September'. "They'd put huge posters in the Tube, for instance, eight feet long," Kneale remembers. "It was hugely advertised. There again they spent a fortune."

But these plans were upended when ITV technicians went on strike, in the second week of August. The entire network was off the air as the dispute rolled on. "The whole of ITV was on strike," Kneale confirms. "There simply wasn't a channel alive. The BBC had it all to themselves for weeks. *Quatermass* had been massively advertised, and it looked as though they would possibly never show it at all." In the meantime, Kneale's novelisation hit bookshops as planned, and impatient viewers were free to read about what was in store.

The intended September broadcast dates came and went, and Kneale took the opportunity to go on holiday. "My wife and I thought, 'well, let's take a rest. We'll go to New York,' which we did, just for a lazy couple of weeks." But while they were away, the ITV strike abruptly ended after eleven weeks, and the Kneales received an urgent call in New York. "My daughter Tacy rang up from home and said, 'they're going to start showing the thing tomorrow.' So, shock horror. Nobody had told me!" The Kneales were, therefore, out of the country when the opening episode of the serial was transmitted on October 24, 1979. Indeed, the viewing audience as a whole was rather reduced. "What had happened," Kneale explains, "was the strike had ended and so they immediately switched all their programmes on, but of course nobody knew they were on. There was no time. I suppose they tried, but it was a total anticlimax, so when the thing did stagger into life it was only with a minuscule audience. That was not the way to do it."

The reaction to the serial was rather mixed, as even the holidaying writer discovered. "I was going out the next day and wanted to know if anybody had noticed it," Kneale says. "The paper shop round the corner had English newspapers, and one was the *Observer*. I looked up the telly criticism by Clive James, and it was total damnation. 'This terrible production, this awful play — urgghh!' he cried. That was a bit of a shock, that the first reaction I'd seen was this furious denunciation by James, who I didn't respect anyway, but it was a bit nasty. We got back home in three or four days and I found that James had been hammered. He said an unbelievable number of fans had written to him and beaten him into the Earth! That was slightly cheering but it would have been better if the thing had been better anyway…" Kneale asserts that, despite his own misgivings about the script, the strike may have hampered the impacts of the serial. "I suppose there must have been a strong feeling of anticlimax when people saw it, because of the delay," he says. "It must have done damage."

The sense of disappointment was felt by even Kneale's keenest young fans. Russell T Davies remembers — at the grand age of sixteen — looking forward to it immensely. "*Quatermass* assumed massive importance because it was one of the first shows broadcast once the strike was over," Davies recalls. "It

in lower ranks roles, but he didn't have the authority for Quatermass." Ultimately, though, it wasn't a matter of whether the writer was happy with the star. "It's more whether he was happy with me, really," he admits. "I think he was very uneasy because it wasn't the sort of thing that he had made his name with. He didn't reckon science fiction was his thing, but his wife had persuaded him strongly. She'd read the script and said, 'oh, you must do this', and she persuaded him into it, so he said. But I don't think he was happy."

Nor did the other leads — Simon MacCorkindale as the scientist Joe Kapp, and Barbara Kellerman as his doomed wife Clare — win the writer's approval. "Simon MacCorkindale should never have been cast as the last rational, intelligent man in the world," Kneale opines. "We had him in *Beasts* playing an idiot, and he was very good at that. And Barbara Kellerman just smiled all the time." Kneale was far happier with the rest of the cast, though. "There was some very good smaller part acting," Kneale suggests, "Very good indeed. In fact, it didn't need stars: it would have been better just to cast down a bit."

The writer also disagreed with the realisation of his Planet People, having hoped for something more contemporary. "The problem with the Planet People is that they were too harmless and really rather nice people," he argues, "too much like flower people, whereas they should have been more like punks. I wanted them to be aggressive, mad, dangerous and out of control — a cross between punks and whirling dervishes. These were the people whom that gods had driven mad in order to destroy."

Aside from the casting of the stars, though, Kneale was generally pleased with Euston's approach. "I think that was the only weakness. As far as the money went, there was plenty of it! They set up their own studios virtually, well outside London, where they hired a sort of park and built buildings they could use for the production office. The whole thing was on film, every inch, so they had to have somewhere to view the rushes, and they *built* the place. They could do that. It was money no object, it really was. They spent a fortune."

Producer Ted Childs was aware of the limitations of the project, though. "Trying to achieve the required Special Effects on a television budget, even a quite generous one, was a struggle," Childs admits. "The later sophistications of CGI were not available to us then." And yet, Childs was proud of the finished serial. "I was pleased with the outcome," he recalls. "I hope Tom was. He never said he wasn't. I was impressed by the prophetic elements he'd included. We had to acquire vans and Landrovers to serve as police vehicles, and adapted them with movable grills fitted over the windows — now a standard fitting on much police transport. Similarly the police armour evolved as per Tom's text, which we now see all too frequently on our streets."

As executive producer, Verity Lambert was similarly satisfied by what Euston managed to achieve. "It was a smooth production," she remembers. "It was quite complex. It had a very large cast and was very ambitious, so it was quite complicated to shoot. I was happy with the result. Much of it worked very well. I thought John Mills was wonderful as the older Quatermass. I don't think it had quite the staying power of the originals, but then that's almost inevitable when you try to bring something back in a slightly different form. It did quite well for us."

Getting the finished article out to the public proved to be difficult, though,

to stop the lightning, the suggestion is that the older generation — thought useless and abandoned — can apply themselves to saving the young. It's a natural concern for a writer moving towards old age.

In addition, there's a great deal in the serial that echoes the long-lost *Big, Big Giggle*, reworking many of its themes and ideas. There too, the young reject their elders and head on a course to suicide. Forming a distinctive, cultist society, they roam the landscape singing marching 'anthems' — the Ringstone Round rhyme directly mirroring the Grad's Boggo Song. And, as in the unmade script, the young people are saved by the applied knowledge and love of their forebears. Curiously, though, Kneale's vision of an elemental youth cult proved, eventually, to be rather forward thinking. Seen today, the Planet People resemble the new-age 'traveller' movement that flourished in Britain in the Nineties, both in attitude and appearance. "It may be completely accidentally, but the way it catches onto the idea of New Age travellers and that sense of cracked drop-out spirituality is really interesting, and extremely prophetic," Kim Newman suggests. "There are lots of other things about the serial that are all too horribly true."

As filming commenced, Kneale laboured over yet another version of the story — in book form. "We thought we'd go all out," Kneale says. "I had a publisher, Hutchinson, and I was writing a novelisation, which is actually rather better than the screenplay!" It was written in between visits to the set at Euston. "I was dashing off to Rickmansworth to see how they were getting on, and then back home to do another chapter of the book." The end result became Kneale's personal favourite telling of the story. "It was good," he says. "If it had been original, no strings about television attached, people would have probably bought it more than they did. They printed a huge number of the paperback version as well as a hardback, and I think it sold alright — as well as could be expected. I had written prose long before, so it wasn't new."

Indeed, this represented Kneale's first venture into prose fiction since the publication of *Tomato Cain* in 1949, but he denies that he'd stayed away from fiction. "I think it stayed away from me," he insists. "*Quatermass* isn't really a novel, although it's more than just a novelisation of the script. There's a hell of a lot in it that isn't in the script. I was writing it while they were shooting and I'd ring them up and say, 'I've just thought of a think we should use,' and they'd say, 'no, no, no more.'" There's certainly an extra dimension to the prose version. Quatermass the character is fleshed out, with more made of memories of his family and his previous encounters with the uncanny. He even enjoys a fleeting sexual encounter with Annie, the District Commissioner. As part of the serial's enthusiastic marketing campaign, the novel, dedicated 'to Judy,' was published by Arrow alongside reissues of the three BBC *Quatermass* scriptbooks — first released by Penguin almost twenty years before — each with a new introduction by the writer.

To star in the screen version as Kneale's eponymous Professor, Euston cast the well-known British actor John Mills, who had decades of experience in the fields of film and television. His familiarity would, it was thought, help bring the production to the attention of international audiences. Kneale himself was unsure of the wisdom of this. "I wasn't keen on the casting," he says. "Sir John Mills, whom the Americans wanted, isn't a commanding actor. He's fine

four-hour serial and a feature-length version simultaneously — Kneale rather lost his enthusiasm for the concept. "I was never that keen on it," he admits. "It was never that surprising. Very, very elaborately done, very well acted, and yet... there was something not right." The flaw, perhaps, lay at basic writing level. "The script went through a lot of changes one way or another," Kneale affirms. "Frankly, I was never really happy with the whole idea in the first place. The central idea was too ordinary."

Certainly, the massive budget allowed for the grand notions of the scripts — twin radio telescopes, a circle of ancient standing stones, and a whole future world necessitating specially-made sets, costumes, props, extensive location shooting and a large number of extras — to reach the screen intact. The BBC had never intended to make the serial entirely on film. As planned, their version would have made much greater use of studio sets, and less of outdoor filming.

The Euston production was far more ambitious. Kneale's down-at-heel countryside space observatory became a lavish, purpose-built set. "The BBC simply wouldn't have afforded that amount of stuff," Kneale insists. "Euston built twin radio telescopes, fully activated, running, working — it probably would have worked if they'd just aimed it properly! You'd have picked up the far end of the universe or something! It looked incredibly impressive. They built a full-size Stonehenge all out of plastic, and that was pretty impressive too. What it all cost I never asked! If it had all been up to that level, it would have been superb. Maybe it's my fault..."

Perhaps the protracted gestation of the piece had done it damage. The original *Quatermass* serials had relied on an almost topical reflection of society for much of their effect. When first conceived in 1973, the concerns of the new serial — a fuel crisis plunging society into chaos, the younger generation dangerously alienated from their elders, the superpowers pursuing hellishly expensive programmes of space exploration — were extremely current. By the end of the 1970s, though, they had begun to look a little outdated. Nor did it help that the writing process was so elaborate.

The story positively teems with ideas. Aside from usual Kneale preoccupations — a *Big, Big Giggle*-esque youth cult, a broken, dystopian future, the conflict between the old and the young, and a *Sex Olympics*-style prediction of television to come in the soft-porn Tittupy Bumpity Show — it follow several different sub-plots. Aside from trying to tackle the perils of the exterminating lightning, Quatermass becomes involved with the Jewish Kapp family, and a hidden society of pensioners, as well as constantly seeking out his lost granddaughter. If anything, there's actually too much going on, and the busy plot never quite settles long enough for the viewer to focus. And yet, many of the ideas are powerful and fascinating, and it almost resembles a compendium of Kneale's favourite preoccupations as a writer.

There was a new element in his fiction, too. *Wine of India* and *During Barty's Party* had touched on the fears of ageing and the frustrations it brings, but the new serial dealt with the theme expressly. Kneale, himself fast approaching sixty, made his lead character frail, elderly and lost in an unfamiliar world — the sort of nightmare the younger Quatermass might have had, perhaps. When Quatermass marshals the pensioners he encounters into using their expertise

had no idea that the serial had first been planned by the BBC five years earlier. "I was aware of Tom's screenwriting reputation before I began working with him," Childs remarks, "I'd seen most of his television drama prior to meeting him. But to be honest, when I became involved at Euston, I was unaware of the provenance of the piece." As the production rolled onward, Childs was more than happy to have Kneale on hand. "I had quite a bit of contact with Tom during preparation and filming," he says. "He was interested in our approach, and we involved him wherever we could."

Completing the team was director Piers Haggard. Haggard was an extremely experienced TV director, and had directed the cult Hammer-esque horror film *Blood on Satan's Claw*. His most recent work was a landmark in television serial, namely Dennis Potter's extraordinary musical 1978 serial *Pennies from Heaven*. His credentials were perfect: his great grand-uncle, H. Rider Haggard, was the celebrated author of fantasy novels such as *King Solomon's Mines* and *She*. The director was thrilled by this latest challenge, regarding Kneale as 'the best science fiction writer in Britain.' In turn, Kneale was impressed by Haggard's discipline. "It was an enormous job it was for the director," the writer remarks wonderingly. "They shot it in mid-summer 1978, a hot, hot year. I found them all practically stripped down to their boots on the lot, shooting under fierce sun. It wasn't easy. I think Piers was very ready for a rest at the end of it but he got through it alright. All that part was OK — so it must be down to me!"

The plot of the serial remained largely unchanged from the original BBC scripts. In an unspecified near-future, a distraught, elderly Quatermass is called in to advise on a troubled US-Soviet space project, although his only wish in life is to be reunited with his lost beloved granddaughter. The space mission is struck by disaster when an unearthly beam of light hits and destroys it. The light is found to be striking sights around the world — places of gathering, from stone circles to sports grounds — where groups of young people, calling themselves Planet People, have amassed. The mystical Planet People believe the light will transport then to a far-off idyll. In fact, it's obliterating them en masse. With the help of a remote radio telescope station, and latterly a reclusive band of pensioners, Quatermass tries to solve the riddle of the lightning, and thus stop the destruction it causes. What he discovers is that the source is deep in space. An unseen alien race is nonchalantly using the beam by remote to collect research specimens.

Nor was the film version titled *The Quatermass Conclusion* for nothing. Kneale had decided that the Professor had saved the world on quite enough occasions, and killed him off, in an act of supreme self-sacrifice, at the story's climax. "The world had crumbled into a dire state," Kneale explains, "and in this terrible, corroded, rotting world Quatermass makes this final gesture, to save the world from this ultimate threat. We never see these creatures from outer space; we only see the evidence of their presence and they don't know we're here. He decides to communicate with them, which he can only do by blowing up a thermonuclear bomb. That's the only way he could show them his presence — by blowing himself up... so I didn't have to write any more about him!"

In reworking the original BBC scripts, though — indeed, scripting both a

BRINGING BERNARD BACK

KNEALE'S SCRIPTS FOR a fourth *Quatermass* serial hadn't lain totally dormant since the BBC had shelved the venture. The Corporation's option to make it expired in 1975. There had been vague discussions about them possibly co-producing it with Hammer Films, but Hammer's own finances were hardly healthy enough for such an undertaking by then, and the BBC simply let it go. Instead, the scripts found their way across to ITV. "Somebody high up at the BBC quit in a rage", Kneale explains. "He said, 'I'm going to take something with me'. He took my script under his arm and went off to ITV and said, 'I'll get this produced.' Well, he didn't. I think he lost interest or found other things to do. I didn't even know his name. But what it effectively meant was that the thing had travelled to ITV, sitting there and waiting for someone to show an interest."

In due course, the scripts were offered to television executive Verity Lambert at Thames. "I was running Thames Drama at the time," Lambert says. "Nigel's agent sent me the return of *Quatermass*, and I just thought it was a fantastically interesting idea, something that would be really good to do." Lambert and Kneale had previously collided back in the early Sixties, of course, when Lambert was the original producer of *Doctor Who*, and Kneale had publicly denounce the series' intentions of terrifying children. Since then, Lambert had forged a remarkable career in TV drama, and remained an admirer of Kneale's work. "He's a fantastic writer," Lambert asserts. "He's hugely imaginative, and he has the ability to make fantastical things quite believable; to make you suspend disbelief as an audience. Considering the impact that that his work had, I think he's undervalued."

Lambert was aware that the new *Quatermass* project had first been conceived for the BBC, but had no qualms about picking it up. "We did a lot of things that had history at the BBC," she admits, "most notably [celebrated 1975 TV film written by Kneale's old colleague Phillip Mackie] *The Naked Civil Servant*, which was turned down by the BBC twice. So that wouldn't have made any difference to my feelings about it."

The fourth *Quatermass* serial had therefore found a new home at Thames, who planned to make it through their pseudo-cinema division, Euston Films, which produced all-film series for television, and theatrical spin-offs thereof. It was a huge undertaking. The budget was well over £1 million. As well as the four-part serial, entitled simply *Quatermass*, it was decided that a re-edited 100-minute version, *The Quatermass Conclusion*, would be released theatrically abroad. "The reason was," Kneale recalls, "they thought they could cover some of the enormous costs by being able to release a shorter, feature film version. So I did that as part of the deal when we first broached the thing."

As producer, Lambert appointed Euston regular Ted Childs to handle the entire project. Childs was already an admirer of Kneale's work, although he

Despite his RADA acting training, he'd never written for theatre before. He was inspired to try by the memoirs of Hugh Crow, a Manx slave trader. Besides his adventures in foreign lands, Crow was famed for claiming to have kept a record number of his slaves alive. When slavery was abolished, Crow washed up in an English port, regaling all within earshot about his extraordinary life, and eventually putting pen to paper for posterity. "He sat in Liverpool on the docks when he'd retired, writing his autobiography, which he did very reasonably," Kneale says. "That was what appealed to me in the first place. There was the Manx element, too, of course. I knew every place he would have been. I thought this would be a good one to do."

Initially, Kneale wrote the Hugh Crow story for the theatre. "I wrote it as a stage play, which my agent never managed to shift," he recalls. "We tried it on the National Theatre and so on." One possible stumbling block was simply a sign of the times in the late seventies. "Most of the characters were black, because it was about the slave trade," Kneale explains. "That was the nature of the thing. It needed lots of black men, but there weren't many black actors around at that time."

For a time, the play — sometimes known as *Hugh Crow*, or, most often, simply *Crow* — sat about unperformed. Eventually Kneale elected to try it in another medium, and offered it to his latest employers, ATV, who accepted it as a lavish television piece. Kneale was set to work rewriting the stage version for TV, and went through various revisions as the production was set up and a cast assembled. "Don Taylor, who I'd worked with on *Beasts*, was going to direct it," the writer reveals. "It was all set up, and they were going to use, for ITV, revolutionary methods of staging — the jungle scenery in particular." A full calypso-inflected score was commissioned from musician Derek Bourgoise, who had also previously done work on *Beasts*.

It was at the last minute, as ever, that disaster struck — for financial reasons. "We were on the brink of doing it when [ATV boss] Lew Grade cancelled it," Kneale recalls. "He'd had a row with his own people who designed the scenery. Lew Grade was a notorious booby. He has more booby ventures, collapses and failures to his credit than probably anybody else in the business. Here he was, too busy humiliating his own scene designers to switch off say, *Crossroads*, his masterpiece. This is the sort of crap person you get in television. He killed *Crow*, which was a perfectly good, viable piece." *

Further frustration was to follow. Working closely with his wife Judith, Kneale had written a feature-length script based on her best-selling book *When Hitler Stole Pink Rabbit*. It was a genuine labour of love, done to the best of the writer's considerable abilities, but the German company who eventually went ahead with the project jettisoned Kneale's adaptation entirely, and the lacklustre result bore scant resemblance to Kerr's source novel. Such is the tangled world of the working scriptwriter that the next piece Kneale got made had actually been written, and abandoned, five years earlier. It was time, at long last, for Bernard Quatermass to make his final bow.

* It's been suggested that the similarity to the successful US TV mini-series *Roots*, which also centred on the issue of slavery, was an additional factor in the downfall of *Crow*.

sprawl, and the sense of confinement adds greatly to it. It's also a classic use of Kneale's key preoccupations: the repressed, 'underground' scuttling of the destructive, hungry animals, as though the frustrations of Angie and Roger's brittle, childless marriage have come to life beneath their feet.

Directed by Don Taylor, *During Barty's Party* has terrific pace and atmosphere. In practise, this was partly a happy accident. The play's different scenes were shot virtually in sequence, and, as time was tight, very much up against the studio clock, lending the result a perfect sense of gathering panic. "It's a tricky one to get right, but they got it right, and it was very effective," Kneale opines. "It was very well acted indeed. Elizabeth Sellars had been a Rank Charm School star, and had retired and married a farmer and gone to the country but this one she wanted to do. She gave a beautiful frightening performance. of somebody really cracking. Anthony Bate played her husband and he was marvellous. I was very, very happy with that indeed."

Not unlike his earliest days at the BBC, Kneale had presented a set of scripts that posed enormous difficulties in the making, but ATV surmounted them with relish. "We couldn't show the animals even if we'd have had Attenborough, but they did their best," he says. "ATV, who were very helpful, had never done much of this sort of thing. Special effects, and there were quite a lot of special effects in this series, were entirely new to them. They had one man and he was a carpenter. He was very keen on doing special effects but he'd never been asked to do any in his whole life, so he was thrilled to bits, having these things to do."

During Barty's Party was a good example of ATV learning to stretch themselves. "They were very enthusiastic and very skilful," Kneale insists, "because they discovered things in themselves that they hadn't previously found they could do. For instance, when the people are being threatened and ultimately consumed by the rats. Nobody had ever been required to do special effects rats' voices. Well, you wouldn't, would you? The sound man there was very keen to get it right. He spent countless hours out of the studio, I should think, on his own, to work it out, and it worked superbly. It was amazingly effective and the sound man got beautiful sounds. They sounded just like rats to me. He worked on those and really went to town. But for him it was totally new. The BBC, who had a huge special effects department, good and bad, would have known what to do. The man at ATV didn't. He had to invent the technique himself, and did it remarkably well too. I have a lot of respect for those fellows."

SOON AFTER *BEASTS* was aired, popular culture was rocked by a more sophisticated feast of special effects: a new science-fiction adventure film shot in Britain, written and directed by a young American cinephile. An unprepossessing idea on paper, George Lucas' *Star Wars* went on to become the biggest box office hit of all time, and influences whole generations of film and TV talents — some for better, some for worse. Certainly, science fiction was the fashionable genre for the time being — but *Star Wars* and its ilk did little for Kneale. "I've never written anything remotely in that sort of field," he insists. "Huge spectaculars are not my kind of thing, and never have been. They have very clever pieces of very expensive scenery. I saw them and enjoyed seeing them, but that's it." Never one to take the easy route, Kneale initially steered clear of the sci-fi boom and decided instead to write a historically-based stage play.

is such a seedy story. Very well shot, I think, but it's fuelled by those amazing performances. Within that there's that lovely expositionary scene where Gerald James [as Curry's RSPCA boss] is actually on the phone talking this woman's cat down from a tree, at the same time as telling Michael Kitchen about Patrick Magee and his strange wolfish thing. It's brilliant. It's obviously quite difficult to get over that fact that he's a bit of a nutcase, but all the time he's doing it he's saying, 'well, try a saucer of milk...' And he puts his hand to the phone. Just marvellous." Gatiss was massively impressed by Kneale's display of skill and technique. "It's that way he has of just unsettling you," Gatiss says. "You start off believing that the pet supplier has been fiddling things by pretending he's sent three Scandinavian wolves to this tiny pet shop — 'how did he get away with it?' — but it's true! Terrific! It's really unexpected, clever moments like that."

The sixth and final play, *During Barty's Party*, was Kneale's personal favourite, and is perhaps the best remembered of the set. It's a masterpiece of Kneale's more minimal, intimate writing style. Barty's Party itself is an inane radio-phone in programme, and the listener we follow is Angie Truscott, an ageing, well-heeled housewife. Angie (played by Elizabeth Sellars) and her husband Roger (Anthony Bate) live in a country cottage, but as Roger is busy with work, Angie finds herself alone for much of the time. On this particular evening, Roger returns home to find his wife in a state of near-hysteria. In amongst the radio chatter, she's heard a fleeting report of mysterious goings-on. Despite her husband's irritable, dismissive attitude, they hear another report on the Barty's Party show — that vicious packs of rats have been spotted in the vicinity. As Angie suspected, just such a rat can be heard under the floorboards of the house.

"Gradually, bit by bit, they realise that there's a rat under their house, gnawing away," Kneale explains. "He tries thinking rationally, and at this point it deliberately turns into a thing of anti-feminism. He says, 'You're being ridiculous, there's nothing. There's a rat under the house? Well, alright, let's get rid of him.'" It transpires, though, that not only is the rat supremely resistant to normal methods of rodent control, but it isn't alone. Swiftly a whole pack of rats can be heard hungrily scratching and gnawing beneath their feet. "The rats don't give up," Kneale says, "and they feel terribly isolated. They're out in the country somewhere on their own."

As the din of the rats increases, Angie and Roger lose control and panic. "Just as it feels as if the rats are going to break in, " Kneale says, "their neighbours, who'd gone out for the evening, reappear, and they're suddenly all rational. They open the window and shout across, 'You're safely back! Come and see us, drop in for a drink...' And then they see the neighbour torn to pieces by the rats. Of course, we never see that. We see the horrified faces of the couple staring out of the window seeing it happen." The Truscotts' own doom, of course, can't be far away.

Mark Gatiss has a vivid recollection of seeing the play as a boy. "*During Barty's Party* is just fantastic," he says. "You never see a thing, just the sound of these rats, and it's so alarming... I remember watching that one alone, and it left me in a kind of sweaty state!" It remains remarkably effective to this day. Again, Kneale deals with a small-scale family setting as opposed to an epic

get very good performances out of people by
not directing them at all, by just watching,
and giving hints. They loved him; that was
exactly the sort of director they liked."

The production pared Michael Kitchen —
now a familiar face, but then a relative un-
known — and acting veteran Patrick Magee,
in another clash of beliefs. "Michael Kitchen
played an RSPCA man," Kneale says. "That
was the first time I'd worked with him and
he was terribly good. Michael's a very, very
subtle actor indeed. He does zero acting.
You don't see it. Patrick Magee as an actor
was always liable to go over the top, and
this was where he really could go over the
top. The more he did the better, because
here he was an old crazy man who was
convinced that he could turn himself into
a werewolf. He had worked at it very hard,
to the extent of injecting wolves' blood into
his arm to get a transformation started. In
fact, all that had happened was he'd killed
the wolves."

In his professional capacity, Kitchen's
young RSPCA officer Bob Curry comes to
investigate the delivery of Siberian wolves
to the pet shop owned by the eccentric Leo
Raymount (Magee) — animals which he
could never sell, but which never reap-
peared. The two square off against each
other as Magee explains his unlikely plan,
and Kitchen tries to talk sense to him. "They
were a marvellous twosome," Kneale says
admiringly. "They played to each other so
well. It was very exciting to watch. Magee of
course was a great classic actor on the stage,
and he could run rings round anybody else
—except possibly Michael Kitchen! They
did that one beautifully." As with many
of the *Beasts* plays, the conclusion was left
deliberately ambiguous. Whether or not
Raymount truly had to power to become a
wolf was merely hinted at.

Mark Gatiss was greatly enamoured of
the play, and marvelled at its boldness.
"It was so experimental. That really was a
Golden Age, I think," Gatiss argues. "You
could do something like that. *What Big Eyes*

More scenes from *Beasts*. Episodes
(from top): *Special Offer, What Big
Eyes* and *During Barty's Party.*

like a Hammer film. I'd watched them at it. They were so cosy, these pictures. There was never anything *less* horrific! But if it had been real and somebody had got accidentally killed well, that would be a different thing entirely. Not something you'd bargained for."

In fact, there was no actual animal featured in the play. The Dummy itself hardly counts, although Clyde Boyd's rage and jealousy — buried beneath his rubber costume — might just qualify. The relative lightness of the script appealed to Kneale, though, and for the most part he admired ATV's handling of it. "It was fun doing that one, and it certainly worked," he says. "They made a beautiful Dummy thing, a man-monster about seven or eight feet high. The only thing that spoilt it was, they had to get outside the studio for a bit of the shooting. Nearby the engineer who worked the central heating refused to turn the engine off, so there's about ten minutes of the whole thing where there's an overlay of engine noise, and that's not the way you should do it." Nevertheless, young viewers like Jeremy Dyson were gripped. "I remember being too frightened to be able to watch it to the end!" Dyson admits.

The fourth play in the series, *Special Offer*, was a descendent of *You Must Listen* and *The Chopper* — another of Kneale's tales of a haunting in a modern, everyday setting. This time, it was a common mini-supermarket, part of the fictional Briteway chain. Clumsy, gauche check-out girl Noreen Beale — played by Pauline Quirke in one of her earliest roles — seems disaster-prone, but insists she's not to blame. Among the aisles and store-rooms of the shop, a destructive creature is heard and its effects seen — but the creature itself never shows its face. At first, only Noreen is aware of it, leading her boss Colin (Geoffrey Bateman) to thinks it's an elaborate excuse, but soon other staff members witness the chaos. Colin flippantly suggests it might be the company's cartoon rodent logo, Briteway Billy, and the notion sticks.

Noreen grows used to the invisible presence of 'Billy', but as the disruption spreads, it becomes clear there's another, more extraordinary cause. "She was a girl who'd had a bad time at the hands of the staff," Kneale explains. "Without intending to, without even realising what she was doing, she'd put a haunt on them. Something materialised in the premises and all hell broke loose. Comestibles were falling off the shelves — great fun!"

In fact, the root cause is Noreen's frustration and jealousy. Again, Kneale hints at the power of repressed lust. As a visiting manager realises, she has a crush on Colin, who thinks he can solve the problem by promptly sacking her. Noreen returns to the shop when Colin is alone — and the entire stock of the supermarket erupts and pounds down onto Colin until he's dead. "She kills the manager by bombarding him with bottles of HP sauce!" Kneale recalls. "It was funny, but at the same time, terribly creepy." Effectively done, and intelligently played by Quirke, despite some dubious acting elsewhere in the cast, *Special Offer* is perhaps the most traditional story in the set of six, akin to a British version of Stephen King's telekinetic youth tale *Carrie*.

After the spectacle of a poltergeist-inhabited supermarket, the penultimate *Beasts* play, *What Big Eyes*, was a pared-down, performance-based piece, the kind of intimate, character-driven drama Kneale was increasingly moving towards. "It was really a twosome," Kneale says, "directed by a fellow called Donald McWhinnie who was a radio producer. He was very clever: he could

'well, let's do one about a Hammer film.' It was very good. It was authentic!"

It takes place within a down-at-heel British studio facility, during the making of Revenge Of The Dummy, seventh instalment of the long-running series of horror films starring the lumbering, terrifying Dummy. Behind the scenes, and beneath his costume, Clyde Boyd, the actor playing the monster, is knee-deep in trouble (with real-life actor Bernard Horsfall appearing as Boyd). "This creature who's had a very bad time and hasn't paid his Income Tax was really being hammered by everybody, and he was having a nervous breakdown inside the rubber suit. The reason was that he had spotted, through the eyepiece, an actor he had not been told about who was playing a big part in this thing, and who had run off with his wife. The actors did some beautiful stuff as they attempted to get him back on the set. They had to finish that day, *had* to, because their eccentric guest actor was going to go off on holiday to the Caribbean. He would not stay and they couldn't hold him, and without him, they couldn't finish the film. Horror, horror."

Drastic measures, therefore, had to be taken to complete the *Dummy* adventure. "They had to get the chap who was playing the Dummy back on the set in any state, even if he was drunk, just so long as he was there," Kneale explains. "They forced some drinks down him and got him to stagger across and he really blew it. He went mad and accidentally killed an extra. From then on, it was just terror. They were all scared in case he killed somebody else, which he would happily have done, particularly as he was eight feet high. And the producer? Never mind having a murderous drunk on set, his terror is that somehow it'll go over budget..."

With a generous helping of barbed humour, Kneale — who'd always been fond of a backstage drama — was using his own experiences at Bray Studios to satirise the glory days of Hammer. "It was staged just

Scenes from the ITV series, *Beasts*. Episodes (from top): Title, *Baby*, *Buddyboy* and *The Dummy*.

"*Beasts* left a very strong impression on me," Gatiss says. "I remember the titles very vividly — the typewriter thuds of the letters, no music or anything. In those days there was so much really strange, bleak drama on anyway, but even for those times it was a very curious six weeks. *Baby* is, I think, the best. It's probably the most disgusting piece of television I've ever seen! I remember I originally watched it with my mother and we were both just absolutely terrified. What I love about it, something that's just gone from television, is that they were shown at something like eight o'clock on a Wednesday on ITV — prime-time, y'know — these incredibly disturbing pieces of drama. You wouldn't get it now."

Dyson confesses to a similar sense of expectation and fear. "I can remember when *Beasts* was on — I was nine or ten — getting excited about it and knowing that this was by the *Quatermass* man," he says. "I watched them once, and of course they made an enormous impact on me. How often do you have that experience in adulthood, that a monster will scare you or upset you or disturb you? But I could put *Baby* on tonight and it would do it for me. It's kind of softened now by the fact that if you've got it on video you can wind it back and freeze-frame it and have a look, 'what is that?' — which me and Mark have done on many occasions! — but imagine the impact it had at the time it was broadcast in 1976, when it was designed just to go out once…"

The second play, *Buddyboy*, was expertly directed by Don Taylor. Once again, the element of a haunting sneaked in alongside the animals. "Martin Shaw played the lead in that, and was very good," Kneale says. "He'd bought a little extinct dolphinarium to fit it up as a porn cinema. The trouble was, it was haunted — by the ghost of a dolphin. He refused to believe this. He said, 'this is ridiculous. Somebody's trying it on. They're trying to do me out of my rights', and he was determined to stop it. So he said, 'I'll sit here all night and if it shows its nose, I'll finish it off.'"

The unsavoury Dave (Shaw) had company during his vigil, though. "He didn't suffer, but his girlfriend Lucy, who he brought along with him, did. She was somebody who had a special affinity for dolphins. She'd worked there when it was a dolphinarium. She was convinced that this thing existed in a little dolphin pool they had there. She talked to it, and was certain it was there. She got into the pool herself — and drowned in it."

Again, realising the final scenes, with Pamela Moiseiwitsch as Lucy, proved tricky, this time due to basic biology. "I remember it was very difficult to drown anybody, because people float," Kneale says. "If you leap into a small pool and you're supposed to 'die' there, you won't. You just pop up and float, unless you had been hit and knocked out. I remember Nick Palmer thought of how to do it, and that was they put stage weights at the bottom of the pool and when she leapt in, she grabbed them, and they held her down. It worked, and she 'drowned'!" One of the least distinctive of the set, *Buddyboy* was, nevertheless, an intriguing brew of familiar Kneale elements — a ghost, a disbelieving main character, and a rather run-down, unremarkable setting.

Next into production was the most outright comic piece in the series. The butt of the joke was one Kneale knew well. *The Dummy* (originally written under the title *Clyde Boyd is The Dummy*) was, as Kneale himself admits, "exactly like a Hammer film, and it was meant to be! Having seen Hammer at work, I said,

the couple are initially dismissive, the wife grows increasingly terrified that supernatural forces are moving against them.

At the conclusion, in the dead of night, the horrified Jo witnesses the witch materialise in a rocking chair, and suckle the familiar. To achieve this effect, as with *The Quatermass Experiment* long before, Kneale found himself dabbling in special effects again. "We didn't have a familiar, so we got a very, very small poodle as a basis. Nick Palmer and I decided to do the make-up job ourselves. We got little gloves with chicken's claws and put them on its hands and feet, and a sort of mask. He didn't look like a poodle any more." In the event, the director, John Nelson Burton, was against using the shot at all, preferring to leave the witch and her familiar unseen, but Kneale and Palmer were adamant, and shot the conclusion without him.

Curiously, the elements familiar from *Murrain* — a straight-laced vet in conflict with a rural community who believe in witchcraft, and the uncertainty as to which is right — are combined with a virtual replay of *Quatermass and the Pit* in miniature. The builders unearth a mysterious capsule, which is found to contain a peculiar, ancient creature. Supernatural forces seem to be released in the process, and sweep up the inhabitants. As in the earlier serial, Peter Gilkes conducts a post-mortem of the thing, with the assistance of his senior partner Dick Pummery (TP McKenna). The difference, though, was that the practices in *Baby* had a firm basis in fact. "This was a real thing — practical witchcraft," Kneale explains. "It happened: there was such a thing. People who declared themselves as witches would do things like stowing an evil object in a house. The trick was, of course, that although the witch person might believe in it totally, a hardened bunch of twentieth century people wouldn't take it seriously. At least not until something nasty happens which they had not expected..." Kneale approved of the production, even though one of the leads was a last minute substitution to the cast. "Simon MacCorkindale played the awful foolish vet, and he was very good. He was dropped in it in every way, but he was excellent."

One impressed teenage viewer was Russell T Davies, today one of the most acclaimed TV scriptwriters in the country. "I remember how much the writer's name stood out," Davies remarks. "It was trumpeted by ITV as 'by the writer of *Quatermass*'. It's still very rare for any writer to get their name heralded on screen, so that made me sit up and pay attention." Nor was he disappointed. "I loved that series passionately," he says. "I loved the anthology format, the fact that they were on tape, the brash ITV-ness of them." It was *Baby* that struck Davies most of all. "The country setting, where the woman worries about miscarrying her child, and something dark and barren is lurking outside — it's still the most frightening thing I've ever seen. Seriously, I'm getting the creeps just thinking about it. There's a stunning lack of hope in that story. It's doom-laden from the start, and the misery and fear escalates until there's no escape. There's not even a catharsis; just a lingering despair. Powerful stuff."

Two fascinated young viewers, Mark Gatiss and Jeremy Dyson, have become, in adult life, members of the *League of Gentlemen* comedy team. Independently, they'd grown up aware of Kneale's work and reputation, even if they hadn't had chance to see much. Now, here was a new run of Kneale's work, and they were both glued to it — when they could summon up the courage.

IN THE SAME PERIOD, Kneale was celebrated with the publication of three of the scripts to three of his one-off plays, namely *The Road*, *The Year of the Sex Olympics* and *The Stone Tape*. The volume, called simply *3 TV Plays*, was published by Ferret Fantasy, an offshoot of a South London bookshop of the same name, specialising in science fiction, horror and, of course, fantasy, and owned by one George Locke. Each script was prefaced by a brief contextualising introduction by the writer. It became a highly sought-after book, and helped keep his earlier work accessible, in some form, to his admirers. But the writer was keen to keep moving onwards, too.

Nick Palmer, who'd produced *Murrain* for ATV, had developed a good working relationship with Kneale, and forwarded the idea that Kneale might write an entire series for the company. Rather than cover just one story, it was suggested that Kneale write an entire run of six self-contained hour-long plays on an umbrella theme, effectively, a strand like *Against the Crowd*, but by one single writer. Kneale agreed, and selected a favourite theme to address. The series, called *Beasts*, would present various perspectives on the animal kingdom, and Mankind's relationship to it. In doing so, it would illuminate the bestial side of humanity.

The seething, primal animal within Man had long fascinated Kneale and influenced his writing. Over twenty years before, he written a play about a natural history expedition wrecked by scientific curiosity and pure greed — entitled, note, *The Creature*. His dystopian tales — *The Big, Big Giggle*, *The Year of The Sex Olympics*, *Bam Pow Zapp!*, and adaptations like *Lord of the Flies* and *Nineteen Eighty-Four*, all painted a grim picture of a possible future where base instincts are allowed to run riot. *Quatermass and the Pit*, too, tells of repressed aggression and hatred being turned loose. Clearly, Kneale still felt there was plenty to address in this theme. Tellingly, the decision was taken that few animals would actually be seen in the new plays. They would simply be heard, or their presence and influence would be felt, a latent, invisible force.

The key to the project, though, was that there would be a great deal of variety between the six plays. "That was the first thing that Nick Palmer and I agreed on," Kneale recalls, "to make them a different as possible from each other: one would be a funny one, another one horrifying, another one more ordinary." This was a mighty undertaking from the writer, as many new one-off plays over six weeks as the BBC had produced in six years. Kneale relished the challenge, though, and didn't miss his old employers. "I enjoyed doing *Beasts*. It took a year or so altogether. They were well done — quite as well as they would have been at the BBC, and possibly with more enthusiasm. There was some very good acting indeed, and good direction, mostly."

When screened across the various ITV regions during late October and November 1976, the six plays were assigned different slots and broadcast in assorted orders. The first to be made, though, was called *Baby*. Not unlike *Murrain*, *Baby* features a vet in a credulous rural community. The vet in question, Peter Gilkes (played by Simon MacCorkindale) has recently moved into a cottage, along with his heavily pregnant wife Jo (played by Jane Wymark). In the course of renovation work, a pair of local builders discover a pottery container behind a wall. Inside is an unrecognisable mummified creature, which even the vet can't identify. The builders assert that it's a witch's familiar, and although

revenge and do something awful to her."

Struggling against his astonishment, Crich (played by David Simeon) tries to intervene. "The vet did his best. He was not just an ordinary vet — he was an official vet, paid by the council, which gave him a bit of extra power. He was determined to help her so that she was fed and so on. Then he realised that they really hated her. They were determined, if necessary, to kill her, so that all the pigs would get better. So he went to do what he could to stop this. All the farmers' men were set to attack her. The vet was appalled. He tried to wave them back and said 'for God's sake don't make yourselves ridiculous.' Then the old woman popped her head out — and the farmer fell dead. He was an unpleasant high blood pressure person anyway and he was in a state of great excitement, so he fell dead. On the other hand, was there another side to it? The vet went up to the woman's cottage. She looked at him and just said, 'Yes'. And that was it!"

As well as returning to a familiar Kneale theme — the conflict of the rational/young and superstitious/old, *Murrain* harks back to the writer's earliest work — the *Tomato Cain* short stories, such as *The Tarroo-Ushtey*, concerning a remote, old-fashioned community with an unshakeable belief in fabulous creatures and powers. Like those stories, *Murrain* is more concerned with creating a mood and establishing character conflict than scaring the audience out of its wits. Despite its content, there are no moments of terror in *Murrain*, but rather a creeping sense of unease, and a healthy portion of wry humour. Throughout, it's entirely plausible that the strange occurrences might be explained rationally and yet never impossible that witchcraft might indeed be the cause. It's not one of Kneale's best remembered plays, but the writer himself was well satisfied with the result, and ATV were sufficiently impressed to offer him a swift return engagement. Indeed, in many ways, *Murrain* was to be a blueprint for what was to come.

Scenes from *Murrain*.

himself approached to pay homage in print to one of his literary heroes. "I edited a book for the Folio Society who were interested in MR James," Kneale remembers. "They asked if I'd like to make a selection and write an introduction. It was just a respectable sort of publication." The handsome, slip-cased edition of James' celebrated ghost stories — taking in accepted classics such as *A Warning to the Curious*, *Casting the Runes* and *'Oh, Whistle, and I'll Come to You, My Lad'* — included lithographic illustrations as well as Kneale's introductory essay. Kneale writes extremely knowledgeably about James' life and writing, noting that 'dry humour often heightens the frightful' — a technique that Kneale himself was fond of employing.

He muses on the apparent contradiction of James, the level-headed Classical academic, conjuring tales of the unearthly and the petrifying. 'To the question whether the stories were based on his own experiences, James replied no,' Kneale writes. 'Or whether they were versions of other people's experiences — again no. The literal-minded were being given deservedly literal answers. Yet the paradox of James's fiction is that... the haunting horror may have been the truth —about himself, about his inner world. In an age where every man is his own psychologist, MR James looks like rich and promising material... there must have been times when it was hard to be Monty James.' *

At the same time, Kneale was beginning to establish himself as a writer for ATV. (*The Crunch* had been made by ATV eleven years earlier, but hadn't lead to any subsequent work at the time.) His first new play for them, *Murrain*, was directed by John Cooper and broadcast on July 27, 1975, as part of a series of one-offs on the theme of the force of the assembled community, entitled *Against the Crowd*. Set in North Cornwall, it places a rational young vet, Alan Crich, in conflict with a profoundly superstitious farmer, Beeley, and his men. "I was approached for a ghost story or something, so I thought of a kind of is-it-supernatural-or-isn't-it story," Kneale says. "There's a farmer, Mably, a rough creature played by Bernard Lee who was M in the *James Bond* films. He was a superstitious, unpleasant sort and he was having a bad time because his pigs kept dying. He blamed an old woman who lived in a cottage not far away, for being a witch and putting witchcraft on his pigs." This supernatural blight of the animals, they termed a 'murrain'.

The perplexed vet opts to confront the supposed witch, Mrs Clemson (played by Una Brandon-Jones). "The rather innocent vet came in on this and found out what shocking things had gone on, this belief in witchcraft. The poor old woman had no food or anything. She was being shunned by everybody. So he went off to get her something to eat, and was drawn into this extremely unlikely story that she was a witch. She didn't seem like a witch to him, just a batty old woman. He realised that they were really taking it very seriously indeed. The wife and child of the owner of the local store had fallen ill. The farmers were absolutely certain that she'd witched them, and they were determined to have

* It's perhaps tempting to wonder what insight this might provide into Kneale's own work. Why, indeed, does a happily married family man, who professes no serious belief in the supernatural, and dislikes most science-fiction, devote so much of his original writing to exactly such tales?

THE OTHER SIDE

KNEALE'S 'DEFECTION' TO INDEPENDENT television was never front-page material on the scale of, say, Morecambe and Wise's later move, but it was certainly significant that the writer had finally had enough of the BBC. At the time, his influence could be detected, however indirectly, in a whole host of TV series. The mid seventies was a golden age of so-called 'telefantasy' — TV dramas with an unconventional, imaginative bent, often employing elements of science-fiction, and usually, it must be said, aimed at children. From *Sky*, *Doomwatch* and *The Tomorrow People* to *The Changes*, *Blake's 7* and *Children of the Stones*, a slew of fantastical television was on offer over that period. Kneale studiously kept his distance from them and their ilk, but despite his apathy towards such shows, his own TV work had undoubtedly paved the way for them, or else inspired their creators.

Chief among the telefantasy boom, *Doctor Who* continued to thrill generations of young viewers. In the world of the series, the Doctor was granted a reprieve by his people, the Time Lords, and allowed to travel through time and space once more. Not coincidentally, this must also have been a relief for the series' production team, who could now broaden the scope of the stories they could tackle again. Consequently, the rash of *Quatermass*-plagiarising Earth invasion adventures petered out. But that's not to say the show entirely ceased to draw on its illustrious forebear. Actor Jon Pertwee announced he was leaving the lead role in 1974, and his successor was named as theatrically trained unknown Tom Baker. Baker's world-famous interpretation of the role was specifically conceived as a blending of Sherlock Holmes, George Bernard Shaw — and one Professor Bernard Quatermass. Perhaps not surprisingly, this amalgam was partly concocted by the series' recently appointed new script editor, Robert Holmes — previously the writer of the *Doctor Who* story (and *Quatermass II* pastiche), *Spearhead from Space*.

In this new capacity, Holmes found himself hurriedly writing Tom Baker's second *Doctor Who* adventure, *The Ark in Space*, virtually from scratch, when a freelancer turned in a substandard script. Screened in January 1975, it featured a futuristic contingent of the human race in a space-faring deep freeze, who are infected by an alien race that manages to break on board. When resuscitated, the humans find themselves transmuting agonisingly into interstellar hybrids. Strictly speaking, it's *The Quatermass Experiment* in space. For good measure, it's the vestige of humanity in the chief victim that saves the future of the race. (Suspiciously, Holmes, as script editor, also elected to change the title of the following story. Boasting the return of warlike monsters the Sontarans, it was submitted under the title of *The Destructors*. Holmes rechristened it *The Sontaran Experiment*, which certainly has a familiar ring to it.)

KNEALE'S OWN CONCERNS, though, lay elsewhere. For one, he found

But as Jonathan begins to investigate for himself, and seek out his late father's friends, he realises his memories have been distorted by his overbearing mother's hidden agendas. In fact, Duggie was a kind and loving man, driven to distraction and drink by his fractious relationship with Linda. Linda, it seems, never wanted a child, but Duggie doted on him. At last, Jonathan resolves to leave home, and in his imagination he finally makes peace with his much-missed father. In short, precious little of the familiar fairy story remains in the play. Kneale uses a few metaphorical associations from the tale to spin out an entirely new piece. The opening scenes, for instance, see Jonathan on board a train to a university interview, only to be dissuaded from pursuing an academic path by a nosy fellow passenger. This parallels the fairytale, in which, Jack, on his way to market, is persuaded instead into returning home with a handful of magic seeds.

More than ever, Kneale's work was moving away from an emphasis on ideas an towards an emphasis on character. Much like the unrealised *Cracks*, this was a small-scale drama, of troubled families and a problematic childhood, rather than a tale of peculiar events impacting on a wide cast of individuals. More than ever before, Kneale was moving into an area of intimate storytelling where the single human face was pivotal. And yet, Kneale's focus remained the conflict between the old and the young. In the event, though, the BBC's production of the script was a little botched. "They did it rather nervously, but quite well," Kneale considers. "But the series was originated by them, not me." Directed by Peter Ciappessoni, *Jack and the Beanstalk* was broadcast on BBC1 on March 24, 1974, making little impact on the viewing audience.

Once again, Kneale had grown decidedly disenchanted. Over two years, two fully written scripts for the BBC — *Cracks* and the fourth *Quatermass* serial — had been shelved late in the day. Even *Jack and the Beanstalk* had been produced in a somewhat lacklustre fashion. Having not long since reestablished his working relationship with the Corporation, it had now soured again. What happened next wasn't, it seems, especially premeditated or seen as final. Simply, Kneale was approached to contribute a script to a strand for independent television over at ATV. But he accepted the offer — and after *Jack and the Beanstalk* he never wrote another script for the BBC.

people's backs up. This was at a time when Michael was falling out with the BBC. In his time there, he'd made too many enemies, because he knew what he wanted and they didn't like that. They found him arrogant. I suppose, although he wasn't. We knew him well. He needed a lot of reassurance. They don't take chances if they can possibly help it."

Matters quickly came to a head. "Michael quit the BBC. He'd had enough. They just never got on. He was too much of an intellectual for them. I suppose he offended them, trod on toes, but he didn't care. So he left them and went off to establish the Royal Exchange Theatre in Manchester. He was happy running that while things moved on." Unhappily, Elliott's exile from television also meant the end of his working relationship with Kneale. They remained friends, but never collaborated again. (After a stellar career in theatre, Elliott died of kidney failure in 1984.)

It's striking, though, that *Cracks* represents a new direction in Kneale's writing. It's much more low-key and intimate than, say, *The Road* or *The Stone Tape*. It's the characters, rather than the central concepts, which drive the piece. For all the talk of spying and subterfuge, it's the tale of a family, and a young man growing up within it. It seems more personal to Kneale than his previous work. His children were then approaching adolescence, and the family lived by a large common, not unlike the one featured in the script. Perhaps the writer was looking closer to home for inspiration, rather than into wider society. Although the script went unmade, this evolution in Kneale's style would continue on, and he didn't feel the loss of *Cracks* too much. "When Michael left the BBC, it just lay on a shelf, " he says. "One thing dies and another thing pops up. It's no good grieving about the one you quite liked, but which didn't go..."

DESPITE THE LOSS of *Cracks*, his writing was moving inexorably in the direction of more intimate, contemporary material, and the BBC was still finding work for Kneale. Under producer Innes Lloyd, they were embarking on a string of dramas under the title *Bedtime Stories*, wherein children's fairy stories would be reinterpreted as the basis for adult drama. "There was a series of stories based on old folk tales. They wanted one more to fit in, and I wrote one based on *Jack and the Beanstalk* — although there was no Jack and there was no beanstalk. It was all entirely psychological." Kneale was intrigued by the concept, "looking for the truth behind fairy tales, in the theory that there was some sort of adult truth behind every one of them."

Rather than accentuating the fantastical elements of the tale, Kneale used it as a metaphorical framework for a thoroughly modern-day piece. Adolescent Jonathan Weir (played by Martin C Thurley) lives with his middle-aged mother Linda (Stephanie Bidmead), on the verge of leaving home and still feeling the loss of his Father, Duggie (Glyn Owen). Jonathan's memories of Duggie, who died when the boy was only three years old, are muddled and unclear. In flashback, from the child's point of view, Duggie is a towering, cruel man to be feared — a giant. Most of Jonathan's memories involve the boy shunning up a table leg and peering over the top to observe his parents, or of happy times with his mother being disrupted by his drunken, unpleasant father. He even feels that he was partly responsible for Duggie's death.

rather dark — not to mention very costly. "I wrote it, and they just simply found it too expensive," Kneale says. "And it was very expensive, there was no question about that. It required either using or building a Stonehenge, and an awful lot of outdoor shooting, which is always expensive. A lot of extras, a lot of people indeed. I think there also was a feeling against it that it really wasn't what the BBC wanted to say. It didn't suit their image at that time; it was too gloomy. So they decided not to do it. It simply died."

By the end of the Summer, the BBC had shelved the serial. As per the contract Kneale had signed, the Corporation maintained an option to go ahead with it until 1975, but made no attempt to do so. The writer was left with a fully-scripted fourth *Quatermass* adventure on his shelf. In due course, it earned its keep.

In the meantime Kneale's dissatisfaction with the BBC began to stew.

A PROJECT DEAR to Kneale's heart at the time was a project he was developing with a valued collaborator, director Michael Elliott. Working closely together, they devised an experimental one-off piece about a middle-aged couple, Tony and Hana Brice, who make ends meet by passing along classified information, to which the husband is privy in the course of his job, to a foreign power in exchange for money. And yet the story would be told almost exclusively from the viewpoint of the couple's adolescent son Stephen. The boy is experiencing the throes of oncoming manhood, and his parent's mysterious behaviour fits easily into his already perplexed view of the world.

He encounters an older woman, Mary, whilst passing time on the local common, and their friendship develops into a secretive affair. When his parents learn of this, they panic in case the woman might be investigating them, and trying to infiltrate the family home. They announce to Stephen that they are all due to leave the country at short notice; but Stephen passes the information along to Mary. Sure enough, when the Brice family car arrives at the ferry port as planned, Mary is waiting with a contingent from Special Branch — and has them arrested. Kneale called this new piece *Cracks*. "It was a notion Michael Elliott and I had," Kneale recalls. "He was rather taken with the idea. I wrote a script, and he was going to direct it."

First, there was the matter of where *Cracks* might find a home. In October 1970, the BBC had moved *The Wednesday Play* to make way for mid-week sports coverage. Now resident on Thursday nights, the strand was reborn as *Play For Today*, and Irene Shubik — previously producer of *Out of the Unknown* — took the helm. She commissioned *Cracks* from Kneale, with Elliott attached as director. But soon after submitting the finished script, a marked departure from his usual style and subject matter, Kneale was informed that it wouldn't be being put into production. Possibly Shubik was taken aback by the different style in which Kneale was writing. Perhaps she felt uncertain of the content — a tale of everyday, suburban spying, and a schoolboy who conducts an affair with an older woman. But then, *Play for Today* prided itself on tackling powerful, controversial material.

To this day, Kneale believes the BBC had their own reasons for rejecting *Cracks*, namely their strained relationship with the play's intended director. "Michael was never an easy man," Kneale acknowledges. "He always got

and the USA were locked into a space race, and staggering amounts of money were being spent on the ongoing 'Cold War'. In the midst of this, the two superpowers were planning, rather uneasily, to co-operate on a prototype space station, Skylab. Since 1960, OPEC — an affiliation of the world's oil-producing companies — had been putting intense pressure on the Western world over the price of their much-needed fossil fuel resources. Consequently, by 1973, the West was undergoing an energy crisis, and Britain was beset by strikes and power cuts. Many observers predicted that the crisis would worsen, resulting eventually in a total breakdown of society. It was feared that ownership of fuels would spark devastating wars.

The proposed serial would see an elderly, frightened Bernard Quatermass set adrift in such a world, or a near-future extrapolation of it. As society capsizes, the Americans and Soviets would be pouring funds into space exploration, and in his expert capacity Quatermass would be drawn in when catastrophe threatens. Feeling alienated among young people, he would nevertheless long to connect to them. Indeed, Quatermass' only concern is for his missing young granddaughter.

As ever, the conflict of the old and the young was a keen concern for Kneale. At the time, the young people of the West were rejecting the Establishment of their parents' generation that had instigated the war in Vietnam, assassinated world leaders, or else fallen, like Nixon in America, into total disrepute. The young generation elected to turn on, tune in and drop out, often seizing on a drug-enhanced lifestyle, finding their own modes of dress and speech, and embracing New Age spirituality inspired by Eastern mysticism. In fact, the hippy movement was like a more good-natured version of the cult of the Grads that Kneale had conceived in *The Big, Big Giggle*. For this new serial, the writer took the idea a step further, creating a near-future in which young people joined together to call themselves Planet People. This cult would roam the countryside, seeking out places of gathering, from ancient stone circles to football stadiums, in the hope of visitation from an unpredictable white light. By their understanding, the recipients were transported to another, better world. In fact, they were being harvested as field specimens by a far-off alien force. Like the Grads, the Planet People would therefore be — albeit unwittingly — enthusiastically suicidal, and sing simple rhymes to demonstrate their togetherness. But the Planet People would have a darker side, inspired by the grimmer aspects of hippy culture. Like Charles Manson and his homicidal 'family,' a rogue pack of Planet People, under the leadership of the charismatic Kickalong, would be quite capable of murder.

Once Kneale had submitted a full set of scripts, the BBC appointed a producer, Joe Waters, to the production, and began drawing up a detailed budget. It was hoped to co-fund the serial with a foreign television station, an approach that the Corporation was beginning to move towards. During the Spring of 1973, Kneale worked at rewriting the scripts, and the BBC Visual Effects department began shooting test footage. When the Department of the Environment refused permission to use Stonehenge for location shooting, the BBC considered building their own mock stone circle. The budget was now estimated at £30,000. In an uncanny replay of the fate of *The Big, Big Giggle*, the BBC began to grow wary of producing the serial, considering the material

Scenes from *The Stone Tape*.

writing. "I think he does something remarkable," Dyson says. "He strikes a note that's so resonant that it just circumnavigates your intellect and gets you on a much deeper level, which is why *The Stone Tape* is I think somehow greater than the sum of its parts. You watch it and it just has this impact on you, rather like being in the room itself. Extraordinary piece of work."

It was only years later that writer Grant Morrison realised the significance of Nigel Kneale. "Things like *The Stone Tape* were really creepy and very memorable," Morrison says. "Just brilliant images. That scared the hell out of me! I didn't know it was Nigel Kneale for a long time, but then I discovered that loads of the plays that I'd seen had been his stuff, and of course that made sense."

Dick Fiddy admires the piece, but has his reservations. "I've seen it a lot of times now. I can remember seeing it when it first went out and I found it very, very scary then, but far less so now," Fiddy opines. "To tell the truth, I don't think it's aged well. The idea is fantastic, that somehow stone can hold on to personalities or situations and this is what ghosts are. This sort of scientific explanation for the supernatural and mythology is very typical of Kneale's work. I think that really does work still, and it's got wonderful performances — Michael Bryant, Jane Asher, they stand out well — but a lot of it's studio bound, and it doesn't look as good as it might do. I think he's done better stuff."

In some ways the piece is actually a throwback in terms of the writer's development. At a time when he was pushing his writing into new areas, *The Stone Tape* is a refinement of familiar themes, established way back in *Tomato Cain* stories such as *Minuke*, and the radio play *You Must Listen*. It also harks back to the 'teams in peril' format of the *Quatermass* serials. But the writer, by now, was extremely adept at dealing with such themes, and *The Stone Tape* is rightly regarded as amongst his finest achievements. It was first broadcast on the evening of Christmas Day, 1972. Weeks before it had even been shown, Kneale had been commissioned to write a new four-part BBC serial, bringing his Professor Quatermass back to the small screen after almost fifteen years.

THE PRECISE GENESIS of the new serial has grown rather hazy over time. Possibly it had some connection to the fourth *Quatermass* film that Hammer proposed in 1969, although that had progressed no further than early discussions. More likely, Kneale was aware that the BBC were open to the prospect of a return for the troubled Professor, and the ideas behind it had slowly percolated in his imagination. Kneale himself is no longer sure who first forwarded the suggestion. "It's hard to say," he admits. "It was probably in the wind, I should think. My agent may have suggested it to them. Anyway, I thought of a story, and I said, 'Let's make it quite different from the previous three', and obviously it had to be. A lot had happened; it was a different, much seedier world." After all, the key quality of the Fifties serials had been their thoroughly contemporary setting: different, in fact, from one another, despite being set just years apart. This, then, would pitch the Professor into the seventies.

The serial — never formally named, but known variously as *Quatermass IV* or simply *Quatermass* — was to reflect troubled times. Kneale drew on many current events for inspiration. Now Man had walked on the Moon, Russia

that matter. "She was only six then. I'm sure she didn't remember anything about it. She'd grown up a lot!"

It's easy to see *The Stone Tape* as a refinement of the 'haunting' themes previously raised by *Quatermass and the Pit* and *The Road* — specifically, the idea of trying to apply science and reason to the supernatural. There's also a subtle link, buried away on the soundtrack. The array of unusual sounds were tailor-made for the production by the BBC's Radiophonic Workshop, just as the earlier projects had featured the department's experimental sounds. Here, the sounds were provided by a small team — Desmond Briscoe (who had produced the special sounds for *Quatermass and the Pit*) and relative newcomer Glynis Jones. Workshop archivist Mark Ayres suggests, "what probably happened is that Desmond 'directed' the sound project, coming up with ideas and planning it out, while Glynis did most of the actual creative work." Between them, they provided electronic sounds and music for the programme; as Ayres points out, more technology was available to the Workshop that in previous times: "They would have had the EMS synthesisers, more advanced filters and mixing techniques". It's canny of Kneale the storyteller to place such store in the power of sound in the piece, and the sterling work of Briscoe and Jones adds much to the mood of the result. Unlike the earlier Kneale dramas they had worked on, though, this wasn't any sort of rare opportunity for the Workshop to showcase their abilities: the department was now a fixture at the BBC. This new assignment fell between a few episodes of *The Goodies* and *Frontier in Space*, another *Doctor Who* adventure. (Indeed, by this point, the time-travelling Doctor was celebrating ten years on the small screen.)

Kneale declares himself well pleased with the play's use of radiophonics. "That was outside my province, but it was very effective stuff." Indeed, overall, Kneale regards *The Stone Tape* as perhaps his very best work. "Oh yes, it's a good one. I mean, that's not to say its perfect. There were things we could have improved, of course. As always, seeing it again you think, 'Oh God, what a pity we've got that in' or 'somebody's voice should just have been a bit louder there.' But they did it very well."

Kim Newman has vivid memories of seeing the play as a boy — and of being aware of the writer's reputation. "When I sat down to watch it, I knew who Nigel was, which is unusual," Newman suggests. "I mean, apart from, say, Dennis Potter, you didn't tend to know who wrote television." Today, Newman rates *The Stone Tape* as his personal favourite of Kneale's work. "It gets better and better the more I see it," he says.

Writer Jeremy Dyson, from the *League of Gentlemen* comedy team, is in awe of this example of Kneale's imaginative storytelling. "He makes this connection between science and the supernatural, which is such a genius, brilliant thing to do," Dyson asserts. "It's remarkable that it hasn't been done more really, but you know this instinctively as a child, because as a child, if you like the fantastic, you're drawn to both. There was an overlap, and you knew that. But Kneale was the only writer I'm aware of who really articulated that and actually fused the two. Really they're both metaphors for the dark side of the subconscious — forces that are larger than ourselves, within ourselves. Kneale combines the two and uses one to illuminate the other."

For Dyson, *The Stone Tape* represents the pinnacle of this strain of Kneale's

longer to write than unusual, because there was quite a lot of technical stuff," Kneale says. "I remember I went down to the BBC's research headquarters. It was an old country house in Surrey, called Kingswood Warren. It had been, in its day, rather grand, and the BBC had bought it for research and divided it all up into little compartments. They had people there working hard on new developments in television. I just came in as a layman. I was shown everything. It was a lot of stuff about simplifying images on television. Just by turning a knob you could have half as many pixels or something, and turn another knob and half as many again, until you got a thing so simplified it looked like a woodcut. Things like that, which were essential and probably very good things to research. It gave quite a good idea of the sort of place that would fit the story, and then I left it to them."

For the production, the BBC used a location very similar to the one Kneale had visited — one with its own links with research. "They found a very good house indeed," he says, "rather better than the BBC's one, also ancient early Victorian. It had belonged long ago to a woman called Ada Lovelace. She was Lord Byron's daughter. She had long gone, obviously, but what was interesting was that, by pure chance, she had sponsored Charles Babbage. He was the inventor of computers more or less, but at a time when there were no electronics, nothing. He made them out of steel and you wound them up. So that's where they shot it. They used this rather strange and wonderful old house, with its chapels and things, for background filming, with the rest being done in the studio."

Even the researchers Kneale met at Kingswood Warren had an impact on their fictional counterparts. "The sort of impression you got of the folk who worked there was a boyishness," Kneale recalls. "They were very cheerful. It was all rather fun to them, which is a very clever way to go about doing that sort of heavy research. You should be able to take it lightly, otherwise it'll sink you. They were nice chaps — and so we got some very nice chaps for the TV version."

The assigned director, Peter Sasdy, was new to Kneale, but their working relationship was a good one. "Peter was a man I hadn't know before, who had a lot of experience in television, since the beginning," Kneale says. "He was a Hungarian. He worked for Hammer too. That was the only time we ever worked together on anything, and mostly he was happy on his own." With some irony, Sasdy adopted new BBC technology for the play. It was made entirely on video, as opposed to film, and within a few years the technique became standard BBC practice.

The studio sets needed to be populated with convincing technology, which the ever-frugal BBC provided via an internal source. "In addition to their research establishment, the BBC also had another research place somewhere off Oxford Street — very central — where they kept computers," Kneale says. "Now the computers at that time were enormous. They'd half fill a room. They carted one down to the studio very kindly and it was genuine. This was the latest state of the art stuff. It doesn't look very state of the art now, but it was then. Jane Asher, playing a computer expert, had to do a lot of work on it. She was bashing away at this machinery." As a child, Asher had, of course, appeared in Hammer's *Quatermass Xperiment* film, but Kneale was prepared to overlook

you're doing a film script, it's only if you do the final script that matters. These were first draft things. It doesn't matter how elaborately you do it. You say 'here you are — 150 first draft pages, all finished'; they say, 'We're going to shoot it'. And you think, 'They're going to make this one.' Then something crops up. You find they have no money to do it with or they're everybody's enemy or something. And they don't make it and it's very disappointing. There were all sorts of things that I wrote which were never made and that wasn't my fault, because the scripts were bloody good. That's the sad bit, really."

In a similar vein, director Christopher Miles had helmed a passable adaptation of DH Lawrence's novella *The Virgin Gypsies* in 1970, and went on to plan a major version of the same author's *The Plumed Serpent*. The novel follows a grieving widow, Kate Leslie, who visits Mexico and becomes involved with a seductive soldier, and thereby embroiled in the Aztec cult of Quetzalcoatl. Popular film actress Faye Dunaway had been approached to star as Kate, and Kneale provided a full draft script. "It wasn't bad. It was quite a decent script. There were two ways of doing it, so I chose one. Faye Dunaway rang me up one night to try and find out more about the project. She wanted to know what she was letting herself in for. It was a very shaky project. There were too many shaky hands on the wheel."

When the project faltered, a rethink was called for. The director's sister, actor Sarah Miles, was now offered the role of Kate, and Sarah's husband, Cheshire-born screenwriter Robert Bolt — whose credits included *Lawrence of Arabia* — provided a fresh script. "Robert Bolt did the script as a gift to the company," Kneale explains. "There were two ways of doing the script. I'd done one and he could see what that was. The other way was to put all the emphases a different way, which he did very effectively." Nevertheless, after prolonged preparations, the enterprise collapsed entirely.

THE BBC REMAINED keen to employ Kneale, especially as an old friend — Christopher Morahan, who had directed *The Road* and the ill-starred remake of *Nineteen Eighty-Four* — was now in a position of some power. "Chris had risen to be the head of drama," Kneale recalls. "He said, 'We could do with a Christmas play'. I said 'Yes, I could do that.' 'We want a ghost story', he said — in a rather tired way. I said, 'Only if we could do a ghost story which had an altogether different twist — such as going at a ghost with science'. He said 'Oh, yes, let's do that!'"

In many ways, what Kneale was proposing was a modern-day counterpart to *The Road*. A band of people turning cutting-edge technology on a haunting — and the state-of-the-art being confounded and defeated by the ancient and mysterious. "It was set in the home of an electrical institute where they are investigating phenomena and they're working towards developing new technologies. They find they've got a ghost on their premises, and they decide to crack it. And that's what it is - a very, very elaborate sort of ghost story."

The blurring of old and new was developed further by the setting. The company, Ryan Electronics, have taken on a sprawling, crumbling mansion, Taskerlands, as a research centre. As such, the newest technology imaginable is shipped into a building with a great deal of history. In itself, this owed something to the genesis of the piece during the writing process. "It took a bit

away from them. But they certainly had assets in the way of studios, and they did eventually contact serious important actors. In the beginning no major actors would touch them. You couldn't ask someone like Alec Guinness, say, to appear — not on *television*! A few years later that had changed. Then you'd certainly get Alec Guinness. He'd be glad of the job."

Kneale was involved in several abortive film projects at this time. Armenian-born producer Edward L Rissien, based in South Hollywood, invited Kneale to write a film titled *Possession*, concerning suspenseful, supernatural go-ings-on between two upper-class families. Kneale found Rissien polite and agreeable but the script never got as far as being written before the project was abandoned.

Another failed venture was an adaptation of Patricia Highsmith's novel *A Suspension of Mercy*. In this instance, Kneale found himself involved with an inexperienced film producer who'd optioned the book. "A terrible figure had turned up — I didn't know he was really terrible — and saw my agent, and said how would I like to script this story," Kneale recalls. "This was a creature called Wilbur Stark. He was the father of Koo Stark, who became Prince Andrew's lover later on. I think Wilbur saw himself getting into the royal family." In the course of their dealings, Stark left a strong, and far from pleasant, impression on the writer. "Wilbur fancied himself as a great Hollywood producer, but he'd hardly produced anything. I remember he and his long-suffering New York partner Jerry came for a dreadful meal in a very trendy riverside restaurant, the White Elephant. Wilbur had booked a table for himself, Jerry and my wife and myself, and spent the whole time accosting waitresses until Jerry, who was a nice man, buried his face despairingly into his serviette, and said, 'He's always like this.' He once came to our house for a party. He was a terrible figure, a hanger-on."

Nevertheless, Kneale turned in a completed script to Stark. Highsmith's original novel tells of a writer, Sydney Bartleby, pretending to murder and bury his wife, who is actually away on a trip — only to find that she has, in fact, disappeared, and he has become the prime suspect in the investigation. Kneale scripted an adaptation under the new title *Foxy*. "It was a bloody good script actually," he asserts. "Certainly the first half which was the half I spent most time on was extremely good! It was one of those stories that tends to lose its way towards the end — it can't quite decide which way to go — but there were some nice juicy parts. In fact, it would have been jolly good if they'd ever made it, but of course they never did."

Wilbur Stark ended up doing the project more harm than good. "Wilbur loved the script, and was just having a ball! Every time he got a company saying, 'Yes, we'd like to do this,' he said 'I've got to get a deal to do six movies; I've got to be a six movie man.' He'd never made anything at all, so they naturally backed off, saying, 'Thank you very much'. He could have set this thing up easily, but he got so greedy that they all pulled out. They said, 'this man's mind is not on making a film.' His partner was in despair. I can't imagine Patricia Highsmith was crazy about the arrangement either. That's the full awful horror of having anything to do with films."

Such assignments were often unfulfilling by nature, but Kneale had long since accepted that this was merely the way of things in the film world. "When

The Quatermass Experiment. You can never have too much, particularly if it's creepy. That's the time to use as much humour as possible."

The BBC publicised *The Chopper* in the *Radio Times*, with a brief interview with the writer (under the glorious heading 'Kneale on Wheels'). "It's an exercise in the kind of ghost story I wouldn't mind hearing myself", he's quoted as saying. "I find the disembodied hand in a well-lit kitchen much more spine-chilling than bats in the belfry." The piece goes on, 'Kneale himself has never seen anything approaching a ghost, although he's inclined to believe there's something in it.' In fact, the writer has always asserted that he remains incredulous of actual existence of the supernatural. "I've always thought if you actually believed in ghosts you wouldn't be able to write a ghost story," he insists. "I make my hauntings up, I hope. Anybody who believed even a little bit would find it a bit upsetting to write ghost stories, to use it simply as material. And you'd run the risk of letting something loose from inside you that could be more harmful than some sort of spoof."

Kneale's detached preoccupation with supernatural occurrences allows him to deal with certain themes, namely the past, and the repressed, impinging on the present, and the extraordinary materialising in everyday settings. But it's always at one remove from an exploitative approach to such material. Plays such as *The Chopper* are deft musings on the nature of the supernatural — without necessarily agreeing that it exists at all. The *Radio Times* piece suggests 'he's inclined to believe there's something in it', but in practice that's simply a fascination with how ghosts and hauntings might be caused. In his next BBC play, Kneale would address this question more directly.

In the period following his appeal to Director General Hugh Carleton Greene, Kneale's reunion with the BBC had proved to be a mixed blessing. "I was able to do plays for the BBC, but with dwindling enthusiasm," he admits. "It was a bad and bitter time, because I never really made friends with them again. Not the lower orders. Mr Greene was good, but there were a lot who didn't like me at all — particularly as I'd run to the Director General. So I had quite a lot of enemies, and not many friends." As a result, Kneale found himself accepting outside writing assignments, and striking hard bargains with the BBC as necessary. "I did quite a lot of feature film work," he says. "That had advantages, mainly money. I didn't miss the BBC or television at all. I worked out a kind of rule for myself, that the only things I would do on television were originals — and being paid as much as possible. Plus they'd be made my way. The only adaptations I was doing were for films."

In the film world, though, the scripting process was often long and arduous. Plus, it often involved rewriting the work of others, hardly a satisfying endeavour. "When they weren't entirely happy with the script they'd got they'd say, 'could you come in make it right?'" he recalls. "It was the American method, really. Americans never felt they got the script right until about ten people had worked on it. But that wasn't fun to do." His own, rather bold approach was to insist on no further interference with a script once he'd submitted it. "I'd say, 'I'll write this thing for you, but nobody else. I will write it, and you make it.' Certain times they were very happy with that. It didn't apply to television, of course, because they couldn't get people to write for them anyway. Not anybody with any class, anyway. A writer with any reputation steered

were creating a raft of fascinating new work just outside the mainstream, often through single-play strands such as those Kneale himself was now working in. Potter, in particular, became increasingly pre-eminent over the years to come. "I didn't know Dennis Potter," admits Kneale. We never met. What he did was nothing like anything I'd ever written — it's probably much better — and we had no contact. I like his work, though. Not all of it. I thought that at the end, poor soul, he folded up. He couldn't help it, he was ill. But he'd done excellent, very original things and those are what he'll be remembered for." On the other hand, Kneale had decidedly mixed feelings about his contemporaries working in American television. "Paddy Chayefsky was very good," he says. "Someone like [*Twilight Zone* creator] Rod Serling was not my cup of tea, a bit too mechanical."

Kneale himself was continuing to present new work to the BBC. He declined an opportunity to write for the ecological disaster drama *Doomwatch*, feeling unwilling to work within someone else's pre-existing format. For some time, he'd also had an offer to contribute to a BBC2 anthology series, *Out of the Unknown*, which had been broadcasting well-received dramas of an imaginative, fantastical bent since 1965. He eventually came up with another twisted ghost story, combining the ultra-modern with the primal and unknown. It was inspired by the then-current fascination with souped-up motorbikes. Kneale was intrigued by a shop in London's Lower Richmond Road which was selling augmented — or 'chopped' — bikes to the Hell's Angel's community, and understood the possible consequences. "I'd been reading something appalling about a man who had been killed going 180 miles an hour down the M4 on his chopped bike," the writer recalls. "They were very fashionable at that time." The 1969 counter-culture movie *Easy Rider* had greatly popularised biker chic, and Kneale planned his own answer to it.

His script, *The Chopper*, is set in a back-street motorbike garage, owned by one Jimmy Reed, housing the wreckage of a chopper formerly belonging to Pete, a biker recently killed in a crash (another entry in the pantheon of Kneale's reckless, self-destructive youths). "It was a ghost story," Kneale explains. "He haunts the bike, and nobody knows quite what to do." A journalist, Lorna Venn (played by Ann Morrish), gets wind of what's happening and arrives in the hope of covering the tale. Towards the climax, the haunting of the garage gathers pace. Venn realises that Pete's relationship with Reed was far from happy. In fact, Pete used violence to get Reed to maintain his beloved bike, and as a consequence Reed sabotaged the bike and caused the biker's death. The final scene shows the haunted garage erupt, the wreckage of Pete's bike twists around Reed's neck and kills him.

Directed by Peter Cregeen, and featuring Patrick Troughton — coincidentally, not long after concluding his stint starring in *Doctor Who* — as Jimmy Reed, *The Chopper* was broadcast on November 16, 1971, and is something of a neglected gem in the Kneale canon. Once again, sadly, no recording of the piece has survived. It's an economical, effective piece, using the 'poltergeist' device of *Quatermass and the Pit* in a far more intimate, enclosed setting. The terrifying events are balanced by a very light, human tone. "It was quite a funny little play," Kneale asserts. "They had some nice actors who were good at comedy doing it, in a kind of dry way. I'd always used humour in things, right back to

FALLING OUT WITH AUNTiE

WRITING WAS KEEPING THE ENTIRE Kneale household busy at the time. Kneale's wife, Judith, wrote and illustrated another children's book, *Mog the Forgetful Cat*, which was first published in 1970. The Kneale family were great cat fans, and a succession of feline pets had prowled their home. The loveable Mog was something of a tribute to them, and was dedicated to 'our own Mog.' The family home is recognisable as the illustrated setting: the young son is called Nicky, and the daughter Debbie, borrowing the middle names of the Kneale's children, whose own real toys can be seen littering the pictured floors. (Similarly, the family name is Thomas — and the bushy-eyebrowed Mr Thomas may look quite familiar.)

Like *The Tiger Who Came to Tea* before it, Mog grew to become a children's classic, and over the next thirty years, Judith embarked on a whole series of books featuring the adorable cat. She also decided to branch out into prose for older children and adults. Many of her friends had encouraged her to write about her own extraordinary childhood experiences, as a fugitive of the Nazis. The end result, published in 1971, was the barely-fictionalised *When Hitler Stole Pink Rabbit*; the German Jewish main character, nine year old Anna (itself an echo of Kerr's own first name, Anne), has a brother, Max, and her father is a famous writer and broadcaster. Her Father vanishes in secrecy, and her mother ferries her and Max from Germany in great haste, so that the family can escape the Nazi regime and be reunited in Switzerland. They continued to stay on the move, and flee through Austria and France. Kerr herself has suggested that the book was written partly to explain her own childhood experiences to her husband and children.

The novel, which Kerr dedicated to her own parents, was a tremendous success, explaining the day-to-day reality of the war in a vulnerable, human way. In the years that followed, Kerr wrote two further volumes of the story, *The Other Way Round* and *A Small Person Far Away*. Their popularity stretched even beyond English-reading audiences. "She wrote them in English, of course, but they were translated into German and became best-sellers," Kneale says. "Rather to the astonishment of older Germans, who saw the name Hitler printed on them, and could not believe it. But there was the curiosity. Children wanted to know more of what had happened, and their parents would not talk about it. Here was a book that explained what it was like to have to leave your country or you would get killed. It was hugely successful. Sales were not just in thousands, but in millions." As such, the Kneale family found itself with two acclaimed writers as breadwinners. Indeed, Judith's success quite outstripped that of her husband.

THE 1970s WERE SOMETHING of a golden age for television dramatists. The likes of David Rudkin, Jack Rosenthal, David Mercer and Dennis Potter

the end they go, and the producer says 'thank you very much...'"

The production, directed by Gilchrist Calder, was greatly appreciated by the writer. "I rather liked it, " Kneale admits. "There were some very creepy good performances. Once they'd got the hang of it, it was extremely good. Brian Blessed, who you wouldn't think of as very spiritual, was the lead." The nerve-wracked Julie was played by Scots actor Annette Crosbie. As Margaret, the on-screen wife of *One Foot in the Grave*'s Victor Meldrew, Crosbie became a TV comedy star in the 1990s.

Wine of India had proved to be another bold, memorable piece of television drama. In all, Kneale's working relationship with the BBC was enjoying something of an Indian summer. Sadly, it wasn't to last.

any harm, officer. I really do believe that children adore that sort of thing, and it's healthy. That's why fairy tales are still so powerful. They're really frightening, and it's lovely. It's part of the process, and it's not necessarily a bad thing to do."

KNEALE'S NEXT WORK was another futuristic tale, *Wine of India*, broadcast as a BBC *Wednesday Play* on April 15, 1970. In a funeral parlour, seemingly cross-bred with a television studio, a couple, Will and Julie, are joined by a gathering of friends to raise a toast to their happy lives. By the end of the play, the couple are to die. In an over-populated future, organ transplants and advances in medicine allow people to live long, healthy lives; but there has to be a limit. Once again, Kneale was extrapolating a foreboding future from developments in the present. "At that time they seemed to be going ahead with doing heart transplants and liver transplants, new knees, new hips, everything," Kneale says. "They could keep people going far beyond what they should have. How did you deal with this? Otherwise they'd all be living far too long. You had to get rid of them at a certain point. The civilised answer to that was at some kind of early stage, say their twenty-first birthday, they would have a huge medical, and have all their organs tested. They then signed a contract that would last, say, 100 years, in which they would enjoy perfect 100 per cent health. The catch was that all of your descendants looked the same age as you. Nobody looked any older than anybody else. They were all living their long lives quite happily, to the age of 120 or whatever. When your contract came up, you must surrender yourself and be quietly put to death."

The ceremony itself, then, enables the characters to be present at their own funeral. "You get a gathering of relatives, who all look the same age, except they aren't. They've all come through to celebrate your going. They all chat very politely because they're never going to see each other again. It's a party, and they have farewell drinks, of wine of India. At that point, India didn't produce any wine at all."

The whole event, then, is about the staging. "What you do is, once your number is up, you go to the funeral parlour and meet the people who are going to do you in. The undertaker, in effect, is the producer. You never see him again, and the party is lead on. You will meet all your people and then you will be the last to leave. When the guests arrive, the producer takes over. You don't see him, he's behind the scenes, watching through electronics, carefully making people don't get too upset."

The intention, indeed, is to make sure all concerned stay buoyant, and demonstrate their understanding of why this arrangement is necessary. In this particular case, though, trouble brews when the condemned wife, Julie, begins to panic openly about her forthcoming death. "She's speechless, " Kneale explains. "She's not sure she can go through with it. Quick as a flash, the producer brings in a lady of the same age, but who has never had any treatment. She looks as old as God. They're all terribly shocked. This is what they'd just escaped. They had never looked like that. They all look at their prime of life, but this old thing looks about 115, which she is. She's bustled out after having shocked them all stiff, and they're so glad to be going. Anything can happen to them now, they've got the nerves for it. They don't want to be like her. At

Whether the idea was actually mooted or not, the end result was the same: *Quatermass* did not return to BBC TV at the dawn of the seventies. And since nothing came of it, the matter's not of great significance in the story of Kneale's career.

But then, there are echoes of this situation elsewhere. Kneale was, of course, actively thinking about a fourth *Quatermass* serial already, after Hammer's approach. Perhaps ideas for such a tale started to coalesce the more he was asked about it. Indeed, within a few years, the project would get a firm footing at the BBC. Strikingly, though, *Doctor Who* did indeed continue on into the 1970s, seemingly because there were no concrete plans for its replacement. But in surviving, it drew more from *Quatermass* than ever before. The series returned in January 1970 — now in colour, and with Jon Pertwee as the new star. The first story, *Spearhead from Space*, featured a swarm of meteorites falling to earth, each containing fragments of a gestalt alien intelligence, gathered together and housed in a secretive factory staffed by zombie-like humans. The opening sequence showed a radar tracking station following the meteorite's descent. The story's writer, Robert Holmes, was gleefully referencing — to put it politely — *Quatermass II*, in specific detail, too. Indeed, Doctor Who adventures from the early seventies are awash with recycled *Quatermass* plot devices: space missions hijacked by aliens mid-flight, with a very different crew returning; an oil refinery as the setting for life-threatening activities... The 1971 story *The Daemons* features a televised opening of an ancient burial mound which turns out to contain an alien spacecraft, whose dormant crew use technology which Mankind has come to know as magic... As Kneale himself has said, "I once switched on a *Doctor Who* and practically heard my own dialogue!"

Although Terrance Dicks makes light of the similarities, his then assistant script editor, Trevor Ray, has been quite candid about his intentions. In an interview in *Doctor Who Magazine*, Ray said "When I had to talk to writers, I said to them, 'Look, what we need with this is to make it more like Nigel Kneale — you know, *Quatermass* — because for that, traffic stopped. People got out of buses to watch it in shop windows." Ray duly decided to check back on his influences. "I thought, 'I wonder what it looks like now?' So Terrance and I went down to Elstree and watched one of the 16mm copies they had — and within ten minutes we were lying on the ground drumming our ears! It was just so awful!" (Dicks himself is dismissive of Ray's tale. "Well, he may have been [unimpressed] but I wasn't!")

Mark Gatiss, a lifelong fan of both Nigel Kneale and *Doctor Who*, has no doubts about this cross-fertilization, though. "Whether they acknowledged it or not, they cribbed an awful lot of stuff," Gatiss asserts. "For a lot of people from my generation, their first experience of *Quatermass II* was probably [*Doctor Who* story] *Spearhead From Space*. To me, it's perfectly healthy. If you think of it as more of an homage, then it's alright, but I can understand why he loathes all that."

Nevertheless, Gatiss feels Kneale may have been a little too hard on *Doctor Who*. "It's always intrigued me that, for a man who's so brilliant at scaring people, he has this thing about *Doctor Who* 'bombing the tinies', as he calls it. I have to say, much as I think he's an absolute genius, I really disagree with him, because I think healthy scaring is what it's all about. It never did me

Rumours have long circulated that Kneale was approached by the BBC at this time with a view to bringing back Quatermass as a replacement for *Doctor Who*, although Kneale himself is adamant that no such discussions took place. (It is known, however, that BBC producer Irene Shubik approached the writer about a potential return engagement for Professor Quatermass back in 1965, which came to nothing, and might just have been the source of the legend.)

But then, arguably there's no smoke without fire. Such stories are familiar to figures including members of *Doctor Who*'s production team at the time. Writer Terrance Dicks, then the programme's Script Editor, is a declared admirer of Kneale's writing. "I used to watch the first *Quatermass* serials when they were on television," Dicks says. "I think everybody did, they were a huge success. I was a fan, absolutely." When Dicks, and new producer Barry Letts, joined the series at this time, it had been steered into a new direction by their predecessors, Peter Bryant and Derrick Sherwin. For reasons of sheer economy, it was decided to set more and more stories in present-day Britain, with the good Doctor repelling alien invasions. To this end, Bryant and Sherwin had devised a secretive army division, the United Nation Intelligence Taskforce (or UNIT), that could assist the Doctor in his work protecting the Earth. The relationship between the peace-loving scientist and the military, personified by UNIT leader Brigadier Lethbridge-Stewart, would cause friction at times, though. In other words, the whole formula owed a considerable debt to Kneale. UNIT had made its debut in the 1968 story *The Web of Fear*, in which the London Underground has been deserted because of the menace of fearsome Yeti creatures animated by an alien consciousness. (In itself, this was a sequel to an earlier story from 1967 called *The Abominable Snowmen*, about the gentle Yeti roaming the Himalayas and an eerie Tibetan monastery…)

"I remember seeing *Quatermass and the Pit* in the cinema," Dicks recalls, "and I said to [producer] Barry Letts, 'it's a UNIT story. They've even got a Brigadier.' But I don't think anybody ever said, 'let's go out and copy *Quatermass*'. A science fiction story with some kind of alien influence coming to Earth is bound to be like it, isn't it? Setting up UNIT was a result of trying to recreate *Quatermass*, in a sense. Those stories are very *Quatermass* in style, but it's partly just genre. If you've got normal Earth human life, and some kind of alien influence coming in and people not being sure what it is, or not believing what it is, the resemblances are going to be there. He was writing science fiction stories set on Earth and at other times so were we. It's kind of like saying two Westerns are going to be very much alike. Well, of course they are, you know?"

Contrary to Kneale's recollection of events, Dicks understands that, with *Doctor Who* in crisis, Kneale was invited to discuss the possibility of reviving his own Earth-saving scientist. "I have a memory that when they were thinking of taking us off, there was a plan to turn *Quatermass* into a series," Dicks says. "That they made approaches to Nigel Kneale to try and get the rights, so that there would be a weekly series called *Quatermass*, and this never came to anything. But others deny strongly that this ever happened. It's just a matter of whose version you believe, but I think he was approached and came in to discuss it over lunch, and either they couldn't get the rights or decided not to go ahead with it."

life and soul, and now a shell of a man — and finds lodgings in his house. "He simply has to be there," the writer says. "He has to *watch* it. He's obsessed with this broken creature that he has created."

The play suggests that Arkie's woeful understanding of violence and its effects stems from his avid reading of comics. Indeed, the attack itself is the gang's attempt at recreating a comic strip. Kneale wrote the script for BBC1's now well-established drama strand, *The Wednesday Play*, and, in recognition of the idea's roots, entitled it *Pow! Bam! Zapp!* (In pre-production, this was changed to *Zapp! Bam! Pow!* which, if nothing else, trips more easily off the tongue.) The director was Bill Slater, later a BBC drama executive, who had worked extensively on Russian productions, "very lavish things like *War and Peace*," Kneale recalls. "Bill was put on that as assistant director because he could speak Russian and so he could communicate between the director and the actors. So after he'd said all this Russian, he came and directed *Bam! Pow! Zapp!*" In the key role of Arkie, Slater cast a talented newcomer, later to become a famous face. "We had Robert Powell, who had never done any television before," Kneale says. "He was very good. After a time he came to play Jesus, and became rather spiritual. He suited that kind of part. He was a good actor, and a nice man."

Bam! Pow! Zapp! is one of Kneale's lesser-known plays of the period. To a degree, it reflects a gradual shift in emphasis in his writing. In the days of his collaborations with Rudolph Cartier, Kneale's work often pushed the medium to its limits, with bold and ambitious ideas. Famously, the writer railed against the accepted wisdom that the small TV screen worked best with 'intimate' dramas. And yet, in the years to come, Kneale became increasingly pre-occupied with smaller-scale drama, driven by characters as much as ideas. The writer always displayed an aptitude for fine character writing, but the emphasis in, say, the *Quatermass* serials and *The Creature* was elsewhere, on the plot and the concepts driving it. Often, he had dealt with teams of characters facing peril. In plays such as *Bam! Pow! Zapp!* his writing evolves into more low-key meditations on the social climate of the present and, thereby, the near future.

As the sixties drew to a close, Kneale's old nemesis, *Doctor Who*, was facing a dire crisis. The series had been running for six years. Initially, it had been a huge success, thanks in considerable part to the popularity of the Doctor's pepperpot arch-enemies, The Daleks, as created for the series by scriptwriter Terry Nation. The Daleks' celebrity was such that it threatened to outstrip that of the show that spawned them. Indeed, when the Doctor himself, actor William Hartnell, elected to bow out from the role, he was simply recast (or, as the series itself explained it, regenerated) — itself an eerie echo of the ever-changing face of Professor Quatermass. His successor, Patrick Troughton, made his debut in a story alongside the beloved Daleks, and the change of actor was duly accepted. But in the years since, the popularity of the show began to wane, and ratings figures fell. Terry Nation decided to remove the Daleks from the series altogether, and tried — but failed — to launch the creatures in their own series for American television. Soon after, Patrick Troughton announced that he too would be leaving the role. It was felt within the BBC that this was an opportune moment to draw *Doctor Who* quietly to a close, having reached the end of its natural life.

and had this meeting. Nobody knew what this meeting was supposed to be about, so I found myself telling the whole story of the film. It took about an hour or two just trying to explain what the thing was supposed to be about and how I'd written it and why. I was left to do all the explaining, which was quite fun actually. I didn't mind that a bit." During the meeting, the two moguls took the opportunity to get the measure of each other. "For the first time Ransohoff and Ponti had worked out that they would have to work together — you know, major producers, each was snatching at his dignity. Ransohoff discovered that he could translate Ponti's name as Charlie Bridges, and that lit him up. He said, 'Oh, that's fine! *Now* I know who you are!'"

It was all to no avail. Despite the money that had been spent, the massive production ground to a halt. Kneale hadn't been the first writer to work on the project, but he felt he'd delivered a workable version. "I'd written this script which was a perfectly viable one," he says, "but they were all up in a huge studio set up in Rome, which was totally empty. Nothing was being made. All the crews and staff were in despair, they had nothing to live on. The idea of doing a big scale movie had them all lit up. They were absolutely high on it and there was great joy. They all believed it could happen but it didn't. Gloom, dreadful gloom." The entire Kneale family had been geared to moved to Rome for the duration of the massive project, but it was abandoned. *

Throughout his experiences in the film world, Kneale came to realise that his role as writer wasn't as valued as it had been in the earlier days of television. "In the old days you were kind of expected to go along and keep as close to the project as possible," Kneale remembers. "There was nobody else to offer useful suggestions, so the writer was useful. But as you got this huge gap between finishing the script and the actual filming, which could be a year later or more, the writer was way out of it. By that time they could probably hardly remember what it was about, so was less and less useful to the enterprise! It's the people who come in last who are most useful, because their brains are still bubbling with it."

SHORTLY AFTER, Kneale found himself back at the BBC, writing another new television play. It was a further exploration of favourite themes: the alienation of the younger generation from their elders, and the proliferation of senseless violence. "It came about because I was offended by the youth cult at that time, which was going fairly strong," Kneale explains. "This was about a little group of youths who decide to perform a very low-scale robbery with violence. They batter some wretched clerk in a back alley who's carrying sums of cash, and give him serious brain damage." One member of the group, Arkie, finds himself becoming obsessed with the consequences of the attack. "He was just a tearaway who was drawn into it by bad companions," Kneale says. "He'd helped to steal, but was then struck by a fierce conscience he didn't even know he had." As a result, Arkie seeks out the victim, Walter Trapnell — once the

* *Tai-Pan* did eventually make it to the screen in 1986, with the daughter of another legendary Italian producer, Dino De Laurentiis, in change, but with an entirely new and utterly unremarkable script.

AT THE TIME (and prior to the recording being wiped), the success of the new play represented a reactivation of Kneale's relationship with the BBC. While further TV work was being planned, the writer accepted another major film assignment. It was another adaptation, this time of James Clavell's blockbusting 1966 novel *Tai-Pan*. Set in the 1840s, the book concerns one Dirk Struan, a trader, smuggler and pirate struggling to develop Hong Kong into a colony of the British Empire. The film project was the brainchild of enterprising American producer Marty Ransohoff, who arranged to bring in to the screen in collaboration with Carlo Ponti, the legendary Italian producer (and husband to Sophia Loren). There was one large stumbling block for this partnership, however. "They'd never met," Kneale says, "but they communicated by whatever means they had and said, 'Let's set up this big scale oldie about the founding of Hong Kong.' From then on it was all hell, really! All I got out of it was a very fat contract, and visits to Carlo in Rome."

Most of Kneale's visits were in the company of the assigned director, British film industry stalwart Michael Anderson. Kneale and Anderson's previous dealings had been less agreeable: back in 1955, Anderson had directed a film version of *Nineteen Eighty-Four*, of which Kneale had been openly critical. "After our version, the film came out, which was spoilt by a number of things. For one, they gave it a sort of happy ending to comfort people. Little hands grasp each other in eternal love, which is not the way Orwell meant it at all. When it came out I remember being hauled by Malcolm Muggeridge in to do a live denunciation of it, on the telly. Michael Anderson was there, and Michael and I argued the toss. I said, 'What you've done is, you've turned the story into exactly what Big Brother would have approved of. You've killed it.' Poor Michael looked put out, because he hadn't intended to kill anything. He was the gentlest of people. He'd simply been overridden by the money men [affects American mogul accent]: 'We've gotta have a happy ending!' And when we worked together later on, we got on very well!"

Kneale and Anderson were impressed by the plans for *Tai-Pan*, but equally, the writer was aware of a certain reluctance on the part of the producers. "You could see money being spent in every direction — except that Carlo was really basically mean," Kneale says. "He just really never wanted to spend a lot on it. They didn't want to go to Hong Kong, even if they could, because the idea of taking a whole crew there feeding them and keeping them for months was too much for either the Americans or the Italians."

Somehow, the film had to feature a convincing version of 1940s Hong Kong. Ponti's solution was rather unconventional. "Carlo said, 'Well, we could shoot it in Sardinia.' Everybody was taken aback and said, 'Wait a minute, Hong Kong is very high and steep, and Sardinia isn't.' And he said, 'Ah, but if we shoot at the right angle, it will look OK.' So they all went off. I came back home to do some writing on it, and the whole crew went there, and they were all terribly ill. They got back to Rome in a terrible state, quite disabused about Sardinia."

As the fruitless project rolled on, an important summit was called. "They thought it might be a good idea that the producers should actually meet," Kneale says. "Ransohoff went to Rome to meet Carlo Ponti for the first time and see what they'd spent their money on. We all assembled in Carlo's office

of the door.' And so they did. They got a BBC commissioner to pop into the studio, grab one of these creatures. He hauled him very visibly and rudely all the way down to the front entrance, led him to the main gate, and threw him out, literally, bang. And that stopped it. No more trouble."

The entire production was imperilled as a result of the delays, though. "In the meantime, we'd lost days," Kneale says. "I remember they all came back to our house — Leonard Rossiter, Brian Cox and the others. They all just sat about here in acute gloom wondering if they'd ever finish the thing, because there was no logical reason that they should be able to. The studio time was now lost, gone to some other show. There was the question of cost. It was a kind of stand-off for some weeks. They then decided to go ahead with it, get Leonard and Brian and the others back, and finish the thing. And it looked very, very good."

The finished piece was extremely elaborate, and Kneale's script teemed with ideas. The designers had taken up the challenge and fashioned an entire future world, sets, gaudy costumes and all. "It was a very splendid show," Kneale concurs." It looked marvellous on the screen. The BBC were terribly pleased with it." It took full advantage of being shot in colour, too, with vivid gold make-up being applied liberally to the actors. In a fulsome contemporary review, TV critic Nancy Banks-Smith remarked, 'If you didn't see it in colour, you didn't really see it.'

Of course, colour TV sets were far from common at the time, and only a portion of its audience saw *The Year of The Sex Olympics* as it was intended to be seen. Nor would they have much chance to subsequently. After its debut screening on July 29, 1968, it was repeated just once, under BBC1's *Play For Today* banner in March 1970. Then it was lost forever.

"What had happened behind the scenes was, they wiped it," explains Kneale. "They showed it once more, and then they had destroyed the colour film. A great pity. They were wiping old *Steptoe*s and Tony Hancock and God knows what else. Comedy series were particularly picked on. There were a very active lot of destroyers at that time, wiping and wiping. They kept checking through those enormous cellars they had, looking for titles. They'd say, 'Oh, nobody'll watch this.' Within seconds it was gone. So easy. Such a sense of power."

Many classic television shows of the period, from drama and comedy to variety and music, are now wiped due to basic economics. Once it was safely assumed a recording was of no further use, the BBC would record over the tape. Kneale claims that prolific TV director Don Taylor, known for his socialist leanings, was a particular victim of this policy, and suggests the pattern wasn't accidental. "It was probably semi-political," he says. "Some wretch somewhere trying to please his masters by letting them know that he'd wiped some left wing serial. You'd get an MBE for that…"

Happily, a 16mm print of *The Year of the Sex Olympics* has surfaced in recent years. Sadly, it's only a b&w copy. It can be seen, then, but, according to Nancy Banks-Smith's review, viewers today aren't really seeing it. It lacks the colour designs which were, ironically, an integral part of the effect. The world of the play is intentionally garish and strident, a barrage of reds, greens — and even gold face make-up. The existing monochrome versions present a grey world, which rather spoils the effect.

with in the theatre. "Brian was outstandingly good," Kneale says. "I think it was one of the first television performances he'd ever given." TV regular Leo McKern, later most famous as the star of *Rumpole of the Bailey*, was offered the senior role of Coordinator Ugo Priest, but was unavailable. Instead the part went to Leonard Rossiter, then a familiar face in stage and TV drama, and later become an acclaimed sitcom actor during the 1970s.

But such a complex production was never going to run smoothly. "It was a funny piece," Kneale says. "It was a nightmare just to have contemplated doing it, and they had every possible trouble." The first hurdle was the formidable Mary Whitehouse, president of the National Viewers and Listeners Association, and the self-appointed watchdog of morality on British television. "She somehow got hold of a script," Kneale remembers. "There was always some little spy ready to slip her things. I don't think she'd read anything but the title and said 'this must not be put on! I will have the producer sacked!' She went after the producer, Ronald Travers, who was a nice, rather quiet, self-effacing man, and she did her damnedest to get him booted out of his job. However, she was overruled."

BBC Director General Hugh Carleton Greene had a zero tolerance policy towards Whitehouse's interfering. Nor, it seems, was he a man to suffer troublemakers in the studio. "We got into the studio to do this very tricky thing and they started an electricians' strike," Kneale says. "There were creatures wandering around among the actors, with long poles in their hands to adjust the lights above their heads. They were deliberately wandering where they would be most trouble, so if Michael tried to shoot stuff they would wander around obstructing. In the end the producer said 'this can't continue; we'll never get it finished and it's being spoilt.' He went to see the Director General who said 'take immediate action. Get one of these people and throw him out

Scenes from *The Year of the Sex Olympics*.

It's hard not to be bowled over by the astonishing prescience of the reality TV concept, which Kneale postulates here a good thirty years before it became a real-life TV scheduling staple. A lesser talent might have opted simply to satirise the then-current hippie movement, but Kneale chooses to work on a wider canvas, extrapolating from late sixties permissiveness to consider its ultimate consequences. In a society where everything is permitted and nothing is taboo, life loses all stimulation, all discipline, and life becomes painfully drab. When lived at one remove — via a TV screen — the two most powerful forces acting on Mankind, sex and death, are reduced to being nothing more than light entertainment.

It's striking, also, that the play constitutes Kneale's first attempt at tackling the issue of sex. It's surprising, for a writer of Kneale's ability not to have dealt with such a major theme before. Of course, television drama of the fifties and sixties didn't much allow for such matters to be handled, much less shown. But much of Kneale's work steers entirely clear from romance. Professor Quatermass, for instance, never has much in the way of love interest, although much of his work is concerned with that other great theme, death. Of course, even *The Year of the Sex Olympics* isn't actually about sex. It's simply one of the human drives that are numbed in the world of the play. Just having the word in the title, though, would cause problem.

The initial idea came from two popular theatrical productions of the day. The full frontal musical *Hair*, and the risqué revue *Oh! Calcutta!* which Kneale was invited to see by its instigator, Kenneth Tynan. The writer began to consider what the benefits might be of a society saturated with explicit pornography. "It was written at a time of people saying 'Let it all hang' out 'Let's have lots of porn,'" he recalls. "I thought, 'OK, but where do you go with porn? You've got to show everything, all the days and all night,' and the reason for that would be to calm the population. If they got too lively and had lots of children, this would cause a huge population explosion. But if they've got it all on television, why try? They're sat watching happily and if they're fed, they'll just carry on being couch potatoes. But suppose you did have that: how long would it last? Some of them would get sick to death of television. A lot of them were dying of boredom. That was the story."

The production reunited Kneale with an old accomplice. "Michael Elliott directed it. We'd worked together a couple of times. He was very keen to do it, and helped raise quite a lot of money. They shot in colour, which you couldn't always do then lightly. And not only in colour, but using Eidofor, a process for replacing scenery with electronics. Michael used it on a big scale, which I don't think they had ever done before." For the scenes of the savage island in the play's last stages, Elliott undertook some location filming, under close advisement from the writer. "Michael went over to Isle of Man to shoot stuff there because they needed a cold desert island. I already knew the locations, and could direct him there. He shot stuff which was made to match exactly with what they had in the studio later."

For a time British film icon Tom Courtenay was lined up to appear as Lasar Opie, but at the last minute he elected instead to star in a major stage production of *Hamlet* — and for his troubles, received some of the worst notices of his career. In his place, Elliott cast a newcomer, Brian Cox, who he'd worked

field, the anarchic Monty Python troupe — natural successors to the Goons — are known to have had been boyhood admirers of Kneale, too. When asked to select his fondest memories of television for an eightieth anniversary edition of *Radio Times*, Monty Python's Michael Palin declared, "*Quatermass and the Pit* terrified me, but in a thrilling way."

It's easy to see why those classic serials would resonated so strongly with the baby-boomer youth, and the hippie generation in particular. They depicted a world where the vastness of space, cutting-edge science, and supernatural forces all blend into one almost cosmic whole. It's a world of terror, paranoia, and bizarre occurrences and creatures. Stored in the memory of a stray child viewer, its natural later use of psychedelics might summon up experiences on a trip that seemed not entirely dissimilar. And a casual examination of psychedelic writing finds the likes of Owsley Stanley and Terrence McKenna espousing alternative theories of human evolution that contain such familiar elements as an alien consciousness sending plants and fungi to Earth that can seriously transform anyone that comes to sample them. All three BBC *Quatermass* serials can seem like coded versions of the same theories — although there's no doubt whatsoever that the coincidence is accidental.

Writer Grant Morrison feels that counter-cultural ideas are peppered throughout Kneale's work, however unwittingly. "There's a lot of altered states, hive minds and alien intelligences controlling the population in his work," Morrison suggests. "There was a real psychedelic sense in that." Similarly, CP Lee argues that Kneale actually shares many of the concerns of the youth movement. "Acid was first synthesised on the same day that they realised that the atom bomb would explode. There used to be this big hippy idea that Mankind was offered these two things, one that could destroy the world and one that could save the world." Additionally, Kneale admired Aldous Huxley, a favourite author within the counter-culture. Having predicted the more destructive elements of Flower Power in the *Big, Big Giggle* — only for the viewing public never to share it — Kneale examined the resultant 'new permissiveness' in his latest work.

The Year of the Sex Olympics is another of Kneale's dystopian fantasies. It's a pivotal piece in several ways. It's Kneale's first fully-realised venture into speculative, futuristic writing, indicating that he was moving in the direction first heralded by the *Big, Big Giggle* script. It depicts a society saturated by insipid light entertainment and jaded beyond all belief. Television is king, and it broadcasts the worst kind of common-denominator bilge. Live sex is broadcast with competing couples, until, as Kneale suggests, it resembles *Come Dancing*. Children's viewing is basically the same, but milder. Such programming is intended as a social placebo, numbly distracting the viewer and blunting their sex drive at the same time, thereby keeping the population down. The drama takes place at a station struggling to get any response from the viewers to keep them watching. Quite by accident, a death takes place on air — and viewer response is overwhelming and favourable. The studio heads, quick to spot an opening, launch a new programme. The Live Life Show features a real-life couple on a deserted, barren island, and follows their struggle twenty four hours a day. To keep the viewers keen, and without the contestants' knowledge, the studio bosses have shipped a deranged killer to the island, too.

you were a fan of *Quatermass*. Well, can you help me?' And he did. He was an excellent man, a journalist, and he took the side of the writer, which nobody had ever done. He went off and persuaded them to produce £3000, which was an enormous sum of BBC money, but with the strict proviso that it was understood that there would be no more. And that that most that their arm could ever be twisted."

While hardly sufficient recompense for the humiliation he'd suffered, Kneale recognised the effort involved in Greene's gesture. He agreed to the new BBC assignment after all, and found himself going on to write a string of new TV plays for the Corporation, the most concerted run of original work in his entire career. To start with, for the colour BBC2 production, Kneale looked for inspiration, as so often before, in the mores of contemporary society.

THE LATE SIXTIES was an amazingly fertile period in Western culture. The post-War baby-boom generation, having reached adulthood, were injecting fresh ideas into all spheres of Society — fashion, architecture, music, film and television… indeed, it looked as though new thinking might overwhelm established lifestyles entirely. The youth movement — call them Hippies, call it Flower Power — were turning on to drugs and expanded consciousness and duly dropping out of straight society. They sported their own sense of dress — bright, psychedelic colours and exuberant designs, kaftans, flares and long hair; their spoke their own lingo, freely sprinkled with the phrases cool, far-out, man, acid, high… they embraced hallucinogenic drugs and casual sex as part of a new, alternative lifestyle. They were, truth be told, almost eerily similar to the Grads from Kneale's unrealised *Big, Big Giggle*.

Nigel Kneale was assuredly not a baby boomer. At the time he was a married father of two, and an established writer approaching fifty. He's since spoken distrustfully of the 'let it all hang out' approach, "Inhibitions are like the bones in a creature. You pull all the bones out and you get a floppy jelly." But far from dismissing a major contemporary movement simply because he wasn't part of it, Kneale was as ever keen to examine the ramifications of this development via imaginative fiction.

It's worth mentioning at this point that, although Kneale had no great love of psychedelic culture, the culture had a great deal of respect for his work. The new generation had been children at the time of the original *Quatermass* broadcasts, and while the writer himself hadn't intended the serials as fit for children, many had seen them, only to grow up powerfully impressed by them, before becoming avatars of the flower power culture. During a BBC anniversary programme, Beatles drummer Ringo Starr remarked, "I was terrified by *Quatermass*. I mean, that show. The one where they did it in some, like, electro-hydro station somewhere, and they all got some mark on them…" In their early years, when asked about their influences, psychedelic rockers Pink Floyd — perhaps wary of admitting to drug use in print instead — cited *Quatermass* and the BBC radio series *Journey into Space*. Another group, signed to early seventies progressive rock label Harvest, simply called themselves Quatermass — and no-one could claim the name was common currency outside of Kneale's work. (When the group reformed for the new millennium, they renamed themselves, with a nod and a wink, Quatermass II). In the comedy

STAYING WITH AUNTIE

BY 1968, BOTH KNEALE'S CHILDREN were safely established at school, and his wife Judith was looking for an outlet for her own estimable creative talents. To this end she wrote and illustrated a children's book entitled *The Tiger Who Came to Tea*, precisely the sort of story she would dream up to entertain her own offspring. Indeed, the tale had been tailor-made for them, and the book is warmly dedicated 'for Tacy and Matty'. Again credited to Judith Kerr, it was published by Collins, and swiftly grew to the status of a classic, adored by generations of young readers. Judith began working on other books for children, and she and her husband found themselves busily occupied in twin work-rooms on the top floor of their family home.

At this time, Kneale was approached by the BBC to write a new one-off drama. British television had evolved greatly since last he'd written for it. In response to ITV's shamelessly populist approach, the BBC had launched a second channel, BBC2, as a safe haven for experimental and non-mainstream 'minority' programming. It was also in the process of switching over to colour broadcasting. Indeed, it was a BBC2 strand of brand-new colour dramas, called *Theatre 625*, that Kneale was asked to contribute to. He said no.

In recent years, Kneale's relationship with the Corporation had deteriorated yet further. Back in November 1965, in the aftermath of the collapse of *The Big, Big Giggle*, BBC2 had remade Kneale's adaptation of *Nineteen Eighty-Four*. Despite being directed by Christopher Morahan, formerly of *The Road*, Kneale was distinctly underwhelmed by the remake. "It didn't work," he insists. "It was a perfectly good production by Chris Morahan, but for the first one the audience had got very upset by all these dreadful images. Ten years later, they were much more sophisticated. It just didn't have anything like the same impact. It came and went." The all-new cast failed to make much impression either. It all contributed to Kneale's ongoing dissatisfaction with the BBC. Deep down, he was still smarting from their dismissive behaviour when the rights to *The Quatermass Experiment* had been sold to Hammer behind his back.

In point of fact, they had made an ex-gratia payment at the time, but one which was almost derisory. "They did give me some extra money," he concurs. "They said, 'in view of the astonishing success of the serial, or words to that effect, we're going to pay you another £80.' This was it. 'There won't be any more,' they said. If you want pomposity, old BBC memos are unbelievable."

Now he was no longer a BBC employer, and had a healthy career writing for film, Kneale simply didn't have to accept such treatment. So, when asked to return to the BBC, he initially refused. Instead, he went on the offensive, and went straight to the top to do it. "I found I couldn't stick these people at all, and I was getting film offers of my own. So I thought, why do I have to pay them any attention? But in the end I couldn't take it anymore. Hugh Carleton Greene had become Director General, and I wrote to him and said, 'you say

pioneer Tristram Cary. Hammer's state of the art effects are effective for the most part, although the dead Martians themselves pale in comparison to those souped-up by the BBC on a shoestring budget almost ten years earlier. Keir's brooding, impassioned performance as Bernard Quatermass adds to the finished film immeasurably. Although it can't measure up to the slowly unfolding six-part TV serial — in comparison, the bold ideas within the script threaten to overwhelm the viewer — Hammer's production is perhaps the studio's greatest achievement. "It wasn't as good as the BBC series, but it was OK," is Kneale's own assessment. "A lot of detail had to be cut. It's a simpler thing. They had more money for sets and actors, really. Roy Baker did a very good job on it. Andrew Keir was fine. I was happy with it."

Author Ramsey Campbell rates the film amongst Kneale's finest work. "I know he's not altogether happy with the Hammer *Quatermass*es, but I do think that a lot of what's best about him survives into them, particularly *Quatermass and the Pit*, which I thought to be an extraordinary piece of work," Campbell says. "I think he really came up with a very powerful structure by dealing with a series of explanations which seem to encompass what needs to be explained only for something else then to appear beyond that — the whole situation to be much larger than thought at first. I don't really know of any other people who've used that structure. I also like all sorts of other little details — the British officer who accuses the whole thing of being a Nazi propaganda plot, which I think is a wonderful touch. There's still too little of this in the field, this insight into how real people might behave in the face of that kind of situation. I think he's a genius at it."

Academic and critic Julian Petley is less convinced of the film's merits. "One of the things I don't particularly like about the film version of *Quatermass and the Pit* is that it's in a big studio. I know that Nigel feels that having the possibilities of the studio gave him a lot more flexibility to manoeuvre, but I'm not so sure. I like the television version better in many ways. One of the most obvious things about Nigel Kneale is precisely that sense of everyday realism and verisimilitude; the setting of extraordinary things in very, very ordinary locations. To me, the studio setting of *Quatermass and the Pit* just looks a bit studio-y."

It seemed that the third *Quatermass* film had not followed too late on the heels of its predecessors. Indeed, it was a highly lucrative success for the studio, both on home territory and in America — where it was released, to Kneale's continued dismay, under the lurid, pulpy title *Five Million Years to Earth*. Hammer's *Quatermass* films gave Kneale's stories exposure far beyond their initial BBC broadcast; their influence would only become clear in years to come. Hammer wasted no time in approaching Kneale about a possible fourth, and entirely original, *Quatermass* serial. The studio even went so far as to announce it as forthcoming, but in practice the project got no further than brief preliminary discussions with the writer. It did, however, sow the seeds for such a return, which would in itself take quite some time to come to fruition.

Hammer gradually assembled a team for the production. The film version had been so long in the planning that original producer Tony Hinds had been replaced by Anthony Nelson Keys. The obvious choice of director, Val Guest, was occupied elsewhere, not least on the catastrophic James Bond send-up *Casino Royale*, and so the job was given to film and television veteran Roy Ward Baker. The next hurdle was, by now, a familiar one. Who should star as Quatermass? This time, Kneale was quite adamant that Brian Donlevy should not return — and besides, he argued, sufficient time had elapsed since the previous *Quatermass* film outing for the part to be recast without resistance from the audience.

Director Baker suggested familiar British star Kenneth More for the role, having previously worked with More on the classic Titanic feature *A Night to Remember*. Hammer, though, weren't taken with the idea. An obvious alternative was Andre Morell; since starring in the television version of the story, Morell had starred in several pictures for Hammer. But when approached, the actor demurred, unwilling to return to a part, and a piece, that he'd already played. The eventual choice was Scottish actor Andrew Keir, another veteran of Hammer productions, albeit previously in second string roles.

Elsewhere in the cast, Barbara Shelley essays Judd, a role played on television by Christine Flinn. Kneale wasn't entirely convinced by the new interpretation. "I'd liked Christine very much," Kneale says, "but she wasn't the kind of screen star that Hammer wanted. So we got Barbara Shelley, who was taller…" In a poignant nod back to the television roots of *Quatermass*, the brief but crucial part of the drill operator, Sladden, was taken by Duncan Lamont — the original Victor Carroon, in *The Quatermass Experiment* fourteen years previously.

Scenes from Hammer's
Quatermass and the Pit.

Baker's direction of the finished article is spirited and assured, and benefits from a memorable score from electronic music

because there weren't six episodes to get worried about. If you went in and watched it and came out again and were still alive, you're OK. It couldn't affect you any more than that. So maybe as a single feature it'd be safe."

Kneale and Neame schemed together to get the project off the ground. Neame knew that the BBC still had an option to make the script which elapsed in 1967, and so the film was planned to go ahead thereafter. It was still thoroughly contemporary. On the cover of his copy of the revamped film script, Kneale jotted down the words 'Rolling Stones', drawing parallels between the band's bacchanalian image and the behaviour of the fictional Grads.

There were still concerns about any potential controversy, though. At the time, film companies were encouraged to submit contentious film scripts to the British Board of Film Classification prior to shooting. This allowed for discussion to occur and agreements to be made before the expensive business of actual filming. Kneale and Neame submitted the *Big, Big Giggle* script and were called to such a meeting. "Ronnie and I went along to see John Trevelyn, who was the chief censor. He said quite firmly, 'I won't permit this. I'm banning it. You can't do it.' We argued most of the day about this, and said, 'Well, if it's only a one-off, it can't do any damage, can it?' And he said, 'Yes it can, and you're not going to make it.' And we didn't. We were told we wouldn't get distribution. Ronnie went back to LA, I went home, and that was the end of it." Even as a film project, sadly, it had failed to get the go-ahead.

Of all the scripts Kneale wrote that went unmade, *The Big, Big Giggle* was the strongest and the most important (not to mention the longest). Unquestionably, it's the key 'lost' work from his canon. It perfectly reflects the major preoccupations and concerns of Kneale's writing from the period. The script has never been neither produced nor published, and what was potentially one of the boldest British dramas of the period has sadly gone unrealised. It wasn't entirely wasted, though. Indeed, it fed into much of Kneale's original work over next ten years. Some later dramas simply spring from the same source as the lost piece, but his next TV serial he was to write reused many of *The Big, Big Giggle*'s strongest elements.

AT LONG LAST, Hammer had filmed Kneale's adaptation of *Quatermass and the Pit*. In its earliest stages, Kneale titled his script simply *The Pit*, as he'd originally done for the TV version, but the full title was soon reinstated. This time, Kneale had written the script without any intervention, and not surprisingly, of the three *Quatermass* films, it was the most faithful to the TV original. For the most part, whole scenes and most of the dialogue was transferred intact. The character of the journalist Fullalove, from *The Quatermass Experiment*, was revived for the TV serial, but didn't make it into the film. There was one more significant difference, though. In the years since 1959, post-war construction sites had grown less common. Kneale was keen to retain a contemporary tone, though, and it was Hammer producer Tony Hinds who suggested relocating the pit to a London Underground station undergoing renovation work. Not only were such sights common in 1967, but it made for a most striking and evocative setting. To realise these scenes, rather than use their own rather limited Bray studios, Hammer leased larger, more lavish facilities from MGM.

in Bray. Joan Fontaine had faded a bit as a star. She was good in it. It was a weirdly sinister film. I was perfectly happy with it. Well, it was all right!"

Renamed *The Witches*, the film follows the travails of schoolteacher Gwen Mayfield (Fontaine). During the film's opening, Mayfield has a terrifying experience with witchcraft in Africa. Returning to the sleepy English village she calls home, Mayfield expects to recover from the episode, but finds instead that a very British form of black magic is flourishing in her local community. Despite some intriguing approaches — including, to Kneale's delight, secretly filming a real witchcraft ceremony as research — the result is a harmless, unremarkable piece, a distant cousin, perhaps, of the popular novels of Dennis Wheatley, or the later, superior *Wicker Ma*n. It was certainly no equal of Kneale's original writing from the same period. Nor was the author himself under any illusions about the value of the piece. "If you do a tremendous Gothic build-up", Kneale suggests, "creaky gates, all that stuff, you don't really need the story, all you have are the gates."

On the other hand, the cast included, in small roles, Duncan Lamont, Victor Carroon from the original TV *Quatermass Experiment*, as well as Birmingham-born actor Leonard Rossiter, who would himself star in another Kneale piece shortly after.

AS HAMMER GEARED UP TO FILM *Quatermass and the Pit*, one of Kneale's lost projects was quite unexpectedly resurrected. After being shelved by the BBC, the completed script for *The Big, Big Giggle* began to find new admirers. "It lay on my agent's desk, just hung around," Kneale says, "and then a year of two later Ronald Neame, the Hollywood producer, somehow got hold of a copy and said he wanted to do it immediately as a feature film. Ronnie was very keen indeed." In cinematic form, many of the BBC's fears about the piece would be resolved. "As a film it was more containable

Scenes from Hammer's
Quatermass and the Pit.

It gradually died. When they had another think about it, they said, 'well, it's just not really very safe to put this out. I don't think we'll do it.' That was the end of it." Contractually, the BBC retained an option to produce the scripts by 1967, but that was standard. As a TV project, it was over.

Kneale's next move could certainly be called unexpected. He wrote a detailed treatment for a proposed film, which he called *Comrade Frankenstein*. Despite the title, it was never intended as an entry in Hammer's ongoing series about the questing Doctor. Instead, it was a comically satirical piece, set in modern day Transylvania, focussing on one Pavel Frankenstein and his unnatural experiments. It's more a send-up of Iron Curtain politics than of the horror film tradition, and it fits, perhaps, into the narrow strain of Kneale's writing previously occupied by his 1960 *Punch* article. Of course, a rather dry sense of humour had always played an important part in Kneale's work and even in the *Quatermass* serials, the odd comic line would be employed to release the tension, or as a devise to humanise proceedings. Further back, several of the stories from *Tomato Cain* are wholly comic in intent, and Kneale's first work for BBC television had been writing puppet shows to amuse children. Still, out-and-out comedy was not a form he was known for, although he was a declared fan of many comic writers, from Spike Milligan to Galton and Simpson.

Comrade Frankenstein was largely written for the author's own amusement, it seems, as a means of letting off steam, creatively speaking. However, the treatment didn't lie entirely idle." It was nice, actually, but it wasn't really meant to be made: it was a sort of joke. I wrote it just for the hell of it, but my then agent sent it to a Czechoslovakian film company. We didn't expect anybody to do anything with it, but when it finally came back, it had been everywhere! They'd spilt tea over it, and practically lived on this thing. The story was so anti-totalitarian, and effectively a joke on Czechoslovakia. The covering letter said, 'In no way would we be allowed to make this, and nor would we want to!'"

MORE OFFERS OF FILM WORK ROLLED IN. Hammer's Tony Hinds contacted Kneale to indicate that, at last, sufficient funds had been raised, for the film version of *Quatermass and the Pit*. "Hammer had tried to make *Quatermass and the Pit* earlier," Kneale recalls, "but it collapsed for the sole reason that they couldn't get the money: not because of purity of mind or anything! The American financiers hadn't come through. I'd written a script — it was all ready and had been for years — but they couldn't raise the money. And then suddenly they did. But before that they said, 'would you do another film first, to give us time to make sure of the whole thing and get the cash in place?'" So as the *Quatermass* film was being prepared, Kneale agreed to Hinds' offer of another assignment in the meantime. It was an adaptation of a novel, *The Devil's Own*, written by one Nora Loftus under the pseudonym Peter Curtis. The project was initiated by screen veteran Joan Fontaine, who purchase the film rights to the novel personally, seeing it as a potentially excellent vehicle for her talents. In due course, the project found its way to Hammer. "The woman who wrote the book I don't think had written very much before," Kneale says. "She knew very little about witches or anybody else. It was a very impractical thing. It was a very cheap little thing, which they shot down

When Kneale submitted the scripts for the serial to the BBC, their controversial content did not go unnoticed, and the Corporation began to get cold feet.

"The BBC took a frightened look at it," Kneale recalls, "and said, 'suppose somebody topped themselves during the run of this thing?' Because there had been a case of a woman who was reported to have died watching *Quatermass and the Pit* on television. What it fact had happened was the poor woman had a terrible heart and she wasn't even watching it; she was in the next room ironing and suddenly fell dead! But it was on. That was enough to frighten the BBC. 'Suppose something like that happened?' And so they said, 'let's not make it over six episodes but four, or even two. There would be less chance of somebody dying during the time it was on.'"

As Kneale reworked his scripts into two lengthy parts, the BBC drama department, still under the leadership of Sydney Newman, began to set wheels in motion for production, working out a budget and looking for suitable locations.

"We went as far as going for the day to South Wales to see if that would be a good place to shoot it," Kneale says. "It wanted to be somewhere outside London. We went down, scouted about and went to the local police, to see if they would co-operate. It was very interesting. The local police were very unsophisticated indeed. I said 'do you use walkie-talkies?' The inspector in charge said 'what's a walkie-talkie?' I produced one I'd bought in and he was amazed — and horrified. He said, 'ooh, we should have some of these. We should buy some.' I'd thought they'd be standard police issue in all directions, but he'd never seen one."

It quickly became clear that the budget required for the fairly epic serial would be an important consideration. In addition, there still lingered strong reservations about handling a teenage suicide drama at all. The combination left the project dead in the water. "It would have cost quite a bit," admits Kneale. "Not that much, but a certain amount. The BBC were wary of the cost — and of whether it would upset the audience, which it possibly would.

Left: The BBC's *Quatermass and the Pit*. Producer Rudolph Cartier (right) with actor Anthony Bushell.

Right: The US title for Hammer's *Quatermass and the Pit*.

heart-stopping scene in the whole serial, and the parallels to Kneale as a father of children only make it more powerful.

Strikingly, this was the first time Kneale had ever used a futuristic setting in his original work. The *Quatermass* serials had been intended as taking place 'a few years hence', but contained nothing markedly uncommon in the time they were made. This, on the other hand, was a full-scale imaginative extrapolation. Kneale was no stranger to dystopian fantasies in his role as adapter — *Nineteen Eighty-Four*, *Lord of the Flies* and *Brave New World* all speculate about societies where current trends have ultimately led to grim resolutions. Arguably *The Big, Big Giggle* also has parallels with Anthony Burgess' *A Clockwork Orange*, which features a violent youth movement of the not-too-distant future, with their own dress codes and lingo. It's interesting that, thirty years later, another first-rate television writer, the dying Dennis Potter, would also envision a foreboding, gang-divided future Britain for his final work, *Cold Lazarus*.

Besides being powerful in its own right, Kneale's vision of a hedonistic youth cult, drawn together by music, drug taking and nefarious activity, proved to be remarkably prescient. "It's interesting that it got so many things right," Kneale says, "like stealing cars and setting them on fire. Separating themselves totally from their parents' generation. And raves, and drugs rather like Ecstasy of which they're now discovering all the terrible side effects. A horrid amount of it has come true."

Exploring the capsule in the BBC's *Quatermass and the Pit*.

discover their plans and prevent this disaster, Bean has an extra complication: his own young children are drawn in by the Grads.

It's a pretty extraordinary premise, and had it been made it might have been a defining drama of the sixties. It has echoes of the destructive battles between Mods and Rockers, but it also predicts the rise of the Hippie movement who would, just a few years later, would reject the values of the older generation and embrace drug taking as a way of life, if not a sacrament. The effect of the 'teardrops' seems akin to the flower-power favourite, LSD. When Bean's daughter Jen, takes her first teardrop, the script remarks that 'in her eyes there is… a hollow, distant look… something seems to well up at the back of them, a vision so sharp and terrible and attractive that it catches her breath.' Jen's reaction is to cry out "I know! Oh God, *I know!*" *

If the Hippies lack the violence and nihilism of Kneale's Grads, then the following decade's big youth movement, punk, fits the bill perfectly. It's tempting to read into Kneale writing in these circumstances: a father of young children in a fast-changing society, who believes he's perhaps fatally ill, seeing a very bleak future for the youth of Britain. It's almost hard not to, as Bean's family, an adolescent daughter and a slightly younger son, is identical to Kneale's, or at least a near-future extrapolation of it. Bean suspects his daughter has Grad connections, which indeed she does, but he overlooks his son Roger, who he finds dead, having committed suicide with a household gas pipe. It's the most

* It's worth remembering, though, that LSD was far from common in early 1965. Even those great avatars of the acid experience, the Beatles, didn't come into contact with the drug until that Spring.

The Witches.

given the circumstances in which it was written, *The Big, Big Giggle*, as written, was extraordinary even for Kneale. It's a subtle change of pace from his previous work, and its central concepts are bold indeed. The setting is Britain in the very near future, specified in the script as the late 1960s. The main character is a police inspector named Bean ("My Detective-Inspector Bean got his name long before Rowan Atkinson's invention," Kneale points out. "I claim priority. It's a good name.") Bean and his colleagues are being severely tested by the development of a troublesome youth cult calling themselves Grads, who wear short cloaks in mockery of University graduation gowns. According to Kneale's stage directions, 'their gimmick is the assumption of 'knowledge' — the drug-heightened belief that they and they alone are seeing things stark'. They are becoming increasingly destructive and reckless, and are using drugs commonly known as 'teardrops'. But things begin to spiral out of control when a Grad called Boggo crashes his customised car and kills himself — seemingly for a cheap thrill. Word spreads around Grad circles, and Boggo is swiftly immortalised by the Grads in a song — adapted from a (fictional) pop hit called I Don't Want Your Love — which catches on and becomes their anthem:

"Boggo went riding / Boggo went flying / Boggo went crashing / Boggo went dying / I don't want the life you gave me / I don't want it / I don't need it / So keep it / Keep it!"

Sure enough, the nihilistic appeal of a glorious suicide becomes the latest Grad fashion, and Bean has to contend with youths killing themselves left right and centre — plus, they care little who else is killed in the process. As the story progresses, Bean becomes aware of coded Grad plans to commit mass suicide on a horrifying scale, and drop like lemmings from a cliff edge. In trying to

StifLing a GiGGLe

SINCE THE EARLY FIFTIES, Kneale's writing career had been progressing at a remarkable rate, but he now had other things to spend his time on. He was enormously fond of family life, and became happily settled in a new South London home with his wife and children. He took great pleasure in his role as man of the house, and even became a skilled handyman.

His children were just reaching school age. In fact, young Matthew had returned from his first day rather dismayed having met his new schoolmates. "They haven't got any pictures in their heads", he told his parents. "I've got lots of pictures in my head…" Such, it seems, is the fate of writers' children. (In due course, Matthew would put his healthy imagination to good use.)

Quite unwittingly, Kneale's daughter Tacy had a hand in what befell her father in early 1965. He fell very seriously ill. The mystery virus he contracted baffled his doctor, who could suggest no effective cure. He was confined to bed, and it was genuinely feared that he might die. "It was a very strange little episode, that," Kneale muses. "I was struck down, and it was something like acute jaundice — your skin turned yellow and you felt awful. Everybody gave me funny looks and my poor wife was driven scatty. We were worried about the children, who were just little. I was determined not to die just yet, so I thought I might as well get on with finishing a script. It didn't take long writing it, anyway."

The script in question was *The Big, Big Giggle*, the new six-part TV serial Kneale had been commissioned to write by the BBC. Consequently, for the most part it was written by Kneale in his sick-bed, when he had doubts as to whether he had long to live. As he wrote, a little detective work helped pinpoint the course of the virus. "We began to suspect it was something to do with the school that our four year old daughter attended", Kneale says. "Other parents went down with it, including a friend of ours, a Jamaican writer and actor called Erroll John. Poor Erroll was horrified. He was having endless tests in the hospital, and they didn't know how to handle it. A Polish doctor's wife went down with the same thing identically. All their children, Erroll's little girl and the doctor's boy, and our daughter, all went to the same school. Ronnie Harwood the playwright, his children also went to the same school, and he was going around taking notes from everybody who thought they had the same thing."

This still didn't help to explain what the illness was, however. Luckily, it simply ran its course and ended as mysteriously as it had come. "All of a sudden it kind of went," Kneale recalls. "At a time when I should have been trapped in the hospital for even more tests it just went, and my skin went back to normal. We all got better."

In the meantime Kneale had managed to write a full set of scripts for his first TV serial since the landmark *Quatermass and the Pit*. Not surprisingly,

with legendary cinematographer Jack Cardiff signed on to direct. "Jack was very enthusiastic", Kneale remembers. "He'd shot so many things for other directors — some of his best camera work — and he wanted to get away from that. He went off to Spain with my script and said, that's where we'll do it." In execution, this would have meant the whole production, Kneale included, decamping to Spain for the shoot, planned to last several months. Kneale, and his whole family, were in the midst of preparations for this upheaval, when word came through that the project was off. "Two days later, Jack arrived and said, 'it's over, it's finished. They're not going to do it. Bronston's gone bust.' So they never made it."

Brave New World joined the long list of projects Kneale had extensively worked on that never saw the light of day. It was a lucrative, but not remotely fulfilling period. *First Men in the Moon* and *HMS Defiant* are perfectly entertaining feature films, but they hardly acted as a showcase for a bright talent fresh from the world of television. Besides, for every film script Kneale wrote that made it into production, many more failed to, and all the furious writing activity was keeping him away from doing original work of his own. He did, however, have an idea for a new television serial, and proposed it to the BBC during 1964. He called it *The Big, Big Giggle*.

It's an unintentional irony, but the plot of *First Men in the Moon* — an eccentric Victorian inventor travelling with his companions to another world and running up against its indigenous inhabitants in the course of a family-friendly adventure — wasn't a million miles away from the stories being told in the earliest days of *Doctor Who*, which Kneale had so vehemently refused to write for. The crucial difference is, the Wells adaptation relies on thrills and spectacle whereas, in Kneale's view, *Doctor Who* was designed to terrify children outright.

For writer and critic Kim Newman, though, *First Men in the Moon* proved to be quite a landmark. "It was the first film I was ever taken to see, so that would have been, not just my first exposure to Kneale's work, but also my first exposure to cinema. I was taken with my younger sister. I must have been four and she would have been two, and she was upset by the whole idea of going to the cinema and had a tantrum and we had to leave. My parents took me back the next night because I was still fascinated and wanted to see the picture!"

ANOTHER MAJOR PRODUCTION, planned but never brought to the screen, was a film version of Aldous Huxley's celebrated 1932 novel *Brave New World*. Huxley's vision is of a numbed, brainwashed society, where science allows unborn children to be selected and shaped, and those who opt out of the would-be idyll live in a savage wilderness. With its themes of a sterile near-future age, the book fitted perfectly with the dystopian outlook of much of Kneale's current work, and his concerns about society for generations to come. Kneale wrote a full feature length-adaptation for producer Sam Bronston. Bronston, at that time, had sundry film financing connections in Spain, and was said to be favoured by the country's dictatorial leader, General Franco.

Scenes from *HMS Defiant*.

Thus plans were drawn up for the large-scale feature to be shot on location in Spain,

scard's World. In the event, though, it dawned on Granada just how expensive such a production might be. "I wrote a script at their request, and they were set to go on it, but they hadn't realised how much it would cost in scenery and sets," Kneale says. "I think that's what broke it. They realised that they'd have had to build *everything*. Granada at that time must have been a bit short or something, so it didn't proceed." Kneale didn't feel the loss too greatly, though. "It wasn't a great thing, but it was alright," he suggests.

MEANWHILE, OVER IN HOLLYWOOD, Kneale's script of HG Wells *First Men in the Moon* — or some descendent of it — was finally about to go into production. Above perhaps all other writers, Kneale adored Wells, and relished the chance to work on the script. "Wells was a genius. I grew up on him. He wrote comedy, horror, science fiction...he could do anything. I admire all his work, everything he did." Never a great fan of science fiction writing in general, Kneale nevertheless holds Wells in the highest esteem. "He had an incredible invention, and was an extraordinary man. The range of those ideas was fantastic. And he chased all those ladies as well..."

The film was produced by Charlie Schneer, then son-in-law to Columbia Sudios boss Abe Schneider. Scheer was also a childhood friend of Ray Harryhausen, the stop-motion effects wizard responsible for the effective animations in *Jason and the Argonauts* and. Harryhausen agreed to come on board to provide the necessary space visuals. "It was fun working with Ray Harryhausen", Kneale says. "He was a very bright individual". Although realised by Harryhausen, the moon's inhabitants, the Selenites, were, in fact, designed by Kneale's artist brother Bryan. The director himself, rather swamped by the talents involved, was Nathan Juran, whose previous credits included *The Attack of the 50 Ft Woman*.

The main problem was one of time, exacerbated, in fact, by the American President. "John F Kennedy had announced they'd have a man on the moon before 1970, and that was getting dangerously close when we were working on this thing." Kneale says. "If a man *had* landed on the Moon, we'd have been quite stuck. 'Ohh... it's happened.' So the thing was to get on with it very, very fast."

This caused Kneale, as adapter, a further headache. If Man were to land on the Moon, there would surely be a major discrepancy between the film's account of its inhabitants and reality. "What about the Selenites?" Kneale asks. "Are they still hopping around on the rocks, or what?" Kneale chose to get rid of the Selenites for good at the film's conclusion, in a suitably Wellsian manner. "I went through Mr Wells' work again, and, of course, in *War of the Worlds*, he despatches the alien invaders thanks to somebody having the common cold. The Martians catch it and die, because they have no protection — so that's how I got rid of the Selenites."

Another stumbling block proved to be producer Scheer himself, who saw fit to tamper freely with the script. Aside from hiring other writers to rewrite it — including Jan Read, who shares the on-screen credit with Kneale — Scheer took to fine-tuning the script himself. "He got other hands to work on it, but the hand I objected to was Charlie's," Kneale says. "We had words and so I left that project. It was a very ordinary film."

"The ambassador is a very honest, decent man," Kneale insists. "Whatever you asked him to do, he'd do. He'd gone along with this half-crazy president who had smuggled the nuclear materials into London. There's panic in the streets." Jimson issues his demands, and a deadly stalemate — the eponymous crunch — is reached. Eventually, it falls to Mr Ken himself to prevent Mr Jimson from detonating the crude device and destroying London — even though all their demands had been agreed to.

Directing *The Crunch* was Michael Elliott, who'd previously been behind the camera for Kneale's *Mrs Wickens in the Fall* back at the BBC. Kneale appreciated Elliott's talent, and was pleased with the end result. "It was a big location job, " recalls Kneale. "They had tanks, and even real army. We had some wonderful people in the cast, too." Harry Andrews appeared as the British Prime Minister, Goddard, and the roles of the British military were taken by Carl Bernard and Peter Bowles — the latter, then virtually an unknown, later became a well-loved name in British sitcoms (as well as becoming one of Kneale's South London neighbours.)

In many ways, *The Crunch* is the modern-day flipside to *The Road*. Nuclear devastation is promised, and there's chaos in the streets. The difference is, in *The Crunch,* the catastrophe is narrowly averted. In truth, *The Crunch* doesn't boast as remarkable a concept as *The Road*, but it's a powerful, evocative study of different types of human behaviour in extraordinary circumstances. It's striking, too, that all of Kneale's original writing during this period seems deeply affected by his having become a father. The nuclear issue was generally a hot topic of the day, but having brought two children into the world, Kneale very clearly began using his work to examine fears about nuclear war and the future of society. *The Crunch*'s Prime Minister, Goddard, is especially sickened by the threat of destroying, amongst others, "little children who hardly know what world they're in yet..." As his own children grew older, this theme in Kneale's writing would only increase.

FOR THE TIME BEING, though, the writer was occupied, once again, with a full slate of adaptation work. One unrealised project was a television version of science fiction author Brian Aldiss' acclaimed debut novel, *Non-Stop*, first published in 1958. The novel depicts a primitive tribe who live in a brutal wilderness, in the grip of irrational worship, until a contingent are recruited on a mission to explore the outer reaches of their world. After the treacherous, eventful journey, it transpires that their home is, in fact, a vast space craft, whose flight has taken so long that the passengers have spawned whole new generations. Meanwhile their understanding of their purpose, and the nature of their home, has gradually been lost to ignorance and superstition.

"Brian Aldiss was a very fashionable science fiction writer at the time," Kneale remembers. "The book wasn't quite television. A good idea and everything, but not quite a television programme. It was about creatures in a spaceship, who think really it's the world. They don't know any better, but it's been going round and round the universe for two centuries, and people have been born there and died there. It's their complete world."

The proposed adaptation was for Granada TV, the Manchester-based region of ITV. Kneale wrote the serial in full, in four parts, under the new title *Ro-*

The Road.

were now equipped to attempt science fiction adventures on television. Their visual effects department, and the Radiophonic Workshop, had cut their teeth on Kneale's dramas, and both became vital to the realisation of the worlds of *Doctor Who*. However unwillingly, Kneale had had a hand in spawning the BBC's new flagship family science fiction show.

KNEALE'S IMMEDIATE REACTION to his disagreement with Newman over *Doctor Who* lead to him offering his next TV play to one of the BBC's independent rivals and, coincidentally, it was Newman's former employers, ABC. For the first time, he chose to work in British television for a company other than his former employers. The result was a modest success. Entitled *The Crunch*, the play was an extension of the nuclear Armageddon fears that had inspired *The Road*, very much in the wake of the near-catastrophic Cuban missile crisis. Unlike *The Road*, though, the new play was entirely free of any talk of the supernatural. It can be compared, perhaps, to its cinematic contemporary, Stanley Kubrick's *Dr Strangelove*, albeit minus the jet-black gallows humour.

 "ATV did it well," Kneale remembers. "It was about nuclear blackmail. A little tiny abandoned colony had got hold of nuclear materials, and proceeded to use it to blackmail the British government." The assault is led by Mr Jimson (played by Wolfe Morris), the president of the (fictional) republic of Makang. In its time as a British colony, Makang had been ruthlessly stripped of tin, its main mineral resource, and the unhinged Jimson means to see the debt repaid. He's accompanied by his loyal ambassador, Mr Ken (played by Maxwell Shaw).

said, 'this is not for me,' and I just walked away. That was it."

This became the cause of some lingering bad feeling between Kneale and Sydney Newman. When *Doctor Who* was launched in November 1963, it became a great success, thanks in part to the popularity of the Daleks, the mechanised pepper-pot creatures who quickly became the Doctor's arch enemies. Legion are the tales of young viewers hiding behind the family sofa while the Daleks, and assorted other alien baddies, were on screen. Kneale became an outspoken opponent of the series' method of scaring audiences of children. "I don't think he approved of *Doctor Who*," admits Lambert. "He thought it was too frightening for children."

Indeed, Kneale has famously lambasted *Doctor Who* for aiming to, as he puts it, "bomb the tinies with insinuations of doom and terror." In due course, Kneale and Lambert appeared together on the BBC arts programme *Late Night Line Up*, for an impassioned discussion about the series. "*Doctor Who* was essentially a children's show, put out at six o'clock," remarks Kneale. "My own children were frightened. They really were. And I didn't want to see that. I didn't want to watch my children being frightened by some clown switching it on in a studio. I had it out eventually on a TV programme with the producer, and I said 'I hate your programme, because you try to use big guns on little children. I can't watch it and I don't like it.' She was very offended." (In due course, though, Lambert and Kneale would, in fact, come to work together.)

Lambert is unsure that Kneale's previous work influenced *Doctor Who* in its early days. "Only in that, in science fiction, there are always similarities," she asserts, "say, dangerous things of which you know nothing taking over your everyday life. I don't think there was anything more than that." But it's clear that the success of *Quatermass* had created a precedent and the BBC

Scenes from *First Men in the Moon*.

impassioned beliefs illuminates the philosophy at the heart of the piece. Many remember *The Road* as a terrifying piece of television drama, a period piece featuring quite extraordinary sounds. But the script, which is all that survives, has maintained a strong reputation, precisely because the writing itself, its themes and ideas, is so very strong.

TV historian Dick Fiddy considers the play to be the lost Nigel Kneale work he'd most like to somehow see again — although his recollection of the original broadcast has grown hazy over time. "It comes at a time when I could have seen it," Fiddy says. "Whether I've read enough about it that I've cheated a memory ... but I think I did see it, and it was a very potent piece."

Once again, Kneale insisted that the BBC kept the details of the play secret before broadcast, but he agreed to a brief interview with journalist Bryan Buckingham for the *News of the World*. Unable, therefore, to discuss the new play itself, Buckingham quizzed Kneale about the making of unsettling television, and the results were published under the heading 'Your Terror is His Business'. "It's difficult to know what people feel as they watch a horror play. But I don't believe it's actual fear," Kneale said. "I think they feel a sympathy with the character in the play who is feeling fear.... one thing I never do is put something in a plot just to frighten the customers. Any effects like fear are demanded by the story. It's not proper to try to horrify the lights out of people." The writer goes on to shed light on the inspiration behind his earlier work. "Some of the *Quatermass* stories were suggested perhaps by the fact that we're living in a world dominated by scientists and technocrats who care nothing about anything outside their own narrow sphere. These people are monsters and they're beginning to run things!"

ALMOST EXACTLY a year after the broadcast of *The Road*, Sydney Newman axed the BBC's *First Night* drama strand that had featured it, and another, *Festival*, that staged classic theatrical plays. In their place came *The Wednesday Play*; a permanent, mid-week evening slot with an emphasis on provocative new writing. Kneale was also approached to work on another of Newman's new initiatives, a Saturday night series for family audiences, featuring adventures that would alternate between science fiction and historical settings. It was to follow in the slipstream of family adventure series Newman had fostered into being at ABC, such as *Target Luna*, *Pathfinders in Space* and, for older audiences, *The Avengers*. After months in planning, the project was christened *Doctor Who*.

A young producer from ATV, Verity Lambert, was attached to the series, along with a script editor, David Whitaker. In discussions between Lambert, Whitaker and Newman, during June 1963, the idea arose to approach Kneale to write for it. "I'd watched *Quatermass* as a child, so I was very much aware of his work," remembers Lambert. "He had written one of the great science fiction serials at that time: it had stopped the whole of Britain in its tracks. It was an amazing success. So, obviously, if you're doing a science-fiction series, you want the best."

When he was contacted, though, Kneale wasn't enamoured of the concept, and his response was firm. "It struck me as being a producer's idea, not a writer's idea. I thought it sounded terribly bad. I knew I couldn't write it. I

buildings in Britain's capital city — stirs up ancient urges of racial hatred and violence, the source of which is literally buried deep in the ground.

Superficiality, the title of *The Road* refers to a twentieth century motorway, which the characters can know nothing of. And yet, the play is much concerned with science and technology, and the mixed merits they might have. In other words, 'the road' is equally the road to progress. During the attempts to cure the haunting with basic technology, the character Gideon Cobb speaks glowingly of a future where technology will rule. "The great steam pumps we see now are going to have a million descendants," Cobb says. "In a hundred years — in two, certainly — machines will do all the world's fetching and carrying. They'll be more obedient, loyal and industrious than any slaves in history. They'll carry men through the air and over the seas." And yet, as we come to see, the dangers of science are huge. As ever, our darker instincts, those that compel us to use new technology for weapons and warfare, will rise up with disastrous results. In a potential future, nuclear science will totally destroy Mankind.

In a preview piece for *Radio Times*, Kneale himself wrote 'Do ghosts and science belong together in the same play? They do in this one. Today science holds all humanity in a death grip. Yet only 200 years ago it scarcely existed.' He goes on to detail the opposing approaches of Cobb and the wary squire, Sir Timothy. 'Cobb has a great and glittering vision, larger by far than his own nature, of how the world should go. Its perfectibility seems not too dizzily distant, and Cobb declares passionately that he knows how to reach it. It will not be Sir Timothy's road but another, harder one... More than a clash of ideas takes place in the wood that night.'

The pairing of Sir Timothy and Cobb parallels that of Quatermass and Colonel Breen in *Quatermass and the Pit*. Between them, their heated discussions and exchanges of

Scenes from *First Men in the Moon*.

Timothy Hassall (played by James Maxwell), the local squire, who is keen to discover the truth behind the phenomena; and John Phillips as Gideon Cobb, an esteemed visitor from London who has great faith in the development of science — but no belief whatsoever in the supernatural. "It was very beautifully done," Kneale says. "Chris Morahan directed it, and it worked very well. Very good acting. It was about the supernatural — but again, it wasn't really at all!"

At the climax, the amassed characters witness what they've heard stories about. The cacophony they hear is instinctively terrifying, but to contemporary viewers, it's also very familiar. Upending the accepted nature of hauntings, this is an echo from the future. "When the sound begins, we recognise it, but they don't. It's the sound of people desperately trying to escape from a gridlock on a motorway; their terror, people shouting to each other. Purely 1963. It's the blown-back image of nuclear war, which is somehow impinging on everyday life in the year 1775. They think it's supernatural. The people in the story hated it, they cried and ran away. What they're getting is a preview of nuclear war in 1960s."

Key to the effectiveness of the piece is the hairpin twist in the narrative. For most of the play, we are steeped in another time, with a full complement of finely-sketched characters. When a nightmare from the modern day comes crashing in at the climax, the viewer's disarmed — and very alarmed. Another vital element was the striking use of sound. The realisation of assorted sinister noises, and the eventual nuclear blast montage, came courtesy of Brian Hodgson from the BBC's Radiophonic Workshop — his department on a return assignment after the success of *Quatermass and the Pit*. For many viewers, the memory of these remarkable sounds lingered long afterwards.

The climax had initially proved tricky to achieve. An initial pass at recording the terrified shouts was judged to be unsuitable, whereupon Morahan contacted his old school in London, and arranged that the school playground be used as a venue for a re-recording. With its expansive concrete floor, it provided the perfect echo for the cries, and it was this version that was used for transmission.

Television technology had advanced enough to enable *The Road* to be pre-recorded, but sadly, the recording wasn't kept. As ever, the benefits of storing a TV drama on expensive videotape seemed to outweigh those of wiping and reusing it. It's a particular shame, as the script is one of Kneale's finest. It continues the writer's meditations on the nature of the supernatural, as seen in *Quatermass and the Pit* and distils them down into one clear, powerful piece.

In Kneale's work, the central dramatic conflict often stems from an untamed, primal element — something from the past, from the subconscious, something buried — crashing into the present day, and playing havoc with a bright, shiny future. The present, it seems, is where the wild past, and a hopefully civilised future, collide with powerful results. Witness how Bernard Quatermass' manned rocket experiment is wrecked by the equivalent of a living space virus; and in *The Creature*, John Rollason's scientific curiosity about the Yeti is overshadowed by Tom Friend's greed. In *You Must Listen*, the installation of a state-of-the-art phone exchange runs into trouble because of a lusty ghost. In *Quatermass and the Pit*, relentless urbanisation — the construction of new

WITH THE INCOME from his film work, Kneale could well afford the occasional return to television. At the time, the BBC drama department was in the midst of drastic changes. In late 1961, department head Michael Barry, who'd first employed Kneale ten years before, resigned from his post in protest at a shift in focus to ongoing series and away from single plays. A replacement was sought by the Director General, Hugh Carleton Greene — brother of the novelist, Graham. Greene had been appointed in 1960, and had many bold plans for the Corporation. For one thing, he recognised that the television drama output needed extensive revamping. His solution was to head-hunt Canadian-born producer Sydney Newman from independent rivals ABC, and install him as the new head of the BBC Drama Group. At ABC, Newman had championed a thrusting, modern style of TV drama, much inspired by the 'kitchen sink' movement, itself heavily indebted to Osborne's *Look Back in Anger*.

Newman took up the post at the start of 1963, and began to instigate plans for a thorough reorganisation of BBC TV's drama output. Henceforth, a clear distinction

A writer who had made it. The 1961 reprint of Kneale's *Tomato Cain and other stories*.

would be made between limited serial and ongoing series, with much attention being paid to the latter. The year before, the BBC had launched *Z Cars*, an often gritty, confrontational police series that was drawing much attention. Newman was keen to capitalise on this, and adopt the American method of series being run by a permanent production team — an overseeing producer, and a story editor to deal with scripts and writers. Producers, though, would no longer act as director as well. 'Director' would be an entirely separate role, which might be filled at any one time by a BBC staffer or a freelancer. At the same time, Newman was slowly formulating ideas for the future of the single television play at the BBC.

As yet, though, there was still an active strand of original TV plays called *First Night*, and Kneale's next piece found a home there. *The Road* was an extension of *Quatermass and the Pit*'s fascination with the nature of supernatural event. Superficially a period piece, it actually expresses very contemporary fears of apocalypse. (Poignantly, it was written in the immediate aftermath of a tragic event for Kneale. "My Father had just died on the Isle of Man," he explains, "so I was having to go back and forth to the island at the time, sorting things out".)

Set in 1775, it follows an investigation into woods that are rumoured to be haunted, using very primitive scientific technology. The key characters are Sir

Kneale was even busy enough to turn work down. Harry Salzman, producer of the John Osborne films, approached Kneale about scripting his next venture, an adaptation of Ian Fleming's celebrated series of books about a calculating British spy. "Harry was going to produce it, and really that's why I was approached, I suppose, because I'd worked with him before," Kneale says. "Harry rang me, and said would I like to write do this. Well, I'd read one of Ian Fleming's books and not liked it, so I said really I'd prefer not to." In doing so, Kneale declined the chance of bringing James Bond to the silver screen. (The mind boggles to consider what he would have made of the assignment.)

In amongst this frenzied activity, Kneale agreed to script an inevitable assignment for Hammer, the film remake of *Quatermass and the Pit*. By 1961, Kneale had written a detailed treatment for the adaptation. It was planned to produce the film during 1963, with, in theory, Val Guest returning to direct and the dreaded Donlevy again starring as Quatermass. Although Kneale completed his script, it became clear that this would be a complex, expensive production, and late in the day Hammer were forced to remove the film from their schedules and shelve it until they could raise sufficient budget.

Already, Kneale was coming up against the severe frustrations of working in film. He wrote a full feature-length script for the proposed film version of Gerard Sparrow's novel *Opium Venture* (under the title *Opium*) only for the project to fall through. "That was for Rank Studios," Kneale says. "There was a producer called Bill MacQuitty, who had made quite a few things for Rank. He'd got this book, about a fellow who had been a doctor in Burma, and wanted it to be filmed. It wasn't bad at all. There was material there, but it was all rather shapeless. I did a script, and it may have been one of Rank's penniless phases. Anyway, they didn't make it. It was a good story actually, quite a nice one, but didn't get past the first draft stage."

He had more success with the script adaptation of *Mutiny*, which was made in 1962 under the title *HMS Defiant* (known in the US as *Damn the Defiant*). A draft script by Edmund H North, previously credited with sci-fi classic *The Day the Earth Stood Still*, was already in existence when Kneale was taken on, but he rewrote it extensively. It proved to be the first thing he'd ever written that was made in full colour. With a starry cast, pairing Dirk Bogarde and Alec Guinness, and action sequences on board an eighteenth century ship, it was an experience Kneale relished. "I liked it, being in a big film situation," he asserts. "It was an interesting thing to do. There was plenty of cash: we had huge half-sized Napoleonic ships. Lewis Gilbert directed it, and Alec Guinness was in it, at the same time as he was shooting in the desert for *Lawrence of Arabia* with David Lean. He was only released from that for short periods, in which he came back to shoot this one."

The film was a modest success, and Lewis Gilbert was keen to reunite the same team for another project, adapting James Barlow's popular novel *The Patriots*. "Barlow was a fashionable novelist at that time, and *The Patriots* was quite a good book about a man who had just done his time in jail," Kneale says. Once again, the writer submitted a full feature-length script adaptation. "It wasn't a great thing at all: it was just something Lewis rather fancied. There was a place for it. It would have been a fairly inexpensive film — but they felt it was a bit too inexpensive, and not too exciting, and so it died."

HAPPILY, 1960 BROUGHT a new addition to the Kneale family. On November 24, little Tacy was joined by a brother, Matthew Nicholas Kneale. As the new decade dawned, the writer, and now father of two, was in an enviable position, with a host of opportunities at his door. After all, he was now an entirely freelance writer whose last work for television had gripped the nation. The Osborne adaptations, coupled with the projects at Hammer, meant he was also an experienced writer for film, too. Indeed, the British film industry would flourish spectacularly in the years to come, and he was in precisely the right place at the right time. He was also married to a woman he loved dearly, who'd borne him two children, and the family had recently settled in a large new home in South London. 1961 saw publication of a new paperback edition of *Tomato Cain and Other Stories*, featuring a slightly rejigged line-up of stories. The cover credits him in large type as 'NIGEL KNEALE, author of *THE QUATERMASS EXPERIMENT*'. The book's title isn't much bigger. This was a writer who'd made it. From this point, literally anything could have happened.

In fact, what did happen was that Kneale largely withdrew from writing for television for much of the decade, and concentrated instead on film work. Such commissions were coming thick and fast, and were lucrative with it. There was an important flaw, though. Although he had more than proved his mettle as a vastly original, imaginative writer, his film writing assignments drew, for the most part on his experience as an adapter. Cinema's never been a medium that takes great risks, and pre-existing material — a novel, a play, a television serial, anything that had a track record of success — is of great appeal to film studio executives. And so, for the most part, Kneale's imagination wasn't taxed too much by his new employers.

There's another key difference between film and television, as Kneale would come to discover. Television, especially in the era of live broadcasts, had a tremendous immediacy. When the first episodes of *The Quatermass Experiment* were being transmitted, the final episodes had yet to be written. Nor was this frisson of speaking almost directly to the audience lost on Kneale, with his fond memories of gazing down on the scattered TV aerials from the balcony of Alexandra Palace. On the other hand, film production is a lengthy process — and it's fraught to boot. Kneale found himself writing scripts for films that would take years to reach cinemas. Worse, he worked on many screenplays that were never made at all. Needless to say, it's far cheaper to commission a writer for a screenplay than it is to make the result. It's also one of the earliest stages of any film project. The percentage of film scripts that go unproduced is amazingly high. During the sixties, Kneale was credited as writer on four feature films. He actually wrote a whole stack more.

Over just a couple of years, Kneale accepted commissions to adapt several books for the screen. From Frank Tilsey's Napoleonic naval adventure *Mutiny*; to voguish novels such as *The Patriots* by James Barlow, and Gerard Sparrow's *Opium Venture*; and even HG Wells light-hearted adventure *First Men in the Moon*. When *Room at the Top* director Jack Clayton chose a version of Henry James' novella *Turn of the Screw* as his next film, he first discussed the project with Kneale, as an accepted master of terrifying audiences. (Kneale had no further involvement in the project, but it was released in 1961 as *The Innocents*.)

by the Minister of Power, 1973', was a fictional address to a parliament of the near future, telling of the dire situation when plentiful new oil reserves are causing havoc for the coal industry. Tory rule is a thing of the past, and the Radical Party are in power. The BBC has lost its charter, and the Lancashire town of Wigan has sunk through the Earth's crust under the weight of unwanted coal. Meanwhile, Russian cosmonauts have discovered untapped coal supplies on the Moon. In other words, it's the sort of dystopian vision with which Kneale would come to deal in increasingly in his work to come, but employed for blackly comic effect. Certainly, Kneale himself has always been wary of any political affiliations. "I don't think I've ever had any politics," he declares. "I'm an absolute non-joiner. I feel a bit like Groucho Marx on that. I don't want to join any club that wants me as a member. I'm sorry for people who enjoy politics: they miss a lot!"

Kneale was being offered a range of new writing opportunities, but first, there came an innovative accolade for his TV *Quatermass* scripts. They were to be published — in an age when scripts were far from accepted as a worthy form of literature, and television scripts even less so. "A fellow called Tom Maschler rang one day," Kneale remembers. "I didn't know him, but he was trying to get himself established working for Penguin Books." Penguin was a relatively forward-thinking publisher, and had some experience with science fiction, from reprints of HG Wells to acclaimed new work by author John Wyndham. Maschler proposed that Penguin could publish the three *Quatermass* serial scripts, one to a volume, and never suggested that Kneale might 'novelise' them instead.

"It was Tom Maschler who was the innovator," acknowledges Kneale. "He had persuaded Penguin, with their ancient set-up, to give it a go. They had been doing science fiction but they weren't at all sure about publishing a television book. Tom had to talk them into trying it." Kneale did some basic tidying-up on the scripts, not least because the form of the published script was virtually unheard of. "I cleaned up some of the dialogue, and took some technical things out — simplified it for the reader."

The Quatermass Experiment script-book appeared in 1959, to test the water. It included eight pages of photographs from the serial, taken on-set, and the cover itself was a plain representation of a silhouetted television screen. The other two volumes followed in 1960, each again with a section of photographs, plus the aesthetically pleasing advantage of fully illustrated covers, courtesy of Kneale's artist brother Bryan. "They were fine, but they didn't sell," Kneale admits. "These days there's plenty of film scripts published, but not then." *

(That same year, though, Kneale's script for *Mrs Wickens in the Fall* was published in *The Television Playwright*, an anthology of BBC TV plays selected by Michael Barry.)

* Over the years a curious legend has developed that, when doctoring them for publication, Kneale excised anti-German elements from the *Quatermass Experiment* scripts. While changes were made, they weren't significant, and nothing that could be seriously considered racist was removed. Besides, it might be remembered that, far from disliking Germans, Kneale had, in fact, married one.

PASTURes NeW

SOON AFTER *QUATERMASS AND THE PIT* came off the air, Kneale wrote an article for the Spring 1959 issue of the British film journal *Sight and Sound*, which was then beginning to cover television. Kneale's piece, 'Not Quite So Intimate', was a virtual manifesto for his vision of TV drama. "I have been writing television plays for about seven years," it began, "an interesting time to be close to the thing, as it included the phase of its most rapid growth in this country, from a social joke to a social problem." For the most part, the article describes Kneale's experiences working for the BBC, combating ill-conceived notions of what could be achieved. "I have no claim to be a pioneer, of course," he wrote. "The covered wagon days of TV were long ago, before the war. But when I came to it I still found people baffled. Plays in particular — what should they be?"

Kneale goes on to argue against the opinion that 'intimacy' was the chief advantage of a small screen within the viewer's home. "We heard reports of an American school of intimate TV writing. But apart from one or two like [*Marty* author Paddy] Chayefsky, their scripts turned out to be disappointing, their gimmick a weird, tiny rhetoric."

Instead, Kneale advocated pushing hard against the medium's limitations, detailing how he and Rudolph Cartier had done so time and again. He even offers a vision of the medium's future. "In a few years screens will probably measure about five feet by three, and have far higher definition than today... The 'intimacy' idea will only be of antiquarian interest, like the tiny screens that produced it." Kneale also recognised the limitations the form would face. "Does the future hold an electronic *Citizen Kane* or *Bicycle Thieves*? Or is it doomed to become a mere home-projection system, endlessly blaring out commercials, rigged panel games, endless streams of vile little quickies? A sort of juke-box with vision."

Despite his mixed feelings about working for the BBC, and his doomy predictions for its future, Kneale clearly felt passionately about television. It was a preoccupation he would return to again and again. He ends the article discussing his own move into the sphere of film writing. "My short experience here seems to confirm that the demands of the, so far, larger screen are not very different from television's. Less load for the dialogue to carry, greater freedom of physical action — on the other hand, there are pressures. Economic, since the costs involved are so much greater. Distributors' pressures, censorship pressures... In any case, it looks as though most of those who work for either will soon enough be working for both — a combined film-and-television industry." In the decade to come, Kneale would indeed find himself split working over both fields.

In November 1960, Kneale tried his hand at another form of writing, this time providing an article for the satirical magazine *Punch*. His piece, 'Speech

"If a series is shown which, like *Quatermass*, attracts a certain amount of attention, somebody has a go at it," he says. "Well, the Goons were excellent people: they were funny and I loved their work, so it was quite an honour to be sent up by them. Spike Milligan was very clever. He was fairly unbalanced, I think, which is probably why his humour was so original. Very genuinely, inventively funny. The Goons I thought were brilliant, so I enjoyed that! I missed the Hancock one, but again he was very good: a very, very clever man."

For Kneale, though, there was a strict limit. "When it got down to the level of [minor-league radio star] Charlie Chester, well, I stopped that. I really did," Kneale says. "He was going to do an enormous number, like fifty-two half-hours, for radio, playing a character called Professor Quite-a-mess. So I got onto the bosses of the BBC and said, 'You can't do this! I know the BBC will destroy its own product, we're used to that, but I will never write anything for you again unless you stop this.' So they did. They made the producer re-write about forty episodes. He must have nearly topped himself. But it was a different thing with the Goons!" Nevertheless, for years to come, a host of comedians, from Frankie Howerd and Jimmy Edwards to The Two Ronnies, staged spoofs of *Quatermass*. For a time, such sketches virtually became a British comedy standard.

Despite its massive success, the serial proved, quite unintentionally, to be the last teaming of Kneale and Rudolph Cartier. As Kneale explored other opportunities, Cartier continued to work for the BBC for a while, before drifting away into other fields himself. "He moved into opera", recalls Kneale, "great big German operas, but I had nothing to do with them." Their partnership, though, had managed a remarkable swan song.

only two channels and therefore everybody watched certain things," Lee points out. "Nowadays, if things on television connect people, we call them water-cooler moments, but it tends to revolve around *Big Brother* and *Survivor* and *Fame Academy*. Whereas in the earlier days of television you'd get on the bus the morning after a show had been on and people would be talking about the ideas behind it. There would be intelligent discussion about a mutually shared experience. It's to Kneale's credit that he was able to involve that many people in a shared experience, which kind of mirrors what he was talking about in the piece anyway."

Lee maintains that the serial hasn't lost its essential power in the years since. "Obviously it's dated now in terms of the technology and the special effects, but technically it's a staggering achievement to have carried through six episodes like that in a more-or-less live situation. Some of the acting's a bit wooden, but that's the acting of that period and in fifty years time people'll probably think our acting is wooden. It's a fascinating time capsule. The ideas behind it, I still find exciting and thrilling and controversial. Race war and genetics were very much ideas that were ahead of their time."

The repercussions of *Quatermass and the Pit* began to be felt almost immediately after broadcast, often in rather unexpected ways. In the week after the final episode was shown, the landmark serial was referenced by two leading comedies of the day. Firstly, by *The Goon Show*, once again, in the episode *The Scarlet Capsule*, a comic simulacrum of the serial's plot featuring Harry Secombe as 'Quatermass, OBE'. And secondly, by *Hancock's Half Hour*, in the episode *The Horror Serial*, in which Tony Hancock was seen scared out of his wits by the final instalment of the *Quatermass* tale, and subsequently calling out the authorities to examine a mysterious object he's found buried in his garden. Kneale could only feel flattered by the quality of these pastiches.

Scenes from the BBC's *Quatermass and the Pit*, including (above) a martian, one of which now resides with Mr Kneale.

Even in terms of Kneale's writing, this serial covered new ground. Today, he's perhaps best known as an imaginative, speculative storyteller, but up to this point he'd dealt mainly with the trappings of sci-fi; often this has been intended to frighten, but the cause was always scientifically possible. It wasn't since a handful of stories in *Tomato Cain*, and the 1952 radio play *You Must Listen*, that Kneale had tackled the issue of supernatural, or the ghostly, head on. In many ways the serial represents a turning point in his writing. Hereafter, Kneale would deal increasingly with tales of ghosts and hauntings.

The writer himself is wary of labelling the serial as supernatural, though. "There wasn't anything really supernatural in it," he insists, "not in the sense of bogie-bogie *X-Files* things. It explained what the supernatural really was, which wasn't supernatural at all. The very opposite. It was something people couldn't possibly understand, something totally unfamiliar. A far cry from the supernatural." Rather than being a supernatural tale in the traditional mould, *Quatermass and the Pit* is an examination of what we understand by the supernatural.

One astonished young viewer was Stephen Gallagher, who later became an acclaimed novelist and scriptwriter. "I've a very vivid memory of being at a family party thrown by my aunt and uncle," Gallagher says, "and the whole thing coming to a halt while a little black-and-white TV was rolled out and everyone watched *Quatermass and the Pit*. I can't have been more than four years old. The impact was two-pronged. First there was the spectacle of almost every adult in my life being spellbound for the entire half-hour. Then there was the matter of what I saw on the screen. I doubt that I could have made any sense of the story, but I was totally gripped by the atmosphere. I wasn't so much scared as awed." Tellingly, Gallagher's imagination was fired by seeing the episode. "For years afterwards I carried a scene in my head that was like a visual distillation of the whole experience... in it there this half-formed, clay-like figure beside a boat in a dripping cave. When the show was eventually released on tape, I waited for the image to come up... and nothing like it ever did! I'd made my own horror out of everything I'd seen. Even now, when I remember it, my point of view's no more than two feet off the floor."

Another contemporary viewer transfixed by the serial was CP Lee, now a respected writer and broadcaster. "I have very strong and long lasting memories of *Quatermass and the Pit*," Dr Lee explains. "It totally affected me and lived within my head. It was a milestone in my viewing habits. I was nine, I think, and it was definitely a behind-the-couch job. I watched it at home. It was absolutely astonishing. I can remember cowering, peeking out from between my fingers, at certain bits of it. Certain visual images stayed forever — the leaping Martians and the ground rippling beneath the man as he lay on the floor."

As well as the more obvious thrills, Lee found the concepts within the serial lingered. "Being a good little Catholic boy, obsessed with history, these idea of the Devil and Hobbs Lane and grounding the force with iron, of good and evil, some kind of spirituality... these made a major impression on me. I'm hard pressed to think of any drama piece that had quite such an impact on me. That's quite a sweeping statement but a true one nevertheless."

The state of television in Britain back in 1959 allowed for a genuine mass audience to be involved in a viewing experience. "In those days there were

ceived unprecedented exposure when it became the serial's theme.

Quatermass and the Pit was unsettling, staggeringly original, and gripping on a grand scale. The impact the serial had on its audience has passed into legend. Seven million watched the first episode on Monday, December 22, 1959, and eleven million watched the last five weeks later. Even by contemporary standards, that's a remarkable viewing figure. In 1959, it was sensational. It represented around a third of the potential viewing audience. In other words, of all the people in Britain who had access to a TV set, virtually one in three was watching by the end of the run. The whole country, according to legend, stopped to watch it. Publicans, it's said, dreaded the weekly broadcasts because they wiped out their business. It was a common story. When *Quatermass and the Pit* was on air, the country stopped to watch. Today, a serial with a sci-fi flavour would be marketed directly at a young, cultish audience, but this was popular, mainstream viewing for all.

The central concept of Kneale's serial, that aliens had influenced the development of life on Earth, became a familiar one over time, but in 1959 it was relatively fresh. Some have detected a kinship with Kneale's approach and the writing of H P Lovecraft, but Kneale denies any influence, on very simple grounds. "I've never read any Lovecraft!" he insists. The writings of Erich von Daniken later popularised the notion of extra-terrestrials guiding Mankind, which also greatly informs the 1968 film *2001 A Space Odyssey*. (Many, Kneale among them, have also remarked on the recurrence of an unearthed alien object in a pit playing a pivotal role in Kubrick's film.) The influence of the serial, as we'll see, was both long-lasting and wide-ranging

At its core, Kneale's serial drew on issues that were highly topical, a quality that informs most of his writing. On a simple level, it concerned the rebuilding of cities and the march of urban Britain. But on a more primal level, the idea touched on violent societal conflict. The notion that man might judge his fellow man, to whom he looks identical, to be unlike him and seek to destroy him was again extremely current in the age of race riots and rampant nationalism.

It doesn't take a qualified psychologist to read into Kneale's notion of digging deep down to find the unearthly source of Man's most primal urges. It's a story about the subconscious, and the human fascination with the supernatural. Lying buried in the recesses of human nature are a swarm of destructive desires, instilled by the Martian heritage. A Freudian reading would recognise the buried capsule as a phallic object — not least because, in the climactic scenes it spews forth a torrent of evil. (Similarly, the rocket in *The Quatermass Experiment* crash-lands in suburbia and unleashes infection and death...)

There's also the matter of Dr Roney's remarkable invention, the 'optic-encephalograph'. In investigating the phenomena fuelled by the Martian capsule, the device is used to form images from the brain, from memory and imagination, on a monitor screen. It a rare example of Kneale stretching credibility by postulating something seemingly beyond the capabilities of modern science. Yet it seems to be a perfect metaphor for what the writer was doing with the medium of television, taking images from his mind and transferring them onto a screen. Indeed, the entire serial, with its depiction of the nation being transfixed as one by the alien influence, is mirrored by the effect the show had on the viewing public.

of secrecy about the serial's content in their dealings with the press to ensure maximum impact on broadcast. Television budgets had risen drastically since the early 1950s and this time out, the producer/director spent a total of £17,578 over the six episodes. This was to be the most ambitious *Quatermass* serial yet.

It was scheduled to be shown over the Christmas period, a high-profile slot, and the BBC made its most cutting-edge facilities available to Cartier. The production was to be staged at the BBC's newly-acquired Riverside Studios in Hammersmith, formerly a feature film facility. "Technology was improving all the time," Kneale says. "The BBC were trying to keep pace, and the Riverside studios were very decent indeed. We thought, 'Here we go!' And yet it was annoying, because these were things we should have had six years ago."

The new studio space afforded the production team many exciting possibilities. Designer Clifford Hatts used the room to solve one of the chief problems presented by the script, namely that the main set would feature the ever-deeping pit of the title. "The designer built an enormous set and filled it with mud. As they were supposed to be digging deeper as the story progressed, they simply raised the surrounding scenery higher, which appeared to make the bottom of the pit go deeper. Very clever. It worked extremely well."

In the time since the second *Quatermass* serial, the BBC's fledgling special effects department, led by Jack Kine and Bernard Wilkie, had become experienced and adept. They were now called upon to realise Kneale's vision of a haunted building site, dead Martians and a living space vehicle, all of which they achieved with aplomb. Wilkie and Kine made effective, resourceful use of flash powder, paraffin wax and basic vacuum-formed models. "They were pretty good", recalls Kneale admiringly. "By now they had a team of special effects men, who had a lot of ideas. Yes, they were fine." (The Martians produced by Wilkie and Kine were especially effective and memorable. When the serial was over, Kneale was presented with one of the models, and to this day, it resides at the top of the Kneale family home.)

The BBC had also established another department for realising unusual ideas. As the special effects department was to vision, so was the Radiophonic Workshop to sound. It began in 1958, initially to provide special sounds for radio, but was beginning to be involved in TV productions, too. By and large, their work for television had been providing odd sounds — literally — for the likes of *Sputnik*, *Eurovision*, *You Take Over* and *Jack in the Box*. More significantly, workshop founder member Daphne Oram had lend her talents to a TV play, *Amphityron 38*, but this latest assignment was to be on an entirely different scale.

Department head Desmond Briscoe was assigned to create special sounds for the entire serial, many of which were forefronted in proceedings, and key to a scene's effect. Using filters and tape treatments, Briscoe synthesised several extraordinary sounds, not least a whooping screech, somewhere between the sound of a bird and an insect, that accompanied the psychic activity caused by the Martian capsule. According to Workshop archivist Mark Ayres, there was even some discussion of the Workshop providing a full score, but in the event Briscoe simply did treatments of the source music, tracks for a stock library, that was selected. Such a piece, *Mutations No. 1* by Trevor Duncan, thus re-

All of which makes it all the more impressive that the third *Quatermass* is often judged to be the finest of all. Thanks to Kneale's relentless drive for originality, the new serial managed to stay fresh, in relation to its predecessors, by moving the goalposts yet again. *The Quatermass Experiment* had featured an on-screen alien 'invasion'. For *Quatermass II*, the invasion was, to a large degree, already well underway. In this third outing, Kneale proposed that an invasion had taken place long, long ago, shaping the entire nature of Mankind in the process.

The story tells of construction work in London uncovering a mysterious capsule. Quatermass is called in to assess whether it might be some kind of rocket, or even a bomb. Quatermass discovers that the location — Hobb's Lane — has long been associated with supernatural phenomena. Slowly, the capsule begins to cause such phenomena on a startling scale. When the capsule is opened, it is found to contain dead, atrophied beings from some other world. In fact, they are Martians. Quatermass deduces that such visitors from Mars have visited the earth down through the ages and influenced Mankind's development. In effect, they have left their race imprint on humanity, and many of our most primal, destructive urges stem from the Martian visitors. Indeed, what we understand as the supernatural is simply the Martian strain within us. As the serial proceeds, the power of the capsule grows exponentially, and these bizarre, destructive forces are released en masse.

Prior to broadcast, the new serial went by two different titles. Internally, the BBC referred to it as *Quatermass III*; it seemed natural as the successor to *Quatermass II*, but was quickly dismissed as being just too obvious. Kneale himself wrote the serial under the stark title *The Pit*. The two were eventually conflated; the end result, *Quatermass and the Pit*, strikes a pleasingly mythic note.

One of the first hurdles was a familiar problem: a new lead actor was required. In the previous serial, John Robertson had never really made the role of Quatermass his own: besides which, he proved not to be available. "He was busy", recalls Kneale. "I imagine he had other things to do." (By 1964, Robinson was starring in *R3*, a suspiciously *Quatermass*-like sci-fi series about a secretive Government research centre). The part was first offered to leading theatre actor Alec Clunes, but he declined. "So we went back to the man who had been Rudi Cartier's first choice," reveals Kneale, "Andre Morell. He was the first choice of all, and he was, by now, ready to do it, which he hadn't been originally." So it was that the Morell, the impassive O'Brien from Kneale and Cartier's *Nineteen Eighty-Four*, finally took on the role of the put-upon Professor. Many now consider Morell to be the definitive Bernard Quatermass.

Kneale's script also necessitated the return of the journalist character Fullalove from the first serial; the original actor Paul Whitsun-Jones wasn't free to appear, and Brian Worth took the role instead. Another late addition to the cast occurred when Miles Malleson, cast as Quatermass' associate Roney, had to pull out. His replacement proved a hit with Kneale. "We got a marvellous Canadian actor called Cec Linder. He later had parts in a couple of *James Bond* movies. He was a great character. He brought a racy vitality to it. I'm sorry we couldn't have made more of Cec to show him off, but we killed him off...!"

Once again, Kneale and Cartier requested that the BBC maintain a shroud

Wickens. "They'd got Mary Astor," Kneale recalls. "She was very, very prolific. She was in hundreds of films. A lot of bad ones too, I should think, but she had been very famous." The slot was for one-hour drama, and so Kneale's script was drastically edited. Indeed, not all the running time was made up of drama. It was regularly punctuated by adverts, exhorting the audience to show their support for the American steel industry. "What astonished me was, I was sent a copy of the script they used," recalls Kneale. "I can't imagine really what they could advertise about steel, but they did. They had cut my script to tiny ribbons. It wasn't that Mary Astor got the lines — she didn't. The Steel Hour did!"

Indeed, the end result was interspersed with, for examples, lingering images of a suspension bridge, with a voice-over declaring, "This is the five-mile bridge spanning the Straits of Mackinac, the bridge that sceptics said could never be built... But built it was — by the American Bridge Division of Unites States Steel. USS means the best possible steel at the lowest possible price!" Kneale was not impressed. "Enormous commercials, half a page long, boasting about steel," he says. "My story was just a kind of commentary instead of a plot, reduced to nothing. The Steel Hour men had taken it over completely."

The drama, directed by Don Richardson, featured Frank Conroy as Bob Wickens, Lili Darvas as Mme Charcot, and English ex-pat Jean Marsh as the unfortunate mother, Cecile. Kneale himself was given only a 'story by' credit, whereas one Lois Jacoby is credited as 'writer' (which seems rather rich, given that Jacoby had merely hacked down Kneale's original). The experience provided Kneale with his first insight into the mighty film and television industries in the States. "This was the first I knew about how they worked in American television, and I made up my mind I would never ever again have anything done on a television network in America," he says. "A film, that's a different story. But not to be treated to this humiliation of having your play ripped to bits, and practically thrown in the waste paper basket, in order to get sponsorship from some probably now bankrupt company, United States Steel: yuck, yuck, yuck! It was enough to put you right off America..."

NEVERTHELESS, KNEALE WAS KEEN to do some more original work, and his next undertaking was couched in familiarity. Collaborating once again with Rudolph Cartier, he created a new *Quatermass* serial for the BBC. This time, as a freelancer, Kneale would retain the rights for his work lock, stock and barrel. As so often before, the initial inspiration came from living in the aftermath of the war. Walking around London, Kneale noticed the vast rebuilding programmes still taking place in the city, as whole areas had been destroyed in German bombing raids almost twenty years ago. Building sites and cranes were everywhere. What, Kneale wondered, might be unexpectedly discovered if one dug right down into the earth? His idea went much further than the simple notion of physical unearthing. What might the human psyche be found to contain, deep down, if one looked?

It's commonly accepted wisdom that sequels are no good. They're usually driven by commercial demands for more of the money-making same; they revisit the formula of a hit without the element of surprise and, usually, with less originality. Artistically at least, sequels often mean diminishing returns.

Sadly, *The Entertainer* was to be Kneale's last work for Tony Richardson. The director went on to make other key films in the British New Wave movement. *A Taste of Honey* and *The Loneliness of a Long Distance Runner* were adapted, respectively, from a play and a novel, but scripted by their original authors. In 1963, Richardson had an award-winning success with a film of the picaresque 18th Century novel *Tom Jones*, adapted by John Osborne. In due course, he went to work in America. "I lost touch with Tony", admits Kneale ruefully. The Osborne adaptations were prestigious credits for Kneale, but in practise working on them had been a decidedly mixed blessing.

ON A HAPPIER NOTE, they provided him with a hefty income at a vital juncture - on January 3, 1958, Kneale and his wife Judith became parents for the first time, to a daughter, Tacy Deborah Kneale. Family life and fatherhood proved to agree with Kneale very nicely.

The writer hadn't entirely abandoned television, though, although bizarrely many of his credits from the late fifties required no input from him. At that time, the BBC were cheerfully reusing earlier scripts Kneale had written — his adaptations of *Golden Rain* and *The Cathedral* — but these were simply standard restagings, and Kneale had no involvement in them. More impressively, his script *Mrs Wickens in the Fall* was bought by American TV network ABC, and remade for US audiences. "It must have been done through my agent," Kneale explains. "They'd probably got a list of recent productions in England and picked this one out as having been... God knows what! I suppose they saw it as a vehicle for an ageing but famous actress, which of course it was not intended to be."

Scenes from
The Abominable Snowman.

The remake aired on June 18, under the bland new title *The Littlest Enemy*, in a sponsored slot, The United States Steel Hour, with a star name as the bold Lyddie

company her afterwards, and the writer was charged with the task. "I had to entertain Edith Evans and Richard Burton. We had a very good lunch." Indeed, perhaps a little too good. It only drew to a close when a well-refreshed Burton took exception to being prevented from ordering more wine, and the party discreetly left.

Look Back in Anger never had the impact as a film that it did on stage. But aside from launching Richardson as a major director, it minted a new wave in British cinema: largely influenced by the French Nouvelle Vague work of Truffaut and Godard, it was entirely contemporary and concerned with thoroughly modern living, however low-key and sordid. This so-called 'kitchen sink' approach didn't delight all viewers, but it was a revolution in home-grown filmmaking. Within the next few years the likes of *Room at the Top*, *Saturday Night and Sunday Morning* and *A Kind of Loving* all followed in its wake.

Kneale had developed a good working relationship with the film's redoubtable producer, Harry Salzman, and it was Salzman that persuaded Kneale to accept a return engagement almost straight away. The producer had optioned Osborne's second play, *The Entertainer*, in which Archie Rice, a tenth-rate seaside comedian, reflects on his altogether underwhelming life. Rice had provided a meaty role on stage for acting legend Laurence Olivier. James Cagney was considered to star in the film version, but Olivier was keen to repeat his performance, and Salzman agreed. The producer also wanted the capable Kneale handling script duties once more. "Harry said, 'Let's do *The Entertainer* — I'll pay you much more'. And he did!" remembers Kneale. "The only catch was that I hadn't seen the play. In fact, when I did, I didn't like it. But I wrote a script and Harry was happy with it. Again, I'd opened it up."

Coincidentally, the film was made for British Lion, now headed by Ealing refugee Michael Balcon. Tony Richardson also returned to direct. The cast, again, was top notch. It provided debut film roles for Albert Finney and Alan Bates, both of whom would become luminaries in the decade ahead. Other roles went to promising young talents such as Daniel Massey and Shirley Anne Field, and established actors Joan Plowright and Thora Hird (herself something of a Kneale veteran, having appeared in the *Quatermass Xperiment* film).

Whereas Osborne had mostly taken a back seat when *Look Back in Anger* was filmed, he insisted on being much more hands-on on this occasion. It's understandable that Kneale found this situation limiting. He'd already proved himself to be a skilful, intelligent adapter of existing literary works, but then, he hadn't had George Orwell or Emily Bronte breathing down his neck at the time. "Osborne picked my script to bits," he admits. In the end, Kneale and Osborne were credited on-screen as having co-written the adaptation. In addition, Olivier, the eminent star, was still keeping a keen eye on his lines, especially if he perceived any that had got him laughs on stage were sacrificed.

Richardson chose to shoot in his home town of Morecambe, whereupon Morecambe's council went to aggravatingly great lengths to make the town look its best, actually hampering filming in the process. After a troubled shoot, the footage was assembled, and an early cut ran to three hours. The job of cutting it down fell, ironically, to editor and Ealing graduate Seth Holt, still waiting to launch himself as a director. "It never looked right," asserts Kneale. "Instead of being fast moving, it became a slow film cut up."

Osborne, who writes in his autobiography, "Kneale had made a reputation as a skilled writer of science fiction with his creation of the enormously popular *Quatermass* series. It was soon evident that though he readily accepted the task, the material was not much to his liking. He and Tony decided to 'open it up'. It seemed to me they were ripping out its obsessive, personal heart."

Regardless, Kneale was very taken with the calibre of the cast Richardson assembled. For a fraction of his standard fee, Richard Burton took on the lead role of Jimmy Porter, with Mary Ure as his wife Alison, and Claire Bloom as Alison's best friend, Helena, with whom Jimmy conducts an affair. Elsewhere in the cast in smaller roles were Donald Pleasance, who'd featured in the BBC version of *Nineteen Eighty-Four*, and George Devine, the Royal Court Theatre boss himself. Kneale, though, felt Burton was perhaps a little old to play the lead, and considered that this marred the film's overall effect.

For the newly-minted role of Ma Tanner (mentioned but unseen in the play), Richardson cast ageing theatrical doyen Edith Evans. Evans proved to be one of the highlights of the finished film, but there was a downside to offering such a respected actress a relatively minor part. "The play had an awful lot of incidental talk about this character Ma Tanner, which I didn't think would work in the film," Kneale remembers. "I said, 'We must *see* her.' And so they got Edith Evans for the part and said, well, now we must have some lines for her." The writer therefore turned his attention to beefing up the Ma Tanner scenes. (Osborne himself claims in his autobiography that, after much protesting, he was allowed to rewrite, among other things, much of Ma Tanner's dialogue.)

Kneale still had a crucial role to play where Edith Evans was concerned, though. When the legendary actress came in to shoot her scenes, director Tony Richardson found he was too busy keeping to schedule to ac-

Scenes from
The Abominable Snowman.

public school boys? Ken was all for it, and I wrote the script on that basis, and it worked very well. But it only went as far as a very elaborate first draft."

The future looked extremely bleak for Ealing, and it was hoped that *Lord of the Flies* might at least be the studio's last hurrah, but it wasn't to be. "They were all set to go straight off to the South Seas or somewhere and do the thing... and then they went bust. I seem to get that a lot! Michael was very upset." A film adaptation did eventually surface in 1963, though. "When Ealing abandoned it, they had to return all the rights to William Golding, who resold them to Peter Brook, the stage producer. Peter wrote his own script, mostly by the simple device of lifting all the dialogue out of the book. That's all he bloody ever did, and his film was terrible. It was so bad that when Ken Tynan saw it, he went and sought Brook out and yelled at him, denounced him in front of everybody."

DESPITE THESE DISAPPOINTMENTS, Kneale was discovering that he had contacts and admirers in the film industry. One such was Tony Richardson, previously the director of Kneale's Chekhov adaptation for television, *Curtain Down*. Richardson had been employed by George Devine, who'd starred in the adaptation, as a director at Devine's new Royal Court Theatre. One of the new plays Richardson had discovered and debuted was *Look Back in Anger*, John Osborne's celebrated study of contemporary relationships and masculinity. Richardson was keen to launch his career as a film director with a big screen version, and Osborne was enthusiastic. But the producer, American ex-pat Harry Salzman, recognised that the script needed to be right. It was actually Kenneth Tynan, on the rebound from Ealing, who suggested that Kneale was the man for the job, and Richardson's previous work with the writer convinced him of the wisdom of the idea. Since the last days of Kneale's BBC contract, Richardson had been pressuring him to join the production. Once he was free to do so, Kneale provided an entirely new script adaptation of the play. "They'd had a big run of it on the stage and wanted to film it," he says. "Osborne had authored a film script which he couldn't get launched — I don't know, but I think it was probably too stagey. Tony knew I could do film style stuff, so I wrote him a film script of it."

The original play had a seething, claustrophobic power, relying on lengthy, impassioned speeches. For the film script, Kneale understood that the same effect couldn't simply be replicated. "The play was quite a mouthful", he says. Instead, the story would have to be opened out. This required fleshing out characters who'd merely been mentioned in the play. This wasn't to the liking of

who was not going to be told what to do. She pretended that she would do anything, and then on the night, when the live transmission was about to go out, she came over to me and she said, 'now tonight I am gonna do it my way!' And my God, she did! The less said about that the better…"

THERE WAS A POSITIVE UPSHOT from *Mrs Wickens*, though. Kneale was already acquainted with Kenneth Tynan, the legendary critic, who'd worked, for a time, at the BBC. Tynan saw the play, and was impressed by the writer's work. "Ken had watched it. He rang up and said, 'Come and work for me'," Kneale recalls. "He had just become the principal script advisor at Ealing Films for Michael Balcon. So I went to see Ken, who I knew already, and I worked with him for a bit."

Ealing had once been a major force in British cinema. Their portmanteau horror classic *Dead of Night* became hugely influential, and they'd become indelibly associated with idiosyncratic comedies, such as *Whisky Galore*, *Kind Hearts and Coronets* and *The Ladykillers*. But in a beleaguered, cut-throat film market, the studio was struggling to survive, and Tynan had been taken on in the hope of launching some radical new projects.

In association with Tynan, Kneale worked on two proposed films. Long-time Ealing associate Seth Holt, who'd first made his name as a film editor, was the intended director of both. One was an unnamed piece concerning poltergeist activity. The idea never got further than being discussed, but Kneale has described it as intended to be a "creepy one… more personal and psychological than Spielberg's film, more like early Stephen King." At this point, Kneale had barely dealt with the subject of the supernatural, other than for the radio play *You Must Listen* and a handful of stories in *Tomato Cain*. It wasn't to be, though. "We never even got it to the first stage of a treatment," Kneale admits. "It was just talk."

The other Ealing project came far nearer to being produced, but still didn't quite make it to the big screen. Tynan suggested staging a film version of William Golding's celebrated novel *Lord of the Flies*. Working closely together, he and Kneale put together a proposal for Ealing boss Michael Balcon. "Ken and I worked out our ideas for a script, and I wrote a very long treatment," Kneale remembers. "We showed it to Michael, who was still there, precariously. He was dead keen. He said, 'Let's start next week!'"

Kneale and Tynan proposed major changes to the Golding's novel, though. The public schoolboys were to become state schoolboys, and they weren't to be stranded alone. "Ken and I had long conferences about it," Kneale says. "The novel is about upper crust English schoolboys, who find themselves stranded on a desert island during some unstated war. It's really about humanity's behaviour under stress. It's a beautiful book, very well characterised, so I was very keen to do this and so was Ken. But there was one obstacle. I said well, what about the girls? Because you can have the story just as it is, but wouldn't it be richer if we saw what girls would do? Not grown-up girls, but nine year olds; the boys are only about that age. They're all under puberty age so that wouldn't be a factor. They wouldn't be chasing each other around the scenery. How would they get on? And wouldn't that be more representative of how humanity behaves itself under stress rather than just being about little English

INTO THE PIT

ON A HOLIDAY IN FRANCE, Kneale had been struck by the lingering after-effects of World War II: the resentment towards former Nazi collaborators and the web of affiliations and hatred between the assorted nations of
Europe. He was already familiar with the shock-waves of Nazism. His wife,
after all, was herself a German Jewish refugee. He decided to write a TV play
that addressed these issues. Just as *The Abominable Snowman* was playing
in Britain's cinemas, the BBC screened Kneale's *Mrs Wickens in the Fall*.
"That was a complete one-off," Kneale says. "There was no science fiction or
anything like it in there. It was about a pair of stranded American tourists,
pensioners on a fairly cheapo holiday in the Loire valley. They had discovered
more than they had guessed about the state of Europe after the war, and got
stuck in to help."

The main characters, Lyddie and Bob Wickens, are laid up in their hotel once
Lyddie trips and injures her leg — hence the title. "They were stuck there for
two or three days, and people in the hotel had all sorts of echoes of the war,"
Kneale explains. "There was a small boy there, who was in fact the child of a
shamed French girl and an unknown German soldier. This child was treated as
a piece of dirt. They all despised him; he had a horrible time. He'd been made
to live in a little awful attic surrounded by souvenirs of his father and mother
to shame him. The Americans realise something horrid is going on here and
the sufferer, the innocent, is this poor boy who has done nothing to anybody.
So they just want him out of it." The Wickens intervene, and visit the local
Mayor. When the Wickens apply pressure, it's agreed that the boy, Francois,
can go back to America with them as their adoptive son.

"A simple story about an Autumn holiday that came cheap" asserts Kneale,
"and Mrs Wickens, who's this very nice homebody from the West." It was certainly a change of style from the *Quatermass* serials that had made Kneale's
name. It works as a very gentle parable of international politics, with the hotel
representing Europe and the Wickens standing in for interventionist America.
In truth, it lacks the imaginative spark that fuels the writer's best work, and
misses its stylistic confidence. But as an example of Kneale beginning to spread
his wings as an original writer, it's a fascinating piece.

Mrs Wickens in the Fall, broadcast on August 8, 1957, was produced, not
by Kneale's usual collaborator Rudolph Cartier, but by Michael Elliott, an
experienced figure in the field of television who would gradually become one of
Kneale's key collaborators. It fell to Elliott to cast the piece, although a name
was already in line to play Lyddie Wickens: a rather faded former silent film
star called Bessie Love. "Bessie was still beautiful, although she was getting
on a bit." Kneale says. "She was lovely. But she didn't do it. Michael Elliott
wanted to have a new face. He thought Bessie had been around a bit, as she
had. So he got his new face all right - a very tough lady called Natalie Lynn

Studios", Kneale recalls, "and it looked good, it really did."

The new script also widened out John Rollason's interests, and gave him an assistant, Peter Fox, and a feisty wife, Helen. Guest, at the time, was directing features at a furious rate with military precision. He took it upon himself to rework Kneale's script prior to shooting, excising much dialogue that he deemed unnecessary. Kneale and Guest disagreed on the point of the Yeti itself. The writer was adamant that the audience needed to see something of the creature in the climactic scenes, but Guest insisted that a glimpse and a shot of its eyes was sufficient. Thankfully, Hammer achieved this with make-up and uncommonly tall actors, and no midget doubles were necessary. (Ironically, the film's trailer makes a great deal of the promise of seeing the Yeti in the actual film.)

The Abominable Snowman is eerie and effective, with a notably evocative score by Humphrey Searle. Although never a crown-pleaser on the scale of Hammer's *Quatermass* films, in many ways it's a more satisfying piece, and much underrated. Nor is it completely without its influence, either. The scenes of lost members of the expedition calling out to their colleagues across the wastelands — which turns out to be the Yeti luring the survivors to their doom — seems to be reprised in the phenomenally successful *The Blair Witch Project*. Although Kneale had largely enjoyed the experience, he was weary of retracing his steps by turning existing TV scripts into films for Hammer. He wanted to write something original, and had several ideas which he planned to propose to the BBC — one being for a brand-new third *Quatermass* serial.

that which Kneale himself had held in his earliest days in television: doing odd-job work. But Judith then found herself commissioned to adapt a novel as a full six-part serial. By her own admission, her husband helped along the way. To avoid accusations of nepotism, she was credited by her maiden name, Judith Kerr. (This carried its own problems, of course. Kneale's old colleague George Kerr, it had to be stressed, was no relation.)

The novel in question was John Buchan's *The Huntingtower*, about the adventures of one Dickson McCunn, a retired Glaswegian provisions merchant who gets involved with the fortunes of a self appointed pseudo-Boy Scout group calling themselves the Gorbals Diehards. The serial was broadcast live from the BBC's Lime Grove studios from June 16 to July 21,1957, a staggeringly warm environment fit to melt candles in one night-time scene. James Hayter starred as McCunn; other roles were taken by Richard Wordsworth — Hammer's Victor Carroon in *The Quatermass Xperiment* — and Scots actor Frazer Hines, who had appeared in *X The Unknown*, and would be a future assistant to *Doctor Who*. The adaptation was a veritable hit, and Judith might have pursued a TV writing career of her own, had other happy events not prevented this.

IN AUGUST, HOT ON THE HEELS of their *Quatermass II* adaptation came Hammer's film version of *The Creature*. The ambiguous original title wasn't to be kept. "*The Creature* seemed a nice vague term," Kneale says, "but they wanted to be more literal." For a time, it was considered calling the film *The Snow Creature*, but it was eventually released in America under the title *The Abominable Snowman of the Himalayas*, and in the UK, more simply, as *The Abominable Snowman*.

Hammer had purchased the right rather late in the day, and the adaptation was made at quite a speed. Almost inevitably, Val Guest was engaged to direct. Several actors from the TV version were brought in to reprise their roles for the film. Arnold Marle returned as the Lama, and Wolfe Morris as Kusang. Peter Cushing had already established himself with Hammer by starring in *The Curse of Frankenstein*, and so it was an obvious choice to ask him to repeat his performance as John Rollason. Instead of the TV version's Stanley Baker — himself, ironically, a well-known film actor — Hammer secured American actor Forrest Tucker as the duplicitous Tom Friend. Although the studio were once again obliged by their distributors to cast a US name, this wasn't another case of the Donlevys. Indeed, Kneale saw Tucker's performance as having equal merit as Stanley Baker's. "Baker played it as a subtle, mean person, Forrest Tucker as a more extroverted bully", he observes, "but they were both good performances and I found very little to choose. Tucker was, I think, an under-rated and very good actor."

Kneale had provided his own script adaptation, not greatly different from the TV original, which, at ninety minutes, had been almost exactly as long as the film. There was greater opportunity for snowy location shooting, which Guest undertook in the French Pyrenees, and therefore scenes of mountaineering peril could be realised far more convincingly than in a live TV studio. Aside from the mountain shoot, the production was blessed with an impressive Tibetan monastery set, which was later resourcefully reused as the lair of the fiendish Fu Manchu. "They shot the whole thing down in Hammer's Bray

In fact, as Petley points out, the film doesn't differ too greatly from the TV source serial at all. "When I saw the television version of *Quatermass II*, which wasn't until much later, one of the things that really struck me was that so much that's wonderful about the Hammer Films version is just a complete lift from the television versions," Petley argues. "They used the same locations. Parts of it are shot for shot, like the figure of the guy who's got burned in the tank coming down the gantry. Actually, I think the scenes filmed around Shellhaven in the telly version are even better than the film. You've got that wonderful scene in the television version which isn't there at all in the film, of the family being taken away from the beach and you later hear them being shot. Also, there's the scene with the old tramp they discover, which is almost like something out of Samuel Beckett, and you've got the tremendous use of music. For me, the television version is infinitely better."

The ending is again changed — Quatermass doesn't get to pilot his rocket into space, but rather his assistant launches it at the asteroid by remote as a dying act — but then, the climax to the TV serial was one of the least satisfying elements of the whole. The film version works as a neat, taut retelling of the serial, and it provided Hammer with another money-making international success. Mindful of audiences who weren't conversant with basic roman numerals, it was released as *Quatermass 2*. In the US, United Artists again renamed the film, this time as the nondescript *Enemy From Space*. The film was released in June 1957, and drew enthusiastic audiences.

AT THE SAME TIME, someone very close to Kneale was also breaking out as a writer. His wife Judith had done assorted pieces of script doctoring for the BBC, with her multi-lingual talents coming in especially useful for translations of foreign works. In essence, her casual role was very similar to

Scenes from Hammer's *Quatermass II*.

United Artists, part of which covered the fee for the sequel's star. For despite Kneale's objections, it was decreed that the star of the first film should return for the follow-up, and Brian Donlevy got his second shot of being Quatermass. It's lucky, really, that the ideas and atmosphere of *Quatermass II* are so strong; just as John Robinson had essayed a rather bland Quatermass in the TV serial, so too Donlevy manages to be even less appealing here than in the first film. His lack of interest in proceedings does show through in the end result, but thankfully doesn't mar it too much. The actor's behaviour on set — particularly tales of his drunkenness — often colours anecdotes of those that saw him at work on the production.

Kneale himself made a point of visiting the set to see how things were proceeding. "The first time I met Donlevy," he recalls, "he was drinking around Bray Studios somewhere, swallowing gin like it had just been invented. He was quite amiable. He hadn't the faintest idea what any of it was about. It wasn't of interest to him, but he knew he was going to get paid what he'd asked for. He was not a creature you could respect, nor did anybody. He'd simply given up acting some years before and turned to drink. For the second one they'd hired a terrible rat-hole little studio, built to do commercials in, somewhere near Elstree but not too near, in case they were spotted. Donlevy was around, gyrating between the studio and the pub. I saw him come back. He was so full of whiskey he could hardly stand up. He staggered over to the set and looked dazedly around. They held up an idiot board with his lines on and he said 'What's this movie called?' and they said, 'Well, it's called *Quatermass 2*'. He said, 'I've got to say all that? There's too much talk. Cut down some of the talk.' He tried to read it and he had to have go after go after go, so crippled with drink he hardly knew who he was…"

Donlevy rather came unravelled while shooting the climactic scenes. "There was a scene later on location — I wasn't there, but he was up on a hill. There was a wind machine set up representing the fearful wind of the rocket take off. And his wig blew off. He had never admitted to having a wig, and then they all got off to search for Mr Donlevy's wig…" Altogether, it wasn't a prestigious enterprise or one that Kneale felt proud to be associated with, although he admired some of the talents involved. "They had a few really good actors, like Bryan Forbes, who was fine. The poor soul must have wondered what on earth he was doing in it. He must have been a bit hard up at the time. I talked to him about it later and said 'what were you doing?' He shook his head and said, 'well, it was a job'."

The film provided academic and writer Julian Petley with his first exposure to Kneale's most enduring creation. "The very first *Quatermass* which I saw was the film of *Quatermass 2*, on a late night double-bill when I was a student at Exeter University," Petley recalls. "In those days, they used to have a lot of late-night horror double bills. It was on with *X The Unknown*, which was also very good. In those days I'm afraid we used to light a joint up in the cinema… and enjoy the films! I remember thinking to myself, 'I wonder if this film would be as good if I wasn't stoned?' — because I was really very struck by it, particularly the opening sequence with its very, very edgy music. Some years later I saw it on television and thought, 'No, my initial reaction was absolutely spot on.' I still like it. It's one of my favourites."

horrors. It was written by *X The Unknown* scriptwriter Jimmy Sangster, and starred Cartier/Kneale veteran Peter Cushing as the titular doctor. The studio was beginning to find its own very lucrative niche, but the Hammer heads remained aware that Nigel Kneale's TV work had played a key part in the turning-around of their fortunes.

When the BBC sold Hammer the film remake rights to *Quatermass II* and *The Creature*, Kneale exerted what pressure he could to be involved in the process. Although he was in the final months of his BBC contract at the time, Kneale was allowed to do script work for Hammer. Besides, the results wouldn't see the light of day until the contract had expired. Val Guest was again brought in to direct the *Quatermass* sequel; Kneale himself adapted the serial into a screenplay, which Guest is credited with refining thereafter (although Kneale claims that Hammer boss Tony Hinds had as much hands-on involvement in the scripting process as Guest).

The result is much more faithful to the television original than the previous *Quatermass* adaptation. It's hardly surprising there are such similarities, though: the Shellhaven refinery, that proved to be such a memorable setting for the serial, permitted Hammer to return for the film version, and the BBC even allowed some of their original costumes to be reused. "The whole thing was largely copied from the television serial," Kneale remarks, "and produced as hurriedly as possible." Kneale's script makes some significant changes, though. The roles of many of the characters are juggled around, and some — like Quatermass' daughter Paula, and his assistant Leo Pugh — are lost altogether, whereas Lomax, from *The Quatermass Experiment*, returns for the film, but hadn't had for the TV serial.

Scenes from Hammer's *Quatermass II*.

The film production had more than twice the budget of its predecessor- £92,000 — not least because Hammer had struck a US distribution deal for the *Quatermass* films with

Xperiment, Kneale was not about to sit back and watch while others piloted his creation for a second time.

1956 WAS THE FINAL YEAR of Kneale's contract as a BBC television script writer. It was a bizarre twist, though, that the contract had given him both job security and more freedom. He was obliged to provide three plays for the BBC during the period it covered; the *Quatermass II* serial had been classed as two, and most likely *The Creature* was retroactively counted as the third. The matter caused quite some consternation in the BBC's contracts department at the time. Internal correspondence questioning the precise quantity of Kneale's output noted that "the question of the Kneale contract is under discussion at the highest level".

But, true to his word, Kneale was unwilling to provide a host of new work only for the BBC to snaffle the rights for themselves. Besides, he had other offers waiting for him beyond the Corporation. "At that time," Kneale says, "we all felt really that really, television will never be paramount. By the time I actually left the BBC I was getting £1000 a year. What they paid you for a script compared to what you could get if you did a film script... and of course, a film looked much more stylish — and it wasn't live, so the actors had time to find out what they were doing. The whole thing was much more under control so I thought well, as soon as I can, I'll get into films."

In April 1956, Cartier restaged *Arrow to the Heart*, the adaptation that first brought him together with Kneale. But that simply involved shooting the existing script for a second time. Kneale wasn't involved at all. "It wouldn't have needed me. Rudi was perfectly capable. It was his pet, so he would have just put it on." In effect, Kneale simply sat out the end of his contract and undertook a spot of moonlighting. As of January 1, 1957, his ties to the BBC were severed, and he didn't consider negotiating a new contract. He was now entirely freelance, although he still had a presence in the building. "They still gave me the use of the office which I'd occupied, although technically I wasn't being paid anything. It was handy, because I was still working with producers like Rudi and others down the corridor, so I had somewhere to have conferences with them rather than having to make a ceremony of arriving each time. But purely that. I didn't belong to the BBC any more. I'd finished."

KNEALE HAD ALREADY been approached with a couple of film offers. "I was getting pressured by Tony Richardson to help him with a couple of things," he recalls. Richardson, who'd directed Kneale's Chekhov adaptation for the BBC, was keen for Kneale to script his film directing debut, but not before the writer had cleared his existing commitments. Perhaps surprisingly, they were for Hammer Studios.

The *Quatermass* success had instigated a rethink of direction for Hammer. Potential new horror projects were actively being sought. It was observed that the classic film monsters, popularised by Universal Studios in the 1930s — Dracula, Frankenstein, mummies and werewolves — were ripe for a modern treatment. They were also safely out of copyright. By the end of the year, Hammer had struck a major new US distribution deal for its pictures, and production began on *The Curse of Frankenstein*, the first of their Gothic

The immediate consequence was a thematic follow-up by the name of *X The Unknown*. Jimmy Sangster, then a Production Manager at Hammer, helped brainstorm the bulk of the ideas for the project and was then entrusted to write the screenplay, his first writing credit. (In due course, he would become an extremely prolific scriptwriter for Hammer and pen many of their key productions). *X The Unknown* is based around a infinitely more cod-scientific concept than *The Quatermass Xperiment* ever was. Trading on then-current fears of radioactivity, it features subterranean slime which seems sentient, and which destroys all in its path as it hunts for radioactive materials. In collaboration with the Army, an atomic scientist, Adam Royston, seeks to stop the killer slime. The similarities to *Quatermass* are obvious, and entirely intentional. But while Professor Royston has to stop the destructive, living mass just as Professor Quatermass had sought to stop the alien fungus, there is not extraterrestrial element in *X The Unknown*. It's closer in tone to the pathological fear of atomic science that bore Godzilla than any thoughtful sci-fi concepts.

Blacklisted American director Joseph Losey was attached to direct, before his supposed Communist leanings became known to Hammer's bosses. They asked him to step down before explaining to the assembled production that Losey had come down with pneumonia. He was duly replaced by Leslie Norman, whose son, cinema critic Barry Norman, became the laconic presenter of the BBC's Film review programme for many years.

Seeking to go the whole hog and produce an outright *Quatermass* sequel, Hammer approached Kneale with a view to inserting his Professor into the main role. Kneale refused, though, denying us *Quatermass and the Slime* and any number of potential follow-ups. There would be more *Quatermass* to come from the Hammer stable, but after his disappointment with *The Quatermass*

make this serial as effective as its predecessor, but in a quite different way. A logical extension… atmosphere is all important". Kneale went on to quote from a review in the *Daily Mail*, which praised the serial, observing that "this grafting of the extraordinary to the commonplace is an old trick — HG Wells used it to great effect — and I congratulate Mr Kneale on perceiving there is no better trick."

Despite his deep admiration for Kneale's achievements as writer, academic and critic Julian Petley feels Rudolph Cartier's role in the success of *Quatermass* is perhaps in danger of being overlooked. "I think Rudi was always really the undervalued side of the partnership," Petley says. "The very first time I went to see Nigel, he said, 'You really must interview Rudi Cartier: a lot of this is down to him'. Nigel has always paid tremendous tribute to Rudi. Obviously they were a very good team together. Rudi really did have that kind of filmic sense, which I think is why the *Quatermass* films are so good: they're just bursting out of the television screen really. Rudi's other work that I've seen for television has a tremendous breadth and sweep about it."

During the new serial's run, Cartier was driven to complain about a sketch in the Bob Monkhouse programme, featuring Monica Grey and the Winnerden Flats guards in a flippant context. Cartier felt it was undermining and inappropriate. The producer also received a letter from one Audrey George, who was due to enter an Anglican Convent in Dublin before the broadcast of the final episode. George enclosed a stamped addressed enveloped and asked if she could be sent a synopsis of the conclusion, rather spend the rest of her life never knowing what happened. "Please consider this request confidential", she wrote, "as people about to enter the religious life are not supposed to be so interested in such gripping drama". Possibly, it was a trick by the press, from whom Cartier had withheld details of the serial. Either way, he gave Miss George the benefit of the doubt and sent her the synopsis as requested.

IN THE AFTERMATH of the success of the new serial, Kneale found his talents caught in a newspaper circulation war between the *Daily Express* and the *Daily Mail*. "It was immediately after we'd put the thing on screen," Kneale recalls, "and they said, 'can you do us a serial?' Each rang up, and my agent bid them up against each other… to an amazingly small sum." The *Daily Express* were the victors, and asked Kneale to come up with a new prose serial. However, his customary wariness of prose writing blocked any inspiration. "In the end, in a very depressed sort of way, they said, 'Oh well, write the thing you've just put on the telly.'" So it was that a illustrated prose serialisation of *Quatermass II* began daily publication. It wasn't to last, though, as the Express' enthusiasm waned after a few days. "One day they rang up and said, 'how much more is there?' I was only halfway through, and they said, 'can you wrap it up..?'"

Nevertheless, given the attention the serial attracted, It wasn't long before Hammer were making enquiries about the film rights. *The Quatermass Xperiment* had done brisk business both in Britain and the States. It's hard to underestimate the impact the film had on the future of Hammer. Although it wasn't their first thriller venture — not even their first dabbling with sci-fi — it quickly struck the studio bosses that providing scares for grown-up cinema-goers was a sure fire winner, and a niche they could make their own.

experts. They were very good indeed. These two who had made the spacesuits had to get onto the set in vision to dress the poor actors. It was the only way we could possibly do it, because they knew how to manoeuvre these terrible rubber suits and get them on. It should never have happened."

It's still a rarity for a follow-up to match the power of its predecessor, but in rethinking *Quatermass* entirely, Kneale's tale was a triumph, a masterly exercise in paranoia. Whereas the first *Quatermass* serial had shown the Professor working, for the most part, with a dedicated team, he was largely haunted and alone in the follow-up. Arguably, the serial's highlight was the fifth part, *The Frenzy*, in which Quatermass and

The dome monster in BBCTV's
Quatermass II.

a group of men from Winnerden Flats seize control of the plant control room. Almost the entire episode is played out in confinement, as the sinister owners of the plant lay siege to the room. The tone veers from dark satire — calming muzak is piped in via loudspeakers — to genuine horror: a voice (actually Kneale himself) attempts to bargain with the group, two of which bolt out in the hope of being spared. Minutes later, it's clear that the oxygen supply pipes have been blocked — with the bodies of the men who escaped.

Author Ramsey Campbell recalls the scene distinctly — if entirely second hand. "The first time I was actually aware of something that proved to be by Nigel Kneale was when I was nine years old, in late 1955," Campbell says. "I was at primary school, and I remember one morning several of the kids in class coming in talking about the thing they'd seen the previous night on television. And one of them said how — I still remember pretty well the words he used — how the monsters stuffed somebody up a pipe and his blood came spilling out. I remember thinking, never — they're making this up, you know... never would you see this kind of thing on television. That imprinted itself on my mind as a very powerful, nightmarish image at a very early age — even though I'd never seen it."

The new serial was broadcast over six Saturday nights from October 22. In all, the reception was decidedly mixed. Kneale himself enjoyed the experience, despite mixed feelings about shooting at the Lime Grove studios, "with less primitive equipment, with cameras that actually focussed, but that 'feeling' was gone." The feeling in question was the sense of immediate audience contact that the home-made environs of Alexandra Palace had afforded. Another critic of the serial was the BBC's controller of programmes, Cecil McGivern, who sent a memo to Cartier, expressing the opinion that "this is not nearly as good as the first Quatermass serial" and making mention of "far too complicated dialogue, incidents which were improbable... and far too little action". In fact, the memo was forwarded to Kneale himself, who responded "I have tried to

keen to make use of location shooting as much as possible, and scouted for locations before writing had even begun. They scouted the Shell company's Shellhaven oil refinery by the Thames estuary. Duly inspired, Cartier received permission to film extensively at the refinery, and Kneale made much of the location's potential in his resulting script. "We were able to get out of the studio," Kneale says. "There had to be a place that the aliens could have built to inhabit, so we picked this oil refinery. Rudi saw all the columns and pillars and things and was determined to get them on the screen. It looked beautiful too." Meanwhile, the serial's fictional town, Winnerden Flats, was represented by the nearby Mucking Marshes.

The key members of the team who had made the first serial were reunited. Along with Cartier and Kneale, Reginald Tate agreed to return as the Professor. "When we got to the second *Quatermass*, naturally we got on to Reggie, and said we've got this ready for you. He read the script and said yes he'd love to do it, all set... and then he died, just like that." At the exact moment of crisis, Kneale was out of the country. "Judith and I were in Paris having a brief break, and when we picked up the continental *Daily Mail*, it said, 'Reginald Tate drops dead.' So — desperation. We got back straight away to London and found Rudi tearing his hair out and seeing who was available as a replacement. Not many were at that time of the year. The ones who had any acre were all abroad."

Eventually, a suitable, available actor was found. "John Robinson played fairly modest things; he was like a bit player," Kneale recalls. " He was quite distinguished in what he did but he didn't do a lot. He was very nice. He was very upset about the technical terms he had discovered were in the script. He said, 'I can't learn technical terms. I'm not good at it.' So he did his best and he worked and worked and worked on them and he never managed to make it very exciting but it was all right." It seems Robinson never felt entirely comfortable working with the curiously remote Cartier. Nor, it seems, was Robinson alone in his wariness. Welsh actor Hugh Griffith, in the key role of Quatermass' technical assistant Dr Pugh, was similarly unsure of some of the detailed dialogue, so his co-star Monica Grey was sure to remember his lines for him, too.

As ever, Kneale had allowed his imagination free range in writing the scripts, safe in the knowledge that his resourceful producer would bring the result to the screen. For the conclusion, Kneale had Quatermass and Pugh travel into space by rocket. The setting itself was a challenge. "Our designer had run out of money", Kneale says. "He'd spent all his money on the early episodes and when we got to the last one, I said, 'OK, build me a satellite spaceship'. 'What with?' he laughed. 'I've got a rostrum here and some carpet!'" Worse still, Kneale's astronauts had to be seen dressing for their journey. "The end was really a horror which I'd wished on these poor creatures. They had to dress in space suits, in vision! You really couldn't be more unkind to actors than put them through that, and of course they were as hot as hell because they were in a studio which was overlit. It had to be — it was the kind of lighting they had then because the cameras were so weak and in that heat they had to get into their spacesuits. They had help putting them on. By then, we had two technical men [Jack Kine and Bernard Wilkie] who became special effects

powerful artillery against them. On September 22, the BBC's popular radio soap opera, *The Archers*, featured a destructive fire which killed a lead character, Grace Archer. The reaction from the public was massive, which was a relief. The story had been a direct attempt to attract attention away from ITV.

At the same time, Kneale was asked to write a follow-up to *The Quatermass Experiment* as part of his new contract, intended to be a popular strike against the independent channel. In fact, what Kneale conceived was a very different work from the first *Quatermass* serial. Again, it would be as current as possible, but far darker, more paranoid and haunted and, in many ways, closer in tone to *Nineteen Eighty-Four* than the relatively upbeat *Quatermass Experiment*. It was a bold move.

Kneale was enthused about the project, feeling there was plenty of mileage in a follow-up if it was suitably different from the original. "In the first one, somebody was going to get into outer space fairly briskly, as soon as they could manage it," he explains. "The second one was about how, if you go up into outer space and start messing about and stirring things, you can bring something on you. But it was rather dull just to have things plopping in and being bad, so I said, let's make it that it's all happened a year before, so the first surprise is over and nobody believes that there was one. Poor old Quatermass rumbles what's going on and he's the one who has got to do some dirty work in showing it. When he tries, all the creatures, the Whitehall lot, had already been infected, and it is very difficult to talk sensibly to anybody in political power because they've all gone under. That seemed to me to be a more interesting thing to write than just creatures plopping down from outer space and that's it." It also drew from the atmosphere in Britain at the time, one of secrecy, technological advancement and suspicion. "At the time, after the war, there was a consciousness that there were dark forces around." Rudolph Cartier, naturally, was assigned to produce.

Specifically, the plot follows Quatermass doggedly continuing with rocket experiments, and proposing a series of dome structures that might make the Moon inhabitable. To his astonishment, he discovers identical domes built in a secure establishment outside London, near a small town called Winnerden Flats. The purpose of the establishment is being kept top secret. In time, Quatermass realises that showers of artificial meteorites have been falling by Winnerden Flats for some time, containing shards of a gestalt alien consciousness. Humans under the influence of this power — many in senior government positions — have ensured that Quatermass' domes have been realised to house and nurture the alien life-forms, and in time a full take-over of the Earth will be effected.

For a time, it was unclear what this new serial would be called. Internally, the BBC referred to it as either *The Quatermass Experiment Two* or *Quatermass Two*. Eventually, Kneale settled on the title *Quatermass II*, although this was long before the frenzied sequelitis of the 1980s and it was unheard of, at the time, to use the now-familiar form of roman numerals for a sequel. To justify this, Kneale christened the Professor's new experimental rocket the Quatermass II, and as the rocket assisted in saving Mankind, its elevation to title character seemed not entirely inappropriate.

The budget for the new serial was set at £7500. Kneale and Cartier were

The BBC were keen not to lose Kneale, though. They offered him his first long-term contract, to join the BBC full-time for two years as a Staff Writer. It wasn't an offer he took up without a fight. "They came and said, 'Would you like to continue with a contract?'" he recalls. "I said, 'Only if you pay me a lot more money, and if, more importantly, I retain the film rights'. They said, 'No, we can't do that. However we do intend to take the principle to its conclusion, and any contracts we issue to writers in future, they will retain the film rights.' Civilisation was breaking out in the BBC. So I said, 'Well, that's fine, can't you just allow that retrospectively to me?' And they said, 'No. This will not be the way we work.' I said, 'Well, in that case I can't write anything for the BBC that is an original, because you'd steal the rights.' They were a bit cross at that being pointed out, but didn't change their view. They said, 'We've made a stand.'"

For a time, there was a stand-off between the disgruntled Kneale and the Corporation. "There was a bit of fuss about that. I said, 'No, thank you. I'm not going to sign the contract. I am now freelance and I want to make that clear.' They sent in contract after contract, with tiny amendments, and I've still got them. Never signed, never returned. Each time we had to start from zero. I had an agent who was an expert in film deals and he could smell what the sort of thing they got up to, so there was no question of them grabbing the film rights. If they wanted to sell something to a film outfit, they would have to make the deal with me. They were horrified, but I had the upper hand." As negotiations went on, Kneale looked for support, but struggled to find any. "I realised at the time that I needed help, and I called the Writers Guild. I hadn't joined. Nor was I allowed to, because they said, 'well, you've never written any film scripts. Unless you have you can't join us.' I couldn't use them. So where did you stand?"

In the end a compromise was reached, and Kneale signed a contract on August 4. It was to last two years, but as Kneale had effectively been working under its terms and conditions for some time, it was set to expire at the end of 1956. Philip Mackie was offered a similar contract, and together they became the BBC's first staff TV writers. (Kneale was assigned BBC staff number 96248.) As well as a monthly salary, he was to be paid set fees for the delivery of new work, or a smaller fee for adaptations, and was tied to a minimum for three plays during the duration of the deal. Despite his increasing reservations, Kneale still enjoyed his work for BBC TV. "The people who actually did the production, the people who work in the studios, are always fine. It's the swine off in the upper levels, who never see any of their things going out and don't care a damn. We didn't have any dealings with them, but all the fellows you met in the studio, the lighting man, the sound engineers, the stage managers, the whole crew — excellent people. Lovely. But don't go upstairs."

SINCE ITS LAUNCH in September 1955, ITV had proved to be an immediate, widespread success with viewers. While the BBC still clung to the patrician, earnest ideals of its founder, Lord Reith, ITV was squarely aimed at being populist. Light entertainment shows such as *Sunday Night at the London Palladium* established the careers of many performers and attracted massive audiences. ITV was a hit, and the BBC were keen to summon up their most

BERNARD AND BRAY

IN LATE 1955, AS THE *QUATERMASS* FILM drew expectant audiences at local cinemas, the BBC was facing a huge change in the face of British television. Independent television companies throughout the country were to begin transmission that Autumn, as ITV. The BBC's monopoly of television was over. ITV were actively recruiting talented people away from the BBC with the offer of more generous contracts, but the beleaguered BBC saw such behaviour as something akin to treason.

In response, the BBC's attitude to its existing staff became increasingly bureaucratic and bewildering. As a government-affiliated organisation, it was already obligatory for many BBC workers, Kneale included, to sign the Official Secrets Act. The writer found himself being called to a meeting with a true figure of bureaucracy. "I met a BBC civil servant," Kneale recalls. "He didn't really believe in television at all. I mean, none of them did, but he patently didn't. He felt uncomfortable to be anywhere near it. Nice man, a gentle fellow waiting for his pension, which must have arrived soon. He said, 'Are you happy here?' — things you were meant to ask — I said, 'Yes, yes.' 'Work alright?' 'Yes, yes.' 'Nice colleagues?' and I said, 'George is a very nice man, yes, all fine.' But he had this other thing, a communication, either in duplicate or triplicate. He said he was troubled about *Nineteen Eighty-Four* being controversial. It got into the press and bothered people and drew attention, and they didn't want that. So I said, 'What exactly would you be happy with? What sort of programme would please you?' He said, 'Oh, something that would cause no trouble nor attract attention. Not too good, and not too bad, but in the middle…'"

The writers of the slowly-expanding Script Unit were certainly not deemed worthy of respect. "Around this time, we had about four of us doing the scripts. One of them was Philip Mackie, who was a good friend. He had a lot of experience. He knew what he was doing, he was a good writer and thought there must be some future in this. There was Giles Cooper. Giles had written a lot of radio plays of great excellence. He was a very, very good writer. Giles regarded himself as an anchorman of BBC drama. So when he moved over to television, which I'm sure they disapproved of, he said, 'Well, I'd rather like to take my copyrights with me from radio plays.' They said 'No, no chance. Thank you, Mr Cooper, you're finished.' Giles couldn't believe it. He'd been not just anybody writing plays but a man who wrote the best plays, and he wrote novels. He was an outstandingly good writer. And he was being treated with the sort of contempt that they tried to treat everybody with. He came round to our flat in Holland Park, and he was kind of winded. He could hardly believe what they'd done to him. So we made him sit down and have a strong drink and stay to supper. That was what the BBC could do to you. Not just any writer but Giles, who was the king. By way of pacifying him, they wangled him a CBE. Poor Giles left them shortly after and went to ITV."

Donlevy had always been a rather lower rung film star, but had had his moments. He'd regularly been cast by screwball comedy maestro Preston Sturges, but by 1955, those days were well behind him "He'd always played the same sort of bullying part", Kneale recalls, "the Town Mayor or something in the Wild West. Some crooked creature. He could be quite funny and he played those things perfectly well. Sturges, of course, kept him rigidly to style and he did what he was told to do. They were fine. But he had become a Hollywood drunk, waiting for death as he sunk down enormous quantities of Martinis."

It's occasionally been argued that Donlevy's Quatermass is a man of action and authority, and therefore a more fitting star of an action-thriller picture that Kneale's often underwhelming, haunted creation. More realistically, a fading American star in a 1955 British feature promised decent takings for the film when released internationally, and this helps explain Donlevy's dubious presence. Just as the film neglects to imbue the thing in the Abbey with any vestige of humanity, so too Donlevy's brash bullying seems too hard and invulnerable to care about in the film, and Kneale has always regretted the casting of Donlevy as his hero. It was some little consolation that actor Richard Wordsworth, cast as Victor Carroon, gave a memorable, haunting performance in a role with virtually no dialogue.

Despite Donlevy's sledgehammer unsubtlety, the feature adaptation was a major success. It's obvious, really, that a strong television serial — screened live, and not recorded for posterity — would have a vast audience waiting to see it. There were those who'd seen the original, who wanted to see it again (with no way of doing so other than catching the film); those without TV sets who'd missed the original — but who'd perhaps heard of its reputation; and best of all, foreign audiences who were as yet unaware of *Quatermass* in any form. Cannily, Hammer made a virtue of the restricted certificate the film had been granted by the British Board of Film Classification. An X certificate allowed only persons aged eighteen or above to see the film. So, Hammer released it under the knowing title *The Quatermass Xperiment*, highlighting the threat of adult terror that the certificate promised. In fact, Hammer had submitted the screenplay to the BBFC before shooting had begun, as was common practice at the time. A report came back from the Board in August 1954 advising extreme caution over 'a film treatment in which the horrific element was so exaggerated as to be nauseating and revolting to adult audiences'. In the event, Hammer cautiously pushed the graphic elements as far as was possible for the time, and audiences jumped at the chance of being nauseated and revolted.

The Quatermass Xperiment was duly released (on a double-bill with the French crime thriller *Rififi*) on November 20, 1955. Many critics were sniffy ('that TV pseudo-science shocker *The Quatermass Experiment* has been filmed. And quitermess they've made of it, too,' quipped the *Reynolds News*). But it drew large, enthusiastic audiences, repeating the trick when released in the US the following Summer, where American distributors first renamed it *Shock*, before settling on *The Creeping Unknown* — which Kneale has since described as "the most awful title visited on any piece of work."

Nevertheless, it provided Kneale with an oblique introduction to the world of filmmaking and in future dealings with the medium, he resolved not to be cast as such a victim.

the human consciousness within the alien creature, which wills itself to death, in the film Quatermass simply has the monstrous hybrid electrocuted, which makes for a fitting action spectacle, but robs the climax of its melancholy power. Nor was Kneale impressed by the work of Hammer's special effects department. For the finale of the TV original, Kneale had lashed up a pretty effective monster from a pair of leather gloves and some random foliage. What Hammer made, Kneale says, "looked rather like an off-duty octopus."

The other major failing was the actor cast as the lead. Kneale himself was kept informed of such developments by Hammer, despite the BBC's stance that the film was none of his business. "I'd been brusquely informed, 'A deal had now been concluded with Hammer Film Productions, and from hereon you have no part in this,'" Kneale says, "but I was in actually contact with Hammer, via [producer] Tony Hinds. He very decently kept in touch to tell me what had been concluded. They had a deal with American distributors. Now that wasn't a thing that any English company could do very easily, because the Americans didn't want to know about British B pictures, and this *was* a B picture. This wasn't a case of some enormous, ponderous thing about the life and death of some eminent Prime Minister here. They might accept that, but mostly there was a barrier against cheaply made English films but that could be broken if they could make a deal with distributors in America. So they found some terribly cheap old creatures who were prepared to distribute it where it was wanted throughout America. Now this meant a lot of money because it was American money and it would flow back to England. The only catch was that the distributors could make their rulings, and they had to have an American star or stars if there was a female role. There was no dodging that one. That's when Mr Brian Donlevy got into the picture. I think Tony Hinds rang me himself and told me who they had."

Scenes from Hammer's *The Quatermass Xperiment*.

When he saw the end result, Kneale was not pleased. "I hated the film. It was terrible. They had some quite decent English actors, working their heads off. It just conceivably could have been even worse — but not much. It was dreadful." Made on a relatively scant budget of £42,000, the film version races at break-neck pace through the events dealt with more broodingly in the TV original. Several sub-plots — the questing journalist Fullalove, the mysterious combining of the three astronauts' minds within Victor Carroon — were excised completely, while the character of Judith Carroon effective vanishes mid-way through. It was inevitable, really. Lopping half the running time off the story away left only the bare bones behind, and somewhat to his credit Guest makes an advantage of the excitement and momentum within the inventive adventure story that remains.

For all its faults, far from ruining the original, the film version is an acceptable and entertaining piece, with many of Kneale's startling ideas shining through still. Guest wasn't a visionary comparable to Cartier, but he was entirely capable of fashioning a thrilling feature film. He also took care to shoot the feature in a gritty, semi-documentary style, often with hand-held cameras, to lend it extra credibility and immediacy. The television version had employed this approach to some degree, but Guest used it freely to good effect. Curiously, one omission was the scene from the serial in which Carroon hides in the screening of a 3D space epic. Kneale's spoofing of sci-fi conventions was excised, and replaced by a scene where Carroon encounters an innocent little girl who tries to befriend him. It's a knowing nod to the classic Universal film of *Frankenstein* from 1931. (The girl was played by child actress Jane Asher, who was to star, later in life, in another major Kneale drama.)

There are two major issues that Kneale himself could not forgive Hammer for, and which do indeed hamper the effectiveness of the result. Many of the more thoughtful elements of Kneale's scripts are lost, sacrificed due to time restrictions, and perhaps the worst casualty is the Westminster Abbey conclusion. Whereas the TV serial had shown Quatermass appealing to

busters like *The Greatest Show on Earth*, *Around the World in Eighty Days* and *Bridge over the River Kwai*, of a scale that TV could never hope to rival and slyly pilfering the cream of television's talent with bigger wages.

British cinema was tackling the problem on its own scale. Hammer Studios had been launched in 1935, and had made a niche for themselves by buying up the rights to British radio successes such as *Dick Barton Special Agent* and *The Adventures of PC 49*, and turning them into feature films with a pre-built audience. As television began to grow and take hold, so the studio began optioning popular BBC TV shows and adapting them for the cinema, too. Thus, Hammer had purchased the film rights to *The Quatermass Experiment*. It turned out to be a momentous project for them.

Val Guest was engaged to direct the adaptation. Guest was already an industry veteran, having worked as writer and director on film vehicles for British comics such as Will Hay and the Crazy Gang. Whilst working with the latter at Gainsborough Studios, Guest had made the acquaintance of comics Ben and Bebe Lyon; when the pair were approached by Hammer to adapt their BBC radio hit *Life With the Lyons* in 1953, they brought Guest on board as writer and director. The success of the resulting feature spawned a sequel, *The Lyons in Paris*, the following year, which Guest again wrote and directed. Guest quickly found himself in clover with Hammer, directing the studio's first two colour features, *The Men of Sherwood Forest* and *Break in the Circle*, both in 1954. The latter, a tense thriller, proved him to be an adaptable talent adaptable to fields other than comedy. When Hammer producer Tony Hinds was putting the *Quatermass* project together, Guest was a natural choice.

In point of fact, Guest wasn't especially keen on the assignment at first. He hadn't seen the TV original, but Tony Hinds insisted that he took Kneale's original TV scripts in his luggage on a holiday to Tangiers. It was only at the end of the holiday that Guest's wife persuaded him to read the scripts. By and large, he wasn't a fan of sci-fi; but then, neither was Kneale. As soon as he'd read the serial, Guest became enthused and agreed to sign on to the production. Reducing down the three-hours-plus of TV serial to an eighty-two minute feature length was quite a daunting task, one which initially fell to seasoned Hammer screenwriter Richard Landau. Guest himself did further rewrites before shooting began. When the BBC requested some last minute stylistic changes, the job, amazingly, fell to the original author.

"I was just sitting there waiting to get a large sack of money from the BBC if a deal had actually been made," reflects Kneale, "but none of that happened. I was simply told that the deal was done, it was finished, and if I could assist Hammer films in any way, that I should do so, particularly in technical things. The BBC were very anxious for their image to be preserved during the making of this film. At the beginning of the story when the rocket had landed and become a sensation, there was a bit about a BBC news bulletin announcing the fact. The BBC were very concerned that the announcement should be true to their method. I remember actually amending what the American scriptwriter had written, a creature called Richard Landau, who was a fairly broken reed but they got him cheap. What Richard had written was not entirely to the liking of the BBC. It wasn't BBC talk, so I changed it to BBC talk. Then they were all happy..."

was no money. Nobody would give us large sums there was no big budget, and so we had to do it with the pitiful amount for a budget. But Rudi was very clever at making the most of a little. We got away with things. If I had an idea, the first person I would take it to was Rudi. All the others said, 'Oh no, can't touch that. Too complicated, we'll never get away with it.' Rudi would just say, 'Yes, we'll do it,' and he *would* do it, which was a great thing."

Some technical sophistication was beginning to creep into the BBC's television output, though. A rudimentary Visual Effects department had been set up, made up of two talented men, Bernard Wilkie and Jack Kine. Wilkie and Kine had previously made a small contribution to the production of *Nineteen Eighty-Four*. The ambitious drama had made modest use of pre-filmed inserts which was an expensive procedure, yet one which was a quantum leap in otherwise live drama. Apart from allowing shots which couldn't otherwise be achieved, it bought time in a live television studio for swift changes in costume or scenery. Cartier was pioneering in the use of these inserts, and successfully lobbied for some simple establishing exteriors to be shot for *The Creature* to be shot in Switzerland, which he oversaw personally.

Nevertheless, this remained a largely live production, and accidents will happen. In this case, disaster struck in the form of an impatient BBC cleaner. As Kneale recalls, "In a scene towards the end, Peter and Stanley were holed up in an ice cave to talk over the horrid problems of discovering the abominable snowmen. A figure suddenly appeared on screen, at the end of the cave — and it was a man sweeping up the sawdust snow…! So immediately Rudi had to say 'Camera 1, off!' As soon as the thing was over, he said, 'Inquest now, who was that man in the brown coat with the brush?' And the wretch said, 'well, I wanted to get home Mr Cartier, and I thought I'd just tidy up.' Rudi said, 'when we do the second performance on Thursday, this man must not be there! Send him home, give him a holiday, just for the night.'" Come the same scene in the repeat performance, it was assumed the unfortunate chap was safely at home. "But he was there..! They'd tried to block the end of the cave with artificial plastic stones, but somehow he registered, the little bastard! That's the sort of thing that you cant account for in your workings out beforehand in live television, this little man who appears on screen because he wants to get home early!" Audiences responded well to *The Creature*, although acclaim wasn't on the same scale as *The Quatermass Experiment* and *Nineteen Eighty-Four*. However, it did attract the attention of Spike Milligan again: on March 8, *The Goon Show* episode *Yehti* picked up on the comic potential of elements within Kneale's drama, and followed Neddie Seagoon on a sadly abortive expedition to the Himalayas to lay hands on the evolutionary missing link.

ON MARCH 10, 1955, Rudolph Cartier staged a TV version of Peter Ustinov's play *The Moment of Truth*. Kneale assisted Cartier in adapting Ustinov's work, but in all his involvement was pretty minimal. During the same period, Hammer Studios were pressing on with their film remake of *The Quatermass Experiment*. In the mid-1950s, cinema was not exactly at its healthiest. The film industry around the world was suffering under the onslaught of popular television, which was keeping audiences gripped indoors, away from film theatres. Mainstream Hollywood used several approaches to combat this: creating huge epic block-

May 1951. Anything was fair game to be lampooned by the Goons, and on January 4, 1955, it was the turn of Kneale, Cartier and George Orwell, for the Goons episode *Nineteen Eighty-Five* — in which Secombe appears as "eight-four-six Winston Seagoon... a worker in the great news collecting centre of the Big Brother Corporation, or as you knew it, the BBC. In every room is a TV screen that gives out a stream of orders..." The beleaguered Seagoon faces temptation from the ITA — the Independent Television Army — which he covertly joins. As part of his induction, he is encouraged to join in a chorus of "Down with the BBC..!"

KNEALE AND CARTIER didn't rest on their laurels. They began work on a new, original television play drawing on the current trend for mountain exploration. As yet, there were corners of the Earth that were uncharted, and the imaginative writer might speculate about what was yet to be found. The new play was to be set on the Himalayas, partly in a Tibetan monastery, following a British expedition's attempts to track down the legendary Yeti, otherwise known as the Abominable Snowman. Two members of the team are at loggerheads: Dr John Rollason has a genuine scientific interest in the existence of such a species, whereas Tom Friend is a mercenary would plans to find and kill the yeti for a substantial financial reward. Of course, both motives are essentially selfish, since the poor Yeti, a gentle, intelligent race, don't want to be discovered at all.

Kneale called this latest script *The Creature*. (The word 'creature' is, in fact, a favourite conversational epithet of Kneale's, usually implying some distaste, and used with reference to TV corporations and those employed within the film industry. As a title for the play, though, it's intentionally ambivalent whether it refers to the yeti or the avaricious explorers on their trail). Peter Cushing was asked back to star as John Rollason, and leading British cinema actor Stanley Baker was secured to play Tom Friend, by arrangement with British Lion Films, to whom he was then under contract.

The play was shown on January 30 with a repeat, this time undisputed, on February 2. This time, Kneale upped the ante for Cartier yet further. His producer had to realise, on live television, the snowy environs of the Himalayas, and a race of towering, non-human beings. Cartier, though, was wont to respond to such challenges with his catch-phrase, "I will do it". The snowy wastes were simulated with generous amounts of sawdust. For the climactic scene where Cushing's character was to encounter the might yeti, Cartier employed a tall actor in a special costume to appear as the beast, and a midget, in a scaled-down replica of Cushing's costume, to appear as Dr Rollason, to accentuate the height differences. Cartier always kept them in long-shot, and when doubts were expressed as to the success of the effect on the screen, he simply replied "They will not notice. Send in the little man..!"

"It was another experimental piece," Kneale suggests. "In addition to Peter Cushing yet again, as a star we had Stanley Baker who was a big film star. Stanley was very nice. Very difficult, but that's OK; stars are meant to be. This really was purely science fiction, set in the eternal snows of the Himalayas — to add a little complication!" Such ambitious ideas required a resourceful talent to bring them to the screen, but Kneale knew he could rely on Cartier. "There

teen Eighty-Four was a small but vital step in this evolution.

TV historian Dick Fiddy holds the collaborative team of Kneale and Cartier in the very highest esteem. *"Nineteen Eighty-Four* is a revelation," Fiddy insists. "Cartier is a pioneer. He is the wunderkind of that period of BBC television. He invented a lot of the rules. It was probably easy to be a pioneer in those days, because virtually everything you did was new, but Cartier showed a style and a flair, and his choice of material is pretty eclectic. I think he's a major figure. We're talking the building blocks of early television, in the early fifties, and here's a guy who's utilising two studios, putting the orchestra in one and the actors in the other. Cartier was a true pioneer, and I think Kneale was a very good bedfellow for him, because Kneale had this quite uncompromising vision."

Kneale and Cartier were certainly keen to shift the parameters of what television could do. "If you look at a lot of the stuff going along at the BBC at the time — most of it doesn't exist of course, but reading the scripts and looking at what they were doing — it was quite middle of the road," Fiddy argues. "Cartier's stuff generally wasn't middle of the road; it was pushing the barriers one way or another. When you ally him to Nigel Kneale, you're way out from the middle of the road: you're definitely on the side of the road now! It's the combination of the two of them that makes it so potent."

To understand the impact of *Nineteen Eighty-Four*, it's worth considering the context it came out of, namely the more mannered TV drama of the time. The adaptation was dealing with extremely provocative ideas and incidents. "Take Peter Cushing's performance in it," Fiddy says. "The moment when he is confronted with his biggest fears and he screams. And, you know, that's a real scream. That's possible the first time anyone had a real bloodcurdling scream on television and that's very terrifying for a fifties audience. They're not used to that sort of thing. Someone screaming is very unsettling, and it's in your front room… it's quite horrific. Those sort of touches, which we would take for granted now, would have been very menacing at the time. I think that's prevalent in *Quatermass* as well. A lot of the great shock moments in *Quatermass* are people screaming or peoples horrified reactions to what's happening, often because of course you couldn't show what was happening so you showed someone's horrified reaction to what was happening and that's quite scary and makes you jump. You're not used to it. When these productions came along, they were really very different."

Significantly, *Nineteen Eighty-Four* represents a shift of direction in Kneale's writing. Previously, he had shown interest in imaginative themes and concerns — the ghostly and the scientific. It seems ludicrous that the BBC could assign him to adapt the Orwell novel on the back of the success of *The Quatermass Experiment* as the two were very different indeed. Although promotional material for the serial suggests it is intended to take place in 1965, it's hardly futuristic fare; indeed, Kneale's writing was usually firmly anchored in the here-and-now. Hereafter, though, his fascination with (often bleak) visions of the future would grow and grow.

The shock-waves of the Orwell adaptation even reached as far as the world of comedy. The pre-eminent radio comedy team of the day were The Goons — ex-servicemen Peter Sellers, Harry Secombe and Terence 'Spike' Milligan. BBC Radio's Light Programme had been transmitting *The Goon Show* since

ably of the play, explaining that both he and the Queen had seen, and appreciated, the broadcast. The *Daily Express* were thus rather confounded. "They had two critics, so the other fellow was told to watch it so he could come up with the same denunciation. Then they heard that the Queen had seen it and had liked it. Horror, horror — the new Queen liked it? And yes, she had. Not to say she understood it, but she'd seen it and liked it, and young Phillip had too. So that changed the tune completely. The *Daily Express* got its second critic to denounce his colleague's word: 'Old Charlie doesn't know what he's talking about, this is a wonderful production...'"

For a time, there was still serious doubt that the Thursday night repeat broadcast would be allowed to go ahead at all. Both Rudolph Cartier and Michael Barry appeared on lively televised debates defending the piece. In the House of Commons, a motion was tabled by Conservative MPs that a repeat be banned. Clearly, the issue had shaken British society. The BBC Board of Governors met to vote on the matter, and were virtually split fifty-fifty. In the end one single vote carried the motion to go ahead with the second performance.

So, the following Thursday, *Nineteen Eighty-Four* was restaged. Cartier, though, was concerned enough to insist on extra studio attendants to be laid on during broadcast, effectively as bodyguards, in light of the threats he'd received. In line with the arrangement with Equity, this second performance was telerecorded, and survives, whereas the first was not. Some contemporary observers noted that the repeat didn't quite match up to the original, but it remains a remarkable, powerful piece of television. More even than *The Quatermass Experiment*, Kneale and Cartier had collaborated to produce a drama that enthusiastically pushed the boundaries of what television could achieve. Serious critics began to take note. The perception of the small screen medium was beginning to change. It was clear that it could produce work that was unique and memorable. *Nine-*

Scenes from *Nineteen Eighty-Four*.

sion studio. "Rudi wasn't going to have canned music," Kneale says. "He had a live orchestra, conducted by the man who wrote the score. He was lodged in the adjoining studio, and he would come in on cue, live, with his orchestra. That was another complication. It already had 100 per cent complication to it. Peter Cushing played Winston Smith in a state of, as usual, emaciation, because he was shaped like that. He even took his teeth out, very nobly, for the very final, tiny scene where he has suffered horribly from torture and all the rest!" Yvonne Mitchell, previously Kneale and Cartier's strapping Cathy, was cast in the key role of Julia. "I made her character a bit intellectual. In the book she isn't very intellectual, but Yvonne was clever enough to do it well." Once again, Kneale made himself useful on-set, providing assorted off-screen voices.

The elaborate staging wasn't without problems, either. In one scene, Cushing's Winston Smith was to examine an antique paperweight, but it was found to be missing from the set shortly before broadcast began. Cartier blacked out the studio and announced that there would be no repercussions if whoever had taken the tint prop would return it immediately, but when the lights came back up, it was still missing. A replacement was provided by the Assistant Stage Manager hurrying home to borrow a paperweight belonging to her little sister. It wasn't entirely suitable, though. Come the scene in question, Cushing found himself handling a paperweight with a Mickey Mouse design, and delivering the line "My word, what a beautiful thing — Victorian, no doubt?" with a straight face.

For all the hurdles, though, it was accomplished. The bold production was a far cry from the light diversion of standard TV drama at the time. It brought Orwell's dark, cautionary vision of a sterile, broken-spirited near-future into the nation's living-rooms with all its attendant torture chambers, cruelty and hungry rats. Indeed, the piece was, if anything, too powerful for some sections of the viewing public. "It worked," recalls Kneale. "It was totally successful. And the next day there were screams of horror in the newspapers: 'What are they doing to us, making us look at live rats? What are they doing to this poor innocent British audience?' That was the tone that we got from all the newspaper reaction, either whole pages of denunciation. Peter Cushing had to disconnect his telephone. I had to hide. We all had to get out. The BBC said, 'Don't answer the phone until further instruction'."

It was always going to be a provocative production. When the set designer, Barry Learoyd, first received his copy of the script, he'd sent a memo to Michael Barry questioning whether such a powerful piece was suitable BBC material. In due course, the audience had responded with outrage, and many calls and letters of protest were logged. One letter denounced the play's makers as 'sadists and readers of horror comics'. Another labelled the piece 'absolutely putrid'. It was, after all, shown on a Sunday night, just two weeks before Christmas, and many thought such timing distasteful. The *Daily Express* were particularly vitriolic, reporting, under the headline 'Wife Dies as She Watches', that one viewer, forty-two year old Beryl Merfin, had been finished off entirely by the experience.

"The *Daily Express* was most vociferous," Kneale recalls. "Their critic wrote pure fury: 'why was this allowed?'" Support came from an entirely unexpected quarter. At a speech to the Royal Society of Arts, Prince Phillip spoke favour-

certificate they would get. If they got something like an 'X' certificate, highly censored, then they would be in trouble with distribution, so they were very anxious to secure themselves before going any further. Sidney was very nice, and they really wanted to do it. They would of course have done it extremely well. They had deals with all the leading English actors, so I was very happy. I assumed the next stage would be that I'd hear from Sidney saying 'let's go ahead — and we're paying you lots of money'."

Eventually, Launder and Gilliat balked over the issue of censorship, but the BBC did manage to sell the rights elsewhere. "They finally got an offer from Hammer Films, who were a small B picture outfit," Kneale says. "They had some very simple contacts in America, so there was a slim chance they could get it distributed over there, and they got the job."

Kneale discovered he wasn't to be asked to adapt his own script for the big screen. Hammer has assigned Val Guest as director, and he would co-write the film version with an American scriptwriter, Richard Landau. Still, Kneale fully expected to be rewarded for his efforts in writing the original. "I said to the BBC people, 'Now you've sold it, what do I get out of it? Do I get the usual small payoff?' — and this icy scene broke out. They said, 'No, you can't.' They insisted there would have been no sale but for the BBC acting as a shop window. I always went on hoping that their mind would change when they actually sold it, but they didn't. I'd assumed, wrongly, that the BBC were gentlemen."

After several years of service for the Corporation, Kneale was still, strictly speaking, employed simply to pen adaptations, on one three-month contract after another, with no actual guarantee that the next would be forthcoming. Therefore the rights to the *Quatermass* serial fell into a grey area, and the BBC asserted that, as a BBC employee, Kneale's script was entirely their property. This disagreement was the first really sour note during his time there. "I assumed that, as the contract I had at the BBC was for adaptation of stage plays, this did not come under it. It was an original story that I had invented, and the characters were mine. I was told very firmly that this did not apply."

Kneale resolved to fight his corner. "I had long, angry correspondence with the man who ran the programme contracts department, a creature called Streeton. He was a man of great power. I remember being summoned to his office and sitting there for some time listening to him having a fearful row with the Musicians Union, who were bitter enemies of his, as, frankly everybody was. He was treating them with the same contempt and rage as he would have done writers. We were slaves. We were the people who just provided the material for programmes. He was the man who signed the deals. It didn't dawn on me that this creature really ran the BBC!" It was unfortunate that this cast a shadow on Kneale's work within the Drama department. "The people I was working with, the directors and actors, were very nice and I liked them. But this was something else again: a different side to the BBC".

BY THE TIME THE TV version of *Nineteen Eighty-Four* was eventually broadcast, on December 12, Kneale, was a thirty-two year old married man, and rather disillusioned with his employers. The broadcast itself, though, was a phenomenon. Cartier's staging was tremendously ambitious, including an original orchestral score by composer John Hotchkis; some feat, in a live televi-

BBC's safe stage play conception of TV drama, where you'd close a scene by tracking in on a bowl of flowers! Everybody was having a go at it and trying to crack it technically." Writer Hugh Falkus attempted a draft, working closely with Orwell's widow. But by January 1954, Kneale and Cartier had been attached to the project, and Cartier asked that the proposed transmission date be put back while Kneale started his own script from scratch. This was going to be a tough nut to crack.

Kneale was well aware of the pitfalls of the assignment, and its history. "Rudi and I were being regarded as a team who could do things fast, and tackle the future or something dangerous or whatever. *Nineteen Eighty-Four* was a kind of horror that had been waiting. Kenneth Tynan, the critic, was involved with the BBC at the time, and he had been very keen to do it himself, as an end to becoming a director. Then he got a job working with Olivier, and lost interest. There was also a feeling that it would be almost impossible to do live in studios, and so we were asked to do it, as we had done *The Quatermass Experiment*. Some simple mind at the BBC said, 'Well, if they can do something a bit futuristic there, they could do a futuristic thing like *Nineteen Eighty-Four*, couldn't they? It all sounds perfectly logical...' So we were stuck with being sort of future specialist creatures."

It was a challenge to relish, if not one to dawdle over. "We read the book and we were appalled by the sheer complexity of it — but it was wonderful, obviously wonderful. How difficult to get that into a live studio, though! Plus, at that time Hollywood was interested. They wanted to make a film of it. As they were preparing, the ultimatum came through: if you can get it on the BBC screen first, you'll get away with it, but as soon as they produce their film, you're out of the picture. We were told, do it now or don't do it at all. So we had to get on with it..."

Due to the sheer scale of the endeavour, the BBC quickly agreed to defer the production until December. Kneale used the time to refine his adaptation. "The great problem was that it was a big story with a lot of characters and a lot of scenes. Just to get it on, live, was a horror. I wrote a script which is very complicated, even for me."

IN THE MEANTIME, Kneale had no other writing commitments, and in the Spring he took some time off. Not simply to put his feet up, but to get married. He and Judith Kerr were clearly a rock-solid couple, and they tied the knot on May 8 at Chelsea Registry Office, with Kneale's father and Kerr's brother as witnesses. Kneale gave his occupation as 'author and scriptwriter'; his new wife gave hers as 'artist (painter)'. The happy pair subsequently found a flat together near Hammersmith.

Around this time, Kneale became aware of a flurry of interest in a possible film remake of *The Quatermass Experiment*. In the first instance, he'd suggested the idea himself. "The audience had loved it, and I said to the BBC, 'Can you sell it to film?' They all looked gloomy and said, 'Oh dear — it's not film material really, it's *television*'. But they tried, and hawked it round some of the more reputable film studios, to the Boulting Brothers and Launder and Gilliat. I remember having a long talk at lunch with Sidney Gilliat. He was very keen to do it as a feature film, but was a bit nervous about what sort of

you had dialogue. It wasn't *Blue Peter*... so it had to be what they had in the Props room. It wasn't special effects, nothing as grand. And they had only half a horse, the rear. It was very old, its skin was flapping down like old pyjamas down around its shoes. Well, as long as the camera didn't show that there was only ever half a horse, it was all right. Rudi carefully aimed the camera. Richard then had to be currying it and rubbing its large bottom, beating it cheerfully. Clouds of dust came off it — which was very funny and awful at the same time. Then he had to pick up Yvonne Mitchell — who was a big girl! Really he shouldn't have been asked to do it, but he valiantly did. They got away with it. But it was really straining the casting there. It was all a bit put together."

Nevertheless, the team of Cartier and Kneale won kudos for getting the production on air, and the BBC began to look consider what they might be assigned to next. Clearly, they were capable of more than run-of-the-mill adaptation work. For a while, it was considered repeating *The Quatermass Experiment* over Christmas, by combining the existing telerecordings with new performances of the rest. For technical reasons, the notion was soon dropped. Of course, there was always the possibility of an entirely new adventure for Professor Quatermass, but Kneale was in no hurry for that. As he says, "I think we'd all had enough!" *

INSTEAD, DRAMA HEAD Michael Barry charged Kneale and Cartier with handling the most ambitious adaptation yet attempted on British television; one that had been a stumbling-block for the BBC for some time. *Nineteen Eighty-Four* was the final novel by George Orwell, a study of totalitarianism and merciless population control, focussing on hapless party worker Winston Smith and his forbidden love for a fellow worker, Julia. Orwell was much concerned with how society could be dominated and shaped by tyrannical regimes, and had addressed it in previous works such as *Animal Farm* and *Homage to Catalonia*. *Nineteen Eighty-Four* was his dystopian view of a projected future: it was completed in 1948, hence the date's numerical mirroring for the title. It was published in June 1949. After a struggle against tuberculosis Orwell died the following January. The BBC were swift to recognise the novel's potential for adaptation, and picked up the rights. (Ironically, Orwell, under his real name of Eric Blair, had worked extensively as a broadcaster on BBC Radio, and drew on his experiences of unshakeable BBC bureaucracy for his vision of Big Brother.)

In January 1950, producer Douglas Clevedon suggested that a radio version of the novel might be suitable for the BBC's highbrow Third Programme. The Corporation demurred, but in time the project was revived as a television production. In August 1953, as the final episodes of *The Quatermass Experiment* were being aired, the Drama department began making tentative plans to have the piece on air the following Spring. "*Nineteen Eighty-Four* had been around the BBC for some time," Kneale confirms, "but it didn't fit in well with the

* Instead, the end of the year was marked in a more low-key fashion with the publication of the *BBC Children's Hour Annual* for 1954, which contained a two-page *Mr and Mrs Mumbo* cartoon, illustrated by one R. Jeffryes and written by Kneale.

BiG BOTHeR

FOR THE BOYS OF THE BBC TV Script Unit, it seemed like things were looking up. "George Kerr and I just soldiered on," Kneale recalls, "and moved in eventually to Television Centre, which was being built all the time we were suffering in the houses, and found it very grand indeed. That was only the bottom layer, in fact, it was due to be turned into a sort of vast canteen or something. In the meantime they were using it as working space, and even studios of a sort."

In the aftermath of the success of *The Quatermass Experiment*, Kneale was still living in a flat in Kensington and working to the terms of his meagre contract, adapting stage plays. On August 2, before the serial finished airing, the BBC broadcast *Golden Rain*, an adaptation of RF Delderfield's comic play about a beleaguered out-of town vicar, which Kneale scripted for producer / director Leonard Brett. Brian Worth starred as the vicar, Roger Strawbridge, and Rona Anderson appeared as his wife Cathy. "It was just a routine thing, for a nice director," Kneale says. "Delderfield wrote slightly sentimental, well-made plays. It was perfectly alright."

Clearly Kneale's interests had been piqued by his recent collaboration with Cartier. The BBC recognised their potential as a team, and charged them with hastily adapting Emily Bronte's *Wuthering Heights*. It went out on December 6 (with the customary repeat four nights later). Actually, the whole enterprise had been instigated by a leading film actor of the time, who found himself paired with an unlikely leading lady. "Richard Todd had turned up at the BBC, and said he'd like to play Heathcliff," Kneale recalls. "I don't know why he thought that was his part. Remember, in the book Heathcliff is rather big. Richard, among many virtues, is really not very big! Anyway, Richard marched in and said 'here I am, I'm available' and willing to do it. He talked them round and they all said, 'Oh yes, it's a great honour for us to have you, Mr Todd, straight from the film world, of course'. They said, 'Well, we've got this girl Yvonne Mitchell, who's willing to do it. She's a very good actress — a little bit on the tall side, but I'm sure you're both so good you'll get away with it...' So they got about doing it."

Kneale found himself handling the writing chores with some haste. "I did a script for them in, I think, a week, which is about the fastest I've ever done anything. But they had to have it because he was only available for a very, very limited time, and the script had to be done and in his hand before he'd finally commit himself. We got away with it in a fashion, as much as you could in a thing that only took about a fortnight to get on." In the key scene where Cathy first meets Heathcliff, he's been brought in by Cathy's father to work as a stable boy. "Yvonne Mitchell was a favoured actress at that time, very good, very intellectual. She was very tall, at least a head higher than Richard. He had to be currying a horse. You couldn't have a horse in a live television studio, where

BBCTV's *The Quatermass Experiment.*

But after the first two episodes were recorded, it was judged that the results were too poor to reuse, and, much to Cartier's annoyance, the BBC decided not to carry on for the rest.

Despite the primitive nature of the resources available, Cartier and Kneale had pulled it off. Kneale is still full of praise for the cast. "It was really held together by the acting. The part of Carroon was played by Duncan Lamont, who was a very good actor. That was the primary thing, to give something to the actors." It had been an exciting, exhausting few weeks for the team. "When the thing was over," recalls Kneale, "we escaped onto the terrace outside the studio and looked down on the streets and houses below, and if they had been watching any television they would have watched us, because there wasn't any alternative. So those who had the little H-shaped aerials were the people who could have been our viewers. It made for a friendly feeling, that our friends down there may have watched us tonight. And this feeling also, rather like having done a performance in a theatre, that you knew the audience had watched you." This fruitful collaboration had also firmly established the team of Kneale and Cartier. "I worked with Rudi, I suppose, on more projects at the BBC than with anybody else. We did that one, and in short order we found ourselves working on another one, and another..."

matters is a scene you don't expect to see, which is an old lady watching a 3D film or a besotted girl wondering about her marital future. They matter. None of the rest of it mattered tuppence."

The unsettling nature of the serial drew the attention of the press. "There was a very nervous review, in a London newspaper," Kneale recalls. "It was very alarmed. It said, 'The BBC were trying to upset everybody last night. If they go on like this, where will we end? Think of the children being exposed to this violent stuff.' In fact it wasn't very violent at all. Most of it was just out of focus!"

The ambitiousness of the script caused several headaches, and on occasion the resourceful Cartier and Kneale found themselves seriously up against it. "We had two designers and they were, frankly, a bit ashamed of it," Kneale admits. "They said, 'This is funny. Science fiction?' They put their noses in the air. So not surprisingly there was nobody dedicated to doing any special effects at all. They made the scenery, it was alright. A broken house, things like that. All fairly simple stuff, but the designers showed no commitment to it. Each tried to avoid being trapped having to do it all by the other. They were perpetually dodging and escaping and they didn't want to be slumming with science fiction. That's the way they saw it."

When it came to the climactic scenes with the monster in Westminster Abbey, Kneale found himself steeping into the breach. "I did the special effects myself, because there was nobody else to do them and nobody wanted to. There had to be a big showcase of some sort at the end. I appealed to the designers. I said, 'Can't you help?', and they said, 'You wrote it — you do it'. So I did. I remember going to the country with Judith in a truck and we gathered all sorts of pieces of foliage. Stole it, I suppose. That had to be the substance of the monster. I got a pair of leather gloves and we dressed them, Judith and I, with rubber solution, and stuck bits of foliage on. There was a thunderstorm going on overhead that night, with terrible crashes and water coming from the ceiling, but we carried on and we made bits of necessary special effects. I find them still quite effective."

That wasn't the half of it, though. In the serial, Kneale's sixty-foot hybrid monster was to appear high up on the interior wall of Westminster Abbey, which wasn't going to be easy to achieve. "We weren't allowed to do anything outside the Abbey itself but we did get the standard handout photographs of the interior that they sold at the door. One of those was blown up the size of about three or four feet, and had two holes drilled into the plywood it was made of and I stuck my hands through the holes! — and waggled them on cue. So my hands were on show the next night. The funny thing was, it worked. It shouldn't have done but it did. I was watching on a monitor what my hands were doing, and the thing was not to do anything. Just the natural anxious shaking of the hands probably did the trick. It was extremely sinister. Really creepy and dangerous. This thing that was sixty feet high and spreading, and you believed it. *I* believed it."

There proved to be a large minus point, though. Cartier requested that all six episodes be telerecorded, to be used within the recaps at the start of each episode, and for trailers. There was even advanced discussion about selling the serial abroad. Canadian station CBLT went as far as scheduling a showing.

On set for the live BBCTV broadcast of *The Quatermass Experiment*.

hiding out in a flea-pit cinema with a largely pensionable audience, watching a bad 3D sci-fi film. "Now, how do you do 3D in a live b&w studio?" asks Kneale. "Problem. Rudi Cartier said, 'I will do it'. And he found a way. All the little cutaway scenes of the awful things on the Planet X he shot twice over and superimposed one image on the other, so you got 3D. It looked just the way it should and it worked 100 per cent. I wouldn't have believed it, but it did."

The parodic 3D film is one instance of the humour in the serial, which has often been overlooked since, but which is dear to Kneale's heart. The crash-landing of Quatermass' rocket is of most immediate concern to Miss Wilde, the pensioner whose house it demolishes, who takes great pains to see that her cat, Henry, is hoisted to safety too. (Kneale speaks fondly of this performance by Katie Johnson, "the little old lady to end all little old ladies", who later found immortality in classic Ealing comedy *The Ladykillers*.) Later, Miss Wilde's neighbour, Len, is wont to overstate his role in the rescue, when prompted by his wife before the news cameras.

Kneale's technique involved dropping in these lighter character-driven scenes to humanise proceedings. "There was another scene where a couple are wandering through St James Park," he says, "and they look across the water and something awful, that we don't quite work out, is going on. The girl never stopped wittering about how many children she would like once they get married, and his mind is distracted by what he thinks he might have seen on the other side of the water. Now that, for me, worked 100 per cent. I didn't care a jot about whether somebody had some awful mark on their face or got overtaken by something. Those things don't matter. That's routine. What

like 'Put down that gun, it might be loaded', or 'Let's not go to the police'. You could wile away seven very tiresome half-hours with that. We wanted to get away from that and do something very adventurous. The Powers That Be were very shocked when we announced we wanted to build a rocket at Alexandra Palace."

Kneale's concept was extremely radical for the time, and Cartier had the skill and vision to bring it to the (extremely) small screen. "I was just really wishing desperately to try something different," Kneale recalls. " I said it would be nice if we had something which really moved as fast as possible. Serials were the only place where you could have any looseness, really. The format was good. I liked it. The idea was to try a new kind of pace and style, to make it more like film." Kneale's fascination with cinema duly began to pay off.

The serial was firmly set in a recognisable London, through which Quatermass pursued the fast-mutating form of Carroon. For the climax, Kneale drew on the familiarity of a setting featured in very recent real-life events. "It was literally weeks since they'd had the crowning of the Queen in Westminster Abbey, and the place which was very near to where we'd last seen the hint of something horrid hanging in the bushes of St James' Park. Geographically its only hundreds of yards to Westminster Abbey, so I thought I'd use it. Of course, we couldn't film anything inside the Abbey — forbidden, forbidden. But we could fake it in a very simple way with a few boxes because everybody, if they were half-awake, had seen the Coronation. The shape of things there lingered in their minds, given a tolerable bit of television scenery, they would turn it into Westminster Abbey in their mind's eye. We did and it was totally accepted; it was a nice bit of scenery. It brought the whole thing up to date in a way, because that had only happened about six weeks earlier." In execution, it all also proved useful to have Kneale, a professionally trained actor, on set: he mucked in to provide several off-screen voices, as well as the 'story so far' recap at the start of each episode.

Kneale's script fused elements of the fantastic — the science fiction concepts of space travel and alien organisms, coupled with the horror of Carroon's transformation, and the threat he comes to pose to Mankind — with a believable character-driven modern drama. It draws on a host of contemporary issues: rocket travel research, lingering fears of wartime bombing raids, outside broadcasts from Westminster Abbey. The elements would have made the piece extraordinarily vivid to audiences of the time. It was fast-paced and balanced thrills with humour. It was a quantum leap from the usual broadcasts of theatre productions. Television drama was evolving, and Cartier and Kneale were right at the cutting edge. Nor is Kneale slow to acknowledge Cartier's skill. "His contribution was immense. He knew his stuff, and he was very imaginative. He could produce stuff on the screen better than anybody else. I enjoyed working with him. We had terrible arguments, but it was only about getting the story right."

Each episode, a suitable tone was set by titles, formed with a basic 'dry ice' effect, and the chosen theme — Mars, Bringer Of War, from Gustav Holst's Planets suite, a piece of music which was both alarming and pre-existing. Cartier was quite capable of providing effective solutions to problems posed by Kneale's script. For instance, one episode saw the deteriorating Carroon

As transmission approached, Kneale and Cartier sought to ensure that BBC kept the precise details of the serial secret from the press. They wanted it to have maximum impact, and they were keen not to allow film-making rivals to plunder their ideas. Cartier secured rehearsal rooms near to the British Museum reading rooms, so the production team could refer to information about the script's scientific content. Meanwhile, Kneale focussed on getting the set of six scripts completed in time. "Some of the actors had hardly the sketchiest idea what was supposed to happen. In fact, I doubt if anybody really knew what was happening! The only people who were really in on the secret were Rudi Cartier and myself. The others had to take it on trust, which they were good enough to do."

The first episode, entitled *Contact Has Been Establi*shed, went out on Saturday July 18. As Kneale recalls, it wasn't an immediate success. "It was received rather sourly when it began — at least, by the critics — but by the time it finished, the reaction had changed and they were much more keen on it." On the other hand, the BBC judged the audience's appreciation of its output by means of research, whereby a cross-section of viewers would rate the merit of a programme, and an average 'reaction index', out of 100, was reached. "It was much cruder then," remembers Kneale, "but it was the same principle: they sent out forms saying, 'did you like this programme? Have any of you watched it?'" The first episode of the serial received an index of 70; the results for the remaining episodes were equally as high. At the time, the BBC placed less store by sheer ratings figures, but these were equally impressive, even by today's standards. The serial began with an audience of just over three million, which rose to five million by the last instalment. It had been judged to be a success.

It's difficult to appreciate, so long after the event, just how groundbreaking and pioneering *The Quatermass Experiment* really was. Suffice it to say, there had genuinely been nothing like it before. The BBC had staged TV dramas with a science fiction theme before — notably adaptations of Karel Capek's *R.U.R.* in February 1938, and *The Time Machine*, from HG Wells novel, in January 1949. But they were exactly that — literary adaptations, which was, of course, the standard mode of television drama at the time. As far as original writing was concerned, there had been a tradition, since the post-war reinstatement, of television staging so-called 'horror plays', an umbrella term for anything with supernatural or thriller content, but they provided nothing especially remarkable.

Only the crime thriller serials of Frances Durbridge, the first of which had debuted in March 1952, had made any great impact, and in truth they weren't greatly different from the usual drawing-room fare. "At the time", Kneale says, "the only safe way to do a serial was to make it a very talky piece, preferably in a couple of rooms where people just threatened each other or said things

* Kneale used several personal touches in naming his characters. Carroon was a traditional Manx name, and Kneale called the poor unfortunate's girlfriend Judith — the echoes of 'Kerr' in 'Carroon' being an added bonus. "Judith didn't mind me stealing her name", Kneale says. In return, Kerr supplied the necessary German dialogue for the character of Dr Reichenheim.

and fused the three men into one. In addition, the survivor was infected with the alien creature, and was slowly transmuting into a monstrous hybrid. The tale would focus on the unfortunate victim, rocket scientist Victor Carroon, and the man in charge of the experiment, one Professor Charlton.

Kneale presented this ingenious proposal to BBC Drama head Michael Barry, who was sufficiently enthused to offer him the incentive of £250, the department's entire budget for original writing for the year. Kneale accepted, and pressed on with writing the proposal up into the necessary six-part serial. "I thought of a story and they said 'OK, fine, write it', so I started writing it in some haste. I got about four out of six parts written, and then it was on the air…"

In turning his idea into a set of scripts, Kneale altered his original concept only slightly. For one thing, there was a general agreement that a better title was needed. *"Bring Something Back..!* was the original title, but didn't look like anything much," says Kneale. "It could have referred to shopping… I thought we could get something better than that." For a time, as broadcast loomed, it went by the title *The Unbegotten*. "That was just somebody else's suggestion," he says. "We didn't take it very seriously. It came from a script reader who was a very devout Catholic, and he thought *The Unbegotten* would very much strike a religious note. But it was a bit too much like that type of title, so we didn't use it. Not a bad one, though."

In the process of writing, Kneale also decided to rename his Professor character. He chose Bernard as a first name, in tribute to Bernard Lovell, then the director of the Jodrell Bank observatory. And he found a suitably striking surname by leafing through the London phone book. "There was a family in the East End who ran fruit barrows. They were the Quatermasses. I suppose it does have a certain ring to it. It's from the same group of names as Middlemass. It goes back to William the Conquerer's time, when he was dividing everything up. It must have been a land division. Middle would be half." The name also has something of a Manx ring to it — and of course, in the wake of the Coronation, 'Qu' was a syllable that was fresh on the lips of the nation.

Kneale had clear ideas about the character of his Professor Quatermass. "He's the sort of person you would trust. He was a decent sort; not ruthless, a good man, who found himself out of his depth again and again." It was widely agreed that Quatermass was a wonderful name, and the serial was duly re-christened *The Quatermass Experiment.* *

To Kneale's delight, his former collaborator Rudolph Cartier was assigned to produce the serial, and was assigned a total budget of £3000, which was gradually increased to £4000. It was to be broadcast, live, of course, from the BBC's oldest studios at Alexandra Palace. Cartier quickly set about trying to cast the lead, and approached a leading television actor of the time. "Rudi had worked with Andre Morell, and sent him the script, as it then was. I hadn't completed it: maybe that's what made the difference. Anyway, Andre didn't want to do it. He thought it was too much of a risk to his career, which was true, particularly as the thing wasn't finished. He turned it down, and then Reginald Tate said yes, he'd do it. And did it very well indeed." (Notably, both Tate and Morell had appeared in Cartier's landmark TV drama *It is Midnight Dr Schweitzer* the previous February.)

called Tatiana Lieven, who was actor Miles Malleson's wife. She spoke fluent Russian, and she reread an awful lot of Chekhov to see if there was something that hadn't ever been translated into English, and she found this one. It was very simple, it was about a Russian touring company long before the revolution which was out in the sticks somewhere, and the leading man has a heart attack. He manages to stagger back to his dressing room and they're all frightened because it probably means the end of the tour. They all come in to help, one after the other, and offer suggestions, all in very primitive Russian. It was very good stuff. So I adapted that as a television play, which Tony directed. George Devine played the leading man, who had the heart attack. Suitably, he ended up running the Royal Court Theatre, and took on Tony to direct plays." Devine's fellow cast members included Alfie Bass and Michael Gough, both destined to become familiar players in British film and television.

IN THE GREAT SCHEME OF THINGS, 1953 was shaping up to be an eventful year in Britain. On the night of January 31, the country's East coast had been battered by phenomenal freak winds and storms: 40,000 had to be evacuated from their homes, and over 300 were killed. On a more heartening note, wartime rationing was finally coming to an end, and on May 29, British explorer (and former beekeeper) Sir Edmund Hillary, and his Sherpa, Tenzing Norgay, became the first men to ascend to the summit of Everest. The year's most media-friendly event of all, though, came on June 2, when the coronation of Queen Elizabeth II took place at Westminster Abbey. It became a turning point in the history of television. The ceremony was broadcast live by the BBC, and the whole nation wanted to see it. There was a rush for sales of TV sets beforehand. On the day itself, those who didn't own a set tried to squeeze into the front room of any friend or relative who did. Again, after the broadcast, many were inspired to go out and buy their own first television.

Not long after, the BBC Drama department faced a small drama of its own. These were less stringent times, in terms of scheduling, than today. Simply put, it became apparent that nothing had been lined up for Saturday nights at 8.30pm, or thereabouts, between July 18 and August 22. Of course, this was the holiday season, and audiences would be expected to be low. But something, at least, had to go on.

The cry went out within the department, as Kneale recalls. "They said, 'For God's sake write something, because the programme is empty in the summer. Please, somebody think of something'. So I did." Indeed, he didn't have much option. All eyes were on the two-man Script Unit to come up with the goods, and Kneale's colleague, George Kerr, was on his summer holidays at the time.

Kneale's solution was rather neat. He could easily have suggested a book that might have made a workable television serial, but after endlessly adapting the work of others, he was longing to write something of his own. He dreamt up a contemporary thriller serial, entitled *Bring Something Back..!* about a disastrous British rocket launch. Three men would go up in the rocket, which would disappear from the scanners, and reappear only to crash-land. Inexplicably, of the three-man crew, only one would remain — although it was impossible that the rocket had been opened during the journey. It would eventually transpire that some basic alien life-form, floating in space, had penetrated the rocket

You Must Listen was produced at the BBC's London studios by Raymond Raikes, and transmitted on the radio Light Programme on September 16, 1952. "It was fun doing it," remembers Kneale. "They did it very well: It was a good one." It was also a natural evolutionary step for his writing from the style of *Minuke*, it that it was contemporary and character-driven, for all the curious goings-on it features. Kneale had fused the tone of his short stories with the craft of scriptwriting. The next chance he'd get for original storytelling would be for television, but it was still some months away.

Kneale was never entirely seduced by radio drama, though. As he saw it, seeing human faces was crucial to storytelling. Not unconnectedly, he was a keen cinema-goer. "In my early writing years I went to the cinema about twice a week and was really influenced," he admits. "I wanted to make my work more visual: less making points in verbal terms and more paying off through images, which you tended not to get then."

FOR NOW, Kneale was busy adapting other work for television, as he'd been employed to do. During the early months of 1953, he scripted small screen versions of Dorothy Messingham's play *The Lake*, and — in collaboration with his colleague George Kerr — both Storm Jameson's play *The Commonplace Heart*, and *Number Three*, from Charles Irving's novel. This last concerned a nuclear power station under threat of being used as a weapon, and starred Terence Alexander and an up-and-coming television actor called Peter Cushing. Kneale was clearly rather ambivalent about what he describes as "this business of amending stage plays to make them workable on television. 'Workable' meant that the actors were in the right place to say their lines, which wasn't always easy, in a live studio. So I went on doing that. Some of it was absolute trivia."

Another adaptation, this time of NC Hunter's stage play *The Affair at Assino*, earned Kneale a little extra something in his pay packet. The script was sold on to Canadian TV channel CBC, to be remade there that September. Kneale recalls, "if by any chance they could sell on one of these adaptations you had done, to a company elsewhere, it was their happy custom, a Gentlemen's agreement, to pay the writer a little more — say, £50, for having written it and enabling a small sale. So I found once or twice that I was given this small sum and would buy a new tie or something with it."

One notable assignment from this period was *Curtain Down*, an adaptation of *An Actor's End*, a lesser-known short story by Anton Chekhov, for which Kneale found himself working with future cinema director Tony Richardson. "Tony had just joined the Drama department. He was a newcomer to the whole business of television or stage. He said, 'Couldn't we do a story of some sort that nobody had ever done? A Chekhov, if possible'. We got hold of a nice lady

Mystery Story, though, is notable at least because of its subject. It concerns the enigmatic Professor Le Normand and his dabblings with the space-time continuum, placing it in the same vein as the 'scientific romantic' writings of HG Wells and Jules Verne, and it therefore counts as one of Kneale's first overt dealings with the science fiction genre.

several paintings, as well as finding work teaching art in local schools. In 1948, her father returned to Germany on behalf of the British Control Commission, to report on the state of theatre in the British Zone of Occupation. Entering a Hamburg theatre for a performance of *Romeo and Juliet*, he was recognised by the audience, who gave him a lengthy standing ovation. Tragically, that night, he returned to his hotel and suffered a fatal stroke.

"So that was Judith's background," remarks Kneale, "vastly interesting. Much better than if her Father had been English musician performing in a German orchestra or something. I never met him. He died before I met her. As a German refugee, she had no assets really, and she'd got herself a job trade teaching — teaching girls to cook, needlework, things like that. She didn't see herself as a great cook, but it was a practical thing you could do. It was quite altruistic. At least they had some knowledge of what they were doing when they left these trade schools." Over lunch at the BBC canteen, Kneale had unexpectedly found his soul mate.

AS KNEALE AND KERR became romantically involved, he was continuing on a succession of three-month contracts for the BBC Script Unit. As per his contract, the bulk of his time was taken up with adapting existing works for television. During the later months of 1952, he adapted Stanley Young's *Mystery Story* and Hugh Walpole's *The Cathedral* for producer Douglas Allen. They weren't jobs of any great significance to Kneale. "Those were just routine things," he says. "They were alright, but they never amounted to anything much. They weren't mine. That was what my contract said — I adapted for television. There was no mention in the contract of writing original material." *

At the time, Kneale was much more enthused about a play he'd written for radio called *You Must Listen*. This he had written himself, and it was a clear development of the sort of stories he'd written for *Tomato Cain*. It concerns a solicitor's office, West and Paley, that's having a new phone line installed — a common occurrence at the time. "There was great difficulty in getting a telephone line in those days," Kneale says. "And they then found there was a voice on it, which never stopped. It was an awful, lecherous, sexual woman's voice and they couldn't lose it. All the staff in the office came in and listened all the time and it had to be disconnected — and it still went on."

The engineer who handled the installation, Frank Wilson (played by Charles Leno), is called back to correct the fault. It's thought, at first, to be a crossed line. The sultry, intimate woman's voice (played by Janet Burnell) implores the listener, whom she calls Harry, "when I'm by myself I can't bear it, I want to hear you and talk to you, only that... you must listen." The fascinated office staff christen the voice 'Passion Fruit' (at one point, an intended title for the play). Over time, though, it's realised that the voice never stops. Neither does another voice answer. Wilson is dealing with a haunted phone line. After a good deal of listening to the urgent, ceaseless voice, it becomes clear that Passion Fruit's addressing her lover, a married man, whom she compels to leave his wife. When that doesn't happen, Passion Fruit takes her own life, and the voice interference ceases. Wilson discovers that the events happened exactly a year ago, when the same phone line belonged to another company.

gratefully to be treated to some mess in the BBC canteen! I just happened to sit at the same table. She was super. I just found her a fascinating character, and very loveable — this pretty girl who spoke rather purer English than I did!" At lunch the next day, Kneale encountered her again, "and I just wanted to know more about her. She said, 'I was born in Germany'. I couldn't quite work this one out, and I didn't want to persevere too hard on her. So over the next few hours I began to work this out. She was about the same age as me, a bit younger, early twenties, and I thought, she's obvious English, so what are her family? Maybe her father was some sort of official in the English government who was in Germany at the time. Or maybe a musician, or a photographer: there were a dozen things he could have been. So when I saw her again, I asked her, 'Where exactly?', and she said 'I was born in Berlin, you do know I'm not English at all? I'm German Jewish'. That was much better, and from then on we had lots to talk about! That was the best possible thing to be. I was much more pleased with the fact she wasn't English!"

Anne Judith Kerr, known to all as Judith, was born in Berlin on July 14,1923. Her parents, Julia and Alfred Kerr, were well-to-do and extremely respectable. Her father, Alfred, wrote for the newspapers the *Frankfurter Zeitung* and the *Berliner Tageblatt*, for the latter of which he was the esteemed drama critic. His opinions were hugely influential, and he was known as Germany's 'Kulturpapst' — that is, 'cultural pope'. "Her father was, in fact, this phenomenal figure," Kneale confirms. "He had been a devoted writer in Breslau, which was an academic town, about the only civilised spot in Germany. He'd got a job on a Berlin newspaper and sent a weekly newsletter from Berlin back to Breslau every week. He was also a critic of enormous eminence, practically the same level as Bernard Shaw."

He was also an outspoken opponent of the Nazis. "He hated Hitler, for good and complicated reasons — as a Jew — and did weekly broadcasts against him. He had to be taken to the studio by men with guns to guard him, because he was a target. By 1933, he knew it, and was tipped off by the police themselves to get out while he could if Hitler got in. And so he went out himself alone, with crude arrangements for the family to follow if the worst happened. And the worst did, and Hitler got in. They escaped the soldiers by one day." The Kerrs fled the evening that Hitler was elected Chancellor, and Nazi soldiers arrived to seize their passports the following day. Thankfully, they were too late.

For a time, the Kerrs lived in Switzerland, and then France. Judith and her elder brother, Michael, adapted easily to the new language and surroundings. Alfred himself was rather lost without his language, and struggled to find work. In due course, they moved again, arriving in London in 1936, to live in a boarding house in Bloomsbury. Alfred found himself engaged by filmmaker Alexander Korda to write a script about the life of Napoleon's mother. It was never made, but Korda paid him £1000 for his troubles. The Kerrs used the money to send their son Michael to public school at Aldenham. During wartime, due to his nationality, Michael was a temporary prisoner of an internment camp as an enemy alien — coincidentally, on the Isle of Man. Meanwhile, Judith worked voluntarily for the Red Cross.

When the war was over, Judith, now living in Chelsea, managed to receive a scholarship from London County Council to study art, and managed to sell

was happy to agree with. And so I anglicised it up a bit." *Arrow to the Heart*, with Kneale credited as providing 'additional dialogue', was broadcast on July 20. The rewrite providing Kneale with his first major credit for television, and his first collaboration with Cartier.

"He was a brilliant cameraman," Kneale says. "He had a marvellous eye for a dramatic scene. It was a great pleasure working with him, because he was very flexible, and most of them weren't. Producers and directors were very stick-in-the-mud, partly because of the way the whole thing was structured. It was so rigid. The BBC went back to 1922, back to when I was born — no connection..! Rudi was very glad to get into the BBC. I think he wanted to re-establish himself in a new medium. He was, in fact, valued very highly. They knew they'd got a good one."

As was the custom, *Arrow to the Heart* was broadcast live on the Sunday night and repeated — that is, staged live all over again — on the following Thursday. It was out of sheer necessity. For one thing, it lightened the workload of the writers and producers having to come up with the dramas. Yet there was no affordable, reliable method of recording performances for repeat broadcasts. The only technique available was telerecording. Basically, this involved directing a camera at a TV screen showing the live performance and filming the result. It was crude and rather expensive, and the result weren't always usable. (Surviving telerecordings of the period often have poor quality sound and images: some even feature flies that have landed on the screen during filming!) Occasionally, the process would be used to provide trailers for serials: say, episode one would be telerecorded, and a clip broadcast to trail episode two. It might even be used to provide that a recap of a previous instalment. Certainly, there was scant hope of these shoddy recordings being repeated in full, or sold for broadcast abroad.

The only strong argument in favour of telerecording was that it avoided the expense of entirely restaging a one-off drama days after the first performance. Equity, the actors union, soon twigged to this fact, and insisted that the BBC could only telerecord the second performance of a play, thereby ensuring their members at least a double fee. (Actors already had a good deal of sway in the new field. The traditional formula — staging a TV drama on Sunday and repeating it the following Thursday — was largely designed to fit in with working actors, who would only be free from commitments in the West End on those evenings.) For the most part, until technology developed further, the work of the BBC TV drama unit, Kneale included, was transmitted once and was then gone forever.

AFTER WORKING ON *Arrow to the Heart*, Cartier and Kneale were assigned to different projects, and their paths didn't cross for a while. In the meantime, Kneale met another German Jewish émigré; in due course she proved to be the most important figure in his life. All this happened in the unprepossessing surroundings of the BBC's Lime Grove canteen. One lunch-time, Kneale sat at the same table as a BBC secretary, who was accompanied by an attractive friend who worked at a trade school directly opposite Lime Grove. The friend rather caught Kneale's eye.

He takes up the story: "She'd been invited to have lunch, so she went off very

in [the BBC's newly-acquired studio premises] Lime Grove itself. I think they'd been bombed and stuck together again. If you walked across a mud-patch you got into the canteen, where they served horrible food. I remember someone came over to inspect the pipes which were leaking and pumping out steam all over the area. He came in and looked around with pity, and said 'How much do they pay you?' That was life in the BBC: there was no luxury!'"

The Corporation's TV service was slowly building up its own dedicated staff. Television producers, at the time, were, in modern parlance, both 'producers' and 'directors', overseeing the entire project from inception to completion, ending up directing the cameramen on the studio floor during the live broadcast. It was certainly a challenge, but not all of them were enthralled by the new medium. "Mostly they had come from radio," Kneale says. "That was the big thing: radio was good, television was bad. Television was a slum. That changed of course, but at that time, that was so." For many such employees, the young medium was just a novel offshoot of its forebear. "There was one fellow who believed that what really mattered was the sound and that the pictures were nothing. He called it 'Illustrated Radio'. That was a very, very important thought, which many adhered to. So the pictures were of no importance, and quite apart from the fact that they were a bit fuzzy anyway, there was no attempt to make them any better."

Increasingly, though, forward-thinking people were being employed to shape the BBC's TV drama output. One such was born Rudolph Katscher, in Vienna, on April 17, 1904. Having studied architecture, and later drama under Max Reinhardt at the Vienna Academy of Music and Dramatic Arts, Katscher had become a scriptwriter of crime thrillers for UFA Studios in Berlin, alongside future luminaries Billy Wilder and Emeric Pressburger. He'd fled Germany in 1935 when Nazism began to take hold, and along with Wilder, sought work for the major studios in America, having anglicised his surname to 'Cartier'. "Billy probably said, 'come on, let's go to America'", Kneale says, "and Billy made a fortune and Rudi didn't!" Like his ex-colleague Pressburger, Cartier was drawn thereafter to Britain. His first work on these shores was in 1948, as co-writer and producer of the melodramatic thriller *Corridor of Mirrors*.

After a few fruitless years, Cartier spotted a new opening for his talents. According to Kneale, "at that time, the BBC were showing signs of interest in television, and he said, do you need a producer?" In 1952, he was duly signed up to the BBC TV's drama department by Michael Barry. In their first meeting, Cartier had spoken disparagingly of the state of current television drama output, which favoured adaptations of stage successes and literary classics over original work. Barry could only agree.

Cartier soon began making waves with his bold, ambitious television work. In July 1952, he was readying *Arrow to the Heart*, a television adaptation of a Albrecht Goes' German novel *Unruhige Nacht*, about the events of one night in January 1943, in a Ukranian garrison town of Prosturov, under German occupation. Cartier had translated it, and written the script, himself, but somehow it wasn't quite right: enter Nigel Kneale of the Script Unit. "We just came together by pure accident," Kneale remembers. "They had this play ready for production, and Michael Barry knew that it could have been tweaked up a bit to make the dialogue sharper. It all sounded a little bit too German, which Rudi

department, the light entertainment and drama departments. I did odd jobs on scripts that needed a bit of fixing. I didn't actually do football matches, but if they'd come my way, I would have done them too."

Kneale remembers it as "a very pleasant time: a lot of wasted time, but also learning a lot about the mechanics of running the very primitive studios they had then. We started with the lowest of the low technically. Just an old set of studios up at Alexander Palace, on the top of the hill, which had been employed as all sorts of things in its time. Finally it got fitted up as a television studio with rather crude electronics stuck in, all very, very home-made. It was no kind of studio, but that's all we had. It was all shot live, with literally the oldest TV cameras in the world, made in 1936 out of pretty rough stuff! They were mounted on things like carts, with huge bicycle wheels to roll about on, which had to be pushed about. Old, old things, the ones put in to disprove Baird's method. What the camera-man saw, God knows. He would have a big 'watch the birdie' screen, and probably got a picture that was upside down and left to right..."

At this point in his career, Kneale was fast learning the most effective ways of using the BBC's peculiar resources. "They had a huge quantity of props", he recalls, "which were mostly bequeathed to them by expiring film companies, so you had to use what was there. I remember going around the enormous props department, looking for stuff you could make a story about because that was the cleanest way to do it".

Kneale's first sustained work for the BBC began in October 1951, when he first wrote for children's puppet shows such as *Vegetable Village* and *Mr and Mrs Mumbo*. The latter was part of a variety show for young viewers, shown on alternate Saturday afternoons. The former was the BBC's first glove puppet series, voiced, Kneale recalls, by "a cast who nearly all went on to act in *Carry On* comedies. It was uproarious". (Indeed, it was the TV debut of later *Carry On* stalwart Joan Sims.)

Having made himself useful, Kneale was soon rewarded with a promotion up from odd-job scriptwriter. "I hung on until they said, well, we think you know the drill by now, you can have a three-month renewable contract. Just touching up stage plays, mostly, so they could put them on television. And I thought, well, this is it. But the trick was that you took that on their terms. There was no-one else you could go to, no rival channel of any kind. So it was them or nothing, and they knew it." Nevertheless, Kneale was struck by the opportunities of being in on the creation of a new medium, and persevered. "It wasn't a very bright future, but it was some kind of a future. I always liked the idea of films and acting and being able to *see* the thing. So I was quite keen just to potter around the studios and watch how a few simple rules — and believe me they were *very* simple rules! — could make a stage performance into a television performance."

And so Kneale found himself employed, for just three months at a time, as a writer/adapter within the BBC Script Unit. On paper, it might sound grand. "I was half of the Script Unit", says Kneale. "There were two of us sharing a little tiny office. The other man, who'd been there a while, was George Kerr. A nice man; he was on the same sort of contract as I was. They'd had one or two people before us, I think. We were in these dreadful broken houses which were

CATHODe RAY ExPeRiMenTS

THE BRITISH BROADCASTING COMPANY, known the world around as the BBC, was formed in London in 1922, under the leadership of a General Manager, John Reith, to make and broadcast radio programmes for the nation. As of 1927 it became a Corporation, owned by the state but vehemently not controlled by it. Either way, the acronym BBC stuck, and their radio service quickly became dear to the hearts of the Nation.

On November 11, 1936, the BBC had begun live television broadcasts from the hill-top Alexandra Palace studio, initially only to the London area, and for just two hours a day. Two competing television systems had been developed, by Baird and Marconi-EMI: the BBC switched between the systems on alternate weeks until the following February, when the Baird method was abandoned. Television sets were, naturally, prohibitively expensive items, which few owned. A major event in the early history of the medium was the Coronation of George VI, the first large-scale outside broadcast, on May 12, 1937. It's estimated 20,000 sets were in use in Britain by September 1939, but they had to be hastily stored away. The nation was on the brink of war, and it was thought best to shut down all but the most essential transmissions. Television simply wasn't significant enough at the time. It was widely regarded as 'the wireless with pictures', both by audiences and, seemingly, most of its makers. Potentially, it was just a novelty. Certainly, it was no rival for radio in the nation's affections. Throughout the Second World War, the BBC's radio services had transmitted news reports to keep the nation informed, and their celebrated comedy shows helped keep spirits up.

Once the war was over, the BBC recommenced television transmissions on June 7, 1946. The rather antiquated equipment at Alexandra Palace was dusted down and pressed back into service. There was still no affordable system of recording, and so programmes continued to be staged and broadcast live. By the time Kneale joined the BBC in 1951, television had been running, on and off, for around seven years, and was still very primitive and largely unloved. It was quite a leap, then, for Kneale to have abandoned his literary work for an uncertain future. What's more, before he worked in television, he wasn't even a viewer. "I'd never seen any television," he says, "because there wasn't any on the Isle of Man. They got it, I think, in the fifties. I remember my Father investing in quite a big set, and that was all new when those came in, but my Father had contacts."

Needless to say, there was no tradition of television scriptwriting at the time. The service wasn't long enough established enough for one to have developed. The BBC employees at Alexandra Palace were making it up as they went along. Kneale found himself earning the petty cash by doing tiny pieces of work, writing or rewriting, not even significant enough for him to be credited. "I was there dogsbodying for everyone — the children's department, the music

```
                    THE LONG STAIRS

1 OPENING ANNOUNCEMENT: This is the North of England Home Service.  We
                       present "The Long Stairs", a dramatised account
                       by Nigel Kneale of the mine disaster at Snaefell,
                       Isle of Man in May 1897.  "The Long Stairs".
2 GRAMS:               (Music 1.  Symphony No.5, Sibelius, 4th Movement
                                                        as marked)
3 NARRATOR: (L)        This is the story of a mine disaster made even more
                       horrible by its very quietness.  There was no
                       shattering underground explosion - no roar of
                       escaping flood-water - no sudden fracture of roof
                       supports and obliterating falls of rock.  The
                       contemporary newspaper headlines were perhaps the
                       only noisy feature of the incident.  And today -
                       fifty years later - the eerie quality of the whole
                       affair survives .........
4 GRAMS:               (Wind registers and continues under)
5 NARRATOR: (L)        From the bare top of Snaefell Mountain the four
                       lands of Britain can be seen.  It has the
                       loneliness of all mountains, and every sound is
                       whipped away by the wind into the coarse, shiny turf.
                       In a cleft on the steep side of the mountain, a
                       thousand feet from the summit, lies the Snaefell
                       Lead Mine.  Tourists pass the ruins at a distance,
                       peering from their crawling rail-cars.  It is as if
                       death had left a mark here.  Inside the rotting
                       fence are huge moss-beds of a dazzling, sickly green;
                       here and there the crow-picked skeleton of a horned
                       sheep.  A stream rushes through broken culverts,
                       past a tall chimney and crumbling stone buildings
                       that cut a shriller note into the wind.  One feels
                       that this must always have been a desolate place.
```

The Long Stairs,
**opening page of
Kneale's first script.**

travel right across the country for work was not an arrangement that could continue indefinitely; besides, only a limited amount of material was made at the BBC's Northern base. Indeed, as far as television went, the BBC had only very recently opened a TV transmitter to serve the region. Television greatly appealed to the writer, as it combined dramatic storytelling with real people and faces, the key element that he felt prose writing lacked.

Frustratingly, Kneale lived just a stone's throw from the Corporation's base of operations in London. Ideally, he needed to start getting writing work there. All he required was a foot in the door. "I went back to RADA," he recalls, "and said, 'can you do anything for me? You've got the contacts and I haven't.'" RADA duly put Kneale in touch with one of their ex-graduates, Michael Barry, who'd recently been appointed head of the BBC TV Drama group in London. "I went along to talk to the Drama people there," Kneale says. "They were nice, too. They said 'Oh dear, we haven't anything to offer you… but if you can live on the petty cash to cover your immediate expenses, then, yes, you're welcome to go in and out the front door. We can give you things to do, odd jobs.' And so that's what I did…"

AS HE CONSIDERED his career options, Kneale won a small role in *Man at War*, a BBC radio play broadcast in May 1950, but it was hardly his big acting break. Kneale's reading of yet another of the published stories, a dark tale of adultery called *Essence of Strawberry*, was recorded at the BBC's Manchester studios and broadcast on the Northern Home Service on March 1, 1950. By that point, though, he was in discussions with his contacts at the BBC studios in Manchester about a drama project based on real events — a mining disaster that had occurred on the Isle of Man in May 1897. The result was broadcast on the North of England Home Service that June as *The Long Stairs*. It was the first script Kneale had ever written.

"I wrote a play, a documentary really about the Snaefell mine disaster," he says. "There was a curious semi-industry they had there at the time. People would work out of a little croft set in the mountains. They'd grow things in the vegetable patch round their cottage and live on the carrots and kale and stuff like that. The thing was, if you left anything out, the fairies would take it. They'd get themselves up in the morning and walk maybe five or six miles across the hills to where the mine was. It'd be a lead mine probably, or maybe a bit of silver. Laxey was a main one. It's still there: sealed up, but it still exists. People who worked there had to climb down ladders immense distances, right into the heart of the hill. We're talking many hundreds of yards, maybe miles. There was no transport, nothing mechanical of any kind. They had to climb down, dig, pile stuff into sacks, and haul it up the whole way to the surface. Not surprisingly, the air was fairly foul — and somebody lit a match. It didn't blow up exactly, but they were all poisoned by the gasses, and there was immense loss of life. All these innocent creatures, living a desperately poor life, were just wiped out." The writer himself had visited the scene of the historical disaster. "I knew the place: I had been up the mountain and seen the closed mine. It was a very creepy place altogether; a strange, haunted sort of thing. Nobody else seemed to have written it so I wrote a radio play about it, which was put on in Manchester."

A major obstacle in making the play was casting. For once, actors with a Manx accent were a wholly desirable, and there were few to be found. Using amateur Manx actors wasn't an option either. The BBC were prohibited from using non-professionals by the actors union, Equity. "There were no Manx actors to call on at that time," Kneale recalls. "I was the only one really!" A compromise was reached. Relatives of the victims of the disaster received a letter explaining that English actors were to be used, due to the dearth of Manx actors of sufficient calibre. The lead role of Dr Clement Foster went to Liverpool-born actor Derrick Guyler, later to become a well-known comedy star, who travelled from his home in London for the recording. "That's as near as you could get, folk who could do a kind of made-up Manx accent. Actually, a lot of the fellows who were in the mines weren't Manx — they were Cornish. So some of these actors had Cornish accents and it was very accurate, in fact." A relatively minor role was filled by the only true-born Manx actor on hand: Kneale himself.

In all, he was very happy with the results of his first scriptwriting assignment. But although he'd developed a good working relationship with the BBC's Manchester studios, there wasn't much further it could be taken. Having to

references to sights and sounds, yet it remains utterly convincing. It simply features extraordinary events colliding with the extremely ordinary.

There was also room in the collection for Kneale's previously published work — *The Calculation of N'Bambwe, Lotus for Jamie* (which had been published in *Convoy* magazine) and *The RAF and the Sleeping Beauty* — this last renamed *Enderby and the Sleeping Beauty*, after its main character. The stories are full of imagination and a generous streak of humour: *Clog Dance for a Dead Farce* even draws on the author's experience of backstage theatrical life. As a whole, the book was well-received, although it never sold on any great scale. Collins put it forward for a number of awards, as well as submitting a copy to the BBC for their perusal. It had even been released in America, with slightly rejigged contents, by the publishers Knopf the following year. In due course, the collection won Kneale the Atlantic award, and the well-regarded Somerset Maugham prize for 1950.

This last was no mere trinket for the mantelpiece. It was a financial award, in effect a grant, to be used specifically for the winner to travel abroad, at a time, of course, when such luxuries weren't always affordable. Certainly, Kneale wasn't remotely well-travelled. "Before that I'd never been anywhere," he admits. "I only knew the Isle of Man and London — although I think I had been to Paris, just to see what abroad looked like." But as luck would have it, Kneale did have contacts in a foreign land. His younger brother Bryan had developed into a skilled artist and, since 1948, he'd been living in Italy, having won a scholarship to study at the Royal Academy of Art school in Rome. Kneale decided to travel out to see him. "Where Bryan lived was very splendid and palatial, so he was ahead of me even though he was eight years younger! He'd got out there and was busy at it, so I arranged with him that I could borrow his living quarters. We went all around Italy, because he'd not had a chance to, and we trawled round Europe doing the obvious things. Compared to what people get up to today, to the ends of the earth, I was just a beginner!"

On his return to London, Kneale had decisions to make. He was sure that an actor's life was not for him, and wanted to capitalise on his success as a writer. But that proved not to be as straightforward as he'd hoped. "I felt I was an established writer, which I wasn't really," he admits. "Because Collins said, 'Now write a novel'. And I couldn't! I couldn't think of writing a novel. I said, 'I can't possibly do this. Can't we just have some more short stories?' And they said, 'No, not really, because, with all the best will in the world, short stories don't sell.' It was the same both here and in America. I remember meeting Alfred Knopf, the American publisher, who had published the same collection. I said, 'Will you be interested in further stories after this?' And he sadly shook his head. So I could see there was not a profitable career in that. However nice people were — they were terribly nice, very nice indeed, wonderful people, Collins here, Knopf in America, you can't do better. But they did not really see me as doing anything but sitting down and writing novels. And I simply didn't know how to." Kneale had no interest in the type of literary career that was being offered to him. "I was stuck with this wretched book, which made no money whatever. It got a prize, but it didn't bring any cash in. I thought, 'How many years can I crawl around living in cardboard boxes?'"

that I'd probably make no money out of it. During the whole of that time I was writing things and getting them accepted." Kneale later summed up this stage of his life as a gradual realisation that he was "the kind of actor who should stick to writing".

IRONICALLY, KNEALE'S NEXT professional engagements combined both skills. After the success of *Tomato Cain* two years earlier, he was invited back to the BBC's Manchester studios on several occasions to record more of his short stories for broadcast on radio. *Zachary Crebbin's Angel*, broadcast on the BBC Light Programme on May 19, 1948, was another tale of a reclusive Manx eccentric. The eponymous Crebbin claims to have received a visitation from a holy being, although no-one believes him. When he dies days later, evidence suggests he was telling the truth. A second tale, *Bini and Bettine*, a blackly comic piece about a showbiz juggling act, was transmitted on the Northern Home Service almost exactly a year later, on May 18, 1949. Kneale enjoyed this experience of broadcasting, but also knew his days as a story-reader were numbered. "There weren't that many stories which were readable," he admits. "But it was a start."

In December 1948, Kneale returned to Stratford to appear in a seasonal presentation of *Toad of Toad Hall*, again billed rather dishearteningly as 'unnamed parts'. In the new year, he made a last-ditch attempt to establish himself as an actor. He secured a couple of auditions at the BBC to showcase his talents. He read for the Features Department that July, and their internal report remarked on Kneale's 'good strong voice, rather breathless'. It didn't lead to any offers of work, though. In November, he auditioned for the BBC Drama Department. The response this time was more enthusiastic: 'Best today. Variable. Probably worth a shot. Recommended.' But Kneale never did get a proper shot at acting.

THE TURNING POINT on November 7, 1949, was the publication of his first book. At last, after six years of submitting short stories to Collins, the publishers decided that they'd accrued enough stories of a sufficiently high standard to form a collection of his work: the result was titled *Tomato Cain and Other Stories*. Kneale was now credited as 'Nigel Kneale', and he dedicated the volume 'to my parents'. A thoughtful foreword was provided by the acclaimed novelist, Elizabeth Bowen. The author himself describes the style of the twenty-five stories as "a mixture: some were in the realms of the fantastic, some were humorous, some were about life in the old days of the Isle of Man". Of the latter, present and correct were the titular *Tomato Cain*, as well as *Bini and Bettine* and *Zachary Crebbin's Angel*, fresh from being broadcast. The longest piece is *The Excursion*, a wonderful, evocative tale of an impromptu Manx village trip, tinged with gentle humour and romance. And if the Isle of Man stories have a slightly unearthly quality, the same is true of many of the present-day pieces set on the mainland. *The Pond* is the alarming tale of a taxidermist who finds the tables turned by his local frog population. The story *Minuke*, in many ways, is the blueprint for much of Kneale's later work. Told in a matter-of-fact tone by an estate agent, it concerns a seemingly pleasant property he sells that turns out to be terrifyingly haunted. The writing is full of memorable touches, and

Spear-carrying and Other Stories

POST-WAR LONDON WAS A VASTLY different society to the one Kneale had left behind. And yet, at the age of twenty-four, he was hardly wet behind the ears. He was already well-versed in the modern world of publishers, actors, lawyers and newspaper editors. Besides, he now found himself much closer to the heart of the industry he was eager to get into. And yet, he was still undecided about exactly which career path to follow. Throughout his time studying at RADA, he continued to write stories and submit them to Collins — to whom, of course, he was also now physically much closer. More and more of Kneale's stories were being accepted by the publishers, who endeavoured to find them homes in short story magazines. Although they still weren't making their author a fortune, Kneale began to feel that this, rather than acting, was his true calling.

Besides, Kneale found his Manx upbringing didn't win him any fans at RADA. "They said, 'You've got to get rid of that peculiar accent'. But I didn't bother," he admits. "That was the one I was stuck with: I couldn't do anything with it. It was the time when a young actor would be expected to talk rather correctly, in a very beautiful sort of way which was known as a 'RADA accent'. It was a term of contempt in the acting profession. But then you got a wave of folk like Tom Courtenay and Albert Finney who stuck to their original Northern accents. They were the ones who made the money! And all the creatures who had beautiful accents would be posted off to the northern tip of Scotland or something for a lifetime. Dead loss. I think even RADA got the message, that if you wanted to go on and make a lot of money like say John Thaw or Tom Courtenay, that you had to be yourself."

But that particular tidal change was still a way off if in the 1940s. Kneale seems to have been a talented actor — he was awarded the special BBC prize during his time at the Royal Academy — but his heart simply wasn't in it.

He graduated from RADA in 1948 — he later described his experiences there as "the only serious education I had" — and tried to make it pay by seeking acting roles. He managed to secure a place in the prestigious Royal Shakespeare Company in Stratford-Upon Avon. His first part was pretty low-key, as 'a citizen of Angiers' in a production of *King John*, which ran from 15 April. In all, he took seven roles in productions at the RSC's Shakespeare Memorial Theatre between April and December that year. He essayed Leonardo in *The Merchant of Venice*, and Bartholomew in The *Taming of the Shrew*; but the remainder of his credits were for a volley of undistinguished 'unnamed parts'. As Kneale himself puts it, "I did about a season in Stratford carrying spears, and that was about the extent of it. It was a curious time. I gradually realised

despite a degree of success, Kneale's story writing was, as yet, hardly lucrative enough to qualify as a career. Equally, establishing himself as a fully-fledged writer was proving to be difficult. "You find it very difficult to impose upon yourself an image as a writer, particularly coming from somewhere like the Isle of Man, where nobody is a writer," he laments. "The most they would do is write 'vacancies' in front of their boarding houses." He'd long decided that his future hinged on leaving the island, and the end of the war made this a far easier prospect. But his experience studying Manx law proved to be useless elsewhere, since Manx law bore little relation to the mainland counterpart. Besides, he'd become disillusioned with the notion of becoming a lawyer. A re-think was called for. "This slow process of story writing seemed like getting nowhere quickly," he says, "and I thought I'd try acting. I'd done some amateur acting in the island, so I thought I would try to get into the Royal Academy of Dramatic Art, to give it a bit of legitimacy. To my surprise, I got in. In fact, they'd let anybody at that time!"

So it was that, in 1946, Kneale left the Isle of Man for good, and moved to London to enrol at RADA, thanks to the generous financial support of his parents. Coincidentally, on June 7 that year, the BBC resumed television transmissions, having closed down during wartime. Before long, Kneale and the embryonic medium would collide, with pretty spectacular results.

of popular short story magazines; now a virtually extinct format, there were a whole raft of titles on the market at the time. "Story magazines flourished during the war," Kneale explains, " because they were bought by the forces, and people who simply hadn't time to sit down with a long book." His first such publication was in the March issue of *Strand* magazine. The story was *The Calculation of N'Bambwe*, a little masterpiece of economy in which a refined circle of ladies taking tea snigger at an anecdote about an African witch-doctor who has predicted that time itself will end that day. Their self-satisfied amusement is rather confounded when existence does indeed stutter to a halt. Much of the story's power lies in the contrast between the foolish 'civilised' ladies and the primitive wisdom of N'Bambwe's vision. The dialogue, too, is sharp and effective. Notably, Kneale had elected to write under a pen-name: his earliest stories were credited to 'Nigel Neale' — that is, his own middle name and his surname, minus the 'K', for alliterative effect.

Short story collection
published in 1949.

More of Kneale's stories followed this into publication: *Tattoo* magazine published *Billy Halloran*, one of Kneale's Manx tales; and the February 1946 issue of *Argosy* featured *The RAF and the Sleeping Beauty*, about an army mechanic who witnesses an unearthly automated construction rising out of the African desert, and explores it in astonishment. At the same time Collins were submitting Kneale's work for potential adaptation for radio. Newspapers were also a target for story writers of the time, and provided a potentially international readership. "The biggest spread I ever had was in a New York paper," says Kneale. "*The Harper Weekly*, right across two pages, which was good going in those days!"

Another impressive career milestone came about as a result of Collins submitting Kneale's stories to the BBC for consideration. The author was duly invited to the BBC's radio studios in Manchester to read one of his stories live on the North of England Home Service on March 25, 1946. The story in question, *Tomato Cain*, concerns a harvest-time feud in a local Manx chapel. "Some people from Manchester made contact to ask if I'd like to read occasional stories," Kneale says. "The very sweet lady producer was the mother of [*Times* theatre critic] Irving Wardle — and actually, her husband, John Wardle, succeeded my father at the *Bolton Evening News*." The Isle of Man was near enough to Manchester to be considered virtually part of the region. However,

people who had most reason to be alarmed by that were the evacuees who had escaped from Germany itself and almost felt they were being followed. If the Germans did invade England, they would be back to concentration camps like Auschwitz, but of course it didn't happen."

Kneale had attended St Ninians High School for Boys in Douglas, just a short walk from the family home in Woodside Terrace. In due course, Kneale's younger brother Bryan studied at the same school, and according to Kneale, began to display a special aptitude for Art. "At school he would do wonderful portraits of his fellow pupils, really sophisticated stuff." The elder Kneale, though, left St Ninians less sure about what to make of his life. Fighting in the war wasn't an option. "I was turned down for military service, and just as well," he says. "If they'd have put me in the sun I'd have gone 'pop' in ten minutes, so I was no use to anybody." Certainly he'd developed a taste for fiction and drama, but felt uncertain of the prospect of making a career out of it, particularly while living on the island. Instead, and in lieu of military service, he was apprenticed as a law student. Studying Manx law was a safer bet, but he also managed to feed his creative interests by getting involved in amateur acting.

Meanwhile, Kneale had started penning his own short stories, and submitting them to publishers. "While I was a law student, I did as little as possible, because at the same time I was writing stories," he says. "I knew really that that's what I should be doing." Many of his stories were of the imaginative, unsettling bent he enjoyed in other authors; others depicted life on the Isle of Man itself, its community and beliefs. Strikingly, though, many of the latter were set in the past. "I was just being cunning there," he confides. "I had to set all the stories safely in the past, because if I'd made them be about the Isle of Man in the present day, somebody would've sued me. 'That means me, and you made a derogatory reference to my character on page forty two!' And as I was working as a law student at the time, I had a pretty good idea what lawyers would do. Particularly Manx lawyers, who tear each other's throats out. They all work in the same street, and I was with a fairly ruthless bunch. Very amusing, but they weren't people to tangle with. Nor would I have wished to, while I was writing stories. So there's two different things: I knew that I just wanted to be a writer, I didn't want to be a lawyer, and the more I thought about it the more certain I was. That was not for me."

KNEALE'S COURSE WAS SET when his short stories began to attract serious attention. In 1944, in response to his submissions, the well-established publishers Collins offered Kneale a contract, and he visited London to sign it, meeting company head Billy Collins for a meagre war-time lunch in Simpsons in Piccadilly (now, coincidentally, a branch of book chain Waterstones). "We set it up that I would write a lot more stories and he'd publish them. So I got on with that, very, very slowly. The Collins office wasn't run by Billy — he was a Colonel and was away fighting the war — but by an American called Milton Waldman; a very bright man and a very sharp critic. When I did write something and painfully sent him about three stories, he'd say 'OK, we'll use *that* one — forget the others'. And they did get them published."

From the mid forties, Collins managed to get Kneale's work into a number

spite historical attempts to move towards it. "They tried very hard to convert themselves to some sort of Christianity," Kneale says. "They even wound up with a bishop. But it was not at all a religious place. Certainly I'd never had any contact with religion, and no wish to. Absolutely not. Not a trace. I hated the Church, couldn't stand it. I was sent to Sunday school once to see if I could take to it. That was it as far as I was concerned: I never, ever went again."

Instead, Kneale grew up steeped in ancient Manx superstition. "It was just there. It wasn't a thing you made anything of, you were just conscious of it. I remember my brother, when he was a boy, went with his dog up in the hills. It came on dark, and they just kept going in the direction of home. And suddenly the dog began to howl, dreadfully, in a completely deserted area. There was no-one near in every direction. The dog suddenly upped and went, and ran like a haunted creature. And Bryan found himself running too...That was a very easy thing to happen. That was the real island. There was a certain mystery about the whole place. It's always been that way".

Kneale's Manx grandmother is said to have gone in for techniques not far distant from magic. A *Radio Times* profile on Kneale from the early 1970s notes, 'Superstition is rife on the Isle of Man (caused by in-breeding he says, like the cats) and his own dear granny with all her friends and neighbours practised white witchcraft'. "Well, that's a bit rough!" Kneale remarks. "She did remember, as a young girl, attending on some old woman who was ill, probably with rheumatic fever. She and her sisters tied white sheets onto the bedposts and sang some sort of suitable verse over her. She remembered it as a funny thing to have happened, and had not quite taken it in, and nor had I: I just thought it was a family joke." Until, it seems, when the forty one year old Kneale discussed the story with the Jamaican actor Clifton Jones on the set of the writer's TV drama *The Road*. Jones confirmed that his own mother had taken part in identical magical rituals. "The principle was the same. The Manx did go in for magic, which I found fascinating."

Such beliefs were legion. During 1932, famed psychical researcher (and debunker) Harry Price visited the island to investigate the case of a talking mongoose. According to reports, it was fully conversant in speaking, and singing hymns, in six different languages, including Russian and Welsh, and is said to have spoken dismissively of Price as "the man who puts the kybosh on the spirits". Sadly, Price's findings on the mongoose aren't known.

The onset of World War II had a curious impact on the Isle of Man. "The island in World War II had become a strange kind of concentration camp," Kneale recalls. "Any 'doubtfuls', like Italian restaurant keepers from England, were poured over there and locked up behind barbed wire. Anyone with a German connection, which included most of the refugees who had come to England for safety, found themselves arrested and stored there." This wasn't an entirely uncomfortable arrangement, though. "We liked them. We used to go down and talk to them through the wire, even. My own future brother-in-law was interned there, although I never met him. In fact, they were shown a lot of respect and had quite a reasonable time. No worse than the natives outside the wire." In many respects, the crude arrangement was mutually beneficial. "After the evacuation of the British army from France, there was total panic that the Germans might come and invade," Kneale explains. "Of course, the

ics. "There was no telly, and not really much in the way of radio at that time. Only what leaked across, mainly from Northern Ireland: they had some good drama from Belfast, and so that was what I grew up with I suppose. The only kind of fiction I enjoyed was short stories. The real stuff, not Agatha Christie, but Maupassant and Chekhov and that kind of thing, because they were much more exciting really. There was nothing better, for me, than the best short story writers. I just loved them." Another favourite of the growing boy was Victorian author HG Wells, who wrote in a great range of styles, but was especially celebrated for his short stories and his fantastical novels such as *The War of the Worlds* and *The Invisible Man*. In such works Wells deals with extraordinary situations which occur to ordinary people in recognisable locations: at once supremely imaginative and yet grounded in characters and a credible reality. Similarly, the young Kneale was a great admirer of MR James, an academic who wrote hugely creepy and believable ghost stories. Both writers share a style that's imaginative and fantastic, but never overly fanciful. It's not hard to speculate on the impact such fiction had on this particular young reader.

There was a great deal in his home environment to fire Kneale's imagination, too. While the twentieth century was marching on elsewhere, the Isle of Man remained relatively unchanged, and saw little of their geographical neighbours. "The English were a different breed of people. We didn't see anything of them much, until the Industrial Revolution I suppose, when people came over from Lancashire to exercise themselves and get away from the mills they worked in. They came over for holiday time, two or three weeks. That season ran through the late summer. They were the only people from abroad who came in. The island itself stayed completely intact". (Manx families were encouraged to take in paying guests over the holiday period; Kneale himself remembers being turfed out of his own bedroom and relocated to the attic on occasion.)

As a result, the island community held fast to age-old superstitions and myths. "They've always gone in for superstition in a big way," Kneale says. "It was very easy for them to believe in practically anything. If you're surrounded by sea, it naturally comes with all sorts of sea-monsters, starting with mermaids and working their way up to things about a hundred feet high. There's a deep belief in ghostly things, fairies, and witches of a sort, and every kind of sea misfortune, that you can get into by going the wrong way at the wrong time, or turning corners, or going to sea in the wrong sort of weather. I suppose you get that in other sea-going places too, around Scotland and Ireland: they take a very, very powerful grip on people. They'd much rather believe in any sort of creature from the sea than in Jesus and co."

The Manx belief system rather appealed to the young Kneale. "They had a home made religion, purely superstition — which I'm not sure I don't entirely prefer," he admits. "We all knew about these ghostly creatures, and they made better sense to me than any established church. Partly because they had grown out of the people's own home made superstitions. It was about showing due respect for things that were not entirely to be understood, namely this score of wild superstition creatures who had grown out of the island's soil, practically, up in the mountains. We stuck with what we'd been given. I found all that totally fascinating."

Indeed, conventional religion has never quite flourished on the island, de-

Down the ages the Manx people developed their own unique culture, long untroubled by outside influence. "They lived simple very peasant lives and nobody interfered with them," recounts Kneale. "The Romans came to England but not one of them ever set foot in the Isle of Man. The only people who came in the end were Norwegians, who sailed down out of curiosity down the Irish Sea and said, 'What's this thing sticking up out of the water?'"

The island's resulting Celtic and Norse heritage is well documented. It was already part of the Viking kingdom when Magnus Barefoot, the King of Norway, landed there in 1098: Barefoot then helped establish the Tynwald, the island's self-governing body. Tynwald still operates today, and stands as the oldest continuous government in the world. Now England's Queen holds the ancient post of Lord of Mann, but while it's technically part of the British Isles and the Commonwealth, the island has never belonged to the UK. But it maintains its independence fiercely, with its own culture, currency, language, flora and fauna.

The island has a famous three-legged symbol, the trje cassyn, comes complete with its own Latin motto, 'quocunque jeceris sabit' — which translates as 'whichever way you throw me, I stand'. Even today, only forty per cent of the Isle of Man is inhabited, with over half of that population living in the close vicinity of Douglas, a busy port on the island's East coast dating back to the time when the island was a major centre for smuggling routes.

When the Kneale family decamped to the Isle of Man, it was to Douglas they went, and found a home on Woodside Terrace, a fair-sized dwelling built of stone back in the 1820s. Thus settled, Kneale's father cheerfully threw himself into his new role as a newspaper owner and editor. "I loved the island and the people", Kneale says. "My parents were obviously happy because it was where they had grown up and all their relatives were Manx. They belonged there, and in the end both died there." The whole island was still a relative novelty to young Tom. "I hadn't been there more than a week in time before that, and suddenly I could see light everywhere. Beautiful, it absolutely was. Except that for me that was fatal, because I can't take light."

It's a rather cruel irony that, having escaped the unhealthy gloom of industrial Lancashire, Kneale then discovered he suffered from a form of photophobia, a skin allergy making it impossible to spend more than the briefest time in direct sunlight without unpleasant consequences. "I'd just burn up after ten minutes. I can't go out in the sun — and the island is really very good at sunlight, it's what it's best at, if you want to sit on the beach or something. Of course, all that stuff I couldn't do. I loved it, but it didn't love me!"

There was plenty to occupy him indoors, though. On June 19, 1930, Kneale's brother was born: his parents named their second son Bryan. Kneale was also now of school-going age, and was beginning to develop a keen interest in reading.

"Always, on a Saturday, you went down to the local newsagent and bought comics — huge quantities of these things, mostly the Scots publications by DC Thompson. Great bundles came in by boat on Saturday afternoon, so you always went down there and got great wodges of these things, and swapped them, so everybody was terribly well read". Needless to say, reading comics was also a useful activity for a child who couldn't safely go out in the sun.

Although Kneale wasn't as yet beginning to write fiction, he was certainly being exposed to it, often of a more mature stamp than Scottish children's com-

of twelve feet by six — and looking up and seeing a curious sort of glowing thing in the sky... and it was the sun! Which you never saw, because the great damp of Lancashire was very concentrated, and you simply never saw really pure light. It was very easy to be ill." Subsequently young Tom had a serious brush with disease. "I was a very sickly creature at that sort of age, around five. I contracted something we don't know about, but it might have been acute rheumatism or it could even have been polio. You could get polio in those days quite easily. I remember seeing, again and again, small children, even smaller than myself, hobbling about the place with an iron structure on their leg to keep them together so they could walk. That was standard, very widely spread, that sort of thing." Thankfully, Kneale manage to shake off the infection without any such disability, although it left him with a lifetime of minor cardiac trouble.

His father had fast risen to the post of chief reporter in the *Bolton Evening News*, and was in sight of achieving his ambition of writing on the *Manchester Guardian*. But the Kneales were far from settled in Bolton, and their son's illness was the final straw.

"Partly I'm to blame", admits Kneale, "but my Mother had always wanted to go back to the island, and my Father was seeing nothing but depression of the worst kind then about to overtake Lancashire. The Great Depression was striking the area very hard, and everyone thought that the Isle of Man offered better prospects." As it turned out, the solution came in the form of a one hundred year-old Manx newspaper which was then up for sale. "Back on the island, my Father, along with his brother, bought an ancient local newspaper, about a hundred years old, called the *Mona's Herald*. It was enormously respectable, if not very exciting. His brother was already there, working on it in a rather unexciting way, but he thought if they could work together in running it, they might bring it back to life. So we all packed up and went back to the island." In 1928, therefore, six year old Tom and his parents moved back to live on their original home.

THROUGHOUT HISTORY, the Isle of Man has held a rather mysterious reputation. According to one myth, the Irish giant Finn MacCuill once flung a massive clod of earth at a similarly gigantic rival as he fled. The resulting hole became a loch in Northern Ireland, and the clod of Earth became the Isle of Man. A less romantic theory is that it became an island due to geological shifts nine thousand years ago: all 527 square kilometres of it sits in the Irish Sea roughly equidistant from any other landmass. It's never been conclusively proven where the name 'Man' stems from, although it's likely to have origins in a pre-Celtic tongue and is thought to mean 'mountainous land'. Certainly, it's known that Julius Caesar was referring to 'Mona' by 54BC. There's been a long, rich tradition of unique mythologies on the island, populated with hobgoblins, witches and elves, and wicked supernatural beings such as the enormous, noisy Boggane and the ghastly Phynnodderee. As late as the fifth century AD, when missionaries arrived to Christianise the populace, it was widely believed to be the home of a foreboding necromancer called Mannanan-Beg-Mac-y-Leir, who kept the island covered in mists to deter strangers. His terrifying powers would be unleashed, it was said, on any potential invaders, who would find one hundred ghostly warriors materialising to repel them.

MANX TOM

MANY OF THE ESTABLISHED facts about the legendary Manx born writer Nigel Kneale are rather misleading. For a kick-off, he was actually born as Thomas Kneale: throughout his writing career, he's adopted his middle name — Nigel — effectively as a pen-name. To his family and friends, though, he's always been Tom. He's also the most famous Manxman ever to be born in Lancashire. Because it was there, in Barrow-in-Furness, that Thomas Nigel Kneale came into the world, on April 28, 1922.

His parents were Lillian and William Kneale. His father had always gone by his middle name, Tom, and, as traditional at the time, his son was named after him.

"I wasn't actually born on the Isle of Man", Kneale says. "My parents are Manx, and my ancestry goes back about a thousand years: old Manx. My Mother was born on a little farm in the island, into a large family, up in the hills above Laxey, a little hill farm called Baldoon. They were all farmers and very proud to be, and saw themselves as a farming town. But then the bank, which had all their money, went bust — as banks did in the island — bang, bang, just like that — before there were any regulations to stop them doing so."

This financial catastrophe forced the family to relocate. "They had to quit the farm, sell it, and take jobs in Douglas," Kneale explains. "My grandmother bought a small boarding house, and my oldest uncle became a policeman, which was a shaming state. Another uncle became a joiner. They were all engaged in trades, and that was not the grandeur they had known when they'd been independent farmers. Actually, my mother much enjoyed it, because she met a lot more people and she had a good time! Then when the First World War came, she met my Father, who was then a junior journalist. They got married in 1920."

Unusually for the time, the couple elected to leave the island, and follow the husband's ambitions. "My father wanted desperately to write, and in the island then, there was no place where he *could* write, so he got himself a job over in Barrow-in-Furness." These were hard times to be living in industrial Lancashire, though. "The area was terribly poverty- stricken, because they'd had a huge steel works, manufacturing arms all through the war. And at the end of the war, the whole lot was pulled from under them. Nobody had a job, they were all on the dole, and it was desperately poor. My Father did a lot of social work there. I've still got a great clock of his to prove it: they gave it to him when he left. Then they moved south to Bolton, and he got a very good job with the *Bolton Evening News*".

As Tom Kneale senior began to develop a successful journalistic career, his young son was finding Bolton a rather unhealthy place to grow up. "I remember sitting outside in the front garden — that sounds rather grand, but it was all

Nigel Kneale, 1960.

THE MARTIAN AT THE TOP OF THE STAIRS PROLOGUE

HAVING RECENTLY TURNED EIGHTY, Nigel Kneale lives with his wife Judith in a leafy-green district of South London. Their neighbours include the actress Geraldine McEwan and composer Howard Goodall. This same house has been the Kneales' home for over forty years. Their children — daughter Tacy and son Matthew — grew up here, and have since moved away. The Kneales' living room is a quiet, unshowy testament to the extraordinary creativity of their family. There's a discreet shelving unit housing video copies of the many films and TV programmes that Kneale's scripted. There are a host of beautiful works by his artist brother, Bryan — including sculptures in the garden and an impressionistic portrait of Kneale himself above the sofa. Three rows of shelves hold books written by the family; volumes of Kneale's scripts and stories, the best-selling children's books that Judith has written over three decades, and the more recent addition of the award-winning novels by their son Matthew. Going right back to the early years of the previous century, there are compendiums of pieces written by Judith's father, Alfred, a Jew who lived in Germany before the rise of the Nazis. Recently rediscovered and republished, Alfred's works are something of a publishing phenomenon in modern Germany.

The stairs leading up are lined with striking photographs taken by Matthew on his travels around the world. On the second floor, at the top of the house, are two workrooms. One is Judith's, where she still writes and illustrates phenomenally successful children's books. Right next door is Kneale's study. Due to his advancing years, he doesn't get up here much anymore. The room has a wonderful view of a nearby common. It now contains a rocking chair, meant for the Kneales' new grandson. On the wall, there's the familiar three-legged emblem of the Isle of Man. There are more rows of books, from volumes on standing stones and Celtic traditions to Elizabeth Bowen novels and the plays of George Bernard Shaw, as well as several copies of *New Scientist*. There are also many stacks of scripts that Kneale's written over the years — some produced, some not. There are pictures of his children, and his beloved wife, and there's a home-made wall-chart, documenting the relative heights of the then-growing Tacy and Matthew through the sixties and seventies.

And then, there in the corner, virtually obscured by the door when it's open, there's a Martian.

It stands at a height of three foot, and dates back to the late 1950s.

Why do the Kneales have a Martian living in their top room? Well, it's quite a story.

Not Rocket Science

Introduction

MY OWN FIRST ENCOUNTER with the work of Nigel Kneale came very late on in his career, and strictly speaking it's a non-encounter. In 1979, when I was seven, ITV screened *Quatermass*, Kneale's belated 'conclusion' to the 1950s serials about the same character. I wasn't allowed to watch it. My parents, who'd grown up in the fifties, associated Quatermass with nerve-fraying fear and decided it would be too much for my young mind. I can't remember ever being stopped from watching any other programme.

A good friend of mine — he'll forgive me for mentioning that he's a shade older than me — tells a similar story. His Mother, whilst she'd been a WREN in the fifties, had gone on an outing to see the Hammer *Quatermass* films. They scared her out of her wits, and even today, it seems, the mention of the name Quatermass turns her white as a sheet.

It's a familiar tale in Britain. An entire generation seems to have grown up petrified by the work of Nigel Kneale. In the days before 'genre television' had been identified and compartmentalised, audiences *en masse* thrilled to Kneale's unique and inventive style. It had elements of what we now call horror, and a dash of science fiction, but it was more straightforward than that. It was just *good*. It's tempting to over-simplify Kneale's career, but along the lines of 'he wrote *Quatermass* and it was scary,' over fifty years he's written a staggering amount of original work, taking in film, television, radio and prose fiction. His quality control has remained inspiring. It's possible to argue that the *Quatermass* scripts are just the tip of the iceberg.

Writing for television might not be rocket science, but back in the early 1950s, it might as well have been. This was an entirely new field, a blank page, devoid as yet of techniques and established approaches. Many of today's leading television writers revere Kneale as the undisputed forefather of British TV drama. His work exerts a staggering and palpable influence even today, several decades after much of it was lost forever when the transmission tapes were wiped and reused. Nigel Kneale is not a household name in this country, as the likes of Dennis Potter and Alan Bleasdale are. This book is an attempt to explain why not and, more importantly, why he deserves to be.

Before we begin this biography, we'd like to say that, in our opinion, it is not suitable for children, or for those of you who may have a nervous disposition.

CONTENTS

A Headpress Book
Published in 2006

Headpress
Suite 306, The Colourworks
2a Abbot Street
London
E8 3DP
United Kingdom

[tel] 0845 330 1844
[email] info@headpress.com
[web] www.headpress.com

INTO THE UNKNOWN
The Fantastic Life of Nigel Kneale
Text copyright © Andy Murray
This volume copyright © 2006 Headpress
Design: David Kerekes & Miss Nailer
Editing: Walt Meaties, with thanks to Karl Wareham
Frontcover: *The Quatermass Experiment*, Hammer Films, 1955
Cover design: Graeme Green [w] www.quatermass.org.uk *
Frontispiece: Keith Hopewell (based on uncredited *Radio Times* art, 1953)
Backcover: Nigel Kneale in 1960, a martian, and *Quatermass II* (courtesy Lucas Balbo)
World Rights Reserved

*A Note About The Cover: A healthy thread developed online (the Roobarb DVD Forum
[w] www.zetaminor.com/roobarb) after the publisher of this book changed the original cover design
(which featured Keith Hopewell's frontispiece artwork). The new cover wasn't well received and forum
members quickly posted mockups of possible alternatives. One of these was better than our own,
and it is this one that now graces Into The Unknown.*

If not credited, all illustrations are from the collections of Nigel Kneale and Andy Murray.
Images are reproduced in this book as historical illustrations to the text, and grateful
acknowledgement is made to the respective filmmakers, studios and distributors.

British Library Cataloguing in Publication Data
A catalogue record for this book is available from the British Library

ISBN 1-900486-50-4
EAN 9781900486507

www.headpress.com

INTO THE UNKNOWN
THE FANTASTIC LIFE
OF NIGEL KNEALE

ANDY MURRAY

headpress